CONTENTS

Introduction

The aim of this Dictionary is to help you when you read about modern photography, image manipulation, digital photography and imaging. Anachronistic as it may seem, it remains true that people like you do continue to learn by reading. You read Good Old Books. You read pages from the Internet and you may even number among the rare few who read their software and equipment manuals. And you are likely to be amongst the millions who read specialist magazines – if only occasionally – in the hope of improving your grasp of the digital world.

This book can be your constant companion. You do not have to switch it on and wait for it to brush its teeth before it gets to work. You do not have to worry about its battery going flat. And it makes as fine a place as any to prop your coffee cup. So, any time you say 'Huh??' and 'Wha…??' or 'Say that again!' and wonder what that sputtering of letters could possibly mean, you simply open this dictionary up (having first moved the coffee mug) and take a look.

How it came to be written

A love of words combined with a deepest delight in anything to do with light is the real personal reason for this book. You could say this work is my homage to our ability to communicate with conceptual subtlety, yet technically missing the nuances. You could say this is the work of a sad, lonely nerd who prefers the company of the dullest kinds of books and his computer screen to that of warm-blooded beings. Or you could decide it is a testament to the ability of an over-elaborated language to confuse and obscure by hi-jacking the very means with which we reach across to one another's minds.

The book – or rather the fact that it is out-of-date even as I hit the 'Save' button – is also a tribute to the vivacity of a language growing faster than ever before, thanks to the verbal effluvia accompanying products and ideas streaming from every corner of science and technology. I have dealt with this problem not quite by ignoring it but by being highly selective. The dictionary reflects my tastes, my interests and idiosyncrasies in the hope that it will provide readers (and coffee-drinkers with demented, glazed eyes) with a one-stop check-point for the meanings and usage of technical terms.

Word-watching changes

The Dictionary's devotion to digital imaging and photography while largely ignoring the moving image is deliberate. For a start, I have enough trouble keeping up with these two fields, without all the areas of video, animation, CAD, 3D, film and broadcast media – each of them equally fast-moving, equally large – also demanding attention.

It is commonplace to note that the meanings of technical terms are changing rapidly as technology changes. The word-watching that has entertained me for the last twenty or more years suggests otherwise. The largest changes in the lexicon are mostly the addition of newly made-up words or acronyms – such as pixel, morphing, JPEG, SCSI – that never existed before. Then there is the emergence, from the shadows of technical arcana, of several words which have had to get used to wider public attention – terms such as fractal, gamut, greeking. These additions usually cause problems only because they are unfamiliar to most people; they seldom cause confusion.

The next commonest change appears to be the new meaning, or fresh colour, given to familiar words – such as 'bucket' in Bucket Tool, or 'blur' as in Blur Filter, or 'dithering' of colour reproduction. These words are not often the cause of confusion either: the context of their use usually makes it clear that a new and specialized meaning is intended, often one bearing little resemblance to the common sense of the word (look, for instance, at 'rubberstamp').

A fourth and comparatively small group of words have had their meanings transformed as a result of changes in technology. These are the culprits behind more confusion and misinformation than all the newly coined terms put together. Words such as 'alias', 'compression', 'output', even 'digital' and not least that master of confusion – 'resolution': someone has to keep an eye on them.

Tom Ang
London
2001

How to use the book

Most headwords are given definitions and explanations in plain English followed in some cases with precise technical definitions, further explanations or elaborations. Some references are also embellished with practical hints, longer discussion of an issue or just an informative curiosity: these are tucked into a nearby side-box.

To save space, a headword is represented in the subsequent text by a tilde: ~.

Where a headword admits different meanings, the variations are not exhaustive. The order in which they are listed reflects the priorities of photographic or imaging practice; not those of philology or lexicology.

The main subject areas covered are today's conventional and digital photography, digital imaging, photoelectronics and those aspects of computing, multimedia, the Internet, World Wide Web, publishing and printing, physics, chemistry and electronics which are cognate or relevant to photography or which writers on digital photography refer to.

Every reader or user of this work will, I am sure, find a definition or explanation in this dictionary that she or he thinks is definitely not correct (probably within the time it takes to turn a few pages over). And I am sure you'd be right: this dictionary is not a historical work. It must evolve with changes if it is to stay upright, afloat and remain alive. At over a hundred thousand words long, it surely contains errors and omissions despite the most careful checking and reference to authorities (who are gratefully listed at the back of the book). So, if you disagree with or have comments on any entry, or if you have suggestions for new entries please post your comments by email to

 angt@wmin.ac.uk

(and don't forget the definition if you are suggesting a new entry). All suggestions, opinions (rude or otherwise) received will be very gratefully acknowledged.

10-baseT

10Mbps Baseband modulation on Twisted pair: Standard for networking which allows data transmission up to 10Mbps (megabits per second). * An Ethernet standard using twisted pair cables. * Do not confuse with 10-base2 which is similar but uses coaxial cables instead. * Also known as thin Ethernet, or cheapernet.

100-baseT

100Mbps Baseband modulation on Twisted pair: Standard for networking which allows data transmission up to 100 Mbps (megabits per second). * Identical to 10-baseT apart from faster bit rate and shorter intervals between frames of data. * Also known as Fast Ethernet.

12-bit

Adjective: ~ depth: 12 bits per channel e.g. a RGB image with 12 bits per channel is a 36-bit image.

16-bit

Adjective: (1) ~ application: written to run on computers using 16-bit operating system e.g. Windows 3.1. (2) ~ colour, ~ sound: coding, bit-depth, monitor or video- or sound-card capable of resolving up to 65,536 different colours or levels or frequencies. (3) ~ operating system, ~ machine: one that

#

works with data or word length that is 16 bits or 2 bytes long, giving 2^{16} = 65,5336 variations or different words.

2-D

(1) Adjective: e.g. ~ graphic: two-dimensional graphic: artwork that creates, simulates or emulates a flat plane or object that has, or occupies, no volume. (2) Noun: two dimensions i.e. a flat plane; an extended object that occupies area but not volume.

24-bit

Adjective: (1) ~ colour, ~ sound: coding, bitdepth, monitor or video- or sound-card capable of resolving up to 16,777,216 different colours or levels or frequencies. * Often loosely abbreviated to 16.7 million colours. * Also called truecolour or trucolor. (2) ~ operating system, ~ machine: one that works with data or word length that is 24 bits or 3 bytes long, giving 2^{24} = 16,777,216 variations or different words.

24X speed

Twenty-four times faster than standard CD-ROM speed.
* Data can, at best, be read from or written to a disc at rates of up to 3600KBs.

3-D

(1) Adjective: e.g. ~ software, ~ graphic: three-dimensional software or graphic: one creating, simulating or emulating a solid or space or appearance of solidity or spatial qualities through use of 2-D representations of space or solids.
* Usually defined by three mutually perpendicular (i.e. orthogonal) straight axes. (2) Noun: three dimensions i.e. solid or space.

3-D head

Design of tripod head in which the camera can be adjusted in three mutually independent axes (i) about a horizontal axis at right angles to the optical axis i.e. to change elevation, looking downwards or upwards (ii) about an axis parallel with the optical axis i.e. to change orientation of the camera (iii) about a vertical axis mutually at right angles to the above axes i.e. to pan the camera.

32-bit

Adjective: (1) ~ application: written to run on computers using a 32-bit operating system e.g. Mac OS or Windows 95. (2) ~ colour, ~ sound: coding, bitdepth, monitor or video- or sound-card with same resolution as 24-bit but uses the extra 8 bits to improve efficiency in e.g. its data handling. (3) ~ operating system, ~ machine: one that can work with or process data or words 32 bits long or 4 bytes at a time.

When 32 is 16

Some machines – e.g. Apple Mac Plus – used a 32-bit operating system but the data buses – i.e. channels carrying information – operate at 16-bit. They are generally regarded as 16-bit machines.

35mm equivalent focal length

Focal length of lens which, on 35mm format, gives the same field of view as that of a lens used for a different format. * Used to compare effect of focal length of unfamiliar formats against the most familiar. * Particularly useful measure with digital cameras as the size of the image sensor is not standard e.g. a 10mm focal length on a 16mm sensor has a different view from 10mm focal length on a 12mm sensor.

36-bit

Adjective: ~ colour, ~ sound: coding, bitdepth, monitor or video- or sound-card: working with 36-bit data giving in theory billions of different colours or levels. * In imaging, up to 12 bits may be allocated to each of the R, G and B channels or it may be fewer bits, with the spare capacity used for other data such as masks and paths.

4X speed

Four times faster than standard CD-ROM speed i.e. data transfer rate is nominally 600KBs. * May refer to either reading speed or writing speed.

8X speed

Eight times faster than standard CD-ROM speed i.e. data transfer rate is nominally 1,200KBs. * May refer to either reading speed or writing speed.

9300

White balance standard close to daylight: used mainly for visual displays as its higher blue content (compared to D6500) gives better colour rendering in normal indoor lighting conditions.

See D6500; white.

When 36 is better than 24

*Quality scanners, scanning backs for cameras and graphic standards may work in 36-bit or higher (e.g. 42-bit) in order to provide smoother tonal gradations and superior shadow and highlight detail. In practice not all of the data length is used: spare bytes may be used for specific types of data or as alpha channels. Few image editing software can handle 36-bit data: Photoshop can open 36-bit files but few effects and controls will work. However, 36-bit or 42-bit scans sampled to 24-bit are generally better than 24-bit scans. * And if you really want to know, 36 bits gives 2^{36} or 68,719,476,736 variations.*

Å

Ångström unit: unit of length: 10^{-10}m, formerly used as a measure of wavelength of light. * Use nanometre (nm) in preference e.g. green light of 55Å is of wavelength 550nm.

A

Ampère: unit of electrical current.

A / B

To A/B (pronounced 'ay-bee') is to make subjective comparisons between two signals or samples – e.g. of photographic prints – by switching rapidly back and forth between them in order determine which is better.

abaxial

Off or facing away from optical axis e.g. rays of light going obliquely through lens system.
> *See paraxial.*

Abbe condenser

Optical component used in microscopes placed on a focusing mount to collect and focus light from a light-source directly onto the object under examination. * Features a two-lens construction with large numerical aperture suitable for medium and high-magnification microscope objectives. * Named after inventor, Ernst Abbe.

Abbe constant

Physical constant for optical media. * Defined as the ratio of media's refractivity to its dispersion. * Expressed as V-value or η-number (read as nu-number or nu-value). * Higher V-values indicate less variation of dispersion with wavelength, i.e. less rainbow and more nearly equal refraction at all wavelengths. * The reciprocal of dispersive power.

Abbe number

Measure of different amounts by which light of different colours is bent by glass i.e. an index of dispersion for given refractive medium. * Often plotted against refractive index in catalogues of glass types: higher Abbe numbers (i.e. higher dispersion) normally go with higher refractive indices.
See dispersion.

Abbe sine condition

A condition that must be met by any lens to be spherically corrected and free from coma near the lens axis. * It is expressed as: $u'/\mathrm{Sin}\ U' = u/\mathrm{Sin}\ U$ where u, u' are the angles of the entering and emerging portions of a paraxial ray from object to image and U, U' are the corresponding angles of a marginal ray. * First stated by Ernst Abbe.

aberration

Defect or imperfection of optical image caused by inabilities of lens system to form perfect image. * Collective name for deviations of image from that predicted by geometrical (Gaussian or paraxial) optics.
See coma; astigmatism; distortion; field curvature; chromatic aberration; diffraction.

aberration, spherical

Defect in image caused by rays of light from edge of lens tending to be focused nearer lens while rays entering lens near axis are focused further away. * That is, focal length depends on distance between the lens axis and point of entry of the light. * Spherical aberration is negative (under-corrected) when rays from the outer zone are focused closer to the lens than rays passing through the central zones; vice versa for positive spherical aberration (over-corrected). Direct aberration that affects entire image field. Worsens with square of the diameter of the lens and as lens focuses nearer. * It is improved by stopping down.

Abney effect

Visual phenomenon of apparent change of hue or colour value following a change in purity. * The change alters colour saturation.

Rationalizing aberrations

A perfect lens is one displaying no aberration. This means (i) it reproduces a point in the subject as a point (ii) it projects a flat plane facing square on to the lens as a flat plane (iii) it reproduces a straight line anywhere in the image field as a straight line (iiii) it reproduces accurately all the colours in the object, without bias or deficiency.

absolute magnification

Measure of enlargement seen when an object is positioned at the focal point of the magnifier lens. * For calculation, taken as equal to the distance of distinct vision (250mm) divided by the equivalent focal length of the lens: e.g. where focal length of lens is 100mm, absolute magnification is 250/100 = 2.5X.

absolute temperature

Measure of thermodynamic temperature. * Measured in Kelvin where 273.16 K is 0°C, the triple point of water.

See colour temperature.

absorbance

Synonymous with density.

absorptance

Measure of amount of light absorped (or absorbed) during reflection or transmission. * Equal to one minus reflectance or one minus transmittance.

See absorption.

absorption

(1) Partial loss of light during reflection or transmission of a light beam. * Light or other radiant energy falling on a material may transfer, and therefore lose, some energy (usually in form of heat). * Selective absorption of light – i.e. some wavelengths are absorbed more than others – causes phenomenon of colour. * Highly selective absorption is exploited in filters, dyes, colourants, etc. and is central to subtractive methods of colour synthesis. (2) Take-up or assimilation of a substance by another e.g. water soaking into paper.

See adsorption; unwanted absorption.

accelerator

(1) Device designed to speed up a computer's operations e.g. by providing specialist processors optimized for certain software operations. * Photoshop accelerators speed up certain processor-intensive operations e.g. Unsharp Masking and operations which require the whole image to be loaded into memory; may also be used for running large, high–resolution monitor screens or for playing games software. * Usually implemented as a card or board that plugs in to the motherboard. (2) Component of chemical developer formulation that increases its speed of action by creating alkaline environment to enable the developing agent to work efficiently.

See additive.

A

Less but not too little

For today's photography, a 30° acceptance angle for exposure metering is too wide, too indiscriminate – which rules out most camera meters. But a 1° angle is too fine: it is too easy to make errors by choosing the wrong area as the key tone. In practice, I find about 5° (when using a standard lens) is ideal: this is approximately 2-3% of the picture area or a 5mm diameter spot on a 35mm focusing screen.

acceptance angle

Measure of maximum spread of light being taken or received by an optical device e.g. exposure meter, wave guide. * The field of view of a detector or guide. (1) For hand-held exposure meters, it is typically approximately 30°, and 1–3° for spot meters. * For cameras with TTL meters, it varies with field of view of lens in use. (2) In fibre optics, it is measured as the semi-vertex angle of the cone of optical power capable of being coupled into bound modes: hence also called acceptance cone.

access time

Time interval between the time a request is issued for an item of information or data and the moment it is found. * The call for data may be to computer memory or to a storage device such as hard-disk, CD-ROM etc. * Random Access Memory offers the shortest access time while those for storage devices are relatively much longer. * NB: you still have to add the time to get the information off and transferred to where it's needed.

accommodation

Adjustment in vision to keep objects at different distances sharply in focus. Change in shape of lens of eye by action of ciliary muscles to maintain lens' focal point at the retina surface. * It is normally automatic (brain reflex) action which can easily be brought under conscious control.

See presbyopia.

achromat

Lens type in which light of two wavelengths are brought to common focus. * An achromat combines a positive lens with a negative element whose dispersions are in opposite directions; these tend to cancel out chromatic aberrations with a peak correction for two wavelengths so light of these wavelengths is focused at the same point on the lens axis. * Uncorrected colours constitute the secondary spectrum.

See chromatic aberration.

achromatic colour

Distinguished by differences in lightness but not of hue or colour e.g. black or white or greys.

See lightness.

acquire

(1) Verb: to download or receive image from capture device e.g. digital camera, scanner. Hence (2) Adjective: ~ plug-in: utility program which adds to an applications program the ability to import an image file, often adding ability to control

the capture device; or: ~ module: a stand-alone utility program used for controlling a capture device and downloading an image.
See TWAIN.

actinic
Adjective: ~ electromagnetic radiation, ~ light: that which is able to produce a chemical change e.g. adsorption of blue light by silver halides creates the photographic latent image.

actinic focus
The point in space at which an optical system focuses the most chemically effective part of the electromagnetic spectrum for a given actinic reaction. * E.g. with blue-sensitive black & white printing papers, the actinic focus of the enlarging lens is the focal point for blue light – hence the practice of focusing the baseboard image with a blue filter when using lenses with under-corrected chromatic aberration. * Also known as chemical focus.

actinometer
(1) Early form of exposure meter used to measure light levels by its darkening effect on prepared samples, then comparing the darkening with standard patches. (2) Detector for measuring the intensity of photo-chemically active radiation, particularly from the sun e.g. fluorescence.

activator
Chemical added to formulation to improve or encourage development e.g. by providing alkaline environment that initiates the activity of built-in developers.

active AF
Active auto-focus: system using a beam of energy to measure distances or range-find for purpose of focusing lens. * Usual arrangement is to use infrared beam which is swung in an arc over the subject area: the nearest point to reflect light is detected and the angle of the beam measured: from this the distance can be calculated, given the distance between the sensor and the source. * Another design uses an ultra-sound beam: the shift in phase of the reflected ultra-sound is measured to calculate the distance.
See coincidence rangefinder; passive AF.

active medium
Light-transmitting medium through which radiation of certain wavelengths is increased in strength i.e. exhibit gain, rather than loss.

active optics
Optical elements whose shape or profiles are continuously

Through the glass, bluely
With blue-sensitive black & white printing papers, the actinic focus of the enlarging lens is the focal point for blue light – from which arose the now largely obsolete practice of focusing the enlarger baseboard image with a blue filter when using lenses with under-corrected chromatic aberration. Modern lenses are very well corrected. Besides, with increased use of multigrade papers, the actinic focus is spread over more wavelengths.

deformed by various means in order to correct or control the performance of an optical system. * E.g. the large, inherently deformable mirrors of mercury used in astronomy; and arguably the mammalian eye is a supreme example.

acutance

(1) In photography: the density gradient across an edge separating light from darkness. * This can be measured with a micro-densitometer and correlates with the subjective assessment of sharpness or definition: a sharp gradient (i.e. rapid change equates with higher sharpness). (2) In machine vision, a measure of the sharpness of edges in an image: equals the average squared rate of change of density across the edge divided by the total density difference from one side of the edge to the other.

adaptation

Changes in a detector or visual system which make it more or less sensitive to light or to a quality of light, such as hue.
See dark adaptation; chromatic adaptation.

adaptive colour

Process in which file size is reduced by reducing the number of different colours in an image in such a way as to minimize loss of image quality by building a colour table based on the most frequently occurring colours. * Required when saving a high-colour image to, e.g., GIF format which can code for only 256 colours.

adaptive compression

Compression technology that alters or adapts the model used for compression according to changes in the character of the data stream as it is processed e.g. LZW compression.

adaptor

Accessory that allows devices with otherwise incompatible connectors, plugs or mounts to work together. (1) Filter ~: – e.g. Cokin holders, step-up rings – allow different filters and different sized mounts to fit onto lenses. (b) Lens ~: – e.g. T-mount, Tamron Adaptall – these allow lenses to be used with different makes of camera. (c) Cable ~: – e.g. USB-to-Serial, Ethernet-to-Serial, SCIS-toUSB: these allow interface-specific devices to work with a far wider range of peripherals than otherwise possible.

That's not all, folks

Managing to plug two machines together via an adaptor is like making two party guests hold a piece of string: communication is not guaranteed. You are likely to need specific driver software to get them talking, let alone working together.

ADC

See Analogue-to-Digital Converter.

additive

(1) Adjective: ~ process: the production of a range of colours by the adding, mixing or superposition of two or more lights

(note: not pigments) of different colours. * Compare with subtractive colour. (2) Noun: substance added to another substance – usually to enhance its reactivity, keeping or other qualities.

additive colour printing

Method of making colour prints from colour negatives or transparencies by making three successive exposures of varying duration in register through blue, green and red filters of fixed density. Any colour print material used for subtractive colour printing may be used for additive colour printing; differences in results are indistinguishable but additive method makes it possible to create colour prints using only a black & white enlarger.

See dye transfer.

additive colour synthesis

Combining or blending light of two or more colours, rather than using colourants, in order to synthesize, simulate or give sensation of another colour. * Any colours may be combined. * For effective colour synthesis, three primary colours are needed e.g. red, green and blue. * Colours synthesized additively are most vivid (saturated) when they result from combining a pair of primary colours; if another primary is introduced, colour becomes less saturated. * Lightness of colour varies with intensity of primary colours. * An equal mixture of the three primary colours produces white light.

additivity of luminance

The luminance of a blend or mix of two or more light-sources is the sum of the separate luminances of the component sources.

address

Reference, code or datum which is used to locate, signify or identify the physical or virtual position of a physical or virtual item e.g. memory in RAM, item on CD-ROM or DVD, sector of hard-disk on which data is stored, a point in space e.g. that corresponding to a dot on a substrate fired from an ink-jet printer, and so on.

addressability

That characteristic of displays which measures its resolution by the number of pixels in the horizontal and the vertical axes of e.g. LCD screen or a cathode-ray tube.

addressable

Property of a point in space that allows it to be identified and referenced by some device e.g. a laser printer that can

A

print to 600 dpi can address only the 600 or so equally spaced points that lie on a line one inch long; no point that lies in between these points can be addressed.

See dpi.

adjacency effects

Group of phenomena of silver halide development characterized by the small details in an image showing variation in their density-exposure relationship compared with the density-exposure relations seen in larger regions of the image. * So-called because the effects occur at the junction of areas of different exposure. * Also known as edge effects.

See Eberhard effect; Sabattier effect.

adsorption

The selective accumulation or concentration onto a surface of a solid sample of another substance – usually present in gas or vapour phase – e.g. in development of daguerreotype. * Avoid confusion with absorption.

aerial fog

Non-image-forming density on photographic material caused by oxidation of developer by air. * May occur when print is taken out of developer too often.

aerial image

Image projected from an optical system which can be seen or observed directly, without having to be caught on a viewing screen. * The real image of an optical system projected into and focused in space.

See real image; virtual image.

aerial perspective

Visual phenomenon in which distant objects appear less saturated in colour, lighter in tone and less distinct in outline than those closer to the observer, due to dispersion of light by particles in the atmosphere.

afocal

Adjective: ~ optical system: one whose object and image points lie at infinity. * Literally: having no focal length. * E.g. lens attachments for increasing or decreasing apparent focal length of fixed lens cameras: their afocality allows the original lens to retain its normal focus setting and focusing range. * The magnification of the image is the ratio between the diameters of the entering and exiting pupils.

after-image

The image or stimulus remaining on a detector after the primary stimulus has been removed. * With the human eye,

We don't like common illusions

Arguably an optical illusion in that one surmises the distant objects are not truly lighter in colour or lower in contrast, etc., but only give the appearance of being so.

the after-image usually appears in the complementary colour of the primary stimulus e.g. a bright red spot in the visual field is momentarily seen as a cyan spot when the red spot is removed. * With certain types of exposure meters such as selenium cell, the after-image due to a strong light can render inaccurate a reading of low light levels if taken immediately after the exposure to strong light.

ageing

Changes in materials which take place over time, usually accelerated by heat, exposure to certain chemicals and humidity. * Changes may not always be deleterious: printing papers may improve in tonality with ageing; some chemicals produce better results when they are not freshly made up.

agitation

Noun: (1) irregular or random movement of processing liquids over material being processed. * Normally intended to replenish exhausted chemicals with less exhausted or more active chemicals. (2) Process of causing or ensuring a random or an irregular movement of processing liquids over the material being processed. * Methods include (a) inverting processing tank (in hand-processing) (b) blowing inert gas e.g. nitrogen through processing bath (c) stirring chemicals either with paddle or through action of rollers transporting film or paper (d) tilting processing dish (in hand-processing of prints or large-format film).

AGP

Accelerated Graphics Port: specification enabling high-performance graphics for e.g. video, 3-D effects and games. * The data bus runs at 66MHz and can sustain transfer rates of up to 533MB (more like 528MB) per second. * Features direct connections between the video controller and main system memory. * Developed by Intel and used in G4 and later Apple Macs and PCs.

air bell

Bubble of air left on surface of material when submerged in liquid. * With film or print, this may cause area under air bell to receive less development than the rest of the material, leaving a neat spot or ring of different density from the surroundings.

Airy disk

The bright spot in the centre of the focal point of an aberration-free optical system imaging a uniformly illuminated source. * Strictly: the centre – i.e. everything interior to the first dark ring – of the focal point diffraction

Agit-propre
Agitation in daylight tanks varies considerably depending on how full the tank is, particularly with tanks that hold three or more reels of film. When processing only one film in a multiple tank, you should (a) load empty reels in and (b) fill the tank with as much liquid as you would for a full load of film. If not, you will be giving far more agitation than with a full tank.

pattern of a uniformly irradiated, fully corrected, circular optical system.

Albada finder

See bright-line finder.

albedo

Ratio of radiant energy reflected from a rough surface to radiant energy (e.g. total solar radiation) incident upon it. * Snow has a high albedo: it reflects most of the radiant energy; black soot has low albedo: it absorbs a great deal of radiant energy.

algorithm

Any set of rules that defines the repeated application of logical or mathematical operations on an object (e.g. a set of numbers) to produce a solution or new object e.g. the long division rules for dividing a large number by another is an algorithm, as is the rule for converting degrees Celsius to degrees Fahrenheit. * Used widely in image processing operations such as filter effectss, blurs and layer modes: each visual effect is obtained by applying appropriate algorithms to each pixel value.

alias

(1) Literally a representation or 'stand-in' for the original continuously varying signal or object e.g. a line, a sound etc. that is the product of sampling and measuring the signal to convert it into a digital form. * Commonly used to refer to visible defects of sampling e.g. stair-stepping, jaggies or stepped gradations that occur when the sampling frequency is not sufficient to preserve the detail. (2) In Mac OS, a file icon that duplicates the original. Used to open application programs, files or folders etc. which can be placed anywhere.
 See anti-aliasing; Nyquist rate.

aliasing

Causing to make visible the defects in the scanning or other digitization process. * It is the visible result of using an input resolution which is too low to preserve the detail i.e. the sampling frequency is less than double the spatial frequencies of the image. * In fact, where there is detail with spatial frequency greater than half the sampling frequency, it will actually appear in the sampled image to be of a far lower frequency.

allochromy

Physical phenomenon in which the wavelength of the light emitted in fluorescence is different from that absorbed.
 See fluorescence.

alpha channel

Unused portion of a file format: in image processing it may be e.g. a spare 8-bit portion of a 32-bit image file. * Such files are designed so that changing the value of the alpha channel can change properties of the other channels e.g. transparency/opacity of some or all of the rest of the file.

alphanumeric

Adjective: (1) Type of display that shows letters and numbers. (2) Data that permits use, manipulation or storage of both letters and numbers.

alychne

Straight line on the CIE chromaticity diagram on which colours of zero luminance lie: used to calculate e.g. colour gamut of a reproduction system such as a monitor.

ambient light

Existing light or that present in the immediate environment or which is not subject to direct control. (1) In photography, usage tends to distinguish such light from artificially introduced or easily controlled lighting e.g. from flash or other luminaires. (2) In physics, usage refers to light that may interfere with a detector or machine vision system and which is treated as noise by the system.

ametropia

Defect of eyesight in which lens is not focused (accommodated) at infinity when at rest. * Short-sightedness and long-sightedness are the two forms of ametropia.

Amici prism

See roof prism.

AMLCD

Active-Matrix Liquid Crystal Display: type of display using micro-electronic switches in series with each pixel to isolate pixels in order to turn them on or off individually. * By applying matrices of coloured filters – of red, blue and green – on the pixels it is possible to provide colour displays.

ammonium thiosulphate

Soluble salt of ammonium which is used as a rapid fixing agent i.e. reacts with silver halide salts (i.e. the undeveloped part of emulsion) to form a water-soluble compound. * Also known as rapid fix.

See sodium thiosulphate.

ampère

Unit of current or rate of flow of electricity. * Unit A; informally: amp. * In a circuit, current increases as resistance decreases, and vice versa, for a given voltage.

amplitude

Strength or quantity of a radiated energy such as light. * In optics: magnitude or maximal value of the electric vector of a wave of light.

anaglyph

Image that appears three-dimensional when viewed through a pair of spectacles of complementary colour filters. * It is composed of two superimposed views of slightly different perspective, one printed in a colour complementary to the other and printed slightly out of register. *The filters in the spectacles are arranged so that each eye sees only the image intended for it e.g. green filter over left eye sees the green, left-hand, image while cutting out the red, right-hand, image. * It is a hopelessly clumsy technology, but every year it re-surfaces in a new guise, with new promises.

analogue

Effect, representation or record that is proportionate to the phenomenon, physical property or change being represented or recorded. * E.g. analogue signals vary proportionately to the physical change they represent e.g. high power is represented by a higher waveform; analogue records are based on changes proportionate to the effect being recorded e.g. higher silver densities represent brighter light. * Almost all recording devices start off with an analogue response – an increasing charge represents brighter light – before a digital code is assigned to the response.

See digital photography.

analogue-to-digital converter

Process of representing a continuously varying signal into a set of discrete or digital values. * For conversion to take place (a) the source signal must be sampled at regular intervals – the quantization rate or interval: the higher the rate or finer the interval, the more accurately can the digital record represent the analogue original (b) the quantity or scale of the analogue signal must be represented by binary code – the greater the length of the code or the greater the bit depth, the more precisely the values can be represented. * Analogue-to-digital conversion can take place largely in hardware e.g. DAT recorders or in a mixture of both hard- and software e.g. scanners. * Also known as ADC.

See aliasing; DAC; digitization; quantization.

analytical density

See integral density.

anamorphic

Adjective: ~ distortion, ~ lens, ~ device: one demonstrating a difference in magnification along mutually perpendicular axes. * Anamorphic lens systems usually have one or more cylindrical surfaces: used to distort images and/or restore them to their original geometry.

anastigmat

Design of lens which is corrected for astigmatism: such a lens usually offers excellent definition over most of the image plane. * It should demonstrate a zero astigmatic difference for one or more off-axis zones in the image plane.

angle of convergence

(1) The angle formed by the lines of sight of the two eyes when looking at an object. (2) The angle at which a ray approaches the optical axis.

angle of reflection

The angle formed between a ray of light normal – i.e. perpendicular to the reflecting surface – and the reflected ray. This angle is equal to the angle of incidence and lies in a common plane with it.

angle of refraction

The angle formed between a refracted ray and the normal – an imaginary line perpendicular to the surface. * It lies in a common plane with the angle of incidence.
See refraction; Snell's Law.

angular resolution

See optical resolution.

animation

Simulation of movement by using a rapidly changing sequence of still images – usually graphical or drawn – but which are not recorded from live movement with e.g. video or cine camera. * With digital animation, entire movements can be created from a single original image using a variety of transformations.
See morphing; tweening.

aniseikonia

Difference in the size or shape of images formed by a pair of eyes. * Caused by differences in the refractive index of lenses of each eye (anisometropia) or differences in the distribution of retinal cells.

anisophotic light-source

One that emits radiant energy unevenly across the visible spectrum. * Most light-sources are anisophotic but discharge – e.g. sodium lamp – sources are highly anisophotic.

Anamorphous analogue

Anamorphic lenses are effectively analogue image compression devices: a wide field scene can be squashed in from the sides in the camera so that it fits onto standard format film for recording. To uncompress the image on projection, corresponding anamorphic optics expand the image to fill the screen in the original true geometry.

anisotropic

Adjective: ~ crystals, ~light-transmitting liquid: exhibiting different properties when measured on different axes of the crystal. * E.g. propagation of radiant energy e.g. refractive index changes with axis; direction of rotation of polarization changes with axis.

anomalous trichromatism

Abnormal perception of colour due to lower than normal sensitivity to one or more of red, green or blue. * The technical term for 'colour blindness'. * There are three kinds according to whether it is the red cone cells of the retina (protanomaly), green cones (deuteranomaly) or blue cones (tritanomaly) which have lowered sensitivity.

ANSI

American National Standards Institute: organization of industry groups formed 1918 to establish and adopt standards and specifications. * Represents USA in ISO.

anti-aliasing

Smoothing away the jaggies or stair-stepping in an image or computer typesetting. * In image processing, an algorithm is applied to even out the density difference between the boundary pixels and their neighbours (i.e. filtering); other techniques include pre-filtering at the display resolution, linear intensity analysis. * In printing, e.g. laserprinters, the size of dots is varied so that the smaller dots fill in the 'step' and reduce the appearance of a stair. * The net effect of any regime is to smooth jaggies to give the appearance of increased resolution.

> See alias; Nyquist rate.

Aliases everywhere

Arguably every digitized or quantized facsimile of a continuous variable is aliased: what really matters is whether we can perceive it or not. And aliasing is in the eye of the perceiver. So the need for anti-aliasing depends on use and consumption.

anti-fog coating

Coating applied to exterior surface of optical component designed to stop the condensation of moisture. * Techniques include using an organic polymer coat that absorbs moisture evenly, to prevent the beading of moisture that obscures light transmission.

anti-foggant

Chemical added to light-sensitive emulsion to restrain development of non-exposed silver halide. * Chemicals classically used include potassium bromide, benzotriazole. * Development products also have a restraining effect. * Also known as restrainers (particularly organic anti-foggants).

anti-halation layer

(1) Light-absorbing coating applied between a photographic emulsion and back support in order to prevent reflection of

stray light from the film support material back into the light-sensitive area. * Also known as anti-halation coating. (2) Light-absorbing material – e.g. black velvet – laid under a brightly light subject to prevent the formation of a secondary image when examined or photographed.

See halation.

anti-Newton

Treatment for contact surface of glass or other transparent material to prevent formation of Newton's rings: patterns of rings or fringes caused by interference. * The glass appears rough in a polished way: the bumps and dips are smooth as can be seen in glass slide mounts and glass holders for negatives, etc. used in enlargers and film-scanners.

anti-reflection coating

Transparent material applied in a thin coat of one or more layers to a lens surface to reduce the amount of light reflected from the surface. * The conditions are: (a) ideal thickness for a single-layer coating is one-quarter of the wavelength at which reflectance is to be minimized and (b) the refractive index of the material should equal the square root of the product of the indices of the materials on either side of the coating (therefore it nearly equals the square root of the refractive index of the glass as the other material is usually air).

See multicoated; vacuum deposition.

Multi-elements, mighty reflection

If it were not for anti-reflection coatings of incredibly high effectiveness, it would be impossible to have today's lenses using multiple elements – more than 12 is not unusual these days – for the numerous interfaces would reflect so much light, images would be very dim and very flat.

antisolar point

A point in space reached by the extension of the straight line connecting the sun to the observer's eye looking at the sun through the atmosphere of the earth. * NB: this point lies above the line joining the actual position of the sun and the observer's eyes because of the refraction of the sun's rays by the atmosphere.

aperture diaphragm

(1) System of blades located in an optical system in order to determine the diameter of the bundle of light transmitted through the lens. * Its effective diameter, if not circular, is the diameter of a circle with the same cross-sectional area. (2) A second-stage adjustable iris diaphragm in an optical system, standard in microscopy. * Usually located beneath the light condenser of a transmitted light microscope and used to adjust the size (i.e. conic angle) of the cone of light entering the objective, within the limits of the condenser's maximum aperture. * Also known as the iris diaphragm.

See f/number.

A

aperture grille

Type of colour monitor display technology. * The name refers to the screen of extremely fine vertically arranged wires carrying varying charges designed to direct the aim of the stream of electrons to hit a mosaic of red, green and blue phosphors in a cathode-ray tube. The screen therefore lies between the screen and the electron gun consisting of the accelerating and focusing electrodes. * Two horizontally strung wires prevent the vertical wires from vibrating.
See shadow mask.

aperture stop

A physical reduction of the diameter of the light bundle allowed to pass through a lens. * Usually serves to reduce internal lens reflections and veiling flare. * May double as a lens retainer.

aperture-priority

Aperture-priority automatic exposure control: semi-automatic exposure control in which user varies lens aperture setting or f/number and the camera system adjusts shutter time to give the correct exposure (for given film speed setting) according to scene luminance.
See evaluative metering.

APEX

Additive System of Photographic Exposure: used to calculate camera exposure based on lens aperture, shutter time, exposure value, luminance level and film speed.
See value.

aplanat

An optic corrected for spherical aberration and coma. * Usually corrected for one wavelength and specific bundle of rays. * The system satisfies the Abbe sine condition. * Also called an aplanatic lens.

apochromat

An optical system in which chromatic aberration has been corrected to the extent that three representative colours are brought to a common focus. * An optical system or lens in which the secondary spectrum has been reduced to insignificant levels. * This requires the use of specialized glass, with low or anomalous dispersion and uses at least three components of different kinds of glass. * In photography, the term is usually applied only to longer focal length lenses (180mm and above). * Also called an apochromatic lens.
See fluourite.

Once were uncorrected

Apochromatism in long focal length was once a dream of spotty technicians but is now commonplace amongst the top-grade long toms from the likes of Canon, Nikon, Zeiss and so on. It's been made possible not just by the invention of glasses with unusual dispersion properties but also the improvements in multi-coating that have made it possible to use many elements without losing quality.

apodization

(1) Removal of zero values as required in e.g. image analysis calculations of modulation transfer function and point spread function. (2) Using a filter with variable transmission across its radius and situated at the aperture stop of a lens in order to modify the optic's diffraction pattern or point spread function. * Low transmission at the centre of the aperture improves high frequency performance, while lower transmission at the edge favours low frequencies.

apostilb

Unit of luminance: a surface of 1 metre square with luminance 1 apostilb emits 1 lumen into a hemisphere. * Unit is candela per square metre.

apparent contrast

The perceived brightness difference between the lightest and darkest areas of a target or subject. * Measured by the subject luminance range i.e. the difference between the highest and lowest luminance of a subject.

apparent luminance

The perceived brightness of an object being viewed through an optical instrument. * This varies directly with the effective aperture of the optics but may also vary with the apparent contrast as well as with the ambient light level.

apparent visual angle

The angle between two lines drawn from the furthest extents of an object to a viewer; the angle subtended by an object at the viewer. * It varies with the size of the object, its distance from the viewer, the intervention of a refractive medium (e.g. water) and whether the object is viewed through an optical instrument.

application software

Computer program designed to do a particular job e.g. edit images, compress files, convert files from one format to another, produce files suitable for printing, create multimedia content, and so on. * Application software may be very large and complicated with many features but can be compact and highly specialized e.g. to capture screen, write to CD-writers. * Most are specific to a particular computer platform or operating system.

apps

Slang: application software.

APS

Advanced Photo System: coordinated system of film cartridges, film, information interchange between cartridges

A

and camera and with processing laboratories. * Format 30x17mm (which is 40% smaller than 135 format). * Cartridges are easy to load, and cameras unwind the entire roll prior to exposure so film is rolled back in as it is exposed. * Film speed, film type, length of roll etc. are automatically input into cameras. * Other features include: possibility of using three different print formats; mid-roll interchange; data imprinting; picture quality improvement.

Arago spot

The spot or point of light that appears in the centre of a shadow – cast by light coming from a point source – of a circular object. * A phenomenon of diffraction.

archive

Long-term storage of computer data files, usually large files that no-one dares to delete but does not expect ever to refer to again, justifying the continued use of slow-working media such as DAT. * Requires stable media with good keeping properties; lows costs per megabyte; reliable and consistent media; confidence in long-term supply of media.

area concentration

The ratio of aperture area over receiving area for a given lens. * Also called geometric concentration.

area detector

See array.

arithmetic speed

System of denoting film speeds in which doubling steps represent twice the speed or sensitivity. * E.g. a change in speeds from 50 to 100 represents twice the sensitivity i.e. for a given scene luminance, half the exposure is needed for the same density.

See logarithmic speed.

array

Arrangement of image sensors. * They come in two main configurations. (i) Mosaic, matrix, grid or wide array: rows and rows of photo-sensors or detectors are laid side-by-side in a grid pattern to cover an area. * The rows define the number of pixels per line and the number of rows define the number of lines. * The grid covers the whole field of view so an image can be grabbed all at once. * In some devices, the grid may be moved around under the scanning bed to increase or decrease resolution. (ii) Linear array: a single row of sensors or set of three rows e.g. in a flat-bed scanner. * The number of sensors define the total number of pixels available. * As the sensors do not cover the entire field of

view, they are usually set up to sweep over or to scan a flat surface: in this case the resolution on the sweep axis may be determined by the fineness of stepper motor movement – which may be higher than that of the sensor frequency.

artificial daylight

Illumination that approximates natural daylight in its spectral properties (a) for photo-sensitive materials e.g. 'blue' flash-bulbs or (b) to deliver a colour rendering index close to that of daylight e.g. daylight fluorescent lamps.

ASA

American Standards Association: now ANSI. * Remembered as designation of arithmetic film speed.

ASCII

American Standard Code for Information Interchange: (1) Coding system using 7 bits to generate 128 keyboard characters: more or less standardly used in programming keyboards to translate keystrokes into characters which can be read by the computer. * Oddly, the main exception was IBM which used a standard called EBCDIC. (2) Simple word-processing file format widely used as almost every word-processing program will read it. * Identified in DOS files by .asc suffix. * Pronounced 'askey'.

aspect ratio

Ratio between width and height (or depth). Key property of film formats as well as in publishing and film media. * E.g. the sides of the 135 or 35mm format are nominally 24x36mm, so aspect ratio is approximately 1.5:1; for 5x4" or 10x8" it is 1:1.25. * Note for precise work, image dimensions on negative should be measured.

aspheric

Lenses with one or more surfaces which are not spherical i.e. part of a sphere. * Used in higher-quality optics and increasingly in consumer-grade optics to correct aberrations which would be otherwise impossible, or need many more elements to correct. * Difficult to make: may be moulded from precision moulds for smaller elements or ground using special processes.

asymetric

Design of lens in which the groups or components either side of the diaphragm vary considerably e.g. retrofocus and telephoto lenses.

See symmetric.

astigmatism

Optics and optometrics: aberration of optical system which

When daylight's green

Daylight fluorescent lamps may produce light that seems cool and white, with good rendering of colours, but colour film thinks different. It will still need filtration or correction after scanning.

A

causes image detail in one axis to be focused at a different plane from image detail in another e.g. a spoked carriage wheel can have its spokes rendered sharp but not the wheel rim, or the rim can be sharp but the spokes will be out of focus. * In primary astigmatism, the axial separation of the tangential and sagittal image planes. * In radial astigmatism, the aberration increases with increased radius or field angle: a large circle centred on the optical axis is less sharp than a smaller circle centred on the optical axis.

ATM
(1) Asynchronous Transfer Mode: a technology for broadcasting large amounts of data at a time i.e. broadband. (2) Adobe Type Manager: software utility designed to improve display of fonts on monitors.

atmospheric attenuation
The loss of brightness of a beam of light due to the atmosphere. * Reduction in luminance of a light beam due to absorption and scattering along its path through the earth's atmosphere. * Also known as atmospheric haze.
See haze.

attachment
(1) Accessory fitted to e.g. front of lens to adapt it to take e.g. filters, ring-flash, etc. (2) File that is sent along with an email e.g. image, animation, sound or other usually larger item. * Attachments need software beyond the email reader to be opened and used.

auto levels
Digital image editing technique which mathematically spreads pixel values equally over the available range and in each of the available colour channels. * The software takes the highest and lowest values in the image – in each colour channel – and moves them to the the maximum and minimum values, redistributing or stretching all the other values at the same time. * Also known as equalization, auto-equalization.

auto terminator
In a SCSI device, a sensor or switch that detects that it is the last connected device in a SCSI or that there is no terminator installed to terminate the chain i.e. closes the electrical loop.

auto-exposure
Automatic exposure control: mechanical or opto-electronic means of controlling camera exposure without user having to make individual settings. * Operation may be semi-automatic or fully automatic, assuming film speed is already

Auto-levelling exposure
Auto-levels are a way of quickly correcting colour or exposure faults for the middle-of-the-road images with no overall dominant colour. But it fails for as many images as it helps.

set: (i) Semi-automatic modes include (a) aperture-priority: user sets the lens f/number, system sets shutter time (b) shutter-priority: user sets shutter time, system sets lens aperture. (ii) Fully automatic modes set both lens aperture and shutter time, the combination of settings varying with scene luminance according to a pre-programmed table or user-selectable preferences.

autopositive

Photographic medium that directly produces a positive reproduction of the original after chemical development or processing, without further intermediate steps using other materials. * This almost always requires bleaching and re-exposure plus re-development steps because photographic processes are inherently negative-producing. * E.g. Polaroid Polapan and Polachrome instant-process, positive films.

Av

Aperture value: f/number setting. * May be used to indicate aperture-priority setting for auto-exposure.

AV drive

Harddisk drive designed for audio-visual work by (a) being able to deliver a high sustained data transfer rate (b) delaying calibration checks to idle periods. * All hard-disk drives adjust the position of the the reading head from time to time to compensate for minuscule changes in disk dimensions caused by temperature changes: this causes a short interruption in data transfer: AV drives delay these calibration checks to idle times.

axial

Ray of light or point that lies on the optical axis.
See paraxial.

axial chromatic aberration

See chromatic aberration.

axicon

Design of lens with a weakly conical surface (i.e. not a sharply pointed cone) on one face: it projects light from a point source as a line image lying along the axis. * Such a lens has no definite focal length.

axis

(1) Straight real or imaginary line that passes through or indicates the centre of a body or construction. (2) Real or imaginary line that joins the centre of parts or elements of a body or construction. (3) A real or imaginary line located in such a way that certain portions or parts positioned of an object are located symmetrically in relation to it.

AV seeing you no more

By the late 1990's, essentially all hard-disk drives were pretty smart about when they did their checks. In other words, most drives are AV compatible. At the same time, drives got much faster – well capable of sustaining the high data-throughput needs of video.

B

(1) Bulb: setting for shutter at which shutter opens when shutter button is pressed and stays open as long as shutter button is kept down. * Used for long exposures timed by the photographer. (2) Symbol for luminance (i.e. brightness): obsolete, but may be found on ye olde exposhure meteres.

B-spline

A fundamental type of line or curve which is defined by a series of control points which influence the line according to certain functions: the position of the control points can be changed and the functions can be varied, thus changing the shape of the curve. * The definition can be applied to two- and to three-dimensional space. * B-spline curves can be changed locally, without the whole curve being altered, in contrast to Bézier curves. * Many so-called Bézier curves behave mathematically more like B-spline curves. * Derived from word 'splines', referring to the strips of wood that determine the shape of a boat.

back focal length

The distance, measured along the optical axis, from the rearmost surface of a lens to its focal point, where the subject is at infinity.

B

back projection
See front projection.

back-up
(1) Verb: to make and store second or further copies of computer files to insure against loss, corruption or damage of the original files usually all important application files, setup files as well as data files. (2) Noun: (also spelt 'back up'): the copies of original files made as an insurance against loss or damage of any kind. * Copies may be made on any storage media: stored in exactly the same form as the original; stored in a compressed form; stored in separate blocks (if the file size is greater than the capacity of the storage media); stored in a different medium from the original.
See CD-ROM; DAT; DVD; RAID.

backdrop
Material e.g. paper or cloth painted with scenes, patterns, etc. or dyed with colour, that is used as a convenient background for portrait, pet or still-life photography.

background
(1) Part or element of scene that is behind – i.e. more distant from the observer than – the foreground. It usually appears above the foreground in the image. (2) See backdrop. (3) Surroundings or environment in which measurement or capture of image is made. * E.g. (a) images are captured digitally against background of electronic noise which increases with higher sensitivity (b) a red square against a blue background appears more intense than the same square on a white background. (4) Computer activity which takes place 'behind' or at a lower priority than the foreground application e.g. printing can take place in the background while word-processing of a different document continues in the foreground.
See noise.

bag bellows
Camera bellows designed for wide-angle lenses. * It is much wider than normal bellows and the material is not folded into pleats.
See bellows.

banding
Defect in printed output seen as uneven or irregular strips or bands or the mis-matching of density or inking across the width of the print – i.e. parallel with direction in which the print-head runs.

bandpass filter

Type of filter with high transmission in a particular band of frequencies and having low transmission – i.e. high absorption – for all frequencies either side of this band. * Term used in electronics as well as optics.

bandwidth

(1) Range of frequencies transmitted, used or passed by a device such as a radio, TV channel, satellite, loudspeaker etc. (2) A measure of the amount of information that can flow through a system, expressed as a frequency: in theory, the higher the frequency, the more information can be carried. (3) Filter ~: Measure of the range of wavelengths that are transmitted by a filter e.g. bandwidth of a blue filter may lie over 375-430nm.

See Hertz.

bare bulb

Use of flash or other light-source without any reflectors or light-shapers. * For practical photography, a small flash-tube or tungsten halogen source can act like a point source characterized by high contrast with sharp shadows.

barium glass

Glass characterized by higher refractive index with relatively low dispersion. * Uses barium oxide or baryta. * Also known as baryta glass.

Barlow lens

Design of lens with negative power used to increase the effective focal length of an objective. * This is the principle behind tele-converter optics which are placed between the prime lens and camera, serving to increase the focal length usually by 2X or 1.4X.

See tele-converter.

barrel

(1) Optics: metal alloy and/or plastics housing for the optical and other components of a lens. * May consist of several nesting barrels, some carrying cams and slots for focusing or zooming functions as well as circuit boards to control mechatronic components such as iris diaphragms and sensors. (2) Fibre optics: a device for joining two connectors carrying fibre optic bundles.

barrel distortion

Aberration that causes a square to be projected barrel-shaped. * Negative distortion i.e. magnification diminishes with increasing field angle. * In photographic use a distortion of approximately -5% or more is generally

B

regarded as unacceptable for professional-quality work: for copying etc., distortion should be less than 0.1%.
See curvilinear distortion; pincushion distortion.

baryta
Barium sulphate: major component of coating used to provide white surface in photographic printing papers.

bas relief
Special effect photograph in which subject appears as if sculpted in low relief. * Obtained by combining a negative film of subject with a positive film of same subject: when superimposed slightly out of register – i.e. not quite exactly on top of each other – the bas relief effect is seen. Effective when subject has clearly defined edges and when positive film is of high contrast. * If positive film is denser and more contrasty than negative, relief appears negative; when negative film is denser and more contrasty, relief appears positive. * Usually seen in black & white; can be applied to colour prints. * Effect can be simulated with a digital filter.

base
Noun: (1) Material used to support sensitive layer e.g. polyethylene coated paper is base for photographic emulsion of printing paper. (2) Substance which, when dissolved in water, produces an alkaline solution, of pH greater than 7. (3) Adjective: ~ density: optical density of base or support material.

base plus fog
Total density of the base or support material – e.g. of film – plus the density of processed but unexposed emulsion.
See fog.

BASIC
Beginners' All-purpose Symbolic Instruction Code: widely used high-level programming language that is easy to learn but runs slowly. * Versions may be found within larger application programs e.g. word-processor to be used for small programming tasks within the specific environment.

batch
(1) All the material produced at the same time and place under identical conditions and therefore sharing identical characteristics of e.g. sensitivity, contrast, colour balance, saturation, etc. (2) All the items which may be processed together by the same regime e.g. (a) all the files in a folder which will be converted from TIFF to JPEG format (b) the films which will be processed at push a third stop (i.e. given extra development).

battery

Device for providing or storing electrical power to provide energy for cameras with electronic circuits, for flash-units, motor-drives and other devices. * Batteries are designed for different types of use depending on specification e.g. voltage, current, internal resistance, capacity, characteristics of discharge, size and cost. Two main types: (i) Primary: e.g. lithium, carbon-zinc, alkaline manganese, mercury – cannot be recharged and must be thrown away when voltage supplied is too low to use. (ii) Secondary: e.g. nickel cadmium, nickel hydride, lead acid – can be recharged i.e. they can store electricity therefore also known as accumulators. * Batteries often used in sets: connected in parallel to provide high current e.g. for flash units or connected in series to provide higher voltage e.g. for camera motor-drives.

Strictly battery

The correct sense of the word 'battery' in physics is: an assembly of cells of basic units generating electricity. But usage is now understandably confused: a car battery is correctly so-called, because it is an assembly of individual units. But a camera battery is only a single cell. But who cares.

Bayer pattern

Regular mosaic or grid of coloured filters placed over sensors to capture colour information. * Consists of red, blue and green filters set in register over image-capture sensors e.g. CCD or CMOS as squares consisting of four filters: one each of red and green diagonally opposite each other, two of blue in the remaining corners. * The filters modulate the light reaching each sensor to provide colour information via luminance values. * Some Bayer patterns are based on filters of cyan, magenta and yellow.

baud

Symbol used by a communication system for transmitting data e.g. on/off states or phase shifts. * Named after J M-E Baudot, telecommunications engineer.

baud rate

Rate of information transmission measured in number of symbols per second. * As a symbol may have more than two states, the baud rate may not be equal to bits per second rate e.g. the baud rate for the V32 standard is 2,400 but the bit-rate is 9,600 (there are 4 bits per symbol); the baud rate for V34 is 3,200, but its bit-rate is 28,800 (9 bits per symbol).

See modem.

bayonet mount

Method of connecting components together – e.g. lens to camera, lens-hood to lens. * Consists of two or more tabs on the item to be attached which slip into notches or cutaways in a flange on the main component: with a small rotation, the tabs hold onto the flange. * Design ensures (a) rapid fit

(b) a precision fit (c) a secure fit. * Less secure than a screw mount but far more convenient.

BCPS

Beam Candle Power Seconds. * Used to express light output of flash-units. Twice BCPS means one stop more light is produced. * Measures light output from flash as if flash were to produce equivalent output for one second. * Guide numbers more commonly used.

beaded screen

Type of projection screen on which is stuck a coat of fine glass balls. * Gives high efficiency as balls act as concave mirrors but image is very directional i.e. optimum viewing angle is restricted to close to the axis of projection.

beam

(1) Bundle or group of light rays: it may be parallel, converging or diverging in shape. * Also known as lightbeam. (2) A stream of particles that is concentrated and unidirectional e.g. laser beam. (3) A concentrated, directional flow of electromagnetic waves.

See I-beam.

beam splitter

More splitting than you can shake a glass at

Strictly speaking, light is always split on entry into a medium and on exit from it: at the change of refractive index, part of the beam is refracted while part is reflected back.

Optical component e.g. prism, system of mirrors or semi-reflecting mirror (pellicle) used to divide up a ray or bundle of light. (1) TRANSVERSE type: beam is divided into different parts across its axis, each part carrying different part of the image e.g. multi-image prism or lens attachment for stereo photography. (2) TOTAL type: light energy across whole beam is divided up for use, each part carrying same image but at different power e.g. secondary mirror in auto-focus SLR cameras, pellicle mirror in SLR cameras or when creating reference and object beams in holography. * Also used to combine two or more beams of light e.g. in front projection systems: semi-reflecting mirror allows combination of image of projected slide with main subject.

beauty defect

Visible effect on or in an optical element which does not appreciably reduce performance. * E.g. a few fine scratches on, or small bubbles in, a large element make no practical difference to a camera lens' performance.

bellows

Flexible, collapsible light-tight component connecting optical components or lens and film carrier. * Designed to allow long extensions without weight penalty of a normal barrel construction or to afford considerable freedom of

movement of the components: for this the material is folded into pleats or corrugated to allow it to be collapsed. * This design usually prevents direct linkage between components e.g. to synchronize shutter cocking and film advance.
See bag bellows.

Bézier curve

In graphics or illustration programs, a curve whose shape and complexity can be manipulated indirectly by moving control handles, usually little squares at the ends of a line that touches the curve. Usually there is a pair of control handles at each turn of the curve. In some programs extra control handles can be added at any point on the curve. * Such a curve is generated by calculating the spatial coordinates of a line lying between control points according to weighting factors. In theory, changes affecting one control point alter the entire line. * This technique defines a line efficiently; allows easy control and is resolution-independent. * Also known as a path.

bias

(1) Verb: to influence flow or a beam of energy or radiation.
(2) Noun: voltage applied to a solid-state device e.g. to prevent flow of electrons or correct for defects.

biconcave lens

Type of lens element both of whose outer faces sink or curve inward.

biconvex lens

Type of lens element both of whose outer faces swell or curve outward.

bicubic

Interpolation method which uses data from all eight pixels surrounding the pixel being worked on. * Because it uses more pixel data than bilinear interpolation, it operates more slowly but produces better results.
See nearest neighbour.

bifocal lens

Design of lens with two parts, each with a different focal length. * Used e.g. in spectacles to correct for both near and far vision; also as a supplementary lens for special effects in photography to allow focus on very near and distant objects.

bi-level

Image consisting entirely of white or black values. * A bit-mapped bi-level image will comprise black or white pixels and no others. * NB: in some usages, bit-mapped means bi-level. * A vector image will write or output only black values.

bilinear interpolation

Interpolation method which uses data from the four pixels at the sides (not at the corners) of the pixel being worked on. * Because it uses fewer pixels than bicubic interpolation it operates a little more quickly.

binary image

(1) Image exhibiting only two brightness levels: black or white e.g. line art. (2) Digital file of image with two brightness values i.e. an image with bit depth of 1.

binary optics

Type of optical elements employing diffraction effects to create the image e.g. 'holographic' stickers. * In contrast to the more usual refracting or reflecting optics. * Elements made by e.g. embossing or vacuum deposition.

binocular

(1) Noun: short for prism binocular: optical instrument consisting of two telescopes – usually made compact by use of prisms – aligned to be used with both eyes to provide enlarged, stereoscopic views. (2) Adjective: ~ instrument: one which allows both eyes to view the image. * If there are two objectives, this enables a stereoscopic effect to be achieved; if not, as in high-power microscopes, the binocular design only improves comfort for the observer.

birefringence

Property of light-transmitting material in which refractive index changes with angle of polarization of transmitted light. * Also known as double refraction.
See Cotton-Mouton effect.

bit

Fundamental unit of computer information: has only two possible values 1 or 0, representing e.g. on/off, up/down.

bit depth

Measure of amount of information that can be registered by a computer peripheral, hence used as measure of resolution of a variable such as colour or density. * One bit can register two states or 2^1: either 0 or 1, hence e.g. either white or black; 8 bits can register 256 states or 2^8 e.g. visually quite an unbroken transition from black to white. * Greater bit depth is generally to be preferred as it allows programmers more room to work with but carries overhead of needing exponentially more computer processing.

bit sex

A bit must register either 0 (off) or 1 (on) but cannot be neither (nor, indeed, both).

bit-mapped

(1) Image defined by values given to individual picture elements of an array whose extent is equal to that of the image; the image is the map of the bit-values of the individual elements. * All popular image formats such as TIFF, BMP, JPEG, PNG, GIF etc. are bit-mapped file formats. * Compare with PostScript or page description formats such as HPGL or Acrobat (PDF) which are outline formats. (2) An image comprising picture elements whose values are only one or zero i.e. black or white: the corresponding bit-depth of the image is 1.

See binary image.

bitoric lens

Optics: type of lens both of whose surfaces are toric (like a ring or doughnut) or cylindrical in form.

black

(1) Adjective: describing an area that has no colour or hue due to absorption of most or all light. (2) Noun: maximum density of a photograph, of any kind.

See achromatic colour; UCA.

black body radiator

Theoretical object that absorbs energy of all wavelengths but radiates energy only as function of its temperature. * Near-perfect substitutes, e.g. carbon or platinum spheres with a small hole drilled in them, may have their temperature correlated with the dominant wavelength or colour of light emitted from the hole, thus giving the measurement of correlated colour temperature. * The emissivity of such a radiator equals 1.

black level

The level of a television picture signal or output from a capture device e.g. CMOS sensor or CCD scanner corresponding to the black peaks or maximal black values.

black light

Radiation from the near invisible region of the spectrum – ultraviolet or infrared – usually in relation to light being used for detection e.g. in surveillance, or for finding way around in a darkroom.

blackout

Total loss of electrical power. * Voltage of electrical supply drops to zero for a period of more than a few seconds. * This is enough to lose all data in any dynamic memory such as RAM which needs power to retain information.

See brownout; UPS.

When black isn't

Black ink itself doesn't make good black: you usually need to throw in a few dollops of one of the separation inks, preferably all three. Similarly, black does not look good if made up only of C, Y and M. This is important as the quality of black is a keystone for picture quality.

Don't let your computer black out

Blackouts can seriously damage your hard-disk, particularly if it is writing data when blackout occurs. If you're lucky it merely crashes your computer to cause loss of unsaved work.

bleed

(1) Material that runs off the edge of the page when printed. Photograph may bleed on any one, two, three or all four sides (in latter case either a cover or double-page spread) according to position on page. * Bleed pictures always lose a percentage of picture area due to trimming of printed sheet down to published or trim size. (2) Spread of ink into fibres of support material e.g. paper through surface tension effects, most obvious with blotting paper; the effect causes dot gain. (3) In computer graphics, the diffused spread of colour from one object to another in close proximity.

See dot gain; spot variation.

bloom

(1) Leakage of excess charge from a highly excited pixel – i.e. one receiving a lot of light – on a CCD into nearby pixels, causing loss of detail, inaccurate colour and inaccurate density readings. (2) Defect of the coating of an optical element, seen as irregular variation in tint on the surface of a lens.

blooming

(1) Loss of image from a sensor because of excessive brightness. (2) Deposition of a thin film or films on the outer surface of an optical element. * Formerly used synonymously with 'lens coating'.

blue wool test

Test for lightfastness: prints are compared with a set of eight pieces of wool each dyed with a different dye graded to fade after a set exposure to light. * Scale is number of pieces of wool which have faded after the exposure needed to fade the sample: one is poor lightfastness, eight is excellent.

blur circle

Optics: the image of a point source projected by a lens system on its focal plane. * The size of the blur circle depends on: state of focus; lens design, lens manufacturing quality, etc.

BMP

Bit MaP: a bit-mapped file format native to Windows and produced by its paint software.

board

Printed circuit board carrying processors, memory, connectors and other devices that can be plugged or slotted into a computer's motherboard in order to add extra capabilities such as video capture, graphics acceleration or communications. * Also known as 'cards' in Mac computers.

bokeh

Subjective quality of the out-of-focus image projected by an optical system, usually a photographic lens. * The unsharp part of an image often makes the major part of a photograph: visually we prefer smooth gradations and spherical out-of-focus highlights: this is good quality bokeh. * Poor bokeh is caused by poor control of residual lens defects as well as the design of the diaphragm aperture blades – particularly those which are irregularly shaped. * Transliteration of Japanese term.

bolometer

Instrument used for the detection and measurement of radiant energy. * Key component is a short strip of metal coated with a dead black absorbing layer. The electrical resistance of the strip varies with its changes in temperature due to absorption of energy.

bomb

Fault or conflict in a computer that causes it to freeze or crash (causes it to 'bomb out'). * Older Mac operating systems warned of a system crash with the symbol of a bomb.

Boolean

System of logical operations or relations (e.g. AND, NOT) originally applied to manipulation of relations between sets. * In computing, most often encountered in (i) database inquiries e.g. searching by 'concerto' AND 'guitar' NOT 'Spanish' probably won't yield very much. (ii) In operations with shapes in graphics or layout programs e.g. a cylinder and a smaller sphere at one end can be combined with a Boolean operation MINUS, which creates a hemispherical depression at one end of the cylinder; while the operation PLUS will give it a rounded end.

borderless easel

Accessory for holding printing paper without creating borders when print is made. * Various methods including (a) use of slightly tacky surface to hold paper (b) use of paper retainers angled so as to hold the paper without casting a shadow (c) vacuum suction.

See vacuum back.

Boys camera

Camera designed to record lightning.

bright-line finder

Accessory that shows a wide view within which is a bright frame that represents the field of view of lens. * Used as

B

viewfinder for wide-angle lenses or attachments in days of range-finder cameras. * Consists of front negative lens whose rear surface carries the silvered frame and a positive viewing lens: light entering from the eyepiece is reflected by the silver frame back to the viewer as a bright line.

brightness

(1) Quality of visual perception that varies with amount or intensity of light that a given element in visual field or optical component appears to send out or transmit e.g. sunny day, powerful lamp, efficient viewfinder. Antonym: darkness. (2) Brilliance of colour, related to hue or colour saturation e.g. bright pink as opposed to pale pink; also in reference to reproduction of colour e.g. this film produces bright colours; colours on this monitor are bright. (British recommended usage, especially in dye industry.) * Not to be confused with lightness.

See luminosity.

brightness range

Difference between the brightness of the brightest part of subject and the brightness of the darkest part of subject. * In practice, brightness range is assessed only in respect of parts of scene which need to be correctly or accurately recorded on film. * Strictly, brightness range equals highest scene luminance minus lowest scene luminance. * Do not confuse with contrast.

brightness resolution

A measure of how fully a pixel in a digital image represents (digitally) the brightness (which is analogue) of the corresponding point in the original image. * It depends on (a) the bit depth of the coding for the sensor output i.e. how many bits are used to represent the steps of the greyscale (b) the linearity of sensor response (c) noise levels from the electronic circuits (d) levels of optical noise in the form of flare in the light-path.

British Standards Institute

See BSI.

broadband

(1) Data communications conveying more than 2Mbps. * That is, communications faster than the E1 or T1 standards. (2) Data communications using a broad range of frequencies e.g. through coaxial cable or radio frequencies.

brolly

Light-reflector or modulator constructed like an umbrella made of white semi-translucent material or coated with

aluminiumized surface: light may be reflected from the brolly or shone through it. * Used with electronic studio or portable flash. * Also known as umbrella.

brownout

Transient drop in voltage of an electrical power supply which may damage sensitive equipment or cause malfunction of a computer e.g. loss of contents of RAM. * The return to full voltage may itself also be damaging.

browse

To look through collection of e.g. images or Web pages in no preconceived order or with no strictly defined search routine. * Browser software allows one to view many – e.g. low-resolution images – quickly and to access high-resolution files when needed.

browser

Software that reads HTML files; usually also combines other functions such as hosting email, launching searches and interfacing with other aspects of World Wide Web as well as handling some of the basic interface with the modem e.g. Explorer, Netscape, Mosaic.

brush

Image editing tool used to apply effects – such as colour, blurring, burn, dodge etc – limited to areas the brush is applied to, in simulation of a real brush. * User can set the size, the sharpness of cut-off between effect and no effect and amount of colour applied, and so on. * Some software permit application of entire images as the brush 'colour'.

BSI

British Standards Institute: Government agency that sets and establishes standards over wide range of scientific, technical and industrial areas including photography. * BS Speeds were established 1962 (black & white) and 1963 (colour reversal) and are determined in an identical way to ASA (now ANSI) film speeds.

See ISO.

buffer

(1) Computing: device or component that stores data between source and application usually in order to allow source to carry with other tasks. * E.g. print buffer can be filled rapidly with data which is then relatively slowly printed out. (2) Chemical that maintains pH of solution at constant level while chemical reactions take place within it e.g. preserves alkalinity. * Used in e.g. developers. (3) Fibre optics: a protective material or cover for optical fibre cover.

When brown is worse than black

Brownouts can cause more damage than a complete blackout or total loss of power because the low power may allow some components to work while others do not, creating current imbalances and strains which the circuit or equipment is not designed to tolerate. The only protection worthy of the name is an UPS.

Broad-brush hints

If a brush appears to be working too slowly (usually happens with the larger sizes), try increasing the spacing setting i.e. increase the intervals or space between each dab of the brush: usually it's 25% of brush width – try setting 50% of width.

B

bug

Error in computer code or programming which causes software application or hardware to behave incorrectly or in an unpredictable way.

bump mapping

Digital process in which the image is modified by changing the properties of its surface without changing its colour: usually to simulate minor imperfections e.g. scratches and bumps. * Distinguish from texture mapping.

bundle

(1) Provision of software and other products for 'free' as part of the purchase of hardware e.g. image manipulation or asset management applications are often bundled with digital cameras or scanners. (2) Combination of switched digital circuits to provide high-speed, high-stability communication services e.g. for video conferencing.

Bunsen-Roscoe law

Observation that the amount of chemical change produced is proportional to the amount of light absorbed. * Applied to photography, the amount of light-induced chemical change is proportional to the amount of actinic light adsorbed. * In fact, this 'law' is inaccurate: the amount of change also depends on the intensity of light – which is also known as reciprocity failure.

See reciprocity failure.

burn

(1) To write data onto a CD-R, CD-RW or DVD-ROM. * So-called because of the use of laser light. (2) To write data onto a programmable read-only memory or onto a flash memory card.

See CompactFlash.

burn-in

The running-in, testing and stabilizing of a laser, drive mechanism or other component before using it at full power.

burning-in

(1) Digital image manipulation technique that mimics darkroom burning-in: applied by brushes of varying sizes and has effect of darkening i.e. increasing grey content (i.e. equal amounts of R, G and B) of affected pixels. (2) Darkroom technique for altering local contrast and density during printing by giving local exposure to a specific area with rest of print masked off to prevent unwanted exposure elsewhere. * With negative-positive working processes,

burning-in increases density at the burnt-in area; with positive-positive working e.g. R-type prints, burning-in decreases density locally.

burst

(1) Noun: transfer of data without a break and possibly at the highest rate the system permits e.g. onto hard-disk. Adjective: (2) ~ mode: method of transmitting data at high speed in which a device dedicates all available resources and channels to transmission. (3) ~ strength: measure of resistance of paper to applied pressure.

bus

Short for databus: part of a computer: responsible for carrying data around the motherboard between various components e.g. between processor and main memory, to and from the input and output ports. * Buses are characterized by their (a) width e.g. 16-bit means they carry 16-bit data, and (b) speed: this is almost always less than the main clock speed but the faster the bus speed, the faster data can be moved around the computer.

busy

State of device e.g. scanner, digital camera, drive, etc. indicating that it is working and will not take further instructions until the busy state is ended. * Usually applies to critical process such as writing information to disk which does not permit other functions to take place at the same time.

butt

To join together two pieces of film, paper e.g. roll of printing paper; two colours or graphic elements without a gap or an overlapping.

byte

Unit of digital information: one byte equals 8 bits. * E.g. an 8-bit microprocessor handles one byte of data at a time.

C

Cyan: a secondary colour i.e. one made by combining primary colours red and blue. * During pre-press separation, it is the plate corresponding to the yellow filter (white minus yellow equals cyan). * The cyan separation used in four- or six-colour printing processes. * Its screen angle is usually about 105°.

C++

An object-oriented version of the C programming language extensively used to write applications software. * Developed in early 1980's in Bell Laboratories; key author: B Stroustrop.

C-line

Light of wavelength 656.3nm. * Used, together with F and D lines, to calculate a medium's dispersive power. * A Fraunhofer line. * May also be used as a target wavelength for apochromatic correction.

C-mount

Standard for lens mount interface used in smaller TV and cine film cameras e.g. closed-circuit television. * Clear internal diameter: 1"; thread pitch $^1/_{32}$"; flange-to-image plane distance: 0.69".

See bayonet mount.

C

Cabled home

In these days of electronically controlled cameras, the mechanical system of cable releases and their associated irritating but standardized nipple attachments has been largely superseded by various systems of cables and switches – the disadvantage is that there is now no standardization.

cable release

Device designed to release shutter of camera without shaking it. * Consists of wire running in a flexible tube: pressure at one end of wire pushes other end which is connected to shutter button, thus releasing shutter.

cache

(1) Portion of computer memory or specialized memory serving the main processor used for temporary storage of frequently accessed data or instructions. * May be configured almost as part of the processor in which case it is known as 'back-side' cache. (2) RAM dedicated to keeping data recently read off a storage device; also known as disk cache. * As the computer often refers back to recently read data, keeping such data in RAM saves on the access time needed to go to looking again for it on the storage device. * Cache may be carried on the device such as the hard-drive itself; be in a reserved area of the computer's RAM; be supplied as a plug-in card or, for CD-ROMs, as a software utility. * Pronounced 'cash'.
See access time.

cadmium sulphide

Chemical used in exposure meters.
See CdS cell.

calcium fluoride

Crystalline substance displaying anomalous dispersion i.e. its refractive index does not change consistently with varying wavelength. * It may be used as optical material to produce lenses with extremely high correction of chromatic aberrations. * Expensive to utilize as it is extremely difficult to manufacture to high quality as large crystals; it is relatively soft, has high coefficient of thermal expansion, and absorbs moisture. * Where used for camera lenses, it must be enclosed air-tight and is never an outer element.
See dispersion.

calendered

Paper whose surface is smooth or medium-gloss as a result of being passed through polished rollers or steam-heated rollers covered in cotton.

calibration

Process of matching characteristics or behaviour of a device to a standard e.g. emulsion speed or to a desired result e.g. neutral colour balance. * ENLARGER calibration determines the output characteristics of the light-source etc. to set up the basic filter settings. * MONITOR calibration adjusts the

colour balance and light intensity of a computer monitor to ensure that it reproduces a range of colours that is perceptually identical to a standard colour chart. * PRINTER calibration determines the output characteristics of a printer to enable adjustments to be made to ensure accurate colour reproduction.

Callier coefficient

The ratio between the density where measured by parallel or collimated light and where measured by diffuse light. * Ratio of specular and diffuse densities. * Unit: Q or Q-factor. * A value of 1 indicates no scattering at all.

Callier effect

The apparent difference in density and micro-contrast seen when illumination on a silver-based negative is changed from parallel or collimated to diffused. * Also seen when dust specks in the atmosphere are invisible in diffused light but clearly visible against a dark background when illuminated by the parallel rays of the sun. * The effect is caused by different way light is scattered according to type of illumination.

calorimetry

Science of measurement of heat. * Do not confuse with colorimetry (measurement of colour).

cam

Mechanical component designed to convert movement in one plane or axis into another, usually in some eccentric or non-linear way. * E.g. rotation of zoom control on lens slides groups of elements in the lens; rotation of enlarger head about a horizontal axis engages on a cam which forces the enlarger lens to slide up and down to focus.

camera

Assembly consisting of light-tight box carrying light-sensitive material or detectors with optical components which focus the image onto the light-sensitive or detecting component, together with mechanical or electronic devices for controlling quantity of light entering the camera and duration during which light falls on the light-sensitive part. * From Latin meaning 'vault'.

camera angle

The horizontal angle between the subject and the camera. * A low camera angle locates the camera below the horizon of the subject, a high angle locates the camera above. * Generally used loosely to be synonymous with camera position or viewpoint.

Sharper light
The Callier effect explains the increase in contrast of a silver-based negative when it is printed with a condenser enlarger compared to printing with a diffused light-source or a cold-cathode light. With colour materials, the diffuse and specular densities are about equal because there is little scattering by the dye-clouds; there is no practical change in contrast with different enlarger heads. (However, you get lots of sharp dust specks with condenser light-sources.)

camera exposure

Quantity of light reaching light-sensitive material or sensors in camera. * It is determined by the effective aperture of lens and duration of exposure to light i.e. the effective shutter time. * The effective aperture of lens depends on (a) f/number actually set during exposure (b) presence of filters (c) transmission of lens and lens extension (d) presence of flare. * The effective shutter time depends on (a) shutter time set (b) shutter efficiency (c) whether flash is used and if so, how much light is emitted (d) and whether multiple exposures are being made. * Note the actual exposure reaching film depends on the subject brightness or luminance.

See reciprocity law.

camera lucida

Accessory used to aid artist to trace outline of subject by hand. * Consists of 4-sided reflecting prism or equivalent set of mirrors which create an image of the subject on a sheet of paper. * Usually a small, portable device that clips onto draughting board.

See camera obscura.

camera movement

(1) Motion of the camera during exposure. * Depending on the exposure time and the degree of motion, camera movement may cause degradation of the image sharpness. (2) Feature of camera controls that allow more or less precise adjustments – shift, swing or tilt – in the relative positions of lens and film, apart from that required for focusing. * Standard in large-format studio cameras, camera movements may be found in 35mm and medium format systems.

See shift; swing; tilt.

camera obscura

Instrument installed in an aperture which connects a darkened room with the outside: the aperture is equipped with a focusing optic which projects the image of the outside onto a screen, usually via a mirror. Observers in the room view the image on the screen. * Ancestor of the modern camera but without photo-sensitive material for recording.

See camera lucida.

camera reduction

The use of photographic processes to reduce an original progressively to very small magnification. * Industrially, reduction can take place to extremely high precision, using

Perceptions of perspective

Shifting is the camera movement most often implemented in SLR camera lenses which are otherwise as rigid as a poker. For one thing, it's the easiest to do. Fortunately, it is also the most useful. You use it to improve shots of buildings by sliding up from the foreground. Unfortunately this has spawned the erroneous notion that such a mount design can control perspective. Nikon is to blame, for calling their shift lenses 'perspective control' or PC lenses. Tut, tut. Just call them 'shift lenses'. For, as you know, lenses do not control perspective, your legs do.

specialist step-and-repeat cameras. * Standard technique to produce microcircuitry for computer chips, memory etc.

camera system

Combination of camera bodies, lenses and accessories designed to work together and offer extensive versatility and functions. * E.g. professional camera systems such as Nikon or Canon offer, in addition to camera bodies and lenses, flash-guns, viewing systems, drives, close-up equipment, releases, and so on.

candela

Fundamental unit measuring luminous intensity. * One candela is the luminous intensity of $1/60$ cm^2 of platinum at its solidification temperature. * Equal to radiant energy $1/683$W per steradian (solid angle). * Roughly equal to international candle or candle, which it replaces. * Loosely, it is a measure of brightness of a light-source. * Used to derive luminance and luminous flux. * Symbol cd.

candle metre

Measure of illumination i.e. quantity of light falling on surface. * Defined as illumination on surface one metre away from light-source of one candle power. * Superseded by lux, the unit of illuminance.

candle metre second

Measure of light energy e.g. amount of light used to expose film. * Unit: lux seconds.

candle power

Unit of luminous intensity. * Superseded by candela.

capacitor

Electrical device consisting of system of conductors and insulators arranged to store electric charge. * Critical component of flash-units: electric current from batteries are built up in the capacitor ready for electricity to be discharged into flash-tube.* Also known as condenser.

capacity

(1) Measure of quantity of data that can be stored in a device. * Capacity of e.g. a hard-disk is measured in megabytes meaning decimal millions of bytes (not binary millions which are multiples of 1,048,576). * NB: actual capacity of most removable media must be reduced by an amount which represents the space used for the directory information needed to keep track of files. (2) Measure of quantity of material that can be processed to specification by a given volume of formulation or chemical e.g. number of films that can be processed by 500cc of made-up developer.

CCD capacities

The CCD at the heart of all digital cameras and scanners is also essentially a multiple capacitor – one in which the charges built up in each little capacitor (the pixel) by incoming light is read off one-by-one to reconstruct the image.

C

caption

Short text written on or supplied with photograph: serves to e.g. identify subject; provide any information e.g. proper names, dates, circumstances not evident from looking at photograph; illuminate intention of photographer; serve to open up layers of meaning deeper than identifiable content of photograph. * Technical captions may need to conform to norms of whatever scientific practice is being illustrated e.g. give magnification factor, precise time of picture-taking.

card

Printed circuit board carrying processors, memory, switches, connectors and other devices that can be plugged or slotted into a computer's motherboard in order to add extra features such as video capture, graphics acceleration or communications. * Synonym: board.

See bus.

card reader

(1) Interface accessory designed to read data from memory cards such as CompactFlash or SmartMedia to input to computer. * May be designed as adaptor to fit into existing media reader, e.g. the Flashpath adaptor. * Also known as transition card. (2) Equipment used to read data from cards punched with holes. * Uses light-detector linked to computer to identify holes. * Obsolete system formerly used to program and enter data to mainframe computers.

cardinal points

Set of points of an optical system from which the main parameters of the system may be defined and, given a subject distance, from which parameters of the image may be deduced. * Comprises the three conjugate pairs of focal, principal and nodal points of a lens. * Also known as cardinal planes, Gauss points or Gauss planes.

Carousel

Trade name for circular design of slide tray or magazine for 35mm transparencies. * Now generic term for any slide magazine that is circular (strictly, toroidal) in shape.

carrier

(1) Stream of energy capable of carrying information through alteration of one of its characteristics. * Modulation of the frequency, amplitude or phase of an analogue signal which enables the signal to carry information. (2) E-mail or other data that contains a virus within it or attached to it. * The attachment may have to be opened or uncompressed for the virus to be activated.

cartridge

Storage or protective device consisting of a shell e.g. plastic or metal casing enclosing delicate magnetic or light-sensitive parts e.g. film, magnetic platter, magnetic tape or magneto-optical disk.
 See cassette.

cascade image tube

Design of imaging device for working in low light levels. * Consists of a series of light multipliers or amplifiers in which the output of the first becomes the input of the second and so on – hence a cascade of amplification. * Used in night scopes and similar principle may also be employed in photo-multiplier tubes of drum scanners.

case hardening

Manufacturing technique for producing glass with a stiff surface that is less likely to break on impact or shatter with heating. * The glass is heated nearly to its softening point, then cooled rapidly with a blast of cold air which causes the surface to harden before the interior. This produces a strengthening tension between the outer surface and inner glass. * Used e.g. to manufacture very thin glasses for use as lens filters.

Cassegrain lens system

Design of telescope using two mirrors: the first, or primary, mirror has a parabolic profile, the secondary mirror is a hyperbola. * Used mainly in astronomical telescopes, also some high-magnification terrestial types. * This design delivers images free of spherical and chromatic aberration.

cassette

Container for roll-film that allows camera to be loaded and unloaded in daylight. * Designed to: be light-tight; hold film compactly; allow film to move freely through camera; be cheap to manufacture. * May be reusable – usually made of plastic, rarely of metal – or disposable – usually made of metal. * Available in various film formats: 126 (cassette incorporates take-up spool for film); 135 (commonest: film must be rewound into cassette after exposure); and 70mm (used in medium format cameras). * Cassettes carry film identification and may contain codes for camera and film processor machines to identify film type, speed, length, etc.
 See DX coding.

catadioptric

Adjective: ~ optical system: one which uses both reflection and refraction of light to form the image. * Usually most of

c

the power comes from use of the reflective surfaces. * The combination of refractive surfaces of low or zero power to correct aberrations as well as a narrow image field produce a highly corrected images with particularly low chromatic aberration for the focal length, usually at least 350mm for use in 35mm cameras.

catch light

Small highlight, usually reflection of light-source i.e. it is specular: usually refers to highlights in eyes in portraiture. Lack of catch lights often regarded as deficiency in portrait.
 See specular highlight.

catoptric

Adjective: ~ optical system: one that directs or focuses light using only reflective surfaces. * Don't confuse with catadioptric.
 See dioptric; mirror lens.

caustic

Luminous curve of light often seen in a glass or cup of liquid either near the surface of the liquid, reflected onto the side of the container, or projected onto a surface. * Formed by the intersection of rays of light (i.e. it is the locus of such intersections) which cross each other due to spherical aberration: rays near the centre converge less strongly than rays near the edge of the lens. * Occurs in reflection as well as refraction of light.

CAV

Constant Angular Velocity: with rotating media such as disks, the rate of rotation is constant irrespective of where the data is being read or written to the disk. * E.g: gramophone record; also some high-speed CD-ROM drives used for reading data.
 See CLV.

CC filter

Colour-correction (or colour compensating) filter: accessory made of transparent, coloured material used to make small changes to colour balance of light entering camera. * Materials used: gelatin, glass, resin or plastics; colours available: either primaries – red, blue, green – or secondaries – cyan, magenta or yellow. Available in densities varying from 0.025 to 0.50 or more, measured for the colour absorbed. * Designated by density and colour e.g. CC025M is magenta of 0.025 density; CC50Y is yellow of 0.5 density. * Colour enlargers may have built-in colour correction filters, often to the manufacturer's own calibration.

CCD

Silicon integrated chip of the metal semiconductor type: a layer of silicon oxide covers a silicon substrate with electrodes set very close together in a regular pattern (line or array according to design) over the oxide layer. These electrodes correspond to the actual sensors or pixels. * Light falling on the electrodes causes a build-up of electrical charge (the signal) corresponding to the amount of light and according to the voltage applied to the electrode. To read the signal charge the electrode voltages are alternately raised and reduced, which shunts the signal charge from one electrode to another to be read off at the end of the line. So far, the process is essentially analogue: when the signal is measured, it is turned into a digital code which corresponds to the light value for the corresponding pixel. * Developed in the mid 1930's; first used in a camera in 1972 on a integrated circuit.

CD-DA

Compact Disc-Digital Audio: the standard used for domestic CDs supplying music – that almost all of us buy. * The original, analogue, music is sampled at a rate of about 44.1kHz with a resolution of 16-bits or more.

CD-I

Compact Disc - Interactive: standard for a type of CD-ROM optimized for interactive software, particularly for education and training.

CD-ROM

Compact Disc - Read Only Memory: storage device for digital files invented originally for music and now one of the most ubiquitous computer storage systems. * Standard discs hold 650MB (74 minutes of audio) but some allow storage of 700MB (80 minutes of audio).

CD-ROM XA

CD-ROM eXtended Architecture: format standard for CD-ROM extended to include more file types. * Consistent with ISO 9660 standard.

CdS cell

Cadmium sulphide cell: exposure meter design based on photoconductive properties of cadmium sulphide. * Electrical resistance of CdS drops as more light is incident on it. * More sensitive than selenium cell – which it superseded – but needs battery for operation. * This once standard solution to camera metering has itself been superseded by the SPD cell.

c

CDV

(1) Compact Disc Video: (a) standard for digital video (b) 5" diameter disc for storing digital video. * Pretty much obsolete, being superseded by DVD. (2) Compressed Digital Video: (a) video signals compressed in preparation for transmission (b) set of compression algorithms for compressing digital video signals.

cell

(1) Part of a lens barrel or optical system holding one or more lenses or groups of lenses e.g. front cell focusing. (2) Unit or element of detector for light or other radiant energy e.g. photo-diode of exposure meter. (3) Unit or element whose electrical resistance varies with incident radiation; used in an instrument for measuring light e.g. CdS cell of exposure meter. (4) Unit that temporarily stores electrical energy, usually as part of a battery.

Celsius

Thermometer scale: measuring temperature such that freezing point of water is 0°C and boiling point is 100°C. * The scale formerly known as centigrade.

cementing surface

Special curve given to the surface of an element to be cemented to another element to make a compound lens. * The inside surface of the element is made so that when the corresponding element is brought together with it, they touch only at their edges. * Also known as inside curve.

centigrade

See Celsius.

centre-graduated filter

Neutral density filter used to even out light fall-off of wide-angle lenses. * The centre of the filter is darkest and the edge is transparent, with the gradient equal and opposite to that of the light fall-off of the lens, for which it is tailor-made. * Generally needed only at larger working apertures.

centre-weighted

Design of exposure metering in which more emphasis is given to the brightness in the centre of the field of view than to the periphery. * Usually applied to metering systems in SLR cameras.

characteristic curve

(1) Graph showing how density of given film and its development is related to exposure given to it. Scale for vertical axis is density and horizontal is logarithm of exposure or relative exposure. (2) Graph relating input

All heated up

Celsius is universally used by the scientific community and most of rest of world – apart, that is, from those characterful folks still working to Fahrenheit (doubtless also hanging on to their feet and inches).

Expensive bit of dirt

Centre-graduated filter (or centre-grads) are terribly expensive, merited only for terribly expensive lenses but, all the same, they just look like a rather grubby bit of glass, being unevenly sooty and grey. The filters also swallow up at least an entire stop of aperture. Strictly for super-wide-angle freaks for whom e.g. 47mm on 5x4" is standard.

values to output values for an image: see tone curve. * For film, characteristic curve is typically a slanted S-shape. Curve characterizes film's response to light for given development regime.

> *See gamma; shoulder; speed; straight-line; toe.*

charge trapping

Loss of accumulated charge into underlying layer or substrate during the read-out process in e.g. charge-coupled device. * A cause of loss of efficiency in semiconductor devices.

charge-coupled device

See CCD.

chemical focus

See actinic focus.

chloro-bromide

Type of black & white printing paper: using mixture of silver chloride and silver bromide, with properties intermediate between chloride and bromide papers. * Offers good speed with warmer image tone than bromide papers.

chroma

Measure of degree of saturation of hue or colour of a sample of light or colour patch. NB: may be incorrectly used to mean the colour value or measure of hue of given light-source or patch.

> *See chrominance.*

chromatic aberration

Defect of lens seen as variation of sharpness or size of image with different colours. * Caused by dispersion of white light by glass i.e. variation of refractive index with wavelength. * (i) AXIAL or LONGITUDINAL chromatic aberration: short wavelengths such as blues are focused nearer lens than longer wavelengths. * Also known as primary chromatic aberration. (ii) TRANSVERSE or LATERAL chromatic aberration (also called lateral colour) is seen as a change in size of image with wavelength e.g. subject illuminated with blue light will be imaged slightly larger than same subject illuminated with red light; or subject will be ringed with red inside, then green, then blue outside. * Lateral colour cannot be improved by using smaller aperture.

chromatic adaptation

Change in colour perception of human eye due to change in colour sensitivity with prolonged viewing.

chromatic colour

Colour that has colour e.g. red, purple. * As opposed to

When colours are unwanted

Chromatic aberration increases rapidly with increasing field angle and focal length, hence the great attention paid to combatting it with lenses of focal lengths 300mm and over – using glass with anomalous or ultra-low dispersion or exotic materials like fluourite. Colour fringing cannot be reduced by using smaller apertures but axial chromatic aberration can be masked by using smaller apertures to increase depth of focus.

Watching colours dry

Chromatic adaptation is the physiological psychology behind why a nearly correctly colour-balanced print looks correct until put side-by-side with a perfectly balanced. The longer you look at it, the harder it is to decide whether a nearly correct print needs further correction: which is why it's useful to show it to someone else for evaluation. Or why processing professionals reach for the densitometer.

C

colour that has no colour e.g. black & white. * Antonym: achromatic colour.

chromatic resolving power

Measure of the ability of a grating to disperse light i.e. to separate a range of different wavelengths.

chromatic threshold

Lowest intensity of light at which colours are just visible.

chromaticity

Measure of colour quality of something seen: its hue and saturation.* That is, those visual sensations not including the quality of brightness. * Given by chromaticity coordinates of visual stimulus where value for e.g. red in coordinate is ratio between stimulus from red and sum of stimuli from red, green, blue. Colours with same hue and saturation have same chromaticity coordinates, but may vary in luminance (or brightness). * Chromaticity and luminance fully define colour of visual stimulus. * It may also be defined in terms of a light's dominant wavelength and the purity of colour of visual stimulus.

chromaticity coordinates

(1) Proportional values of red, green and blue needed to define a colour or to obtain a colour match. (2) The ratios of the tristimulus values for a colour to their sum. * Coordinates are X, Y and Z in the CIE system.

chromaticity diagram

Diagrams of space
To show all three coordinates or parameters used to define colours would need a three-dimensional diagram – such a diagram is then usually taken to define a colour space.

A graphical representation of colours and their relations created by plotting one of the three chromaticity coordinates against another – usually to leave out lightness values. * The most common is the CIE diagram.

chrominance

(1) Value of a video or other signal that carries colour information. (2) Hue and saturation values of a colour i.e. ignoring luminance. (3) The difference between a colour and a reference colour where both are equal in luminance.

chromogenic

Process or substance that produces colours or which uses dyes. * E.g. chromogenic black & white films are based on standard colour negative processing chemistry to create neutral coloured dyes to make up the image: once processed, these films do not carry any silver.

chronophotography

Photographic recording of a movement, action or other phenomenon which consists of a series of still pictures taken at regular intervals during the action. * The pioneering work

of Eadweard Muybridge is the most celebrated oeuvre of this type which led to the invention of cinematography. * Do not confuse with multiple stroboscopic images, e.g. of Harold Edgerton in which the sequence of images is superimposed onto the same record.

CIE

Commission Internationale de l'Éclairage: International Commission on Illumination. * Sets standards for colorimetry.

See chromaticity; CIE L*a*b.

CIE L*a*b

Commission Internationale de l'Éclairage L*a*b*: a colour model in which the colour space is arranged around a sphere. * The vertical axis L represents lightness i.e. achromatic colours: black at the bottom ranging to white at top. The a axis is circular and runs horizontally and normal to the L axis: from red (positive values) to green (negative values). At right angles to this the b axis is also circular and runs from yellow (positive values) to blue (negative values). * Also referred to as LAB. * This is the basic colour space in which Adobe Photoshop operates.

See colour models.

circle of confusion

Size of smallest detail that can be distinguished from a viewing distance of 250mm: usually taken as spot or circle with diameter 0.25mm. * Strictly, circle of confusion is size of spot that cannot be distinguished from true point at a viewing distance of 250mm. * Any image detail smaller than 0.25mm in a well illuminated subject cannot be distinguished by normal unaided eye at distance of 250mm: therefore detail finer than this is not required in final print. * This figure is used as basis in lens designs; when calculating depth of field tables and determining screen sizes in printing. * Circle confusion is approximately equal to 1/1000 focal length with e.g. large format or medium format.

circle of least confusion

Smallest image (also called the 'blur patch of light') of point source at infinity that optical system can project. * As the optic moves in and out of focus, the blur patch of light grows and decreases in size: smallest size is circle of least confusion and optical system is said to be in focus. * Note: due to the wave nature of light and depending on lens design, circle of least confusion does not necessarily give best definition.

See point spread function.

An ICE confusion?

Note that CIE may be known as ICI standards. Confusingly still, for an international standards, they are known in Germany as IBK standards.

Confusingly close

The figures opposite assume that the photograph is viewed from a viewpoint that gives correct perspective. Prints are often examined much closer than 'correct' so sharpness requirements are more critical. In that case, circle confusion may then be taken as 1/2000 focal length or less with 35mm format. Obviously there is a certain practically determined arbitrariness in the actual figure used.

C

circular birefringence

The observation that right-circular polarized light may travel at a different speed than that of left-circular polarized light in certain media or conditions such as presence of an electrical field.

circularly polarized light

Light whose wave travels in a spiral, instead of the usual two-dimensional wave-form. * If a wavefront of light is held back (retarded) by $1/4$ wavelength and rotated 90° or 270°, the combination of the original wavefront and the retarded one creates one whose electric vector rotates as it propagates. * Mica is an example of a quarter-wave retardation plate.

cladding

The glass that surrounds the core of fibre optic. * It has a lower refractive index than the core.

Clayden effect

Desensitization of light-sensitive emulsion by high-intensity radiation of short duration when followed by low-intensity light of longer duration. * Usually seen as local desensitization which may lead to reversal with older types of emulsion e.g. lightning or explosion may appear dark instead of light on printing.

clear

Verb: (1) to remove unwanted silver salts from developed film or print material.
Adjective : (2) ~ spot: area of optical component without surface texture – e.g. as used with ground-glass focusing screen – or of smooth profile e.g. level area of Fresnel lens. (3) ~ aperture: the opening in the barrel or mount of an optical system or its components which limits the size of the bundle of rays transmitted through the system. (4) ~ eye distance: the distance, measured on the optical axis, between the last mechanical surface of an eyepiece to the surface of the eye.

clipboard

Area of memory reserved for temporarily holding items during editing. Usually making a cut or a copy of selected text, graphic or other item puts it into the clipboard. Once in the clipboard, the item can be pasted elsewhere into the original file, or, in most desktop operating systems, the item can be pasted into a completely different file.

cloning tool

Image manipulation method of replicating or copying one

Auto-focus in spin

Circular polarization is optical obscurity; but it is important with modern auto-focus (AF) systems as they cannot read light which is plane-polarized certain angles: circular polarization allows use of the photographic effects of filtering polarized light without impairing the workings of AF sensors.

Clip box

First, don't forget that the clipboard takes only one item at a time: cut a second item onto an already cut item and you've lost the first one forever. Hint: so don't interrupt cut and save operations. Second, remember that clipboard takes up system memory: when it's stuffed with a big cut, there's less memory for the program to work with; and that when you've pasted, the cut still resides in the clipboard. When working with images, it's easy to forget a simple cut could be several megabytes in size which can seriously drag down a program like Photoshop. Answer: select a tiny weeny area of the image and copy into clipboard to 'empty' it. Later versions of some programs offer a 'purge' function to clear memory.

part of the image directly into another part of the image.

See rubberstamp.

closed-loop

Adjective: e.g. ~ colour enlarger: electronics monitor the lamp output to use the measurements to maintain steady colour balance of output and/or feed corrections to a colour analyser.

clumping

Uneven distribution of grain, ink or other material that leads to larger groupings or clusters which appear to – or actually – merge together. * E.g. clumping in silver granules causes the graininess of an image to appear greater than the size of granules i.e. to increase granularity. Clumping in ink-jet print-outs causes pools of ink to form, reducing resolution, muddying colours and increasing drying time. * Also known as pooling.

CLUT

Colour Look-Up Table: the collection of colours used to define colours in indexed colour files: usually a maximum of 256 colours is defined. * E.g. the set of so-called 'Web-safe' colours.

See colour mapping.

CLV

Constant Linear Velocity: specification for or technique of ensuring that data is read off a storage medium at constant rate. * As those parts of a rotating disk near the perimeter travel faster than the parts near the centre, if data must be written onto or read off a disk at a constant rate, then the rate of rotation must slow down or speed up according to where the data exchange is taking place.

See CAV.

CMOS

Complementary Metal Oxide Semiconductor: device consisting of pairs of transistors integrated on a silicon chip. * Used for RAM, switching and as image sensors. * They are characterized by high-speed operation, low power consumption. * For imaging applications they permit x-y addressing i.e. each sensor can be separately read, offer higher signal-noise ratio, rapid data transfer and much easier power-handling requirements but suffer from high noise.

CMYK

Cyan Magenta Yellow Key: the first three are the primary colours of subtractive mixing i.e. the principle on which inks rely to create a sense of colour. * A mix of all three as full,

Speedy spinners

Music CD-ROM players are CLV as their rotational speeds are modest. But high-speed CD players working at 8X speed and over are generally not CLV machines as (a) they spin so quickly their momentum makes it tricky to vary their speed easily (b) unlike music, general data does not need to come on stream at regulated speeds.

C

solid primaries produces a dark colour close to black. For good quality blacks, it is necessary to use a separate black or key ink. * The set of four inks are standardly used to print colour on paper stock: hence the term 'four-colour printing'. * The screen angle of each colour must be different from the others to avoid moiré.
See SWOP.

coated optics

Lens elements of optical system whose refracting surfaces are evenly covered with one or more extremely thin layers of material. * These layers improve transmission of incident light i.e. they serve to reduce losses from reflection. * Some types of coating also used to protect the surfaces or prevent fogging by moisture condensation. * Materials used include: magnesium fluoride, silicon oxide, zinc sulphide, which are deposited using using vapour or electron beam methods.
See multicoated.

cobalt glass

Formulation of glass designed to transmit near-ultraviolet radiation. * It is opaque in the visible region. * Also known as Woods glass.

codec

Compression decompression: routine or algorithm for compressing and decompressing files e.g. JPEG, MPEG. * Codecs may be implemented as software or are put onto a microprocessor chip. * Image file codecs are usually specific to the format, but it is important that video codecs are not tied to a video format. * Codecs take up a lot of computing power: with image files this can be handled by the software but with video, speed is vital: in consequence, most available codecs are hardware-based.

coherent light

Beam of light characterized by its having nearly every particle of light vibrating in step or in phase with each other. * It follows that nearly every ray of light is of the same wavelength. * Such light is produced by a laser.

coincidence rangefinder

Optical instrument designed to measure the distance from the observer to the target being observed. * The principle used is triangulation: the further away the target, the smaller the angle between the target and a fixed base-line at the observer. * E.g. Leica rangefinder: the target is viewed by two optical systems – one sees the target directly, the other via a rotating prism – which create two superimposed images,

Humble origins
This rangefinding principle, much refined during the world wars for improving the accuracy of artillery, is also used in today's compact auto-focus cameras and even some digital cameras. An infra-red beam scans the scene ahead: the angle of beam which gives a maximal reading is a measure of the focusing distance.

one fixed, the other moving. As the prism is rotated, the image projected by it changes position: when it is correctly superimposed or perfectly coincident on the fixed image, the prism's setting measures the distance.

See active AF.

cold cathode

Device that emits radiant energy in the form of e.g. light or electrons by using a high-voltage gradient at its surface. * Contrast with hot cathode, which works by heating up the emitting element.

cold cathode enlarger

Black & white enlarger using a cold cathode as its primary light-source: it provides a cool-working source of highly actinic light because it is rich in blue light. * NB: it is not suitable for multigrade papers.

cold colours

Subjective term referring to blues and cyans. * Cold colour casts are seldom preferred over warm colour casts i.e. are usually regarded as something needing correction.

cold mirror

Mirror designed to reflect visible light radiation while letting infrared through. * Uses coating techniques to achieve this effect: used where intense light is needed but heat from infra-red is unwanted e.g. projector lamps.

See dichroic.

cold-light illumination

Design of lighting with very low infrared – or heat-producing – component. * The infrared may (a) be removed by absorbing filters e.g. heat filters in projectors (b) reduced by use of cold or dichroic filters e.g. dichroic bulbs (c) eliminated at source e.g. using cold cathode.

collecting lens

Optics designed to collect energy and direct it into the rest of the system. * Usually an over-sized positive lens located at or close to an image plane e.g. collector lens for a projector or enlarger is placed next to the transparency or negative being projected. * It is over-sized to collect as much light as possible and to bundle it into the projection or enlarger lens. * Also known as 'collective lens' (US usage).

collimated

Adjective: ~ light: a bundle of light in which every ray is parallel to every other e.g. that produced by a correctly set up collimator. * Usually applied to larger bundles of light e.g. that incident on camera optics.

collimator

Design of optical instrument used to produce: (i) a wide beam of collimated light for holography – usually by expanding a laser beam or (ii) target that appears to be at infinity for testing or measuring lens performance: this makes a compact test-rig. * Consists of a highly corrected projection optic with a light-source or reticle (or target pattern) at its focal point.

colorimeter

(1) Instrument in which amounts of three primary coloured lights shining on a test panel can be varied: the proportion of primaries that match a test or sample colour when additively mixed provides the tristimulus values of the sample colour. (2) Instrument for measuring colour using three broad-band filters. (3) Chemistry: an instrument used to measure the concentration of a colorant.

colorimetric purity

Ratio, to the luminance of a test colour, of the luminance of the spectrum colour that matches the test colour when mixed with white light.

colorimetry

Measurement of colour quality of visual sensations, in particular hue (colour name or dominant wavelength), saturation (purity or depth of colour) and brightness (luminance). * Subjective methods require observer to match given sample in colour order system or colour atlas e.g. Munsell colour space or ICI colour atlas in terms of hue, chroma and value. * Objective methods involve measuring spectral composition of colour; or determining proportions of primary colours which will reproduce visual match with sample colour using colorimeter. * Structure of colour atlas discovered in 1611 by Sigrid Aron Forsius, a Swedish monk.

colorize

To add colour to a grey-scale image without changing the original lightness values.

ColorSync

Proprietary colour management software system designed to help ensure that e.g. colours seen on a monitor screen match or duplicate those printed or reproduced. * Standard test targets are printed or displayed and the results are checked by colorimeter in order to generate a colour profile specific to the instrument and the test conditions: the profile is used by ColorSync-compliant instruments in order to create an image or output which matches that of the

original instrument. * Developed by Linotype-Hell for Apple operating system and is widely supported by other manufacturers e.g. Adobe, Kodak. * Part of the Mac operating system; available for PC machines from Windows 98/NT5.

colour

(1) Noun: quality of visual perception characterized by hue, saturation and lightness: it is perceived as attributes of things seen. Caused by quality of light emitted, selectively transmitted or reflected by object and its interaction with eyes and brain. Determined primarily by wavelength or dominant wavelengths of light: visible range is approximately 300nm to 300nm but range of perception and accuracy may depend on abilities of observer; presence or absence of colour vision defects; and ambient lighting conditions. * Black, white and greys are known as achromatic colours i.e. visual sensations with no perceptible hue. (2) Verb: to add colour to an image by hand: using dyes, oil paints with brush or spray (air-brush) or in an image manipulation program.

colour ageing test

Standard procedure for measuring the rate of fading of coloured materials. * Procedure will vary on application e.g. for exterior paints: exposure to weather and direct sunlight; for printer dyes: exposure to light and dry conditions.
See blue wool test.

colour analyser

Instrument for measuring colour balance of image. * Used in colour darkroom to help determine filtration to be set for neutral colour balance. * Most colour analysers measure image as projected onto baseboard; some sample light within enlarger or enlarger lens. * May also incorporate exposure meter to measure brightness of image.
See closed-loop.

colour balance

Evaluation of predominance or lack of particular colours or range of hues in an image or print. * (i) CORRECT or NEUTRAL colour balance indicates: (a) that hues in image accurately reproduce those in scene (b) that no hues predominates i.e. there is no overall colour cast or bias (c) that greys and whites are neutral. (ii) WARM colour balance indicates overall red, yellow or orange bias to image e.g. greys have slight hint of orange, blues are slightly magenta. (iii) COLD or COOL colour balance indicates overall cyan or blue bias to image e.g. greys are cold, yellows carry hint of green.

What colour is not
It might be instructive to note which attributes of visual perception or experience colour excludes: extent (i.e. orientation, size, shape, texture, etc.); duration (i.e. flicker, movement, etc.); value (brightness, contrast, etc.); definition (i.e. sharpness, indistinctness).

On the scales of colour
*With colour photography, balance is determined by properties of the taking lens, use of any filters as well as colour balance of film and its match to colour index of light-source e.g. daylight film gives correct balance for daylight but not for tungsten light. * With colour printing, balance is determined by properties of paper, film being printed, filters set on enlarger and properties of the enlarger e.g. type of light-source.*

colour balancing filters

Coloured glass or gelatin filters fitted to lens used to tint or colour light entering camera to match available light colour temperature to the colour balance of film in use. * They are designated by mired shift i.e. change in colour temperature, in mired units. * Also known as colour conversion filters.

colour blindness

See anomalous trichromatism.

colour camera

Instrument for making three separation negatives in one exposure: consists of arrangement to split incoming image into three parts using mirrors, semi-reflecting mirrors or prisms. Each beam of light goes to different part of camera to expose film through respectively red, green and blue filters. * Original cameras were horribly cumbersome and delicate. Principle lives on in professional video cameras and in some designs of digital camera.

colour cast

Tint or light hint of colour evenly covering an image. * Usually most visible in light or medium density neutral tones.

colour centre

A defect in a crystal which absorbs light and may cause a transparent crystal to appear coloured or partially coloured. * It is a defect in the crystal lattice in which a vacant negative ion site possesses a bound electron and is therefore usually absorbing in the visual spectrum. * Also called F-centre.

colour circle

A model of colour relationships consisting of fully saturated colours arranged in a circle in spectrum order such that complementary colours were opposite each other. * Used in most early treatises on colour e.g. classics of Goethe, Itten and elaborated e.g. by Munsell.

colour compensating filter

Lightly coloured filters in range of densities in red, green, blue, cyan, magenta and yellow designed to produce to match with precision the colour balance of film to ambient light. * These filters do not produce the conversion of e.g. daylight film to tungsten light. * Designated e.g. CC05R meaning: colour compensating of 5 density units in red.

colour conversion filters

See colour balancing filters.

colour correction

(1) The reduction of chromatic aberrations in an optical system. * Usually implies two spectral colours e.g. red and green are brought to a common focus. (2) Image editing or manipulation work that aims to bring an image to a neutral overall colour balance i.e. to remove any colour cast due to mismatch of film or sensor spectral sensitivity with illuminant colour temperature or from errors caused by scanning.

colour fringing

Imperfection of image due to aberration in the optical system producing the image. * Lateral chromatic aberration is the major contributor to this fault: hence also known as lateral colour. * Most commonly seen in magnifying glass, inexpensive loupes. * In camera lenses, it reduces the image quality e.g. of fast wide-angle lenses.

colour gamut

Range of colours producible by a device or reproduction system.

See colour mapping; gamut; out-of-gamut; SWOP.

colour harmony

Subjective evaluation of a colour image in terms of its balance of complementary hues, the choice of colours, quality of use of colour, etc.

colour holography

Method of creating a full-colour hologram by using three separate holograms – each representing and projecting a different range of colour – so that reconstruction of the image creates three separate wavefronts, each carrying one of the primary colours. * Some attempts made to combine all three separations in one hologram. * Generally, the procedure is complicated and results are dismal: not to be confused with holograms which give coloured images whose colours are not related to those of the original.

See Denysiuk hologram.

colour management

Process of controlling the output of all devices in a production chain to ensure that final results are reliable and repeatable from the point of view of colour reproduction. * Software systems are available that help e.g. from Kodak, Pantone, Linotype etc. but all rely on accurate calibration of monitor and printer outputs.

See ColorSync.

Matching gamuts
Reliable colour reproduction is hampered by the differing colour gamuts of devices that are supposed to work together: colour film has the largest gamut, computer monitors have less than colour film but greater than ink-jet printers; the best ink-jet printers have a greater colour gamut than four-colour SWOP printing.

C

colour mapping

Procedure of allocating a given hue or colour from a wide or unlimited range of colours to a limited range of colours such as a colour look-up table. * This is the basic processing step when e.g. images are converted from their full palette of millions or thousands of colours into the limited palette of e.g. GIF, or sVGA, etc.

colour match

Condition in which two or more samples appear to an observer to be of the same colour or hue (but the lightness or saturation values may not be same). * For precision, the source of illumination – which should light both samples equally – should be specified.

See metamerism.

colour matching

Process or procedure of making adjustments to machinery, colourants, etc. in order to match a sample colour.

colour measurement

See colorimetry.

colour model

Systematic scheme or theory for representing the visual experience of colour by defining any given colour perception in terms of three or more basic measures. * All colour models acknowledge perceptual distinctions of hue and brightness, but take different account of saturation. * Different models have their own distinct advantages according to the use made of them: e.g. LAB is versatile for computation but is not as intuitive in its metrics as HSB but HSB is inadequate at creating practical colour spaces. * NB: do not confuse with colour space which defines range of colours that can be reproduced or perceived.

See CIE L*a*b; Munsell system; YCC.

colour perception tests

Equipment or accessories used to evaluate or test an observer's colour vision. * Type of tests include (a) the identification of coloured samples: e.g. the Ishihara plates: observers with normal colour perception can see patterns which perception-deficient observers cannot (b) placing a series cards of varying hues but similar saturation and lightness into hue order e.g. Farnsworth-Munsell test (c) attempting – e.g. using the Nagel anomaloscope – to match yellow light by controlling the additive mixture of red and green light: observers who have colour-deficient vision obtain different results from those with normal vision.

Smart matching

The trick is in knowing what to do with a colour that lies midway between two colours in the look-up table: the wrong choice can cause artefacts to appear, with a sudden jump in hue in an otherwise gradual transition. Smart colour mapping adjusts the mapping according to the hue of neighbouring pixels.

Win some, lose some

In experiments comparing the colour rendering index with the efficiency of lamps in terms of how much light is emitted per watt of electricity, it has been found that generally the most efficient lights have the poorer colour rendering index.

colour picker

Part of operating system or application which enables user to select a colour for use e.g. loading the digital 'paintbrush' for painting, for filling a gradient etc.

colour rendering index

Measure of how well a light-source renders a range of colours: a monochromatic light-source renders colours poorly: its rendering index is low: e.g. 20; sunlight renders colours well: its rendering index is high: e.g. 100. * There are two methods of calculating the index, based on the CIE chromaticity diagram or on the spectrum of emitted light.

colour sensitivity

Measure of variation in way film responds to light of different wavelengths, particularly in reference to black & white films. * For example if film is more responsive to blue light than to red light, it records greater density to blue than to red light of identical luminance or luminous intensity.

colour space

Theoretical construct that defines range of colours that e.g. (a) can be reproduced by a given output device or (b) can be seen by human eye under certain conditions.

See CIE.

colour synthesis

Recreating original colour sensation by combining two or more other colours. * Two classes of methods: (1) additive colour synthesis i.e. final image is formed by combining primary colours e.g. red, blue and green as in colour monitor screens; (2) subtractive colour synthesis i.e. final image is formed by combining secondary colours e.g. cyan, magenta and yellow as in colour transparency film.

colour temperature

Measure of colour quality of source of light: expressed in Kelvin. * Colour of light is correlated to the temperature of black body radiator when colour of its radiation matches that of light being measured. * Warm or red colours are relatively 'cool' or are correlated to low colour temperatures; cold or blue colours are correlated to high colour temperatures.

Tempting colours

The approximate colour temperature of some common luminaires are:

candle	1930 K
tungsten bulb	2400 K
photoflood lamp	3400 K
noonday light	5400 K
average daylight	6500 K
blue sky	18000 K

colour temperature meter

Instrument for making indirect measurement of colour temperature of light by measuring relative proportions of red and green or blue. * Based on principle that proportion of two primaries is closely related to colour temperature. * Instrument consists of light-sensitive cells covered by filters:

C

output of cells are compared and read out as Kelvin. * Read-out may be calibrated as density of colour-correcting filter needed to balance light-source to preset type of film.

colour vision

Physical, physiological and psychological processes by which colour is perceived. * In humans, available only to photopic (daylight) vision where ambient light levels are high. * Essential sensors in retina of eye are the three types of cones with peak sensitivities to reddish, greenish and bluish light. * The human eye is able to distinguish about a million different hues in good light.

coma

Aberration usually seen when point of light far from centre of the image is projected as a comet-shaped blur of light, usually with the head of the 'comet' pointing away from the centre of the image. * Oblique rays from an off-axis object produce an asymmetric patch of light resulting from increase in magnification in the direction away from the optical axis towards the periphery. * Difficult to correct, but symmetrical designs may be effective.

CompactFlash

Removable data storage device with on-board processor. * Measures 1.4x1.7x0.1" – about quarter size of PCMIA card. * Capacity: up to 128MB.* Widely used in digital cameras and some MP3 players.

compensating developer

Formulation of developer designed to develop low-density (i.e. low exposure) areas actively and work less with less energy on high-density areas with the effect of producing less contrasty negative than with normal developer.

compensating eyepiece

Optics used with apochromatic objectives, particularly with microscopes, but also with high-quality spotting scopes. * Usually overcorrected for lateral chromatic aberration to balance undercorrection in the objectives.

complementary colours

Pairs of colours which produce white when added together as lights e.g. secondary colours – cyan, magenta and yellow – are complementary to primary colours: respectively red, green and blue.

complementary wavelength

The wavelength of light which, when mixed with the sample colour, produces a grey (achromatic colour). * On a chromaticity diagram, it is that wavelength on the spectrum

The last coma

Stopping down the lens aperture reduces coma as the smaller aperture vignettes off the oblique rays that are the cause. Unfortunately this is no help in the very instances coma is a problem, namely in photographing lights at night. The black background in these situations makes comatic defects all too apparent – but the last thing you want to do is to stop down.

Compliment them on their colour

Coloured filters generally transmit the colours of their colour-name while absorbing light of the complementary colour. Given our fickle language skills, the most common filter – the UV filter – breaks this rule: it stops ultraviolet while passing all other visible wavelengths; it should be called a minus-UV. A true UV filter appears black.

which lies on the projection of the line joining the achromatic point and the point for that colour – usually a non-spectral or secondary hue.

compliant
Device or software that complies with specifications or standards set by corresponding device or software to enable them to work together. * E.g. (a) modems must be compliant with telecommunications protocols in order to communicate with the telephone system; (b) software for digital cameras must comply with the computer's operating system in order to be able to off-load images.

component
(1) Optical part of a lens consisting of single lens element or two or more elements cemented together and treated as a unit. (2) Part of electronic circuit board – e.g. resistor, capacitor, switch – that is usually soldered or attached separately i.e. not integrated on the board.

compositing
Picture processing technique which combines one or more images with a basic image. * Typically, the composited image is held in a virtual layer above the base image to allow changes in scale, position and orientation to be made without affecting the base image.
 See layer mode.

compound shutter
Shutter located within an optic, i.e. between-the-lens. * Also known as leaf or diaphragm shutter.

compression
Process of reducing size of digital files by changing the way the data is coded. * NB: it does not involve a physical change in the way the data itself is stored; there is no physical squeezing or squashing. * Uncompressed data may be re-coded in a more space-efficient form without any loss of original information (the compression is 'lossless') or it may be coded to lose specific parts of the data which are considered less important than other parts (the compression is 'lossy').
 See encoding; GIF; JPEG; LZW.

computer-generated hologram
Hologram produced synthetically using a plotter controlled by computer programmed to plot the requisite wavefront information. * The resulting plot is obviously large-scale so it must be reduced, often in several steps, to be small enough to diffract light.

Last orders
Data is generally not stored in compressed form in the first place because it is then not in a form optimized for actual use such as pixel editing; the main exception is music with compressed formats such as MiniDisc. When image editing, then, don't work in JPEG or GIF format: leave that for the final save. Note that compressed files take longer to open up (they must be uncompressed) and may trip up systems that expect 'pure' files e.g. RIPs (raster image processors) at the printers.

C

computer-to-plate

CTP: workflow in mass printing in which page-layout files are used directly to create printing plates. * This process avoids the usual steps including production of page-layout separation films which need to be stripped or laid precisely onto foils for plate-making. * Disadvantages include difficulty of proofing (has to be digital i.e. soft-proof) prior to print-run and cost of correcting mistakes. * Also known as direct-to-plate.

computerized tomography

See CT.

concave

Inwardly curved, hollow surface: one that would hold liquid.

concave grating

A ruling or etching on a concave spherical surface that disperses and focuses light at the same time.

concave lens

Type of lens that causes parallel light rays to spread out: its centre is always less thick than the edge. * The lens surfaces may be flat and concave, both concave or one convex and one concave. * Also known as negative lens, divergent lens or dispersive lens.

concavo-convex lens

Type of lens with one surface concave and one surface convex. * Also known as a meniscus.

concentric

Of optical, graphical elements or other components: sharing the same centre while arranged on the same, shared plane.

condenser

Lens, Fresnel lens or group of lenses used to collect light from a source to evenly illuminate a film or transparency for projection. * Used in slide, overhead and cine projectors, enlargers, etc.

cones

Cone cells: light receptor cell of retina responsible for detailed and colour vision. * Human retina may contain some 6 to 7 million cone cells scattered between rod cells, with highest concentration of cones in macula in which rods are absent.

confocal scanning microscope

A microscope that uses a Nipkow disc or a laser to produce point-probing raster scanning, yielding images with very high contrast in the third dimension. A small aperture at the secondary focus of the objective lens narrows the depth of

Condenser milk

Condenser enlargers are commonly thought to produce completely undiffused light. In fact the light-housing for all condenser enlargers I've ever seen are painted white inside, thus creating a fairly diffused light-source – resulting in what is best referred to as a semi-condenser source.

focus and obstructs most of the light reflected from out-of-focus objects.

See scanning electron microscope.

conjugate

(1) Adjective: describing points on an optical axis related by their representing the object and its corresponding image. (2) Noun: distance between the object and the front nodal point (the object conjugate) or the distance between the image and the rear nodal point (the image conjugate).

conjugate holographic image

Image produced on the side of the hologram closest to the observer, in addition to the primary image: it is indistinct and distorted. * It appears as a real, distortion-free image when the reference beam is reversed. * Also known as real holographic image.

conjugate points

The pair of points on the principal axis of a mirror or lens such that light emitted from either point will be focused at the other, conjugate, image points.

See conjugate.

conservation of radiance

The principle that the radiance of a source cannot be increased by observation or instrumentation, therefore the radiance of an image cannot exceed that of the object.

constringence

Reciprocal of the dispersive power of an optically transmitting material.

See Abbe number.

contact print

Print made for proofing or record-keeping purposes in which the original is pressed flat against the printing paper – either directly or through a transparent holding sheet – for the exposure. * This produces images the same size as the originals. * Also called contact proof. * Concept has been extended to digital equivalent in which small copies of each image file are arranged for proofing or record-keeping.

See enlarged contact print.

continuous ink-jet

Type of ink-jet printer in which a stream of droplets of ink are shot out from a reservoir continuously during printing: most drops are sucked back into the reservoir but where ink is needed to print, a pulse of electricity changes the direction of the drops (because they are electrostatically charged) so that they shoot past a shield to fall onto the

Handy contact

The easiest way to make contact prints is to store the film in transparent polypropylene or archival polyethylene sheets: you can press the sheets flat with a pane of glass onto the paper. Also try scanning the strips on a flat-bed scanner – the result is a set of thumbnails which are easily picked off and used.

C

paper or other medium. * This system allows dots of variable colour, thus greatly improving apparent resolution: it is capable of photographic-quality printing, or better – but the machinery is costly to manufacture and maintain. * The need to carry an electrostatic charge reduces the range of inks that can be used.

See drop-on-demand.

continuous spectrum

Light in which most or all visible wavelengths are represented more and in which all wavelengths are more or less equal in power. * Usually radiated by solid or liquid matter. * The antonym of line spectrum.

continuous tone image

Record in dyes, pigment, silver or other metals in which smooth, unbroken transitions from low densities to high densities are enabled by varying amounts of substance making up image.

See digital image; half-tone.

continuous-wave laser

Type of laser which emits a continuous beam at constant power rather than in brief bursts or fluctuating power. * E.g. the HeNe gas laser. * Also known as a CW laser.

contone

Adjective: reproductive, printing or display system: one that provides continuous tone reproduction.

contrast

(1) Of ambient light: the brightness or luminance range in scene: the difference between highest luminance and lowest. * High contrast indicates large subject brightness range. (2) Of processed film: rate at which density builds up with increasing exposure over mid-portion of characteristic curve of film/development combination. * Also known as gamma: equal to slope of straight portion of curve. Objective measures: G-bar or contrast index. * May also be used to refer to the gradient or slope of other parts of curve i.e. toe or shoulder region. (3) Of light-source or quality of light: directional light e.g. spotlights give high contrast lighting with hard shadows; diffuse light or large light-source give low-contrast lighting with soft shadows. (4) Of printing paper: grade of paper e.g. high-contrast paper is grade 4 or 5, grade 1 is low-contrast. (5) Of lens performance or image quality: usually in reference to measured MTF: high-contrast lens delivers image of object with high MTF. Also subjective evaluation of image quality: high-contrast usually preferred

to low contrast. (6) Of colour: colours opposite each other on the colour wheel are regarded as contrasting e.g. blue and yellow, green and red; colours of adjacent hues do not contrast as strongly. (7) Of monitor image: maximum brightness range of images viewed on the screen. * Measured by gamma applied to electron gun; not to be confused with photographic gamma.

>*See G-bar; gamma.*

contrast control

(1) Dial or other means on enlarger of setting contrast grade for variable contrast papers. (2) Means of adjusting, either directly or via software, the contrast or highlights and shadows of an image projected on a monitor, or seen on screen of e.g. digital camera, laptop computer, etc.

contrast filter

Filter designed to improve contrast in an imaging system. * In black & white photography, a yellow-green filter is an all-round improver of image contrast; in distance viewing systems e.g. binoculars, a yellow filter can improve clarity by blocking bluish haze.

contrast grade

Measure of contrast or gamma of printing paper. * Usually runs on scale between 0 and 6, depending on manufacturer, where low grade indicates low contrast, 2 or 3 being 'normal'. * No standard that has been formally agreed has been widely adopted, except the *de facto* norm that higher contrast grades correspond to higher contrast index.

>*See multigrade.*

contrast index

See G-bar.

contrast threshold

The contrast level at which two areas have a just perceptible brightness difference at a given brightness level. * E.g. a lens manufacturer may quote a high resolving power but if that is at a contrast below threshold – the resolution is wasted.

convergence

(1) The coming together of light rays or a bundle of rays which progressively becomes smaller. * Typically the rays coming from a convex or positive lens are convergent. (2) The turning of forward-looking eyes so that the optical axes meet at or near object being viewed. (3) The coincidence or meeting at the mask of a colour monitor of the three electron beams for each colour. (4) Supposed increase in common ground between developing technologies.

c

converging lens
One that brings to a focus or converges a bundle of rays to a real image. * Also known as positive or convex lens. * Antonym: diverging lens.

converging meniscus
Lens with one convex and one concave surface which converges a bundle of incident light. * Compare with diverging meniscus.

convertible lens
Design of lens consisting of least two components which can be used in combination or separately. * E.g. many view camera lenses offer increased focal length when the rear component is removed. * Also known as separable lens.

convolution
Transformation of the values of pixels of bit-mapped images by applying a mathematical function to either single pixels or groups of pixels without changing the number or position of the pixels for purpose of image enhancement. * It is fundamentally what happens when filters such as sharpening, blurring or edge-finding, are applied to the whole image (values of the pixels are changed), when the image is compressed (the values are re-encoded) or when a fingerprint is applied (certain values are systematically changed).

See bit-mapped; fingerprint.

convolution kernel
Group of adjacent pixels on which mathematical operations are applied during image processing or the application of image manipulation filters. * That set of pixels – usually groups of nine or more arranged in a square – are convolved in a given operation.

cookaloris
Mask used in front of lamp to create pattern of light and dark on a background e.g. in studio set-ups to simulate sunlight penetrating layer of leaves or through the grilles of a window.

Cooke triplet lens
Standard lens design capable of giving good correction at low cost. * Consists of positive elements air-spaced either side of a bi-concave (therefore negative) element. * Evolved from anastigmat and Petzval design by H D Taylor for Cooke in 1893.

cookie
(1) Data or small text file exchanged between a server (e.g.

Close-up from Cooke

A few modern lenses, particularly standard macro lenses, can trace their ancestry to the Cooke, via the classic Tessar designs – themselves an elaboration of the Cooke triplet – which were the mainstay of standard lens design for several decades. Tessars were noted for their excellent all-round correction and reasonable speed of f/2.8, yet were relatively inexpensive to manufacture. Another line of development from the Tessar gave us the classic Biogon and Sonnar families of high-performance optics.

for a Web site on WWW) and a client (e.g. browser software being used by a net surfer who has logged on). * Used to identify or profile client's preferences to customize information or track usage. (2) Short for cookaloris.

copying camera
Design of camera for copying flat originals such as prints, paintings: the camera and easel are mounted on a common sliding frame or runner which fixes the camera at right angles to, and centred on, the easel.

copyright
'Property right which subsists in original literary, dramatic, musical or artistic works' – which includes photographs, which are in turn defined as 'a recording of light or other radiation on any medium on which an image is produced or from which an image may by any means be produced, and which is not part of a film'. * It is the right of control over various uses of an artistic work (e.g. reproduce, publish, broadcast, alter) which only the copyright holder can do, grant, sell or license to another person or undertaking. * Exceptions are allowed in limited circumstances e.g. research, criticism. * To do any of these acts without permission is to infringe copyright. * The first owner of any copyright in photograph is 'the author' who is 'the person who creates it' e.g. the photographer, unless an employee whose job it is to create the photographs; or if contracted otherwise. * The law also grants the first owner certain moral rights including right to object to derogatory treatment of work e.g. addition to, deletion from, alteration or adaptation that amounts to distortion or mutilation of work and the right to object to misattribution of authorship. * Copyright holder also has right of possession of the work. * Note: copyright does not in itself establish the right to publish, print, etc. * Copyright in a photograph expires 70 years 'from the end of the calendar year in which the author dies' unless copyright is assigned to a surviving party e.g. estate or agency. * Note that copyright is not vested in the person who pays for the film or processing or in the purchaser of the print, unless agreed by both parties otherwise. * It is not necessary to use the © sign to demonstrate ownership, but it helps. (Extracts taken from UK Copyright, Designs and Patents Act 1988.)

core
The central region of high refractive index of an optical fibre: light is conducted along this region.

C

cornea

The transparent membrane that covers the front of the eye. * The first and optically most important surface of the eye. * It is richly supplied with nerves, making it highly sensitive. * Any disturbance to its regular collagen structure reduces its transparency.

coronagraph

Design of telescope for observing and photographing the corona of the sun: a mask covers the solar disc i.e. creates an artificial eclipse, thus protecting the eyes and measuring instruments from the sun.

corrector plate

Optical element designed, usually, to correct for spherical aberration. * E.g. such an element was used to correct manufacturing defects in the Hubble Space Telescope.

See Ivanoff corrector; Maksutov corrector.

correlated colour temperature

The temperature of a black body or complete radiator at which the colour of light emitted is nearest to that of the light or colour sample under test.

corruption

Unintended or accidental change to computer file or record which results in damage to the file. * It may be rendered unreadable or cannot be opened, or may produce gibberish or defective information.

cosine law of illumination

The illumination on a flat, diffusing surface varies with the cosine of the angle of the incident light to a line perpendicular to the surface.

cosine to the fourth law

The brightness of the image away from the optical axis falls off at a rate proportional to the \cos^4 of the angle the light makes to the perpendicular at the focal plane. * See side-bar.

Cotton-Mouton effect

Double refraction or birefringence of light by certain liquids when placed in a magnetic field.

coulomb

Standard unit of electric charge: equal to the electricity moved in one second by a current of one ampere. * Unit: C.

coupled rangefinder

Mechanism of camera that integrates the rangefinder measurement with the lens focusing mechanism: as the rangefinder determines an object's range the lens is automatically focused.

Darkness at the edge

In a super wide-angle lens, the fall-off from the cosine to the fourth can be more than two stops i.e. the periphery is darker than the centre by two stops – unless corrected. This may take the form of optical tricks such as carefully introduced coma. Oddly, lenses with the widest of views – fish-eye lenses – are immune from this law and that precisely because of their curvilinear distortion.

It takes two to rangefind

Formerly the term was applied to a mechanical linkage, e.g. a cam and lever, in which rangefinding and focusing of the lens occurs simultaneously thanks to the interconnection. Now it also refers to electro-mechanical links between auto-focus ranging and the lens. In this the range is first determined, then the resulting data is used in a separate operation to drive a stepper motor which sets the lens.

coupler

(1) Organic compound used in colour film or print processing that reacts or combines with development by-products to form a coloured dye. * Couplers are colourless until they react with the developer (usually para-phenylene diamine or the like) oxidized from turning exposed silver halide to silver. * They are made to produce dyes with the subtractive primary colours of cyan, magenta and yellow in separate layers of colour film. (2) Component in optical rigs used to distribute or divide optical power. (3) Device used to join optical component with a light-source or detector. * Also known as connector.

covering power

(1) Indication of ability of ink or dyestuff to hide or cover what lies beneath e.g. yellow ink has a lower covering power than black ink. (2) Ability of lens to project an image for the format in use: the diameter of projected image is normally just larger than the format diagonal.

CPU

Central Processor Unit: part of computer which receives instructions, evaluates them according to the software applications, then issues appropriate instructions to the other parts of the computer: in short it is the brains of the beast. * It is the part that is continually being upgraded to work faster, more efficiently and more powerfully. * Often referred to as the 'chip' e.g. G4, Pentium etc.

crash

The sudden, unexpected and always thoroughly unwelcome non-functioning of a computer. * Due to one or a combination of the following sadly not comprehensive list: (a) a fault or problem in a program e.g. a bug (error in programming) (b) interference from virus or corrupted file (e.g. an 'end-of-string' message in the middle of a string of data); (c) error in reading or using a stored file (d) failure of a hard-disk e.g. damage to the read/write head (e) transient change in power supply e.g. sudden, brief drop in voltage (f) conflict between programs or their calls to the system via extensions, settings. * Also known as a bomb.

See freeze.

critical angle

The angle at which total internal reflection takes place.

See Snell's Law.

critical aperture

The aperture setting which gives the best overall

Stop stopping down two

The commonest advice for using critical aperture was to stop down two stops from maximum: this continues to be useful for standard lenses of modest aperture and enlarging lenses, but not for other types. High-speed telephoto lenses (e.g. 300mm, f/2.8) are often already at their best at full aperture or just half a stop down. Ultra wide-angle lenses often need to be stopped down three or four stops to be at the best. And zoom lenses, particularly those with large zoom range of inexpensive construction, may need to be stopped almost to minimum aperture to be at their best (and still none too good).

c

performance. * The relative aperture at which an optical system delivers the best balance between aberration correction and contrast rendition.

critical illumination

Set-up of lighting in which the light-source is projected onto or imaged at the object being illuminated. * Used in microscopy where maximum utilization of light is important e.g. to minimize operator strain.

crop

(1) To use part of an image – i.e. not the entire image – for one or more of the following purposes (a) improving composition (b) fitting image to fit space in publication (c) fitting image to broadcast format (d) removing defect such as hair, scratch or processing mark from image (e) squaring up image to correct horizon or vertical axis. * In photography, some photographers abhor a crop and may go so far as printing blank negative around image to prove it. (2) To scan only that part of an image that is required: this reduces the resulting file size from what it would be and can reduce the scanning time.

cross-platform

Application software, file or file format which can be used or opened on more than one computer platform or operating system. * E.g. TIFF files may be opened both by suitable applications in either Mac or PC computers; FileMaker files open on both Mac or PC computers.

crown glass

Type of optical glass characterized by low dispersion and high hardness. * Family of glasses with Abbe number greater than 50 with refractive index of 1.6 or greater, and Abbe number greater than 55 with refractive index below 1.6.
See flint glass.

CRT

Cathode-Ray Tube: the basic technology of computer monitors, just like domestic TV. * A source of electrons – the cathode – produces a stream or ray of electrons which are accelerated towards a screen covered in phosphors that glow when hit by electrons, the whole process taking place in a vacuum in an evacuated glass container – the tube. * To obtain variations in colour, red, green and blue coloured phosphors are used, with the beam directed at the correct dot of phosphor by a screen with precisely punched apertures or precisely located wires to direct the beam.
See aperture grille; shadow mask; Trinitron.

Glass not crystal

Glass, familiar to us as the key component of camera lenses, mirrors, etc. is not a crystal despite appearances. Technically it is a solidified liquid: when sufficiently heated up, it simply loses its shape – but not its optical properties.

C

crystal
Solid substance whose structure is essentially symmetrical and geometrical. * Crystals are vital to photography as silver halide in light-sensitive emulsions. * Crystals are also vital to computers as they are used in the clocks that regulate and time every computer operation. * Most natural crystals e.g. calcite are birefringent or doubly refracting. .

crystal optics
Science of the transmission of radiation through crystals. * As most natural crystals are anisotropic, it is also the science of birefringence.

crystalline lens
The lens of the human eye. * A transparent, bi-convex body made of lens fibres, suspended between muscles which can change the shape – i.e. radius – of the lens; it is situated behind the iris and the vitreous body of the interior of the eye. * It has a high refractive index and a power of about 20 dioptres.

CT
Computerized Tomography: use of low-dosage x-rays to image soft tissue by using a computer to create or synthesize a three-dimensional image – which may be viewed from different angles – from a sequence of two-dimensional cross-sections. * Also referred to as CT scans.

CTP
See computer-to-plate.

curvilinear distortion
Defect of a lens' projection of an image onto the focal plane that causes straight lines to appear curved and conversely which tends to straighten out curved lines. * Caused by variations of magnification over the image – which may increase or decrease depending on position. * Usually regarded as undesirable but may be specifically designed into e.g. fish-eye lens to allow an ultra-wide angle of view or an even light distribution of the projected image.
See pincushion distortion; barrel distortion.

custom colour
A specially formulated colour used together with black ink or in addition to the separation colours. * A spot or non-process colour applied to normal four-colour printing e.g. solid purple, gold, silver.
See custom palette.

custom palette
Set of colours selected by user or software for a specific

Lots from less
Few images actually use more than thousands of different colours and most images are satisfactorily reproduced with two hundred or so colours – particularly when only seen on monitors. In software designed to compress image files, it is surprising how much colour you can remove (giving you smaller file) and still have a perfectly acceptable image.

C

purpose e.g. to ensure satisfactory reproduction of image with the smallest number of different colours in order to minimize file size; also to specify the colours approved for corporate publications.

See GIF.

cut and paste

To remove a selected bit of text, selection of cell contents, selected part of a graphic or image etc. from a file and store it temporarily in a clipboard to be used elsewhere, at which point the cut selection is said to be 'pasted'. * In the best-known systems, the cut item can be pasted into an altogether different program from the original.

See clipboard; drag-and-drop.

cutoff wavelengths

(1) In colour filters: those wavelengths at which the transmission through the filter falls below 5%. (2) In light detectors: the longest wavelength at which detector response falls to 50% (or other pre-set percentage). (3) In fibre optics: the wavelength at which light is not internally reflected along the fibre.

CW laser

See continuous-wave laser.

cyan

Blue-green: primary colour of subtractive mixing; secondary colour of additive mixing. * It is the complementary to red.

See CMYK.

cylinder

(1) A set of tracks on a floppy disk or hard-disk that are in the same relative positions on opposite sides of the disk or platter. * In hard-disks which consist of several platters, a cylinder comprises all the tracks with the same numbers on all sides of all disks. * Cylinder information is important for correctly setting up a hard-disks but rarely concern the user. (2) Axis used to define astigmatism in an eye. * The cylinder axis is the principal meridian of the lower focal length of an astigmatic lens.

cylindrical lens

Design of lens in which there is at least one surface formed from a part of a cylinder. * Used to correct astigmatism in the eye; to produce astigmatism e.g. stretching a point of light into a line for rangefinding purposes e.g. in auto-focus cameras, etc. * Also for analogue image compression in one axis. * Also known as anamorphic lens, toric lens.

Strange, but blue

Cyan comes from the ancient Greek 'kyanos' which, as an adjective – we are told – means 'dark'. Ancient Greeks, as Goethe was the first to point out, did not have a word for 'blue'. Were the old Homeric yarn-spinners just colour-blind? Or did they just 'see' their skies as 'dark'? Note: kyanos, the noun, referred to the stone lapis lazuli, which is a beautiful sky-blue – from which we obtain the present meaning of cyan.

D

Density units.
See density.

D *

Measure of the sensitivity of a detector. * Higher D* values indicate a relatively better detector. * Pronounced 'D-star'.

D-line

Light of wavelength 589.6nm. * Used, together with F and C lines, to calculate dispersive power. * A Fraunhofer line.

D-max

Maximum density. (1) Measure of greatest or maximum density of silver or dye image attained by film or print in given sample. (2) Point at top of characteristic curve of negative film or bottom of curve for positive – i.e. region of high exposure – at which density reaches maximum for given film, development time and developer: just before curve levels off or begins to turn.

D-min

Minimum density. (1) Measure of least or lowest density of silver or dye image attained by film or print in given sample. (2) Point at bottom of characteristic curve of negative film or top of curve for positive – i.e. region of lowest exposure – at

High, max!

High D-max, synonymous with the accolade 'good blacks', is regarded as A Good Thing as it contributes to subjective assessment of high quality image; also objectively important, especially in projection of transparencies. Applies in equal measure to prints, whether made by ink-jet or off-set lithography: but beware paper is not soaked saturated by ink, which is to use more ink than needed.

D

which density reaches minimum for given film, development time and developer. (3) Lowest density of sample of film – usually after processing. * This is sum of density of film base plus density of unexposed but processed emulsion. * A high D-min lowers image quality.
> *See fog.*

D6500
White balance standard used to calibrate monitor screens: used primarily for domestic television sets. * White is correlated to colour temperature of 6500 K. * Recommended by some authors for colour print soft-proofing, but many find it too yellow.
> *See 9300; white.*

DAC
See Digital-to-Analogue Converter.

Dall-Kirkham telescope
Design of telescope employing an ellipsoidal primary mirror with a spherical secondary mirror. * Layout is similar to the Cassegrain design.

dark adaptation
Adjustment by the human eye to low light levels. * The retinal pigments and pupil take part in the adjustment: light sensitivity is increased. * Slower to take effect than light adaptation.
> *See Purkinje shift.*

dark beam
Light-source designed for darkroom use: delivers a tiny beam of light suitable for reading with but designed not to spread and is safe for all but colour materials.

dark box
Box used for storing light-sensitive materials. * Usually constructed with light-traps so that it is easy to open and close for use in the darkroom.

dark current
Unstable reading given by a CCD when powered to operating voltage but when no light falls on it, thus causing noise in the signal of e.g. digital cameras. * Worsens with greater sensitivity of chip and at higher temperatures.
> *See CCD.*

dark noise
Electronic activity caused by the dark current in a photo-detector.

dark-field condenser
Design of light-concentrating device: light is formed into a

Cool and wide

Dark current is enough of a problem with high-resolution scanning camera backs – e.g. for use in the studio – that many carry their own refrigeration unit. But don't complain: the result of a chilled sensor is great dynamic range: these backs can record high highlights to deep shadows, covering dynamic ranges which far exceed even colour negative film.

hollow cone-shaped beam of light focused on the plane of the object. * Used primarily in microscopy. * The objective must have a numerical aperture smaller than that of the hollow beam so the only light entering the objective is that scattered by the specimen – which is seen as a bright object against a black background.

dark-field illumination

Lighting technique used in photographing close-up and magnified subjects in which subject is lit but not the background: therefore subject appears to float in a dark field or background. * Effective for showing up detail in translucent subjects, particularly in microscopy.

darkroom

Room designed for working in the dark e.g. to make prints or handle light-sensitive materials. * It is made light-tight to create total darkness with working illumination only from a safelight appropriate to materials in use.

DAT

Digital Audio Tape. Music format that has found, like its CD-ROM cousin, use as a general digital data storage format. * Capable of storing enormous quantities of data very cost-effectively but it is very slow and, like all tape-based media, limited by physical character of tape i.e. you have to wind through it to find data.

data compression

Technique for storing digital data so that it needs less transmission capacity (bandwidth) or takes up less memory or storage space than basic storage methods would. * All data compression methods seek to re-code the information in ways that reduce the size of the file. There is no physical change in the size of the storage medium holding the data. * Also known as data compaction or file compression.
See GIF; JPEG; LZW.

daylight

Noun: (1) Light that comes more or less directly from sun: it varies very widely in brightness, colour and quality. (2) A notional standard light: an average mixture of sunlight and skylight with some clouds typical of temperate latitudes around midday. * Daylight has a correlated colour temperature of roughly 5400-5900 K.
Adjective: (3) ~ film: one whose colour balance is correct for light-sources whose colour temperature is 5400-5600 K. (4) ~ artificial light-source e.g. ~ light bulb: one whose colour rendering index approximates that of daylight i.e. a certain

set of standard colours will appear the same colour when seen by this light-source as by daylight.

See D6500.

daylight lamp

Design of lamp whose light is similar to that of daylight. * Its spectrum or colour rendering index is similar to that of daylight. * May be an incandescent (e.g. tungsten filament light with a blue envelope) or fluorescent (with phosphors designed to emit a broad range of colours).

DCF

Design rule for Camera File system: specification for a digital camera file format. * Drawn up by JEIDA.

DCS

Desktop Color Separation: a file format which consists of PostScript files of each of the CMYK separations at high resolution with a fifth, low-resolution Encapsulated PostScript (EPS) file used for positioning and proofing. * DCS version 2 allows for more files e.g. to allow use of a fifth, or spot, colour.

See EPS; CMYK.

DCT

See discrete cosine transform.

decamired

Unit of measurement of colour temperature: 100,000 divided by colour temperature. * Used to calibrate colour filters.

See mired.

decentration aberration

Degradation of image quality caused by one or more of the optical elements being incorrectly aligned. * The defects in imaging caused where the optical centre of one or more elements in an optical system does not lie on the image or optical axis.

definition

(1) Subjective assessment of the clarity and quantity of detail visible in a test image produced by an optical or imaging system. * (2) Assessment of optical or imaging system, based on assessment of the clarity and quantity of detail visible in a test image. * Objectively measured in an optic by considering parameters such as resolution and contrast for the image produced by the system. * For photographic negative or print, other relevant parameters (to be excluded or accounted for) include: acutance, granularity, gamma and other factors such as edge effects.

See MTF.

deflection

Change of direction of a wave or beam of light, other radiation or stream of particles. * Usually in the sense of a bending away from an expected path e.g. by diffraction, reflection or, with charged particles, by a magnetic field.

deformable mirror device

Semiconductor device consisting of a tiny mirror controlled by a transistor: a change in charge of a transistor deforms or moves the mirror. * The mirror is a metal-coated polymer film which is stretched over a metal-oxide semiconductor field-effect transistor. * Used in an array as a spatial modulator e.g. for video displays: each mirror is aligned to either a red, green or blue laser thus controlling the colour of each projected pixel. * Also called DMD, or deformable membrane device, or digital micromirror device.

See DLP.

defragmentation

Process of re-arranging files which have become scattered about in fragments on different parts of a hard- disk so that all the fragments are as close together as possible.

See extents tree.

degaussing

Process of removing excess static charge that builds up on the outside of CRT (cathode-ray tube) monitors. * On high-resolution, colour-critical monitors, the charge will both distort and colour the image and so should be removed regularly – which usually occurs automatically on start-up on most modern monitors.

See CRT.

delete

(1) To render a file unusable, usually by removing its reference from the list of contents or file allocation table for the storage medium on which the file is kept. * A distinction is sometimes made between logical deletion after which it is possible to recover the file and physical deletion, after which file recovery is difficult but may be possible. In both cases, the original file itself may still be lurking on the floppy or hard-disk and only the cataloguing data is lost. * Special undelete and recovery utilities may be able to reconstruct the file. (2) To remove an item, such as a letter, selected block of words or cells, selected part of a graphic or an image, usually by hitting a delete or back-space key. * Compare with 'cut', when the selected element is removed to temporary storage in a pasteboard.

De-frag for all you're worth

Working with de-fragged files is like having all your papers in the one pile: it's faster, easier and almost fun. For the hard-disk that translates into easy work: it can read a large file in one go as all the parts are in easy, sequential reach – which can speed up work by as much as 70%. It's worth running de-fraggers (e.g. Norton SpeedDisk) on your hard-disk at least every month or so, or weekly if you do heavy manipulation of big files (over 15MB). Most defrag software run a profile test to see whether it's worth taking action.

densitometer

Instrument designed to measure the degree to which a sample absorbs light. * May be used to measure pigments, dyes or particles in dispersion or suspension. * Various kinds, depending on method of assessment and type of density measurement required.

densitometry

Study and analysis of changes in the amount or density of silver or dye images in film or on print. * Density is usually measured indirectly, in terms of amount of light absorbed or scattered by film or reflected by print. Used to evaluate film speed, contrast, granularity, colour balance and related parameters. * For colour materials, densitometry through sets of red, green and blue filters are required for each type: Status A for transparencies; Status M for colour negative; Status D for colour prints.

> See densitometer; sensitometry.

density

(1) Measure of darkness, blackening or 'strength' of image in terms of its ability to disperse or absorb light i.e. its opacity. * It is logarithm of ratio between light incident on the sample to the light transmitted or reflected by the sample; also the logarithm of opacity. * In practice, a change in density of 0.3 equals approximately a doubling in opacity i.e. the sample appears 'darker' by one stop. * Density is measured in variety of ways i.e. illuminated with diffuse or direct, parallel, light and then all or only part of emerging light is measured. (2) The number of dots per unit area given by a print process such as laser or ink-jet printer. NB: This is always smaller than the printer's actual output resolution. (3) The number of sensors packed into a unit area e.g. CCDs per square millimetre.

Denysiuk hologram

Single beam reflection hologram. * The same i.e. single beam of light serves both as the reference and the object beam: this results in a reflection hologram.

depth

(1) Dimension of e.g. picture or page size measured on vertical axis, at right angles to width measurement. * But may (confusingly) be referred to as 'height' in printing and publishing. (2) Sharpness of image i.e. how much is sharp; loosely synonymous with depth of field. (3) Subjective assessment of the richness of black in either print or transparency. * Loosely synonymous with maximum density.

*Note: high maximum density does not necessarily give greatest depth of black as this also depends on e.g. surface quality, tone colour.

depth of convergence

Measure of distance over which object position may vary while being sufficiently imaged for or while falling within performance limits of an application e.g. machine vision. * Also known as depth of range.

depth of field

Measure of zone or distance over which any object in front of lens will appear acceptably sharp: it lies in front of and behind the plane of best focus. * Depth of field is due to geometry of image formation plus inability of eye to distinguish a circle blur from a point in the image: it cannot be affected by lens design. * It is proportional to the circle of confusion, to f/number (i.e. increases with smaller apertures) and is inversely proportional to the square of focal length (i.e. depth of field decreases very rapidly as focal length increases) and is proportional to square of focus distance. * The other factor that affects depth of field is the angle of the plane of best focus: usually this is assumed to be at right angles to the optical axis but can be angled in tilt lenses or tilt movements of large-format cameras.

See Scheimpflug condition.

Deeply digital

Depth of field applies to digital images just as much as to analogue: the difference is that digital pre-processing to increase sharpness can give the appearance of increasing depth of field.

depth of focus

Measure of zone or distance over which an image projected by the lens will appear acceptably sharp: it lies in front of and behind the focal plane. * Varies proportionally with aperture for given circle of confusion and inversely proportional to focal length.

depth of range

See depth of convergence.

depth perception

Perception of absolute or relative distance of object from viewer. Most acute with binocular vision or stereopsis. * Also possible with monocular vision, aided by information – which also contributes to depth perception in binocular vision – such as (a) overlapping i.e. nearby objects overlap things farther away (b) relative size e.g. lamp-posts of same size get smaller with distance (c) linear perspective e.g. converging parallels of walls, roads (d) relative position e.g. further objects tend to be high in horizon (e) progressive loss of detail e.g. textures smooth out as object recedes (f) aerial perspective e.g. effect of haze increases with distance

Eyes wide focused

Depth of focus is the reason why lenses with small maximum apertures are so hard to focus and why we focus at maximum aperture with single-lens reflex cameras and enlarging lenses. This practice assumes that the focus does not shift with stopping down – not guaranteed with cheaper enlarger lenses.

D

(g) relative position of shadows (h) contrast e.g. contrast decreases with distance and (h) parallax.

See aerial perspective; binocular; parallax.

descreening

Process in image processing designed to remove moiré effects in images caused by the scanning of photo-mechanically reproduced photographs or the capture of subjects with fine, regular pattern e.g. weave of jacket. * May take place during image capture or in post-processing.

destructive interference

Phenomenon of wave nature of light: it occurs when there is a superimposition of coherent light from two sources in such a way that the combined intensity is less than the sum of the individual intensities before they were superimposed. * This occurs when troughs of one wave more or less cancel the peaks of the other wave.

detective quantum efficiency

Measure of performance of a light-detecting system. * Ratio of energy required by a perfect system to that needed by the test system – e.g. light-sensitive emulsion – for a given result.

detectivity

A measure of the sensitivity of a detector, without reference to other properties e.g. wavelength, duration, etc.

deuteranomaly

Abnormal perception of colour due to lower-than-normal sensitivity to green. * Commonest type of colour vision deficiency occurring in as many as 1 in 20 males; it is much rarer in women.

See anomalous trichromatism.

developer

(1) Substance used to convert the exposed silver salts of the latent image into metallic silver. * It amplifies the latent image into a visible image. (2) Individual or group of programmers or commercial enterprise responsible for creating software or other applications.

development

Process of converting the latent images of an exposed film into visible ones. * In photography, it is usually the conversion of exposed silver halide into silver plus free halide during which the developing agent is oxidized.

development effect

See edge effects.

Why is it never straightforward?

After going through all the palaver of improving CCD resolution and so on, we discover that we have to reduce some of that quality we fought for. Why? Because certain subjects like woven jackets or the fine lines in some metalwork offer a pattern which will cause moiré effects by interference with the CCD array. The only way to avoid it is to reduce the high frequency pattern i.e. to lower the resolution of the image. Kodak use a brilliantly designed anti-aliasing or low-pass filter in their professional digital cameras (an extraordinarily cunning use of birefringence), but others will just have to put up with the problem.

device resolution

Ability of device such as scanner, printer, etc. to distinguish detail or to output detail. * In the case of input device, e.g. scanner, ~ is the finest detail of workable contrast that can be resolved or discriminated. * In the case of output device, e.g. printer, ~ is the highest density or frequency of addressable points that the device is capable of handling.

See output resolution.

diaphragm

Design of lens aperture control designed to cut out peripheral rays not required for image or application. * Consists of set of flat, opaque blades with curved cut-out positioned inside lens and pivoted so that they partially overlap to leave hole centred on lens axis: the area of the hole determines the lens aperture setting. * Setting the aperture is controlled by ring or other mechanism that changes the angle at which blades overlap.

diaphragm shutter

See leaf.

diapositive

Synonym for colour reversal or transparency film. * Imported from the French.

See colour.

DIB

Device Independent Bitmap: image file format that either allows use of indexed colour – in association with a colour map or palette to define a pixel's colour – or defines 24 bits of true colour. * Used in multimedia where its compactness and flexibility are favoured. * Originally created for IBM's OS/2 operating system for PC-compatible computers.

See indexed colour.

dichroic

(1) Material displaying different colour seen in transmitted light compared to reflected light. * Literally: two-colour. * Adjective: (2) ~ mirror: one used to reflect light selectively, according to its wavelength. * Also known as diathermic mirror. (3) ~ polarizer: one that transmits light that is almost completely plane polarized. * The transmitted intensity is half that of the incident intensity. (4) ~ bulb: one using a dichroic mirror to reflect visible light but allow passage of infrared light. (5) ~ fog: thin, fine deposit of molecular silver on film or surface from e.g. exhausted fix: its colour appears to change with viewing angle due to diffraction.

See pellicle mirror.

Shaping the highs
The shape of the diaphragm hole is determined by the number of blades: the more blades, the nearer hole can be to circular. This may seem a dull and obvious fact but the shape of the hole has important consequences for the image. It determines the quality of the out-of-focus image – especially its highlights – and it plays a part in controlling lens flare and internal reflections. Unfortunately, multiple blades are more difficult to manufacture and create more resistance against closing and opening.

D

dichroism

(1) Optical phenomenon exhibited by certain materials in which light is selectively transmitted or reflected depending on its wavelength. * The colours of such materials change with (a) the thickness of the material (b) illumination or (c) angle of viewing. (2) Optical phenomenon exhibited by certain, usually crystalline, materials in which light is selectively absorbed according to its plane of vibration with respect to an axis of the material.

didot point

Typographical measure: one didot equals 0.0148 inch; 12 didot points equal one didot pica or cicero.

diffraction

Optical phenomenon in which light appears to bend round corners or to spread out when a beam of light passes through narrow slit. * Part of beam of light passing the obstruction is deviated – by an amount proportional to wavelength – by the interaction of the obstruction with the wave-like nature of light. * The edge of the obstruction is the point at which new secondary wavefronts are generated: these naturally spread round the edge, making light appear to turn the corner.

diffraction grating

Optical component used to diffract light, consisting of transparent or reflective plate etched with lines which are very closely spaced – 2-30μ (micrometres) apart: each pair of lines acts as slit through which light is diffracted, in proportion to wavelength. * Used as (a) special effects attachment in photography in which variation in diffraction with wavelength i.e. dispersion effects are exploited (b) to disperse light for experimentation (c) in camera viewfinder systems as beam-splitter. * Hologram systems are effectively complex diffraction gratings.

diffraction limited

Optical system in which all aberrations have been so fully corrected, that the only limit to optical performance is diffraction effects. * In practice, a lens is considered diffraction limited where the residual wavefront errors are less than a quarter of the wavelength of a specified radiation. * Many of the top-class, high-speed, long telephoto lenses are practically diffraction-limited optics.

diffractive lens

Design of optical device that uses diffraction to form image. * For example: holographic lenses, binary lenses.

Round the bend

This seemingly obscure bit of physical optics is actually photography's glass ceiling: it sets the limit of resolving power of a lens and indeed any optical system. Diffraction effects increase with longer wavelengths and smaller aperture setting (so avoid setting small apertures like f/22); and it sets more severe limits on the performance of long focal length lenses than on shorter lenses.

Free light shows

The wild colours visible on the active side of CDs are caused by the millions of microscopic pits and lands acting as diffraction gratings.

diffractive optics

See binary optics.

diffuse density

Measure of density in which either incident illumination is diffuse and measurement is of directly transmitted light or the incident illumination is direct and the measurement is of all or nearly all of the transmitted light. * This represents behaviour of film during projection, and is a widely used mode of measurement in pre-press, monitoring colour processing lines etc.

diffuse illumination

Lighting in which the light rays are highly scattered i.e. they fall on the subject from many different angles. * Such lighting produces very soft, if any, shadows and few, if any, specular reflections.

diffuse reflection

Reflection of light such that the light rays leave the surface at many different angles e.g. from a rough surface. * Also called non-specular reflection.

diffuse-cutting filter

Design of colour filter in which absorption of light gradually increases or decreases with change in wavelength.

diffuser

Accessory fitted to front of light-source or placed close to illuminated object which is designed to scatter or disperse light. * Usually semi-translucent material e.g. nylon weave, frosted plastic sheet, etc.

diffusion

(1) Of light: scattering beam of light in many directions caused by sending light through semi-translucent screen e.g. nylon sheet or cloud or through smoke; reflecting light from matte surface e.g. ground glass or paper. Effect is to 'soften' light and results in lowering of contrast and blurring of edge of shadows. (2) Of chemicals: movement of molecules in gas or liquid medium from region of high concentration to one of low concentration.

digital camera

Electronic imaging system using an array of light-detectors to record an image, coupled with a device to store the digital record. * The typical arrangement is to have a lens of fixed or zooming focal length projecting onto a CCD or CMOS type of detector or sensor. This is commonly a wide array of sensors (single-shot camera) but may be a line of sensors (scanning camera). * The sensors convert or

transduce light energy into electrical energy which is measured to provide image data. * For colour discrimination, the sensors are covered in a grid of red, green and blue filters so each sensor's reading is related to the colour of the filter that lies over it. * The image data is stored in devices such as PCMIA hard-disks or memory cards or can be transferred to a computer via cables or infra-red link.

See 35mm equivalent focal length.

digital densitometry

Representation of digital image as a series of bands or lines showing the distribution of density or value.

digital filter

Method of transforming or selecting data: series of mathematical operations iteratively (repeatedly) applied to input data results in new output data. * May be effected by software or by hardware. * In digital imaging, many operations on the image e.g. sharpening, blurring, distortions, adding textures, etc. are effectively digital filters.

digital image

Image which has been produced by transforming a picture into a digital record followed by reconstruction of the picture on computer screen or other visible medium such as print. * Process consists of: (a) Image capture: optical image is scanned or captured by regular array (raster) of picture elements (pixels) (b) Translation or transduction: brightness and colour values (if recording in colour) are evaluated and recorded together with location or address of each pixel (c) Storage: record is kept in electronic form (d) Output: when digital image is required, electronic record is read for its information in order to reconstruct image using output device such as monitor screen, printer: each pixel in raster is printed or displayed according to brightness values appropriate for it (e) Reconstruction: when digital image is seen, human eye blends brightness or colour values into an integrated picture, with more or less detail according to quality of image.

digital image processing

(1) Techniques for converting analogue image into a digital equivalent, namely: a representation of the position of each of a finite number of pixels each with appropriate numerical values. (2) Series of manipulations or analyses applied to a digital image for purpose of correcting image values, applying special effects, preparing for output, for storage or transmission, etc.

digital photography

Type of photography in which one or more stages in the process works with, involves or uses a digital image. * E.g. image may first be captured on film which, after processing, is scanned i.e. turned into digital image which is then edited and finally output to film.

digital paint system

Computer software or graphics application designed to simulate tools and media of conventional artist. * Also known as natural media programs.

digital-to-analogue converter

Device that transforms a stream of digital data into an analogue signal. * With images, the digital file is converted into image that can be viewed on a monitor. * Arguably a printer attached to a computer is itself a digital-to-analogue converting machine.

See analogue-to-digital converter.

digitalization

See digitization.

digitization

Process of translating values for brightness or colour into electrical pulses representing alphabetic or numerical code. * A fundamental process that enables optical image to be converted into a form which can be handled electronically. Digital code enables record of image to be manipulated by computer programs and result can be output into visible form using printer or monitor screen. * Also found in cameras using computer-controlled systems e.g. with auto-exposure meter and auto-focus sensors. * Also known as analogue-digital conversion, digitalization.

See data compression.

DIMM

Dual In-line Memory Module: type of memory module in which the connector pins are arranged along two rows.

DIN

(1) Deutsche Industrie Norm: organization setting industrial standards in Germany, comparable to BSI and ANSI. (2) Measure of film sensitivity or speed: DIN speed is denoted by degree number on logarithmic scale e.g. 100 ASA is equivalent to DIN 21°. * One-stop intervals are 3 DIN degrees apart so 400 ASA is DIN 27°, 800 ASA is DIN 30° and so on. * Stubbornly still used in continental Europe but, as it is measured by ISO procedures, corresponding ratings are exactly equivalent to ASA speeds.

Natural software

The finest example of natural media software is perhaps MetaCreations (at time of writing: Corel) Painter: it is tremendously versatile and I've always said it's far more fun than any so-called computer game. It's as deep as Photoshop in terms of its abilities and in many ways goes much further. There is no substitute for giving it a go – you'll either leave bewildered by its huge range of effects and seemingly infinite possibilities – or you will not be able to leave it.

D

dioptre

Measure of refractive power of lens: calculated as 1000/focal length in millimetres where a positive value indicates a converging lens, a negative value indicates a diverging lens. * Unit: D. * Strictly there is a factor for refractive index of the image space – as it is usually air, the factor is 1. * Used to specify supplementary lenses used for eyepiece correction and for close-up attachments and for prescribing spectacles.

dioptre movement

Adjustment built into the eyepiece of optical instrument to accommodate (a) differences in closest comfortable focused distance for viewfinder optics of camera or (b) differences in focal length of each eye when field binoculars, binocular microscopes, etc. are used.

dioptric

Adjective: ~ optical system: one which uses refraction of light to form an image. * Antonym: catoptric.

See catadioptric.

dip and dunk

Film processing technique, usually for large format film, in which film is submerged and taken out by hand in an open tank of processing chemicals, working in the dark.

diplopia

Condition of vision in which a single object appears as two, usually because the images do not stimulate the corresponding retinal area.

dipvergence

Difference between the lines of sight of the left and right components in a binocular instrument. * Measured as the vertical angle between the axes of the two components. * The figure is where the right image points below the left one. * Dipvergence in a field binocular may cause eye-strain and headaches after prolonged use.

direct

Adjective: (1) ~ illumination: light falling on an object from a light-source without interruption or intervention from e.g. diffuser or without reflection. (2) ~ ray: light that is not deviated by reflection or refraction i.e. travels from one point to another in a straight line.

direct screen focusing

Method of bringing image into focus by placing the focusing screen at the focal plane. * Once focused, the focusing screen is replaced by the film, at the focal plane.* E.g. is ground-glass focusing of monorail cameras; also seen in

Blurred distinctions

There are many causes of double vision, of which only the commonest experienced reason appears to be alcohol intoxication. But in fact physiological diplopia – out-of-focus images are doubled – is a normal condition although is not usually noticed.

copy cameras where the film back and focusing screen are on a common slider so one takes the place of the other.

direct vision finder

Type of viewfinder in which subject is observed through e.g. peep-hole or through reversed Galilean type telescope or other optical device and not via a reflection in mirror (as in reflex camera). * Used in most auto-focus compact cameras as well as most lower-priced digital cameras. * Antonym: reflex viewfinder. * Also known as direct viewfinder.

See SLR; TLR.

direct-to-plate

See computer-to-plate.

discontinuous spectrum

See discrete spectrum.

discrete cosine transform

Mathematical manipulation that turns data describing variations in two-dimensional space (e.g. a pattern of lines or an area) into representation as data of changes in frequency (e.g. the frequency of occurrence of the lines). * It moves information from the spatial domain into the frequency domain. * It is a vital part of image compression routines used e.g. in JPEG and MPEG.

discrete spectrum

Distribution or spectrum of wavelengths making up the output of a light-source in which there are large gaps between wavelengths featured. * Typical of emission of vapour and fluorescent lamps. * Antonym: continuous spectrum. * Also known as discontinuous spectrum.

dispersion

(1) Phenomenon of light in which degree to which beam of light is refracted or diffracted depends on its wavelength. * Dispersion can be by two mechanisms: (a) refraction: due to increase in refractive index as wavelength decreases (b) diffraction: due to increase in diffractive effect as wavelength increases. * Dispersion of white light by refraction causes the splitting up of beam into its wavelength components i.e. a spectrum or rainbow of colours. * Also called chromatic dispersion. (2) Suspension or distribution of substance in liquid to form colloid or suspension. * Also called disperse phase.

See Abbe constant.

dispersion filter

Design of filter that transmits nearly monochromatic light. * It employs polarization and interference effects.

dispersive power

Measure of the dispersive properties of a glass: defined as: (nF-nC)/nD-1) where nF, nC, nD are the refractive indexes for Fraunhofer lines F, C and D. * The reciprocal of relative dispersion is the Abbe constant, also known as constringence, or V-value.

display

(1) Device that provides temporary visual presentation of data e.g. monitor or LCD screen, projector or information panel on camera. (2) Representation of data or status of settings as seen on monitor screen or LCD, projector or information panel on camera.
See LCD.

dissolve

(1) Noun: process of fading or blending one image into another during In film, audio-visual, animation or video projection – first image is dimmed gradually or faded while second is made brighter. * Also called fade. (2) Verb: to cause solid substance to go into solution.
See fade.

distance of distinct vision

Conventional distance for the closest a normal eye can see clearly: nominally taken as 10" or 250mm. * Used to calculate magnifying power of lens, etc.

distance-luminosity relationship

See inverse square law.

distortion

(1) Deviation or variation of image from being an accurate or true reproduction of an object. * There are many types of distortion, some of which may not be true distortions. (2) Variation or alteration of a signal's waveform.
See curvilinear distortion; keystoning; panoramic distortion; perspective distortion; radial distortion; stereoscopic distortion.

dithering

Technique for simulating effect of many colours or shades by using a smaller number of colours or shades in e.g. monitors, LCD screens, printers and digital cameras. * Dithering patterns differ according to device and application: for photographic use, random or diffusion patterns are most effective.

divergence

(1) Bending of light rays away from each other e.g. as caused by a negative power lens. (2) Spreading out of a laser beam i.e. increase in diameter of beam, which increases with

Erratic chess-play

To understand dithering, it helps to recall the normal meaning of the word: lacking a definite pattern, unpredictable. Such are the properties needed when laying down the dots needed to create half-tone cells: if you filled them in a regular – i.e. undithered – way such as representing mid-tone grey with a chess-board, areas of equal tone would be covered in regular patterns. This is obviously undesirable.

distance from laser. (3) Failure of the two optical axes of binocular instruments to lie parallel.

diverging lens
See concave lens.

diverging meniscus
Lens with one convex and one concave surface (more curved than the convex face) which diverges a bundle of incident light. * Compare with converging meniscus.

DLP
Digital Light Processing: application of deformable mirror device (DMD) technology by Texas Instruments to make projectors controlled by computers.

DMD
Digital Micromirror (or Deformable Mirror) Device: technology for projecting digital images using a semiconductor chip covered with thousands of tiny mirrors each of which can be tilted to reflect or not a part of the image. * Implemented e.g. as DLP.

dodging
(1) Technique for controlling local density during printing by selectively reducing amount of light reaching parts of print which would otherwise print too dark. * Used to 'hold back' or preserve shadow detail. * Dodging tools are usually small bits of card stuck onto ends of long thin wires. * Note: dodging with reversal or pos-pos paper results in darkening of area. (2) Picture processing editing technique giving effect similar to that of darkroom technique i.e. with effect of lightening the image.

dot gain
(1) Increase in size of a half-tone dot that occurs when it is transferred from the plate to paper. * Caused by ink spreading as it is absorbed by paper fibres. (2) Increase in size of image of a half-tone dot during film-making.

dot matrix
Printer or display technology based colouring, marking or lighting LEDs on a fixed matrix measuring e.g. 5 dots x 7 dots. * In printers: different symbols created by laying down dots by impacting on a ribbon carrying black carbon or colour: a full matrix of dots would print a black rectangle, the dots down a column would print a vertical line and so on. * Largely obsolete except where impact printing is required e.g. in printing multi-part forms.

dots per inch
Measure of resolution of device as density or frequency of

Outshining the LCDs
DLP or DMD projectors are vastly superior to LCD type projectors, giving a brilliant, contrasty image (because they rely on reflection of light, not on relative absorption) of excellent stability (because there is no need for scanning or interlacing techniques) and easily software controlled to give projection at different resolutions.

Dodgy hints
Digital dodging promises unlimited dodging potential but beware: it is great for working on small areas but unless very carefully done, it is hopelessly all thumbs with large areas. If an area is more than a few fat brush-strokes wide, it is generally better to rope the whole area off with lots of feathering and applying tonal controls such as Levels or Curves.

Drives you dotty
Do not confuse dpi with the actual output resolution of printer which will always be smaller because each of the dots must be used in groups in order to simulate tonal variations i.e. to create the half-tone cell. Note that, to add to the confusion, dpi is at times used, wrongly, as if equivalent to lpi (lines per inch).

D

points or dots which can be addressed or referred to by the device. * E.g. an ink-jet printer capable of 2000 dots per inch can lay up to 2000 dots of ink per linear inch.

double diffuse density

Measure of density in which the incident illumination is diffuse and the whole of the transmitted light is measured. * Little used these days.

See diffuse density.

Double Gauss lens

Family of lenses used to create fast lenses of symmetrical construction on either side of the aperture stop, offering good correction with flat field and wide to medium fields of view. * Widely used for very fast standard. Based on the Gauss group – a pair of meniscus or concavo-convex lenses. * First developed in 1896.

double-page spread

See dps.

double-raster format

Method of providing improved laser printer quality by printing each pixel four times. * Compared to single-raster output, can print lines as sharp and continuous tone as good quality as using four times more data.

double-weight

Adjective: ~ paper: printing paper that is thicker and heavier than single-weight papers. * Now more or less the standard weight for papers as there is little call for other weights.

doublet

Design of lens using two elements which may or may not be cemented together. * Typical examples are achromatic close-up lenses and good quality loupes or magnifiers.

down-sampling

Reduction in filesize when a bit-mapped image is reduced in resolution. * Done by systematic throwing away of unwanted pixels and information. * Not fully reversible: re-interpolation can restore number of pixels but not the full information.

download

To copy a file or data from a remote server onto a local computer e.g. transferring up-dates and shareware files from the Internet.

See upload.

dpi

See dots per inch.

See lpi.

When is double twice?

As it was never clear nor standardized what was meant by single-weight, ideas vary as to what constitutes double-weight, but the typical substance is paper of 200-250gsm or, at one time, even more. Heavier papers sound nice and feel nice when dry, but are a nightmare to handle when wet, take ages to dry and are more difficult to dry flat. Lighter, or single-weight, papers are just too flimsy and lack the quality feel.

dps

Double-page spread: the two pages on view when a book is opened up. * Photographs which take up more or less the whole width are referred to as 'dps' or 'doublespread'.

drag-and-drop

Software technology that permits file, selection or similar object to be taken from the operating system or a program or part of a program to another by the simple mouse action of clicking on it, holding the key down while dragging and then releasing the object. * E.g. in some operating systems, it allows a user to print a file by simply dragging the file onto a printer icon; text from a word-processor can be selected, then dropped into a database field – an action much used in writing this dictionary.

drift

Change in output of a device where there is no change in the input. * E.g. colour balance of monitor screen, print-outs from a printer, read-outs from any measuring instrument.

driography

Reproduction process based on an ink-repelling coating on the printing plate. * Where ink is required, the coating is removed. * Almost entirely superseded by lithography.

driver

Software used by computer to control or drive a peripheral device such as scanner, printer, removable media drive connected to it. * May range from a simple utility that is hidden from the typical user to a substantial program in its own right e.g. those used to drive scanners.
See TWAIN.

drop shadow

Graphic effect in which object appears to float above a surface, leaving a more or less fuzzy shadow below it and off-set to one side. * Used to give impression of three-dimensional lighting.

drop-on-demand

Type of ink-jet printer in which ink leaves the reservoir only when required. * Most ink-jet printers in use are drop-on-demand: tiny drops of ink are squirted out by a pressure wave caused either by the pulse of a piezoelectric element or by superheating the ink solvent which causes a bubble to form.
See continuous ink-jet.

drop-out

(1) Noun: defect in image or reproduction process in which

Keeping a watchful eye
Drift is the reason why any device critical to quality of output should be regularly calibrated: some, like processing machines, should be calibrated every day while others, such as monitor screens may need to be checked only every few months. But all depends on the quality standards needed.

Road rage
Computer problems are often caused by conflicts between device drivers e.g. a modem driver and the printer driver may make the same call on the system at the same time e.g. trying to get at the same output port, so confusing the computer which, with its low tolerance of conflict, simply has a breakdown or goes into denial, so nothing can work.

D

information is lost or not displayed: (a) In lithography: loss of dot in highlight regions (b) In visual output devices e.g. monitors, printers: pixels which do not register their proper value but appear as either black or white. (2) Adjective: ~ ink: used for marking photomechanical film, etc. with instructions. * It is visible but is not 'seen' by reproduction process e.g. red ink is invisible to exposures using red light.

drum camera

High-speed camera for recording changes during a brief event e.g. explosion or lightning flash. * It uses film wrapped round a drum which spins at a high, constant speed and exposure is made by a shutter.

drum scanner

Type of scanner employing a tightly focused spot of light to shine on the subject that is stretched over a rotating drum: as the drum rotates, the spot of light traverses the length of the subject, so scanning the whole area. Light reflected from or transmitted through the subject (in which case the drum must be transparent) is picked up by a photomultiplier tube. * Scans of this type produce the highest available quality but require costly machinery and a good deal of skill in operation and preparation. * Chief advantage over other types of scanner is that its optical arrangement makes possible the recording of very high densities and tonal definition over a wide dynamic range.

See scanner.

duotone

(1) Photomechanical printing process using two inks to increase tonal range: two half-tone screens are made at different angles. Darker colour ink is used to print solid and near-solid areas, lighter colour ink is used to print mid and lighter tones. * Used in high-quality print reproduction of photographs for books, posters etc. (2) Mode of working in image manipulation software which permits the printing of image with two spot colours, each with its own reproduction curves (or the CMYK equivalent).

See tritone; quadtone.

duplex

(1) Noun: communications in both directions between connected devices. * If transmission in both directions can occur simultaneously, it is known as full duplex. * If only one transmitter can send at a time, the system is half-duplex. (2) Adjective: ~ printer, ~ paper: capable of printing – or of being printed – on both sides of a sheet.

duplicate

Photographic copy of original photograph, usually transparency or negative: copy should reproduce colours, contrast and detail of original as closely as possible. * Duplicate may be larger than original. * Each duplication step causes a loss in accuracy of colour reproduction, in sharpness and in resolution but some improvements in e.g. colour balance can be made. * Duplication or copy of a digital file entails no such losses.

duplicating

Process of making duplicate of original photograph – usually transparency or negative. * Two methods (1) ANALOGUE uses traditional photographic means – camera, lens and special duplicating film. Advantages (a) cheap to set up and produce many copies (b) ability to change colour balance. Disadvantages (a) loss in image quality (b) impossible to correct faults such as cracks or dust-specks (c) difficult to control contrast (d) difficult to alter colour in specific area. (2) DIGITAL uses electronic means to create digital image of original and manipulate that on computer screen with computer program: result can then be printed out on film to create final duplicate. * Advantages: (a) can improve on original (b) possible to correct faults (c) can change colours locally (d) can control contrast precisely. * Disadvantages (a) extremely expensive in equipment and (b) the operation too slow for economic production of multiple copies.

See slide duplicator.

DVD

Digital versatile disc (not digital video disc): derived from CD-ROM technology but offering vastly improved capacities of minimum of 2.6GB per side of a DVD disc (which can be double-sided) up to 17GB depending on formatting.

DVD-R

A DVD, i.e. digital versatile disc, variant that produces a write-once, read-many times format: it carries 3.95GB per side. * Used by content producers.

DVD-RAM

A DVD, i.e. digital versatile disc, variant which is write-many and read-many times: according to type, it may carry up to 4.7GB per side (i.e. each disc can hold nominally up to 9.4GB). * Provides backwards compatibility with CD-ROM with relatively inexpensive drives, hence the most popular of the DVD formats for computer use. * Cannot be read by DVD-V or DVD-R drives.

DVD-ROM

A DVD, i.e. digital versatile disc, variant providing up 17GB per disc: it carries read-only or video data.

DVD-RW

A DVD, i.e. digital versatile disc, variant allowing data to be streamed: the discs are re-writable and carry 4.7GB.

DVD-Video

A DVD, i.e. digital versatile disc, variant intended for consumer video use, not for computing: it is read-only and can provide up to 7 hours of video.

DX coding

System for marking film cassette in such a way that film speed is communicated automatically to the camera when film is loaded. * Consists of pattern of insulating paint and bare which correspond to pairs of electrical contacts in the camera: according which pairs of contacts are conducting, the appropriate film speed is set in the camera.

dye

Substance that is (a) coloured and (b) soluble. * Colorants are used to give colour to relatively less coloured material.
See pigment.

dye destruction process

System of colour reproduction in which dyes already present in the material are selectively removed during processing to form the image. * The best known example is the Cibachrome (later Ilfochrome Classic) process. * Also known as dye bleach process.

dye sublimation

Printer technology based on rapid heating of dry colorants held in close contact with a receiving layer; it turns the colorants to a gas (without an intervening liquid phase i.e. it sublimes) which transfers to and solidifies on the receiving layer. * Colorants or dyes are usually carried on ribbons, one for each colour separation, and applied one separation at a time onto the receiving layer which is specially coated to receive the dyes. * As the image is built up of clouds of dye, it can closely resemble a photographic print.

dye transfer

Assembly process for making colour prints using three separation images. * One technique is to make red, green and blue separation negatives to the full size of the final print through respective filters or via separation negatives onto special matrix film incorporating dichromated gelatin. After development and curing (or hardening), the matrix is

treated with dyes of secondary colours: cyan (red separation), magenta (green separation) and yellow (blue separation) and each is printed in register on the other in the above sequence onto heavyweight receiving paper. * Capable of producing extraordinarily sensual colour prints with excellent archival qualities. * Formerly known as wash-off relief.

dynamic range

Measure of spread from the highest to lowest energy levels that can be captured by an imaging or recording or reproduced by a play-back device. * E.g. a top-class scanning camera back can capture a range of 11 f/stops; a good film-scanner may be able to manage under 9 stops. * Concept of energy levels is usually converted to densities in devices such as scanners e.g. dynamic range is '0.2 - 3.0D units'.

dynamic stare sensor

Design of mosaic or wide array light-detector that combines features of scanning and one-shot (or staring) sensors by using a scanning or x-y motion. * Used by some cameras: (a) to cover a large area using a CCD array that is smaller than the area to be captured or (b) to improve resolution by shifting the array by a distance smaller than the interval between individual CCD photosites or (c) to improve colour resolution by shifting the array under a stationary filter screen.

Eberhard effect

Smaller spots of exposed areas in a film are observed to be more dense than expected due to developer effects. * In larger spots, developer gets exhausted more than in smaller spots so a small spot with the same exposure as a large one develops to a higher density.

edge effects

Local distortions of image density in film due to the movement of developer and developer products between regions of different exposure. * In an area of high exposure, developer is used up rapidly but in areas of low exposure, developer is comparatively active as there is little work to be done. This active developer migrates to area of high exposure and its activity causes a slight local increase in density. In areas of low exposure, the opposite happens.

See Mach bands; unsharp mask.

edge sharpening

Process of making edges easier to see, therefore appearing sharper – usually by digitally creating a slight local increase in contrast at image boundaries using so-called sharpening filters. * Various techniques are available to image processing software: some are better at sharpening lines,

Effective family

There is quite a family of edge effects, all caused by the same basic mechanism which are seen typically in slow- to medium-speed films developed by high-energy developers used at very low concentrations. They may also be seen in colour films that use developer inhibitor release couplers. Some image processing techniques e.g. edge sharpening through digital filters cause analogous effects.

others have a side effect of making noise more visible while others may suffer from defect of shifting slightly the position of boundaries. * Sharpening filters need care in application: often best applied locally rather than globally. * Do not confuse with the filter called 'find edges' which simply locates edges and removes everything else. * Also called edge enhancement.

effective aperture

Diameter of a bundle of parallel light rays entering an optical system that just fills the aperture. * For non-circular aperture diaphragms, it is the diameter of a circle with the same area as that of the aperture. * Also known as entrance pupil.

See effective f/number.

effective colour

The observed colour of an object or medium that is illuminated by a light-source with white light.

effective f/number

f/number of lens corrected for close focusing distances. * The f/number multiplied by the result of dividing the image distance by the focal length. * The focal length divided by effective diameter of aperture.

See effective aperture.

effective resolution

Apparent resolution of a device's output after application of a processing technology designed to give appearance of improved resolution. * In output devices e.g. laser printers, varying dot sizes improve the appearance – hence effective resolution – but not the actual resolution of the print-out as the addressable points remain the same in number. * With input devices e.g. scanners, software and hardware interpolation produce more pixels – and bigger files – but with no actual increase in resolution.

See addressable; interpolated resolution.

effects filters

(1) Lens attachments designed to distort, colour or modify image to give exaggerated, unusual or special effects e.g. blurring of subject outlines, creating multiple images, colouring subject irregularly, diffracting highlights into star-bursts of light or colour and so on, and on. * Usually made of dyed or moulded plastics or resin in standard squares which fit onto filter holders. These carry adaptors to enable them to fit onto variety of lens filter sizes. * No better when called special effects filter. (2) Digital filters that have effects similar

Only infinity counts

The correction for close-up work is needed because f/number is defined by the lens' focal length which is in turn defined relative to infinity. So if you focus much closer than infinity, you must make a correction: through-the-lens metering does that for you (but even then manufacturers have to exercise care over where they locate the meter). Any separate, off-camera metering must take account of the error, in general, when focusing nearer than half a metre.

Effective waffle

Essentially the term 'effective resolution' is marketing waffle to allow inflation of resolution figures to fancy sizes without attracting legal attention for misrepresentation.

E

to their lens attachment counterparts giving e.g. star burst, diffraction, softening, distorting effects but also giving effects impossible with analogue filters e.g. pixelation, tiling, controlled distortion and multiple light-sources.

efficiency

(1) Of camera shutter: ratio of effective shutter time divided by actual time shutter is open. * Shutter efficiency drops with shorter shutter times and focal plane types are more efficient than between-the-lens types. (2) Of appliances or devices, e.g. flash-guns, motor-drives: comparison of total power input to the usable power output. * For luminaires, light output is compared to the electrical power input, therefore the units are lumens per watt. * By using suitable units, a ratio may be obtained.

efl

Effective focal length: measure or comparison of actual focal length of lens (for a given format or sensor size) to the equivalent focal length of another format. * E.g. a zoom for a digital camera of focal length 8mm-24mm may have the 35efl of 40 mm-120mm i.e. the effective or equivalent focal length range for 35mm format would be 40mm-120mm.

EGA

Enhanced Graphics Adaptor: video adaptor standard for graphics on personal computer for displaying up to 16 colours simultaneously at resolution of 640x350 pixels, with text characters built from 8x14 pixel panels. * Total palette of colours is 64 from which the viewable 16 are chosen. * Obsolete for desktop use, but survives where graphics requirements are very simple e.g. cash-points.

> See VGA; SVGA.

EI

See exposure index.

eikonometer

(1) Device for measuring dimensions of object seen under a microscope. * Consists of eyepiece with finely etched scale which appears superimposed on the image: length calculated from markings on scale and magnification of image. (2) Device for measuring the difference in the size of images of a person's two eyes.

elbow telescope

Design of telescope which bends the optical axis by e.g. 45° or 90° to improve ease of viewing. * Usual configuration is to use one or more prisms to bend the axis: this has useful effect of increasing path-length, making more compact

E

designs possible. * Used for spotting scopes and bird-watching monoculars.

electro-optic effect

Change in the refractive index of a material in an electrical field. * Seen when certain liquids are subject to a strong electrical field.

electro-optic shutter

See Kerr cell.

electromagnetic radiation

Radiation consisting of waves which are a combination of vibrating electric and magnetic fields that are emitted by vibration of charged particles. * The electrical and magnetic fields vibrate or oscillate at the same frequency for a given wavelength and propagate at a speed equal to the frequency multiplied by wavelength. * Different types of radiation are defined by their wavelength: e.g. visible light is of wavelength 420nm-700nm.

electromagnetic spectrum

Range of frequencies or wavelengths over which electromagnetic radiation propagates. * In practice, the range extends from very high frequencies of nearly 10^{23}Hz to very low, of around 1000Hz.

electromagnetic wave

Radiation consisting of vibrating or oscillating electric and magnetic fields.

electron lens

Electric field designed to change the direction of an incoming stream of electrons in order to focus it. * Used in electron microscopes.

Electron highs

Magnifications possible with TEM can be 5,000,000X or more. With SEM, magnifications to 200,000X are possible with comparatively large depth of field. Results are always black & white though many photographs receive subsequent colouring.

electron microscope

Instrument using accelerated beams of electrons to form extremely highly magnified 'images' of objects: the beams are focused using electronic lenses – essentially coils producing a magnetic field – and the image is viewed on a cathode-ray tube. * High magnification is possible as the highly accelerated electrons have a very small wavelength, allowing higher resolution than light.

See scanning electron microscope.

electron photomicrography

Making photographs of images from electron microscope which produces magnified image of subject by focusing beam of electrons either to pass through subject or to reflect off subject. Two main methods: (1) Transmission electron microscope (TEM): a beam of electrons passing

through subject is scattered and modulated by subject's structure: this beam thus carries image, much as light carries image, and is made to fall directly onto special film. (2) Scanning electron microscope (SEM): a beam of electrons is focused onto subject to be reflected off it: reflected electrons are focused onto sensor which scans image and rebuilds scans onto a monitor screen. * Image on screen is then photographed.

electron print

It is a silver image print made by using radioactive isotope – a rather obscure variant on the electronic image. * Ink is prepared with radioactive isotope, then used for painting or drawing. In dark, when ink is dry, photographic paper is placed on top: radioactive emissions of the isotope exposes paper which is processed normally to give negative copy of ink original. * Invented by Caroline Durieux, 1952.

electron trapping optical memory

Type of re-writable data storage which uses a beam of visible light to write information and an infrared beam to read it back. * Higher levels of infrared light are used to erase the disc, allowing re-writes.

electron-beam film scanning

Method of creating image using electron-beam techniques or a derivative. * E.g. (i) using electrons from cathode ray tube as the illuminating source or (ii) original e.g. film is copied onto material that, after processing, emits light when scanned by an electron beam. * May be used where a positive-working system is essential or for direct copying of television image.

electron-beam gun

Component of cathode-ray tube in e.g. television or monitor: used to produce a continuous beam of electrons moving at uniform speed in a straight line. * Consists of (a) cathode which emits electrons (b) anode which accelerates the electrons through a hole or between a set of plates. * May be found in other devices e.g. for electron beam deposition: using electron beam to deposit mineral material onto lenses during multicoating operations.

electronic flash-unit

Type of light-source which produces light over a short duration from a small flash-tube. * Consists of (a) tube filled with rare gases e.g. xenon (b) electrodes which are connected to (c) electrical condensers which store charge at high voltage. * When electrical charge is released from the

Flash this knowledge around

Flash duration in microseconds is approximately equal to the condenser capacitance in microfarads. Most flash-units vary the power of the unit by varying capacitance, hence when most studio flash-units are varied in power, the flash duration changes. However, this cannot work with automatic flash-units: here the flash-duration is cut short as needed, using thyristors i.e. a pulse of electricity turns the circuit on or off.

condenser into the tube via the electrodes, the gas flashes brilliantly for a brief duration, which depends on the capacitance of the condenser.

See strobe.

electronic image

Synonymous with digital image.

See digitization.

electronic shutter

Type of camera shutter which uses electronics to control shutter time. * Strictly an electromechanical shutter: the shutter mechanism may be of the type that can be controlled by clockwork or other mechanical timing device or may be of type that must be controlled by an electronic circuit. * Advantages of electronic shutter over mechanical one are (a) more accurate timings at short and long duration (b) more compact mechanisms possible (c) direct control by exposure system possible. * Disadvantage: (a) necessity for electrical power source (b) more difficult to service than purely mechanical shutters.

See Kerr cell.

electronic viewfinder

Monitor usually of LCD type that shows image picked up by sensor: used in digital cameras.

electrophotography

Process for making record of an image using the action of light to alter the electrical properties of a sensitive material e.g. electrostatically-charged drum. * Variety of processes in use, the widest-known being used in photocopiers.

electrostatic tape camera

Type of camera which uses a strip of plastic tape to record an image with a pattern of static electrical charges. * Used in situations where radiation would harm or fog film.

elliptically polarized light

Variant of circularly polarized light. * The electric vectors differ in phase by odd fractions of the wavelength.

email

Electronic mail: simple files which can be sent from one computer or network to another or from one user to one or more users of the same or other network, such as the Internet. * Emails have the ability to carry bigger, more complicated files with them, as attachments.

emergent ray

The ray of light which leaves or exits a medium. * Antonym: incident ray.

emissivity

(1) Comparison of a body's radiation to that of a black body radiator. * The ratio of radiance of a body to that of a black body radiator at the same temperature. (2) Energy flow of radiation per unit area of a body that emits perfectly diffuse radiation.

emittance

Light energy emitted by a surface: used to calculate the energy exchanges between two mutually visible surfaces in radiosity modelling. * Equivalent to exitance.

> See radiosity.

emmetropia

State of human eye in which the objects at infinity are sharply imaged on the retina when the lens is fully relaxed. * When accommodation is relaxed, the conjugate focus on the retina is at infinity. * This is the normal condition. * Antonym: ametropia.

empty magnification

Increase in size of image which does not increase information. * Magnification which does not contribute to improved resolution or resolving power and which is beyond what the system can deliver. * E.g. enlarging a photograph beyond a certain point only creates a bigger picture, with no increase in usable information.

emulsion

(1) Layer of light-sensitive chemicals. * Dispersion of silver halide crystals plus other components – e.g. sensitizers, colour couplers if colour film – in gelatin, laid in one or more layers onto a film base or backing material. (2) A colloid in which both the dispersed phase and dispersion medium are liquids.

> See gelatin.

emulsion number

Code identifying the production number or batch to which a film belongs. * Films with the same emulsion or batch numbers can be expected to demonstrate speeds, contrast and colour balance which are much better matched than films with different emulsion numbers. * Also known as batch number.

emulsion speed

Measure of the sensitivity of a photographic emulsion to white light where the exposed film has been developed by a standard processing regime. * Film speed is calculated from emulsion speed.

Dispersing misnomers

A photographic emulsion is not, strictly speaking, an emulsion because the thing that is dispersed or spread out in the medium, namely silver halide crystals, is not in liquid form. However, the term 'photographic dispersion' never caught on, for obvious reasons, so 'emulsion' is what we are stuck with.

E

encoding

Translation or mapping of some data into a set of names or numbers to represent the data e.g. (a) colours can be encoded as coordinates in a specified colour space; (b) encoding fonts will map character codes to character names and so on. * The same data e.g. colour may be encoded in different ways, leading to the creation of different file formats: the aim is always to encode in such a way that the codes take up less memory than the original data.

See Huffman coding; RLE.

encryption

Computation which takes a message or data and turns that into a ciphertext that looks like or comes out as gibberish. The encryption is based on a key, therefore, in order for the message or data to be read back i.e. decrypted, the recipient of the ciphertext must possess the correct decryption key.

See fingerprint.

endoscope

Optical instrument used to view in inaccessible places e.g. inside human body, in confined spaces of buildings or machinery. * It uses a bundle of fibre optics arranged coherently to relay images from the objective at the far end to the eyepiece. * Cables running along the outside of the fibre optic allow the operator to manipulate the fibre optic while light is led down non-coherent fibres in an outer layer of the fibre optic bundle.

endoscopic photography

Use of endoscope to photograph in accessible places. * The camera is attached to eyepiece or a mirror or prism is used to direct the image to the camera when required. * Lighting is piped down the same fibre optic which carries the lens or through supplementary fibres sharing the same or, rarely, a different entry point.

Energy Star

Program initiated by environmental concerns to reduce electricity used by computers, monitors and printers, especially when they're standing idle – which is most of the time. * Energy Star compliant devices typically can go to sleep e.g. use minimal electricity without actually being turned off yet are ready to run at a moment's notice or can selectively turn off unused components such as the monitor's electron gun.

engine

(1) The main or central internal mechanisms which drive

devices such as laser printers, scanners. (2) In relation to software: the core parts of a software application, usually kept proprietary secrets. * See side-box: opposite page.

enhanced graphic adaptor

See EGA.

enhancement

(1) Change in or alteration of one or more qualities of an image in order to improve the visual or other property of the image: e.g. increase in colour saturation, apparent sharpness, or to remove image defects, etc. (2) Effect produced by a device or software designed to increase the apparent resolution of a TV monitor screen.

enlarged contact print

Print of strips of film arranged as if to make a contact print but projected in an enlarger to make enlarged copies of the original.

enlargement

Photographic print which is larger in size than the original frame. * Usually applies to print made in enlarger or printing machine.

enlarger

Device for creating prints, usually but not always, enlargements from a negative or transparency. * Consists of enlarger head assembly which consists of (a) light-source (b) film-carrier (c) enlarging lens (d) focusing mechanism that can slide on a column or optical bench arrangement nearer or further away from a baseboard that carries the photographic material for making the enlargement: the further away the enlarger head from the baseboard, the larger the enlarged image will be when it is focused. * Also (pedantically) referred to as projection printer.

enlarger meter

Light meter designed for making enlargements. * Calibrated to paper and development in use by evaluating test-strips, with read-outs as exposure times. * May also incorporate means to determine contrast grade of paper needed. * May be connected to enlarger bulb to provide timed exposures.

enlarger paper

Light-sensitive material on paper base designed for use in projection printing: its speed, contrast and, if colour, colour balance is adjusted to be suitable for use with enlargers.

enlarging easel

Accessory used in projection printing to (a) hold printing paper in position (b) hold printing paper relatively flat

Querying the pitch

When is an enhancement an alteration? This may seem an academic question but it exercises the minds of everyone concerned with publishing photographs in newspapers and magazines and on television. Maybe it's okay to increase the overall contrast of a picture (enhancement) – we do that all the time in photography where it goes unquestioned, but is it okay to change the colour of the sky (alteration)? Removing unsightly lens flare from an image is okay (as it was not really part of the picture) but is it acceptable to remove a pesky telegraph pole coming out of someone's head? Some people think that any changes in a photo render it suspect when used in certain situations like depicting news or documentary features. The big problem is that the transition from an innocuous enhancement to a significant change in the content of the picture is seamless – there is no clear dividing line. Worse, that dividing line drifts about depending how the final image is used and the expectations that we entertain of it.

E

(c) provide non-printing margins if required (white margins with negative-working materials, black margins with positive-working materials). * Easel may use clips or retaining masks to hold paper or, rarely, vacuum power (sucking air through small holes under the paper) to hold paper flat where critical sharpness is needed.

enlarging lens

Optic designed for making projection prints. * Features include (a) flat field (b) very low geometrical distortion (c) minimal focus shift (d) correction for short object distances.

entrance pupil

The hole seen from the front of the lens through which light enters the camera. * The virtual image of the aperture as seen from the object side: its diameter is used to calculate the f/number of the optic. * Note: the entrance and exit pupils of multi-component photographic lenses are usually not the same size, particularly inverted telephoto type wide-angle lenses. * Also known as effective aperture.

See exit pupil; f/number.

envelope

(1) Housing that encloses the gas and element for a light-source. (2) Range and conditions over which an instrument operates normally or within specification. * Also known as performance envelope.

epidiascope

Instrument designed to project an image of opaque objects onto a screen. * As illumination must come from the same side of the object as the projected image and the lighting must be very bright to project a sufficiently brilliant image, high-quality epidiascopes are very difficult to construct.

EPS

Encapsulated PostScript: File format that stores an image (graphics, photograph or page layout) in PostScript page description language. * EPS files are resolution-independent vector-based images: they must be interpreted and rasterized before they can be seen on screen or printed. Usually a low-resolution screen image is kept with the EPS file for easy previewing. * EPS is recognized widely enough to be a de facto standard in graphics on all platforms, often used to move CMYK separation files between applications and production houses. * EPS files can be stored in binary form (actually hexadecimal) or ASCII: 'binary' is more compact but ASCII is more widely used.

See DCS; PostScript.

Enlarging on the advantages

For such specialized optics, enlarging lenses are actually more useful than usually thought. Even very average enlarging lenses make superb close-up lenses when used with a bellows attachment and they are the bee's-knees when it comes to making duplicate transparencies. Generally they are at their best used one or two stops from maximum. Modern designs are achromats or better and don't shift the focus on stopping down because they are very flat-field objectives, so the old precautions of focusing through blue glass and checking focus after stopping down are obsolete.

EPS 5

See DCS: named after the presence in a DCS format file of a fifth EPS file (not to be confused with a fifth column).

equal-energy white

Light which has more or less equal energy at every wavelength in the visible portion of the electromagnetic spectrum. * A pure white, with no colour or wavelength measurably more prominent than another.

equalize

Image editing process which maps the lightest pixel to white, the darkest pixel to black and spreads all the remaining values between the two extremes. * Generally results in an image that is higher contrast than the original. * Similar to the effect of applying auto levels but with less control; it is generally of limited usefulness.

equatorial mount

Stand for optical equipment – e.g. telescope – designed to allow sustained observation of stars which appear stationary despite rotation of the earth. * The mount is articulated so that one axis (the polar) can be set parallel to the earth's axis of rotation and another axis (the declination) which is at right angles to the first axis. * If the telescope is turned at a rate of one revolution in 24 hours about the polar axis by a clockwork or motor mechanism the same part of the heavens is seen in the field of view.

equiluminous colours

Colours which differ only in hue, not in brightness. * Colours of the same luminance but varying in chromaticity.

equivalent colour temperature

Light sources that cannot have a colour temperature correlated to them e.g. fluorescent or metal halide lamps – with discontinuous spectra – can be assigned an equivalent colour temperature which is that of a standard source whose continuous spectrum produces the same visual effect on a specified film or receptor as the test source.

See colour temperature.

erasable

Digital storage media whose data can be removed or eliminated, enabling it to take more data. * E.g. CD-ROM is not erasable but hard-disks, magneto-optical discs are. * Also known as re-writable or reversible.

erase

To remove or wipe a recording from a disk, tape or other recording medium (usually magnetic) so that it is then

Deleting all evidence is not erasure

It's better not to be confused as to the difference between erasure and deletion. If you delete a file, you can get it back again provided you haven't written over it on the storage medium. But if you erase it, no-one can retrieve it as it will contain no data or only gibberish. In fact the best way to erase something is to write a file full of nonsense over it. Fortunately, criminal types often don't know the difference, making the job of forensic computing much easier.

E

impossible to reconstruct the original record. * A recording can be erased by scrambling the medium with a high frequency or random signal or by writing over it with a new recording. * Most operating systems simply delete files and only specialist utility programs offer a true erase.

erect image

Image which is or is seen to be orientated the same way as the object. * Note: this distinction is needed because, of course, the image on the retina is inverted with respect to the object.

erecting eyepiece

Ocular optics which uses a prism, mirror or lens system to project an erect image. * E.g. eye-level finders for waist-level cameras use a prism or system of prisms to correct the lateral reversal of the reflex image.

error correcting code

Information in a data stream or signal used to ensure the original message can be decoded without degradation or errors in the decoding. * The code (a) checks for basic errors (e.g. sum of all terms should be a positive integer) and if it detects an error it (b) calls for re-transmission or re-reading of data or (c) indicates an error. * For CDs, the so-called cross-interleaved Reed-Solomon code is used. * May be called error detecting codes.

Ethernet

Standard for local area networks. * Data is transmitted in packets over 50-ohm coaxial cables. * Nodes in the network may be transmitting or receiving at any time. * The bandwidth varies with standard: it is about 1Gbits/sec for Gigabit-Base-T. * Developed by Xerox in 1976 and now in Version 2.

See 100-Base-T.

etalon

Optical component used to create interference, used e.g. in gas laser to regulate light output. * It consists of a pair of flat glass plates held parallel to each other with their partially reflecting coated faces facing.

EV

Exposure Value: scale used to measure camera exposure: for a given EV, there is a set of shutter and apertures settings all of which give nominally the same camera exposure. * In normal use the scale runs from about EV-1 to EV18: EV-1 is equivalent to a setting of 4sec at f/1.4, 8sec at f/2 etc. EV18 is equivalent to 1/$_{500}$ sec at f/22 or 1/$_{1000}$ sec at f/16 etc. * Note

Redundant errors

In a sense, the error correcting code is redundant data in the information stream since its absence does not lead directly to loss of data. But such codes are vital for reliable communications: with digital files, a single misplaced term could render billions of other terms an indecipherable heap of code.

Ever useful

*EV numbers were formerly used widely as the means of translating read-out of exposure meters into camera exposure settings. They can even now be found on some cameras, notably Hasselblad. * Also, with film speed quoted, EV was used to give general indication of brightness level to describe e.g. operating limits of exposure meters e.g. 'readings from EV-3 to EV21 at ISO 100' or auto-focus cameras e.g. 'autofocus works down to EV-1 at ISO 100'.*

that there is no reference to film speed as the scale is set relative to film speed.

See value.

evaluative metering

Camera system for determining exposure settings for a given scene by evaluating the scene into a number of individual sectors for their luminance, then looking up previously collected data to determine the best match between the scene evaluation and the camera setting. * This pre-programmed approach provides far more reliable results than cruder methods such as centre-weighted.

event

Action or input from human or other generator (e.g. mouse-clicks, input from keyboard or a triggering pulse from an infrared detector) to a software program which initiates a response by that program. * An event may cause a simple action like a letter to appear on screen or, in computer games and interactive multimedia, cause a whole train of complex actions such as the running of an animation sequence, together with sound-track and even movement through actuators in the case of a simulator. * Clearly, most modern software is event-driven, i.e. it sits around waiting for an event to kick it into action. * Events cause a hardware interrupt i.e. they produce a signal that tells the microprocessor to attend to what is coming in, to check to see what to do with it and finally, to do it.

excimer laser

A rare-gas halide or rare-gas metal vapour laser emitting in the ultraviolet (126-558nm) that operates on electronic transitions of molecules, up to that point diatomic, whose ground state is essentially repulsive. Excitation may be by E-beam or electric discharge. Lasing gases include ArCl, ArF, KrCl, KrF, XeCl and XeF. * Also known as rare gas laser.

excitation purity

On the CIE chromaticity diagram, the distance from the achromatic point to the sample point, divided by the distance from the achromatic point through the sample point to the spectrum locus or purple line.

existing light

See ambient light.

exit angle

Angle between a light ray emerging from an optical system and the system's optical axis. * Usually applied to the outermost ray in a bundle.

Accuracies: go forth and multiply

The 'effective diameter' is so qualified because few, if any, apertures are circular. It's important because the size of the exit pupil as seen by a through-the-lens metering system obviously affects the meter reading: as different focal length lenses may present different sized exit pupils to the metering system, the lens must signal a correction in order for metering to be accurate.

The value of exposure, the worth of everything

Exposure is like shopping for expensive things: you're having always to ask 'how much?'. In photography – whether classical or digital – we rely on exposure meters to work out how much exposure to give the film. The basic idea is this: the correct exposure is the one that gives you the results you want for the processes you use. This means, assuming that you always want the best image quality, that there's usually only one correct exposure. Forget anything you read about exposure latitude: just work out your exposures as accurately as you can.

exit pupil

Image of hole or aperture formed by lens (which may be limited by the iris diaphragm) as seen at the focal plane i.e. from the image side of lens. * The effective diameter of the exit pupil is one factor determining the effective f/number of lens.

> *See entrance pupil.*

exitance

Measure of the power of light or energy radiation that is output, through reflection or radiation, from a surface. * For light exitance, the preferred units are lumens per square metre. * Note: the radiation is the sum total of power radiation in all directions from the surface.

> *See luminance; radiant.*

expansion card

Accessory which slots onto the motherboard of a computer to add extra functions usually to enable connection with peripheral devices.

exposure

(1) Process of allowing light to reach light-sensitive material to create latent image: by either (a) opening shutter to expose film or (b) illuminating dark subject with flash of light or energy or (c) both. (2) Amount of light energy that reaches film: it is given by H = Et where E is illuminance and t is time in seconds. * Note: while in theory, any product of E and t that gives the same H gives same exposure, in practice the effect of H on light-sensitive materials will be the same only over small range of E or t. (3) Total radiant energy incident on a surface. * Also known as radiant exposure.

> *See reciprocity failure.*

exposure factor

Number indicating degree by which measured exposure should be corrected or changed in order to give exposure corrected for use with an accessory e.g. filter, extension tube or when certain working circumstance e.g. close-up focusing, or reciprocity failure need correction. * Exposure factor increases exposure (a) by simple multiplication of exposure time e.g. factor of 2 increases exposure time from $^1/_{500}$ to $^1/_{250}$ sec or (b) by changing the set f/number by number of stops equal to \log_2 of the factor i.e. a factor of 2 equals 1 stop; a factor of 4 equals 2 stops.* Exposure factors are often quoted in stops e.g. 'add an extra 2 stops' means an uncorrected reading of f/16 for $^1/_{60}$ sec should be corrected to e.g. f/8 for $^1/_{60}$ sec or the equivalent.

exposure index

Also abbreviated to EI: setting used to calculate camera exposure settings. * EI is set on the exposure meter or camera in order to give exposures based not on actual film speed but on an adaptation or correction of it for a special purpose. * E.g. (a) ISO 400 speed film may be exposed at EI 800 in the expectation of being given extra development (b) ISO 100 film may be exposed at EI 125 in order to compensate for its emulsion speed being faster than nominal (c) ISO 25 film may be exposed at EI 12 in anticipation of fine-grain processing.

exposure latitude

Range of variation of exposure on film which produces no significant effect on image quality or required results.

exposure meter

Light-detecting instrument and calculator used to indicate settings for a camera exposure based on its measure of light in a scene, corrected for film speed or sensitivity and other factors. * The light-detector receives either (a) light reflected from the scene (reflected light meter) or (b) light falling on the subject (incident light meter). This reading produces a measure that is used to calculate the aperture and shutter settings, based on the assumption that the indicated exposure produces a mid-tone in normally processed film.
See spotmeter; incident light meter; reflected light meter.

exposure time

The length of time during which a light-detector is exposed to light or is irradiated.

extension factor

Increase to nominal exposure required when normal camera lens is focused on a close-up subject. * Factor equals lens extension squared divided by focal length squared or the image magnification plus one all squared.

extents

The smallest and largest dimensions of an object. * Used in computer graphics to help define a bounding volume which simplifies calculations for 3-D manipulations. * Also known as bounding volume.

extents tree

Data held by storage device such as hard-disk which keeps track of where all the non-contiguous fragments (i.e. the parts of a file that aren't next to each other) of a large file are being kept.
See defragmentation.

It all depends on give-and-take
Exposure latitude is a stretchable commodity: film manufacturers and their kin prefer to think of their products having large latitude when the fact is that the extent of latitude depends inversely on the quality standards to which the photographer is working: high standards greatly reduce latitude. The other main factors which reduce latitude are high contrast of material or subject luminance. In practice, take my advice and forget it: latitude does not exist. Just expose as accurately as your equipment allows (which these days is pretty accurate).

Misery by extension
The extents tree must be updated every time the file changes in size: thus minor damage to it can make life seriously miserable as it could render a large file unreadable or, and obviously worse, cause a hard-disk crash.

E

extinction

(1) Level of lighting at which a reduction of lighting level is not discernible: highest luminance level at which drop in luminance causes no change in appearance. * E.g. shadow detail visible in a print in good light disappears when the ambient light level drops below extinction level. (2) Full or nearly total absorption of plane-polarized light by a polarizer that has an axis at right angles to the plane of polarization. (3) Loss of a diffracted beam's intensity caused by a nearly perfect crystal.

extinction meter

Design of exposure meter which measures a test source reducing its brightness using a calibrated mechanism until it matches a standard light or patch in the instrument. * Obsolete in photography but has industrial applications with bright light-sources.

extinction ratio

Power of polarised light that is maximally transmitted through polarizing filter compared to its power when minimally transmitted. * The ratio of a plane-polarized beam's transmitted power when the plane of polarization is parallel to that of the polarizer to the beam's transmitted power when the axes of polarization of beam and polarizer are perpendicular to each other.

extrude

To create a three-dimensional solid by defining a cross-section and a path along which the cross-section extends: the volume thus enclosed is the extruded solid. * Used in computer graphics and 3-D modelling programs. * The extrusion may be made more complex by defining rotations and changes in scale, even distortions, of the cross-section as it traverses the path.

eye

Organ of vision on which all life, as photographers and other imaging artists know it, depends. * It is a roughly spherical body about 24mm in diameter consisting of a cornea or lens in front; a sclera, or external fibrous coat; a vascular layer consisting of iris or pupil of eye; the ciliary body controlling the shape of the cornea; and the choroid, a layer carrying the inner retina that contains the light-sensitive cells. * The eye is contained in the eye socket of the skull, moved by set of six extraocular muscles and protected by both skull and eyelids. * Focal length of normal human eye is about 16mm. * The pupil has a normal working range of rapid adjustment

of about $f/4$ to $f/8$ but it can cover a wider range of $f/1.8$ to $f/12$ allowing more time for adjustment. * Entrance pupil – i.e. the pupil as one sees it – appears about 13% larger than it actually is, due to the magnifying effect of the cornea.

See cones; light adaptation; power spectra; rods.

eye lens
The element of an eyepiece nearest the user's eye.

eye relief
The distance between the rear of the eyepiece to the focal plane of the eyepiece optics. * The distance measured on the optical axis from the vertex of the read of the eye lens to the exit pupil. * Also known as eye distance.

eyeguard
Cup or petal-shaped shield of rubber or plastics designed to (a) prevent stray light from interfering with viewing (b) maintain the eyes at the correct relief or eye distance.

eyepiece
That part of an optical system which relays the image to the eye. * In most systems – e.g. microscope, telescope – it magnifies the real image from the objective. * In SLR cameras it provides a magnified view of the focusing screen and forms part of the viewfinder system. * Also known as ocular in viewing instruments.

See dioptre.

The longer, the easier

Eye relief is an important measure of comfort for the user of optical equipment, from binoculars and microscopes to cameras. Too tight a distance, and the user must align the eye too closely to the equipment for comfort – which makes it difficult for spectacle wearers. Longer distances are more difficult to design but benefit most users; but eye relief can also be too long for comfort.

f

Focal length: usually engraved on optic e.g. f (or F) = 250mm: focal length is 250mm. * Do not confuse with focusing distance.

F

(1) Fahrenheit: thermometer scale measuring dynamic temperature such that freezing point of water is 32°F and boiling point is 212°F. * Still in use in USA and parts of UK, elsewhere superseded by Celsius scale. (2) Farad: measure of capacitance or electric charge.

F-line

Light of wavelength 486.1nm. * Used, together with D and C lines, to calculate dispersive power. * A Fraunhofer line.

f-theta lens

Design of lens used in document scanning, reading or printing systems in which the image height is proportional to the scan angle (theta). * Usually image height is proportional to the tangent of q, the scan angle.

f/number

Setting of lens diaphragm that determines amount of light transmitted by lens. * Equal to focal length of lens divided by diameter of entrance pupil. *f/numbers are, for

Assuming the ideal

The f/number of a lens is defined by simple geometry (a length divided by another) so it assumes that the lens passes all of the light entering it. But no lens does: each interface between media of different refractive indexes causes a loss of light. Modern lenses are amazingly efficient so losses are very small and, anyway, losses are automatically compensated by TTL metering.

convenience and by convention, placed on a scale in which each standard f/number step (f/1, f/1.4, f/2, f/2.8, f/4, f/5.6, f/8, f/11, f/16, f/22, f/32, f/45, f/64 and so on) represents a doubling in the amount of light transmitted e.g. f/4 transmits twice as much light as f/5.6; conversely, f/16 transmits a quarter of f/8. * Since f/number is usually calculated from simple physical dimensions, different lens designs, varying focus and the use of accessories may all affect the actual amount of light projected: one lens set to e.g. f/8 may not give quite the same exposure as another lens set to f/8.

See T-number; transmittance.

f/stop

Loosely synonymous with f/number.

See stop.

facsimile

(1) Copy that closely matches the original – almost to point of being indistinguishable. * In photography, the synonymous term 'duplicate' is more often used. (2) Reproduction and transmission system with which a picture or text is scanned in one facsimile machine by converting the original into a stream of analogue electrical signals that are transmitted via telephone to the receiver which reconstructs and prints out a copy of the original. * Also known as fax.

fade

(1) Presentation technique in audio-visual or multimedia shows in which image is made to darken from full brightness to black i.e. fade out; or emerge to full brightness from black i.e. to fade in. (2) Gradual loss of density in a silver or dye image over time caused by deterioration. * Can be due to one or more of following (a) inherent instability of chemicals making up image (b) bleaching due to action of light (c) bleaching due to action of chemicals in material (d) bleaching due to action of pollutants in support material, in air or storage conditions (e) decay of support material (f) biological action on gelatin e.g. fungus attack. (3) Change of a colour in strength, hue, brightness or darkening – or any combination of such changes.

See dissolve.

fake colour

See false colour.

fall time

Time interval during which a light-detector's signal drops

from 90% to 10%. * If this interval is extended, it interferes with subsequent light detection e.g. prevents rapid-sequence digital photography.

fall-off

(1) Loss of illuminance in the corners of an image as projected by a lens in e.g. a camera or a projector. (2) Loss of light towards the edges of a scene that is illuminated by a light-source whose angle of illumination is too small to cover the required view e.g. electronic flash with normal coverage used to light a very wide angle of view. (3) Loss of image sharpness or illumination away from the centre of a scan or scanner.

false colour

Assignment of arbitrary colours to an image. * Usually applied to images derived from extended spectral range imaging e.g. (a) colour film with infrared sensitivity (b) multispectral imaging from remote sensing satellites e.g. reds may be allocated to infrared, greens to visible wavelengths, blues to ultraviolets.

far distance

The further limit of acceptably sharp focus in a given depth of field and focused distance.

farad

Measure of electric charge or capacitance. * A capacitor of one farad stores one coulomb of charge at a potential difference of one volt. * One farad is, for most purposes, a huge charge: the commoner unit is the microfarad.

Farmer's reducer

Chemical used to reduce density of silver image e.g. brighten highlights in black & white printing. * Solution of potassium ferricyanide with sodium thiosulphate.

fast

Adjective: (1) ~ film; ~ emulsion: one with comparatively high sensitivity: small quantities of light produce relatively large response in density of image. (2) ~ lens: one with a large maximum aperture for its class e.g. $f/1.4$ for 50mm lenses, $f/4.5$ for 500mm. (3) ~ shutter speed: shutter setting giving a relatively short or brief duration of exposure time for a given class of equipment. (4) ~ developer: one which works at high dilution or requires short processing times. (5) ~ printer; ~ hard-disk: equipment which takes a relatively short time to complete a given task. (6) ~ processor: one with a high clock speed or rate of calculation e.g. 500MHz. (7) ~ colour: one that is resistant to fading.

Playing with colours

Infrared colour film is, ipso facto, false colour because we cannot see infrared so what colour can it be? The answer is 'red', which means that actually red objects must be shown as another colour – usually green – while green objects are shown blue. Film consists of the usual subtractive tri-pack structure but: cyan dye is infrared-sensitive; yellow dye is green-sensitive and magenta dye is red-sensitive. Poor old greens obviously get squeezed out to grey i.e. they are not 'seen' at all by such films.

Hare and the tortoise

Note that of two computers, one with a faster processor than the other, it does not follow that the faster computer is the one with the faster clock. Very confusing, to be sure. That is because a fast computer is fast in the sense of completing certain tasks quickly: a faster processor helps, but better use of resources e.g. faster data bus, faster disk, more efficient processing, etc. are just as important. For many tasks 500MHz G4 Mac can work more than three times faster than a 600MHz Intel machine.

fata morgana

Type of mirage which makes flat objects look like huge mountains or cliffs, even castles. * Differences in the refractive index of rising columns of air distort images of distant scenes and have been known to cause viewers to believe they were seeing mountains in the distance.

fatigue

In light-detecting instruments or materials: loss of efficiency, sensitivity or response due to repeated or high exposure to radiant energy. * E.g. selenium-cell exposure meters cannot measure low light levels accurately soon after being used in bright light.

feather

Noun: (1) Indistinct or gradual border or selection in image manipulation programs. (2) Small, equal additions to leading in computer typesetting. (3) Fluffy, feather-like flaw in glass. Verb: (4) To blur or make indistinct a selection (i.e. selected part of the image) during image manipulation. (5) To illuminate a subject with the an off-centre beam of light in order to e.g. reduce illumination or contrast.

feathering

(1) Blurring of a border or bounding line by reduction of the sharpness or suddenness of the change in value of e.g. colour, brightness, etc. * With image manipulation programs, feathering can often be set by pixel width (a) very wide gives the greatest feathering (b) narrow or no feathering gives sharp outlines. (2) Blurring or ragged edge to a printed outline due to seepage of ink into the support material. (3) Adding equal amounts of space between lines of type i.e. give equal increases in leading in order to force vertical justification in desktop publishing programs.

feature extraction

Process in which an initial measurement pattern or series of measurements is transformed to a new pattern. * In pattern recognition the information relates to e.g. outline shape, background, etc.

Fechner's Law

An arithmetic increase in visual sensation requires a logarithmic increase in visual stimulation. * E.g. a series of densities doubling in density (logarithmic increase in stimulation) is seen as evenly increasing steps of density (arithmetic increase). * Also known as Weber-Fechner Law (as it is a specific application of Weber's Law).

See Weber's Law.

feedback

The transfer of a part of a device's output to its input.

feedback control

Electronic or other system designed to control the output of a device by transferring or feeding back a portion of its output signal. * The returned signal is used to measure the output or response to the output, thus to control the relationship between the input and output signals. * Used e.g. in colour enlargers to maintain an accurate output; in flash-guns in which the light reflected from the flash is measured and used to control the exposure.

Fermat's principle

A light ray always follows the path requiring the shortest time. * This is the basis for the law that light travels in a straight line i.e. that its propagation is rectilinear. * Also known as principle of least time.

ferrotype

Technique for producing a high-gloss finish on fibre-based prints by drying them with the emulsion under heat and pressure on a highly polished metal plate.

ferrotyping

Defect on prints seen as glossy spots or areas caused by pressure against smooth surface e.g. glass.

fibre optic

Optical system using bundle of narrow glass or transparent plastic fibres to relay or pipe light from one end of fibre-optic to other: each fibre carries part of image that enters it to other end, therefore it is essential that relative positions between each fibre are maintained. * Used in endoscopes and vital for land-based high-speed data communications.
See optical fibre.

Fibrous focusing screens?

An unusual application of fibre optics has been to use a thin but extensive sandwich of fibres to construct focusing screens for reflex viewing cameras.

fibre optic cable

The entire package of an optical fibre: includes the cladding for the fibres, strengthening wires and outside jacket.

fibre-based paper

Black & white photographic printing paper whose base or core is made from cotton or paper fibre or a mix of these. * Contrast with polyethylene papers which sandwich a fibre core within plastics.

fiducial mark

Spots or crosses in the field of view of an optical system or engraved on a glass to provide reference points. * These marks can be positioned with extremely high accuracy and are vital in e.g. photogrammetry.

F

field

(1) The area covered in one cycle of scanning e.g. in a television or video projector: the scanning beam starts at the top and reaches the bottom of the screen. * This is equal to a frame in a non-interlaced device and equal to half a frame of an interlaced device. (2) Volume of space in which objects are imaged with acceptable sharpness for a given lens, focus and aperture setting and viewing conditions. * Measured as depth of field. (3) Area or extent of a subject that is seen or imaged by an optical instrument. * It is measured by field of view. (4) Box or space in dialogue box or form presented by software application which user has to fill in e.g. field in database requires data to be input.

field curvature

Defect or aberration of lens that causes a flat surface to be imaged onto a curved rather than flat surface. * Primary aberration in which the locus of image points of an object plane parallel to the focal plane lies on a curved (i.e. not planar) surface. * Also known as Petzval curvature.

field flattener

Lens designed to correct curvature of field: usually a weakly negative plate placed near focal plane. * Invented in 1875, but fell out of favour because of problems with dust on the optic.

field glass

Binocular of simple construction. * Usually a pair of Galilean telescopes.

field lens

(1) Optic at or near the focal plane designed to collect the light for an observer or a viewfinder. * In cameras, a Fresnel lens is usually used. (2) Component of an eyepiece closest to the objective. * So-called because the size of this component decides the field of view of the whole optic.

field of view

Measure of the extent of a subject that can be seen with or utilized by an optical instrument. * May be given as (1) the angle distended at the eye by the limits of the field or (2) as the width of the subject space that can be seen at a given viewing distance e.g. 100m at 1km.

field stop

Mask or aperture that determines the size and shape of the image.* It is placed close to the focal plane of an optical system. * E.g. the film gate of a camera as used in APS cameras to change format.

Great curves, pity about the outline

Field curvature was a great problem for lens designers working in photography, made worse with the ever-present demands for wide-angle lenses. Early cameras – notably Box Brownies – and even the sophisticated Minox reduced the problem by bending the film with a curved film gate. Latterly, the main advance has been the increasing use of aspherical lenses. In practice, stopping down decreases the defect by increasing depth of focus.

Vignettes on life

In contrast to a field stop, which produces a sharp margin to the image, vignettes such as the heart-shapes and ovals favoured by soppy portraitists, all project a fuzzy outline. Vignettes are strictly speaking also stops but are placed in front of the lens. This means the sharpness of the outline increases with larger f/number.

fifth-order aberrations

Aberrations which are not the primary monochromatic aberrations of spherical aberration, astigmatism, distortion, curvature of field and coma. * Also known as secondary aberrations or non-von Seidel aberrations (which are themselves third-order).

file attribute

Code kept with the file's directory information that indicates its status e.g. whether it is locked or read-only, whether it is hidden and for use only by the system etc.

file compression

Reduction in size of a digital or computer file by re-arrangement of the data. * Day-to-day, only data is compressed; application software may be compressed for file transfer purposes e.g. downloading off the Internet or distribution on CD-ROMs.

file format

The way in which a software program stores data: determined by the structure and organization of the data, specific codes e.g. for indicating the start and end of a segment of data together with any special techniques used such as compression. * Formats which are specific and optimized (for speed, compactness etc.) to an application program are called 'native' e.g. Photoshop format is native to Adobe Photoshop.

fill

In software programs: the application of a colour or colours, texture or gradient into a defined area or volume.

fill-in

(1) Verb: to lighten or illuminate shadows cast by main light by using another light-source or reflector to bounce light from main source into shadows. (2) Noun: light used to lighten or illuminate shadows cast by main light. * Both apply to shadows cast by sun or other available light as well as lighting on studio set.

film gate

Physical aperture in a camera that lies on the film to mask the image projected by the lens: its size defines the shape and size of the image that is captured on the film. * It usually also carries precision formed or ground focusing rails that position the film precisely at right angles to the optical axis.

film loader

Accessory for transferring standard lengths of film from a bulk roll into a cassette. * After loading, the film loader works

Higher order of mathematics
Today's requirements for top-notch lenses call for computations to correct fifth-order aberrations. (If you really want to know, the name comes from the power-series expansion of the basic Snell's Law). But designing for aspherical lenses, optical scientists have to work with seventh-order aberrations and even higher.

Filing for divorce
Some formats, thank goodness, were designed from the outset to be usable across different application programs: e.g. TIFF, JPEG, PostScript or even across different platforms. But wait: (they keep quiet about this) note that new versions of a program usually create what is effectively a new native file format – which cannot be read by earlier versions of the program. If you want an earlier version to use the new file, you usually have to save it in the old file format, naturally at the risk of losing new features.

Convicting with the gate
Microscopic imperfections of the film gate, seen on the edge of a negative or transparency, are like 'fingerprints' and can identify an individual camera body. Budding black-mailers take note!

with all other operations – such as measuring film length and cutting to length – taking place in daylight.

film plane

Position of light-sensitive material or detector behind lens at time of exposure. * It usually corresponds to and coincides with the focal plane but e.g. in studio cameras it may be displaced for specific purposes. * It may be curved e.g. in panoramic camera.

film platen

Mechanism designed to position precisely the film on the focal plane in a camera. * May work by applying pressure but also by applying slight vacuum to suck the film flat onto the platen. * Also known as pressure plate.

film recorder

Instrument designed to place non-graphic information, usually generated by a computer, onto photographic film. The information is generally encoded as a series of opaque and translucent spots, or light and dark spots.

film scanner

Scanner for digitizing photographic film i.e. designed for transmission originals. * Consists of light-source and array of photo-detectors focused onto the film stage which lies between the light-source and the detectors: the film is scanned either by moving the film over the array or by moving the array. Differences in light and colour are registered by the array and converted into digital data which are sent to a computer to be used.

film scanning

(1) Using a film-scanner to digitize the analogue information held in photographic film. * (2) Process of encoding cine or photographic film into a signal for TV transmission.

film speed

Measure or indication of sensitivity of light-sensitized material to light. * To determine, film is precisely exposed in a sensitometer and processed to a standardized routine after which densities corresponding to the exposures are measured. By plotting exposure against density, film-speed can be determined, following standardized mathematical procedures. * It follows that film speed is relative to the procedure adopted for its measurement which may, in certain picture-making situations, not be appropriate. * ISO film speeds are the accepted international norm. It consists of both the ANSI and DIN speeds.

See characteristic curve.

Photographer's secret weapon

The film scanner has been the biggest transformation in conventional photography since the invention of colour film: with comparatively modest outlay any photographer with a computer can produce reproduction-quality scans at home, in comfort and with no further outlay. It turns the publishing industry on its head, fully democratiszing printing for the first time in its four hundred year history.

film writer

Device for turning digital image file into a film image by 'writing' data onto film: may use high-precision, flat monitor screen with rotating filters to turn data into image on monitor which is exposed onto film or may use scanning laser beams. * Capable of producing very high resolution images but very slow in operation.

filter

(1) Optical accessory used to cut out certain wavelengths of light and pass others: consists of transparent medium coated or dyed with material that selectively absorbs certain colours. * Usually named after colour or band of wavelengths that is transmitted e.g. red filter transmits red by absorbing blues and greens. NB: UV filters in normal usage means minus ultra-violet i.e. UV is absorbed, other wavelengths being transmitted. * Also available for special effects e.g. diffraction, pseudo-motion blur and specialist uses e.g. precise colour corrections. (2) Part of image manipulation software written to produce effects such as sharpening, blurring, smearing and simulating effects of photographic filters. * Most work by applying mathematical function to blocks (or kernels) of pixels. (3) Part of application software that is used to convert one file format to another e.g. in for importing a foreign format into an application. (4) Program or part of application used to screen incoming data e.g. refuse email messages from specified sources.

filter factor

Measure of the increase in camera exposure needed when a filter is used. * Usually expressed as a factor – i.e. used to multiply – the exposure time e.g. a factor of 2X will double exposure time. * Filters absorb some light (usually the unwanted wavelengths) while transmitting the required wavelengths: the loss of light is compensated for by the factor, assuming the image under-exposes the unwanted wavelengths while correctly exposing the required colour.

filter pack

Set of filters or filter settings used to create a given effect e.g. the filter settings used to create a colour print; the separation filters of an integral tri-pack colour film.

fine

Adjective: (1) ~ grain: film with low granularity. (2) ~ grain developer: black & white developer producing films with low granularity e.g. hydroquinone types. (3) ~ grained: focusing screen, paper, etc.: one with a smooth texture.

F

fingerprint

Technology for marking a digital image file in a way that is invisible and which survives all normal image manipulations but which can still be retrieved by suitable software: the marker carries an identifier for the copyright holder. * The favoured way is to superimpose a signal onto the waveform of the image, i.e. to apply the marker in the image's frequency domain. Editing changes usually take place in the spatial domain i.e. on the image as seen and have little overall effect on the frequency domain. Spare bits or channels in graphic file formats may also be used.

See steganography; watermark.

fingerprint camera

A specialist, usually fixed-focus, camera used to record the ink impression of fingerprints.

finite sampling theorem

A finite version of Shannon's sampling theorem that states that a class of functions can be reconstructed exactly by a sufficient number of spectral samples; the reconstructed function is an explicit function of these samples.

FireWire

Standard for high-speed data communications between peripheral devices and a computer. * Implementation of IEEE 1394 by Apple Computer Corp.

See IEEE 1394.

first principal point

The principal point of a lens closest to the object space. * The intersection of the first principal plane with the optical axis. * Also known as the first nodal point.

first-generation copy

Direct, analogue, copy of an original: several copies made directly from the original are each of them first-generation copies. * Second-generation copies i.e. made from the first-generation show degradation of facsimilitude – in contrast to digital copies, in which there is no clear distinction between generations.

fish-eye lens

Design of ultra wide-angle lens whose field of view is between 180°-210° and whose image has barrel distortion. * As a result of the allowed distortion, these lenses do not obey the cosØ⁴ law i.e. the image illumination is even across the field.

FITS

Functional Interpolating Transformational System: file format

used by Live Picture family of software. * FITS files are a mathematical description of the editing effects and are therefore resolution-independent.

See IVUE.

fixed focus

Type of lens mounting which fixes lens at set distance from film: usually focused on hyperfocal distance. For normal to slightly wide-angle lenses this is at between 2m-4m from camera. * Used with moderate wide-angle or standard focal length lenses in cheaper cameras to eliminate expense of providing focusing mount with aperture restricted to around $f/8$. * Some lenses – e.g. fish-eye – may not need focusing.

flange

Ring used to retain or hold an item in place e.g. to hold lenses on lens panels for enlargers or large-format cameras.

flange focal distance

The distance, measured along the optical axis, between the face of the lens mount and the film plane. * Standardized for all optics and accessories for a particular lens mount to ensure the image plane of all mounted lenses focused at infinity falls on the film plane.

flare

Non-image-forming light in optical system that degrades image quality. * Light may (a) enter optics obliquely and reflect around inside of camera or lens (b) leak into system e.g. through hole in bellows (c) be deviated from forming image by marks or particles on lens surfaces or by defects in glass, with the net effect of reducing contrast of image. * In bad cases it may form one or more spots of light, often of shape derived from that of diaphragm or aperture stop. * Flare is reduced by (a) coating or multicoating all air-glass surfaces of optics (b) providing shade or hooding to prevent entry of stray light into optical system (c) providing stops within optical system to block oblique rays (d) blacking or flocking all reflective surfaces e.g. rims of individual lens components and interior of lens and camera to absorb stray light.

When no flare is bad flair

The funny thing is that lens flare sometimes authenticates – almost validates – an image as a photograph so its presence in a digitally manipulated image helps make it look more 'realistic'. Most image manipulation software offer some kind of flare filter effect. There is even a plug-in for Photoshop that offers nothing but lens flares.

flash

Verb: (1) To provide illumination with very brief burst of light. (2) To reduce contrast in a sensitive material by exposing it to brief overall or fogging burst of light prior to the final imaging exposure. (3) Noun: equipment used to provide brief burst or flash of light.

See electronic flash-unit.

Flash

Format for animated graphics on the Web. * It is vector-based and therefore files may be very small. * It is native to Macromedia Flash, but produced also by e.g. FreeHand, Illustrator, LiveMotion. * The file suffix is .swf.

flash photographic density filter

Neutral density filter operating over near-ultraviolet, visible and infrared wavelengths i.e. it is almost equally opaque to all wavelengths in this range. * It is made by exposing and processing silver-based photographic film.

Flashpix

File format structured to hold image as a series of differing resolutions at a half, quarter, eighth, etc. of the original image size. * This allows rapid use of the image with minimum re-sizing and ability for low-end equipment to open any image. * File sizes are at least a third larger than equivalent uncompressed TIFF files. * Standard from consortium including Kodak, Hewlett-Packard.

See pyramid.

flat

Adjective: (1) ~ tone, ~ contrast e.g. flat negative or print is low contrast i.e. shows only grey tones. (2) ~ light, ~ conditions tending to produce evenly lit or low contrast results e.g. flat lighting is lighting producing small variation in brightness between brightest and darkest parts of subject. (3) ~ field: optical system offering a low level of field curvature in its focal plane e.g. enlarging and macro lenses are flat-field lenses. (4) ~ film: condition of film at film gate such that the curvature or buckling of film is kept to within the depth of focus of the optical system and settings in use. (5) ~ -file database, ~ structure: organization of information in any database-like structure e.g. Web site with minimal use of sub-levels or secondary branching. (6) Noun: panel or other flat, mobile surface on which to hang pictures for exhibition or used to make scenery and backgrounds.

See contrast.

flat copy

Photography of two-dimensional objects e.g. paintings, murals, prints, pages from magazines, etc.

flat-bed scanner

Type of scanner for reflection originals and can be adapted for transparent originals. * Employs a set of sensors arranged in a line and focused via mirrors and lenses on the subject which is placed face down on a flat glass bed facing a light-

Cheap and very flare-ful

Flat-bed scanners are by far the most versatile design and good value-for-money. Quality can range from adequate for scanning text to top-class reproduction quality with prices from low two figures to anything up. The main limitation of the design is the inefficient optical arrangement which has very high flare levels that limit the maximum density that can be measured so limiting its use as a film scanner.

source: as the sensors traverse the length of the subject they register the varying light levels reflected off the subject. * In some scanner designs, the subject is carried on a moving bed which travels over a stationary arrangement of light, mirrors and sensors.

flatten

To combine together the multiple layers or floating elements of a digitally manipulated or composited image into a single, 'flat', image. * Usually final step of working with layers in illustration or image manipulation applications.

flicker

Rapidly changing, irregular effects seen on computer monitor screens. (1) Apparent variations of shape or position seen with change of display: the change e.g. scrolling or change of viewpoint is faster than the display refresh can keep up. * Frequently seen when LCD screens of digital cameras are used as the viewfinder. (2) Rapid variation of density most visible in even, light areas on a monitor with interlacing, due mainly to low refresh rates. * The maximum rate of variation is roughly the reciprocal of the period of persistence in vision.
 See interlace; refresh.

flint glass

Type of optical glass characterized by high dispersion and high refractive index. * Family of glasses with Abbe number less than 50 with refractive index of 1.6 or less, and Abbe number less than 55 with refractive index above 1.6. * It is relatively soft and not durable, therefore its use as the outer element in a system is avoided. * One of the major families of optical glass.
 See crown glass.

flipped

Image which is laterally reversed, as if turned over or seen from the wrong side so the left side is on the right. * Also known as reverted image.

floodlight

Luminaire providing a broad beam of relatively soft light with minimal central hot-spot: recognizable by very large diameter reflector, often with baffle in front of the lamp. * Often shortened to 'flood'.

flow camera

Apparatus for high-speed recording of images of documents. * Film and documents are synchronised to move in opposite directions: over 500 records can be made per minute.

Leading questions
Optical glasses are mixtures of oxides of silicon, mainly, plus oxides of aluminium and rare earth metals plus lead. Larger quantities of lead increases refractive index and dispersion. Lead glass elements were popular with designers but not with users: the glass is very heavy.

F

fluorescence

Physical phenomenon in which energy of one wavelength is absorbed by a substance which then emits light of different (usually longer) wavelength: e.g. ultraviolet light is absorbed and visible light is emitted. * Effect ends very quickly after incident light is removed. * A form of luminescence. * Used in microscopy and ophthalmology: fluorescent substance e.g. fluorescein absorbed differentially by certain tissues or parts of cell. When illuminated with e.g. UV radiation, only parts which have absorbed fluorescein will be visible. * Used also in optical brighteners to improve apparent whites of black & white prints.

See allochromy; phosphor.

fluorescence photography

Photographic recording of a subject that fluoresces. * Photography of subjects that luminesce for shorter than 10 sec after end of application of excitation energy. * Characterized by need for extremely high sensitivity of photographic material, use of very wide aperture optics and sensitivity to narrow wavebands of light. * Used in forensic examination, microscopy and dermatology, etc.

fluorescent lamp

Type of light-source which exploits phenomenon of fluorescence. * Tube fitted with electrodes is filled with gas e.g. mercury vapour: when a sufficiently high voltage is applied between electrodes, current flows through the gas, exciting it to produce ultraviolet radiation which strikes coating of fluorescent substance or phosphor on inside of tube: this in turn radiates visible light. * Due to nature of its production, only few wavelengths of light are present in light from fluorescent lamps i.e. they show highly discontinuous spectra.

fluorescent screen

Plate coated with a layer of an x-ray sensitive fluorescent material – e.g. phosphor – to make x-rays visible for observation without need for film. * Also used for photography as image intensifier, with film held in contact with the screen. Most films are far more sensitive to the light emitted by a phosphor than to x-rays.

fluoride glass

Optical glass doped with zirconium fluoride to improve e.g. transmission characteristics.

fluorite

Calcium fluoride crystal in form suitable for optical use. *

Fragile fluorite, untouchable performance

Fluorite is highly favoured for its ability to help produce apochromatic correction in longer focal length lenses. However it is extremely difficult to fabricate: difficult to grow and very fragile to polish. It also must be protected from the environment being soft and water absorbent. Canon has taken the trouble, however, and its lenses with fluorite elements are amongst the very finest photographic optics anywhere.

Characterized by low refractive index, very low dispersion. * Also transparent to infrared and ultraviolet.

fluorite objective

Optic which uses fluorite in its construction. * Fluorite contributes to considerable reduction of secondary spectrum, usually to apochromatic standards.

fluorographic camera

Equipment for photographing x-ray fluorescent screen images. * Usually consists of a camera with a very large aperture – e.g. $f/0.8$ – lens or mirror system for 70mm film.

flux

Rate of flow of energy. * E.g. luminous flux is rate of flow of light energy. * It is measured in lumens.

fly-back

(1) The vertical re-trace in a computer monitor between completing the drawing of one frame or field of a screen image and the start of the next. * (2) The time interval between the last line in a frame and start of the next in an interlaced monitor. * In computer monitors, each frame or field is drawn by an electron beam scanning across and down the screen in a zigzag: when it has covered the screen it flies back again to the same point. * May also refer to the movement of the beam as it returns to the start.

See refresh.

FM screen

Frequency Modulated screen: see stochastic screen.

focal length

(1) For SIMPLE LENS: distance between centre of lens and sharp image projected by it of a subject at infinity. (2) For thick, or COMPLEX LENS systems: distance between rear principal point (or rear nodal point) and rear principal focus. (3) For MIRROR: distance between optical centre of mirror and image: is equal to half radius for spherical mirror; an ellipsoidal mirror has two foci. * NB: focal length always measured on optical axis with object at infinity. * Focal length is effectively distance between point from which image of object appears to be projected to image itself: this point of projection may be in front of and behind lens itself as well as being inside it. * Focal length does not necessarily correspond to physical length of photographic lens. * Fundamental characteristic of optical system which (a) determines image size relative to subject distance (b) determines relative aperture or f/number.

See telephoto; retrofocus lens.

Compromising the focus

The surface on which an image is sharpest is, for normal photographic lenses, not very flat. Indeed, early cameras curved their film in order to optimize image quality. So by necessity, the focal plane is placed in a compromising position: one which catches as much as possible of the image sharpness over as much of the film as possible. As a result, the fall-off in quality at the corners of a film does not mean the lens is not sharp there, it may simply mean the film was not quite in the right place to catch the sharp image.

focal plane

(1) The plane lying at right angles to the principal axis of a lens or mirror which goes through the focal point. (2) The plane surface which optimally collects the best image or on which the sharpest image lies. * This plane may be inclined to the optical axis e.g. when lens and/or film planes are tilted such that the Scheimpflug condition is met.
See Petzval surface.

focal plane array

Set of photo-detector elements placed at the focus of an imaging system and arranged variously as a linear array or two-dimensional matrix. * Most digital cameras conform to this arrangement, the exceptions being those that split the image into three components for colour separation.
See array.

focal plane assembly

Infrared imaging device in which the detector array, electronics and possibly the cryogenic cooling system are located close together and at or near the focal plane. * The arrangement minimizes noise due to stray thermal emissions. * Used in meteorological and surveillance satellites, low-light vision systems and heat-seeking missiles.

focal plane shutter

Mechanism for exposing photo-detector or film to light for a precise period of time. * Consists of two sets of opaque roller blinds or blades which traverse the film gate at constant speed with a slit of adjustable width: a narrow slit provides a short exposure, a wide slit provides a long exposure. * The slit may run vertically or horizontally, progressively exposing the film or detector.
See shutter time; shutter speed.

focal point

(1) The point on the optical axis on which light rays entering a perfect lens will converge. * When the subject is at infinity, the intersection of the parallel rays of light is the principal focal point. (2) The intersection of the focal plane with the optical axis.

focal power

Measure of the influence of an optical system on the light rays passing through it. * Also known as optical power.

focometer

Optical rig or instrument for measuring the focal length of an optical system or lens.

Battle-lines are drawn up

The obvious way to arrange a matrix array is like rows of soldiers: one behind the other and next to each other. But there is another way: with each sensor behind the gap between the two in front: technically, each row is half a cycle out of phase. Boring technicality? Far from it: this geometry has many advantages including better signal/noise ratio and slightly better resolution for the same number of detectors.

focus

(1) Verb: to make image look sharp, usually in order to bring film or projection plane into coincidence with focal plane of optical system. * To adjust an optical system so that an observer sees a clear image. (2) Noun: rear principal focal point. (3) The point or area on which e.g. attention or compositional elements converge.

See focal point; focusing.

focus control

(1) Mechanism for focusing an optical system e.g. rotating lens elements on a helical thread or driving elements backwards and forwards on e.g. rack and pinion. (2) Adjustment of size of spot projected by a cathode-ray tube display on a phosphor screen.

focus shift

Change in the position of plane of best focus. * In zoom lenses, focus may change slightly with change of focal length. * In other lenses, focus may shift with change in aperture – most seriously with enlarging lenses – often due to under-corrected spherical aberration.

focusing

(1) Noun: act of setting or driving lens in such a way as to make image look sharp. * Achieved either (a) indirectly e.g. by observing image on focusing screen or by using optical range-finder e.g. swing wedge type or (b) directly by driving focusing mechanism as in auto-focus systems or by direct observation of image on focal plane itself as in enlarging or slide projection. (2) Adjective: ~ device, ~ component: designed to achieve or help achieve focus e.g. focusing aid is any device ranging in character from (a) optical e.g. split-image rangefinder or microprism screen to (b) mechanical e.g. focusing handles on a lens that are designed to improve manual focusing.

focusing anode

Positively charged electrodes used to focus the electron beam of a cathode-ray tube. * Variation in the applied voltage controls the size of the spot.

focusing coil

Electromagnetic device used to focus an electron beam: a current through the coil creates a magnetic field which 'squeezes' the beam of electrons.

focusing magnifier

Magnifying glass on a mount to aid fine focusing on a ground glass screen of large-format studio or field camera.

Focus on focusing

There are many methods of adjusting a system to obtain a clear image: in close-up work e.g. microscopy or macrophotography it is often easiest to move the whole assembly. With long distances, you can adjust the focus by moving lens elements e.g. as in camera lenses or binoculars. But for very long distances it may be easiest to adjust just the eyepiece optics e.g. astronomical telescopes.

Dream on, dreamers

Ever dreamt of the day you'd never have to fumble around to focus a lens again? And you thought 'focus-free' lenses were a technological leap forward? Sorry, focus-free lenses are simply ones glued into place: lenses that have never been within touching distance of a focusing mechanism. Forget them for all but the least demanding uses. On the other hand, photographers may, on occasion, turn their focusing lenses into fixed focus by taping the focusing ring e.g. in aerial photography. Note some cameras – e.g. Contax auto-focus – focus by moving the film.

focusing scale

Graduated markings on an optical instrument e.g. extension bellows, slide duplicator which indicates the focus setting. * May indicate the distance to the object or from infinity focus or the effective diopter.

focusing screen

Plate of glass or plastic material on which the image projected by camera lens can be viewed by the photographer, to compose and focus image. * May consist of diffusing screen to capture image, features to improve light-gathering and evenness plus focusing aids. * In view cameras, the focusing screen is replaced by the film-holder so that the film lies exactly in the same position as the screen, to maintain focus. * In reflex cameras the distance from the focusing screen to the lens is exactly the same as the distance from the lens to the film. * Also, but less commonly, known as viewing screen.

Sophisticated focus

The modern focusing screen is a highly complicated optical device, incorporating e.g. laser-cut microprisms or Fresnel lenses to improve the brightness and contrast of the image, as well as aids for manual focusing such as split-prisms, or components such as beam-splitters for exposure measurement or light-piping for projecting information.

fog

(1) Non-image forming density in film that has effect of reducing shadow contrast. * Caused by (a) density of emulsion even when unexposed; or (b) stray, non-image forming light and other radiation due to light scatter or internal reflection in optical system or background e.g. cosmic radiation; or (c) unwanted chemical effects during processing e.g. development of unexposed silver halides; or physical changes in film due to e.g. heat. * In general, fog effects increase with film speed, increased development (as result of increasing either development time, agitation or temperature or all) or increased speed of development.
(2) Atmospheric phenomenon in which droplets of water suspended in air scatter light to varying degrees according to size and concentration of droplets and presence of other particles such as smoke or dust. * Has effect of softening details, diffusing colours, making objects seem further away – and is extremely difficult to model digitally. (3) Clouded or diffused appearance of insufficiently polished glass. (4) The condensation of moisture on a surface, particularly an optical one.

foil

Transparent sheet used to hold separation films prior to plate-making for printing presses.

fold

(1) Change or bend in the direction of an optical axis or light-path using prism or mirror assemblies e.g. in

binoculars, catadioptric lenses. * Usually used to make system (i.e one with 'folded optics') more compact. (2) A flaw in an optical blank caused by wrinkling the surface during its production.

folded optics

Optical system made compact by 'folding' the light-path.

See fold.

folder

Location for collecting or organizing files related by function, project or other use e.g. applications are all kept in the Applications folder, all operating system files are in the System folder, files for an exhibition are in the Big Project folder. * Folders may be kept within folders. * Effectively a sub-directory on a hard-disk, used mainly in MacOS (called 'directory' in Windows).

folio

(1) Short for 'portfolio': set of prints gathered together for presentation. (2) Page number, in page-layout applications. (3) Sheet of paper folded once – giving four pages – from which a book is made up (the original meaning of the word).

font

Collection of all the characters in the alphabet including numerals and symbols of one typeface design (including its weight (e.g. roman, light, black), posture (e.g. italic) and size.

See PostScript; TrueType.

foot candle

Unit (fc) of illumination i.e. amount of light falling onto or incident on surface: lumens per square foot i.e. amount of radiant energy or luminous flux (measured in lumens) incident on surface area of one square foot where surface is at right angles to incident light. * Obsolete: use lux instead.

foot lambert

Unit (ft L) measuring luminance i.e. amount of light reflected or emitted from a surface: lumens per square foot i.e. amount of radiant energy or luminous flux measured in lumens being emitted or reflected from surface area of one square foot. * Obsolete; use candela per square metre. * Still in use to measure brightness of image projected on screen.

footprint

(1) Space, size or shape of space occupied by a device or instrument on the surface upon which it rests or is mounted. (2) Surface area taken up by a light beam incident on an optical component. (3) Surface area of the earth 'seen' or imaged by a remote sensing device.

F

foreground

Noun: (1) Part of scene or space around object that appears closest to camera. (2) Element or feature of composition of photograph that is depicted as being nearest viewer. (3) Adjective: ~ application: software application which is active or receives highest priority where more than one application is running at the same time.

See background.

forensic photography

Use of photography with help of ultraviolet, x-ray, infrared and other specialized light-sources and techniques to aid police e.g. to gather evidence, provide records of crimes, etc.

format

(1) Noun: shape and dimensions of image on a film as defined by the shape and dimensions of the film gate of the camera in use. (2) Noun: orientation of image: landscape (if image orientated with the long axis horizontal), portrait (if image is oriented with the long axis upright). * The convention is to quote depth i.e. vertical dimension followed by width e.g. A4 upright is 297mmx210mm. (3) Verb: to arrange data or text following a fixed design, grid or outline. (4) Verb: to set out the layout of tracks and sectors in a magnetic medium prior to recording or writing data. Noun: the specific layout of tracks, sectors, etc. in a storage medium. (5) Dimensions of paper stock, hence also publication size, usually the final, trimmed size.

See film gate.

Rounding off

Standard formats e.g. 6x6 or five-four indicates the image size plus or minus a nominal margin. Even within an established format like 35mm, there are small variations of format: precise size of image varies with individual cameras and for a given camera and may also vary slightly with focal length or focus of lens in use. Note, in contrast, the actual dimensions of the film material itself are extremely precisely controlled.

Foucault knife-edge test

Test for optical quality of an imaging system: a knife edge is inserted from one side into the image of a small point source which is observed through a camera or other optical instrument being tested.

Fourier analysis

Mathematical technique for analysing the components of a complex wave-form into a sum of sine and cosine waves. * The superposition of periodic functions or a Fourier series to provide an equivalent to a given complex wave. * Used in analysis of image quality and as model for optical phenomena e.g. holography.

Waving good-bye to Fourier

Inadequacies of this analysis, which do not sufficiently reflect the complexities of natural waves and data, have led to the development of the concept of wavelets. The flexibility of the wavelet concept has in turn opened the door to new techniques for compressing images, reflected in new JPEG standards being proposed.

four-colour

Printing process which uses four inks – cyan, magenta, yellow and black – to simulate a wide range of colours. * Do not confuse with full-colour, which may be used to suggest true-colour.

fovea

Area of the retina containing mainly cone cells each connected to its own ganglion, with no supporting cells: it has the greatest acuity (resolving power and colour discrimination) of the retina. * It lies in the centre of the macula lutea or yellow spot and is about 1.5mm in diameter, and the visual field is about 5°. * Anatomical name: fovea centralis.

fpo

For positioning only: low-resolution image or file standing-in for the high-resolution file during page layout or design.

See thumbnail.

fps

Frames per second: measure of rate at which individual exposures are made by motor-driven stills camera or cine camera.

fractal

Curve or other object whose smaller parts are similar to the whole. * In practice, a fractal displays increasing complexity as it is viewed more closely and where the details bear a similarity to the whole e.g. a tree shows an irregular branched outline at one distance, closer up it shows the large branches, still closer, the branches can be seen to break into smaller and smaller branches. * The underlying mathematics can be used to generate interesting images from raw data or when applied to an existing image. * Term coined by Benoit Mandelbrot, who worked in 1970's.

frame

Verb: (1)to arrange the elements of a picture within the format, to compose an image. Noun: (2) an entire screen's worth of information. * This may be formed of two interlaced fields as in video i.e. a frame is the combination of the field containing all the even numbered scan lines with a field containing all the odd numbered scan lines. * The rate at which one frame succeeds the next is the refresh rate. (3) An image in a sequence of inter-related images such as an animation or in a cinematographic film. (4) Page layout or graphics element in which objects such as text, graphics or images are placed: moving the frame moves the object contained within.

See field; tweening.

frame camera

Equipment designed to capture at high-speed a short-duration or high-speed continuous event as discrete frames

F

of the event. * Compare with streak camera: in which the photographic record is spread across one frame.

frame grabber
Combination of hardware and software used to sample, digitize and store a video frame or sequence of frames into a computer.

frame rate
Number of frames or separate images of an animation or film displayed per second. * NB: not to be confused with refresh rate of frames in a CRT monitor.

Fraunhofer lines
Dark lines representing adsorption by elements observed in the spectrum of the sun.* Wavelengths of the key lines for photography as used, e.g. in dispersive power formula are: F: 486.1nm; C: 656.3nm; D: 589.3nm. * First observed and named by Joseph von Fraunhofer (1787-1826).

freeware
Class of software that is free to copy and use without payment of fee. * Note that copyright of the work usually continues to reside with the author of the software.
> See shareware.

freeze
A crash or bomb in a computer system that causes it to refuse to respond to commands from e.g. mouse, keyboard, etc. * In fact the computer may be repeating an instruction in an endless loop but who cares: you will still need to re-start it anyway.

frequency
The number of peaks or crests of waves which pass a fixed point in a given unit of time (usually one second), in light, other electromagnetic or other wave motion. * Expressed in hertz or cycles per second.

Fresnel lens
Flat optical component that has the effect of a lens element. * Effectively consists of successive narrow rings of the lens which are flattened: in plan view, the lens consists of concentric rings; in section it is jagged like a row of teeth. * Can be of positive or negative power. * Used to replace normal lens to reduce weight and thickness where image quality is not critical e.g. lighthouse or searchlight collecting lens or as a field lens to improve light distribution in camera viewfinders.

Fresnel number
Measure of the effects of diffraction in a lens for a given

Free doesn't mean everything

Users of freeware do not have the right to trade the freeware e.g. offer it for sale as if it is theirs to sell or alter it in anyway. And if you distribute it, you are usually asked – as a courtesy – to include stuff like credits and version history.

wavelength. * Equals the square of the radius of its aperture divided by the product of the focal length and the wavelength. * Lower Fresnel numbers indicate greater diffraction effects.

front projection

(1) Arrangement for the viewing of projected images in which the screen lies in front of the viewer and the projector, with the image being projected onto the front of the screen. * The viewing room must be darkened for this arrangement to be effective. (2) Arrangement for combining a subject with a projected image for special effects photography. * The camera lens and projector share a common optical axis on a special rig based on the use of a highly efficient and directional projection screen. The subject is lit with studio lights. The projected image is not apparent on the subject because it is flooded by the studio lights but appears bright in the background thanks to the projection screen.

Sit down in front
Front projection is at best a measure of last resort: even when done with great skill – which needs excellent images for the background and great studio lighting – it is very seldom convincing, merely indicating a budget that could not stretch to working on location.

front-cell focusing

Method of focusing an optical system by moving solely the front component, leaving the other elements in position. * Advantage is simple lens mechanism but not so easy to couple to rangefinder and aberration correction is limited. * Best known in the Tessar series of lenses, in which only the front element was focused: hence front-element focusing.

front-surface mirror

Reflector with the reflecting coating applied to the front surface e.g. mirrors of single-lens reflex cameras, beam-splitters e.g. as used in holography, front-projection. * Front-surfacing eliminates the secondary or ghost image formed where the reflecting surface is behind the substrate or glass e.g. as in domestic mirrors.

FST

Flatter Squarer Tube: design of monitor screen of a cathode-ray tube in which the visible face is not part of a sphere but is aspherical i.e. flatter and squarer. * Such screens are easier to view, can give a larger viewable area for a given size of tube and catch fewer reflections. * As the distance between the electron gun and screen varies from the centre of the screen to the edge, the electronic control of the electron beam is extremely complicated.

See NF.

ftp

File transfer protocol: used for rapid transfer of files between

F

computers connected e.g. via the Internet. * Anonymous ftp allows users to log on with the name anonymous or ftp, but it is polite to give your email as the password. * Defined in RFC (Request For Comments) 959.

full-frame sensor

Type of CCD photo-detector in which charge from an exposure must be cleared off the entire CCD before it can be exposed again. * There is no shift register built into individual detectors, therefore a mechanical shutter is required to blank off the detector during read-out. * Lack of a shift register improves sensitivity and avoids need for micro-lenses to improve light gathering.

fusion

The neural and central nervous system processes by which two or more stimuli are combined to form a single percept or sensation.

Fusion arts

The concept of fusion is usually applied to two quite distinct visual phenomena. Binocular vision: where two disparate retinal images are perceived as one. Flicker: at a critical frequency, flashes of light or variations in light intensity are perceived as unvarying: obviously this depends on the intensity, the value of the difference between light and dark, etc. Cinematography, video and fluorescent lights depend on fusion to be acceptable.

G-bar

Average gradient of the mid-tone portion of a characteristic curve. * Slope of the line joining two defined points – usually from the usable density above shadow to the usable density below highlight. * Usually resorted to when there is no obvious straight-line portion to the characteristic. * Also known as contrast index.

See gamma.

gain

(1) Increase in the strength or amplitude of a signal as it traverses a circuit or material. * Also called amplification. (2) Relative brightness of a rear projection screen as compared with a perfect diffuser i.e. the ratio of brightness to incident illumination. (3) Number of electron-hole pairs generated per incident photon in a photo-detector.

See active medium.

gamma

(1) In photography, a measure of the response of a given film, developer and development regime to light e.g. high gamma indicates high contrast. * Measure of sensitometric contrast obtained from the slope of the straight-line portion of a characteristic curve: although the ordinates of the graph

Gamma a break

In practice, an increase in the gamma setting of a colour monitor equates with darker screens e.g. a PC screen gamma of 2.2 is darker than the Mac screen of 1.8. Strictly, although gamma is not a measure of contrast, a higher gamma setting may at the same time have the side effect of increasing contrast in the mid-range brightnesses.

are density and log exposure, gamma is given as a numerical value. * Gamma is 1 where the slope of the straight-line portion is 45°. (2) In monitors, a measure of the correction to the colour signal prior to its projection on screen. * Gamma is the exponent of the transfer function or curve relating video input and output.
See G-bar.

gamma correction

Electronic techniques used to ensure correct conversion of input to output values e.g. to convert video colour signal of monitor to the required on-screen result. * Usually a circuit or micro-chip designed to produce linearity of response.
See gamma; colour management.

gamut

Extent or range of colours which a given system is capable of producing or representing. * Gamut of, e.g. three-ink printing system, is more limited or smaller than that of a four-ink system, which in turn may be smaller than that of a colour monitor using three primary colour phosphors.

gas discharge display

See plasma display.

gate

See film gate.

Gauss, Karl Friedrich

Great German mathematician: 1777-1855. * Described the normal distribution, giving his name to the Gaussian curve which is the mathematical basis for picture processing filters used e.g. to introduce noise, blur.

Gauss points

Also known as Gauss planes.
See cardinal points.

Gaussian optics

Part of physics dealing with geometrical optics at or very near the optical axis and at small apertures. * Part of optics in which angle ø can be substituted for sinø in Snell's Law. * The deviation of the actual image from theory defines the lens aberrations. * Also known as paraxial or first-order optics.

Gbps

Giga bits per second: measure of rate of data transfer.

GCR

Grey Component Removal: technique for reducing equal amounts of cyan, magenta and yellow ink where they occur together to create grey by replacing all the trichromatic grey

Gamut, match and set

The usual way to display gamut graphically is to draw a boundary over a range of colours so that colours within that boundary are 'within' gamut. Unfortunately, the graphical device usually used is the CIE Chromaticity Diagram: this displays the gamut of hues accurately but does not display lightness or darkness. For this, we need a three-dimensional diagram for gamut.

with an equivalent quantity of black ink. * This not only reduces use of more expensive coloured inks but reduces colour variations during printing. * A more severe form of undercolour removal.

 See UCR.

gel
Noun: (1) Gelatin filter: very thin, fragile but can be precisely coloured; used in front or, occasionally, behind lens. (2) Coloured filter used in front of luminaires. (3) Gelatin: colloidal protein. (4) Verb: to turn liquid into a solid or jelly-like form e.g. making emulsion for coating. * Pronounced 'jel'.

gelatin
Material used to hold silver halide crystals and other chemicals in photographic or printing film. * May also be used to carry dyes e.g. in filters, as protective layer, etc. * Colloidal material (i.e. consists of dispersed materials held in a dispersion medium) made by boiling up skins and bones of animals).

geometric centre
An imaginary point lying on the central axis of the lens, midway between the front and rear vertices. * Usually also corresponds to the mechanical or physical centre of a finished lens.

geometric distortion
Apparent change of shape of objects at edge of field of wide-angle lens: round objects appear elliptical, square objects become trapezoid. * Effect is usually caused by failure to view the image from the correct perspective: when so viewed, the distortion disappears. * May be referred to as a perspective distortion.

geometric image
Position and shape of the image of a point as predicted by pure geometrical optics. * Contrast with the diffraction image, which results from the physics of light.

geometric metamerism
Metamerism (apparent change in colour) which occurs with variation in the geometry of illumination or viewing. * E.g. changing colours of CD at different viewing angles.

geometric operations
Image manipulation or processing operations which have effect of transforming geometry of image e.g. change of shape, size, sideways movement (translation), rotation, perspective distortion, etc. * Also known as geometric manipulation.

Illusions of geometry
Arguably, geometric distortion is not a true distortion at all since it is not caused by a defect in the image projection. Rather it's caused by the psychology of viewing from a geometrically improper position, so it is more accurately classed as an optical illusion.

G

geometrical optics

Branch of physics which assumes light consists of rays which travel in straight lines, which are turned or bent at points of refraction or reflection, and which ignores effects such as diffraction or phase.

germanium

Semiconductor material characterized by ability to refract infra-red light. * Used to make germanate glass for optics working in near infrared; also for photo-detectors.

ghost

(1) Secondary image adjacent to the main image, caused by reflection e.g. as seen in back-surfaced mirror: the reflecting surface is the main image, the reflection from the front of the glass is the ghost. (2) One or more spots or shapes of light superimposed on an image, caused by images of the lens aperture reflected within optical components. (3) False spectral line seen in spectral pattern: caused by irregularities in diffraction gratings.

GIF

Graphic Interchange Format: a compressed file format designed to use over the Internet: comprises a standard set of 216 colours. * It is best for images with graphics i.e. larger areas of even colour; it is not recommended for photographic images with e.g. subtle tone transitions. * The 89a revision of the standard allows for transparent colours. * DOS files carry the suffix .gif. * Compressed losslessly using LZW algorithms. * Developed by Compuserve.

See adaptive colour.

glare

Discomfort felt by an observer due to presence of a very bright light-source in the visual field.

glass

(1) Hard, brittle, lustrous and non-crystalline solid that is transparent to visible or other part of spectrum. * Made by the fusion of metallic oxides and glassifiers such as oxides of silicon, phosphorus or boron by melting the components together at about 1400°C, mixing slowly and allowing to cool slowly. * Some glasses, e.g. obsidian, are opaque to visible wavelengths. (2) Optical component or instrument e.g. as in 'eye-glass'.

See glass laser; opal glass; tempered glass.

glass laser

Type of laser in which the active medium is based on neodymium and is held in a glass rod.

Gif me a 51, give me 256

The GIF standard actually allows for a maximum of 256 colours but Web colours are limited to 216, so in practice, GIF colours are limited to 216. That is because Web colours have RGB values in which each channel has a value of either a multiple of 51 or zero – six values for three channels makes 6 to the power 3 different combinations, equals 216.

glassine
Semi-transparent paper used for storing negatives and prints. * Not as widespread use as formerly; supplanted by archival-grade transparent plastics such as polypropylene.

glazing
(1) Process of giving a hard, glossy finish to a print e.g. a print is dried by pressing it against a polished metal plate under heat and pressure. * Also known as ferrotyping. (2) Process of placing glass or lenses in a frame e.g. spectacle lenses; window glass when picture-framing.

gloss
Property of a surface which causes it to look shiny and smooth, more or less mirror-like. * Light is reflected specularly rather than diffused. * Light-sources or images may appear to be superimposed on such a surface.
See specular reflection.

glossy
Quality or property of a paper or surface that has a gloss finish. * May be informally graded into a range from semi-glossy (or semi-gloss) to hard gloss, where hard gloss indicates a highly smooth, polished surface.

GN
See guide number.

gold reflector
Warm or light yellow coloured reflector used to bounce a light-source and warm the colour balance at the same time in e.g. portraiture or still life.

gold toning
Use of gold chloride to tone silver/gelatin print to give rich red or brown image tones. * Do not confuse with gold process, in which precipitated gold forms the original image.

GOST
Film speed standard established in Soviet Union. * Similar to ASA scale. * Now obsolete.

gr
Grain: measure of weight in avoirdupois standard: 7000 grains equal one pound. * Obsolete but may still be encountered in chemical formulations.

gradation
Changes or transitions in a characteristic or quality of a part of an image e.g. its lightness, texture, density – either within an area of the image or between one area and another. * May be described as 'smooth', or 'even': in which the transitions are not sudden or broken into discernible steps;

G

or as 'uneven', 'posterized', 'poor': in which the transitions show sudden changes or stepped progression where one expects smoothness or even transitions.

See bit depth; posterization.

grade

(1) Noun: short for contrast grade. (2) Verb: to sort prints or other material according to quality factors such as density, contrast, colour balance.

See contrast grade.

graded-index

Type of optical fibre whose refractive index decreases rapidly from the centre outwards. * May be called graduated-index.

gradient

(1) Rate of change in density with exposure e.g. in mid-portion of a characteristic curve. (2) Rate of change of pixel intensity e.g. in image processing and machine vision.

gradient index lens

Optical component whose refractive index changes along an axis or direction e.g. radial gradient lens: refractive index decreases with distance from the centre.

graduated filter

Camera lens filter in which the depth or density of colour changes smoothly from a maximum density to clear or to another colour e.g. top of filter is dark tobacco ranging to transparent at the bottom to simulate sunset colours in the sky with minimal colour to leave the foreground unaffected. * Also known as grads.

grain

(1) In photographic film: the individual silver (or other metal) particles that make up the image of a developed and fixed, possibly also toned, black & white film. * In the case of colour film, with exception of Polachrome, the appearance of grain arises from the individual dye clouds that make up the image of a developed film. (2) In photographic print: the appearance of individual specks comprising the image in monochrome papers, caused by exposure of the paper by the passage of light through gaps between the grain of film or between the dye clouds of colour films. * The specks in a print are themselves made up of individual grains. (3) On paper or other substrate for printing: the texture or finish of the surface, given to it by the calendering and other finishing stages during paper manufacture.

See clumping; gr.

Fast-track graduation

The effectiveness of grads depends considerably on both focal length and aperture. Long focal lengths reduce the appearance of the graduation whereas an ultra-wide angle lens can make even the smoothest transition seem too rapid. By a similar token, small apertures make the transition more rapid than large apertures.

granularity

Measure of variation or non-uniformity of grain size of processed photographic materials. * Equals the standard deviation of density values for a given average density in the material. * Determined by micro-densitometer readings, therefore depends on the size of aperture of instrument used, which is usually quoted.

graphics accelerator

Accessory add-on card designed to speed up operation of monitor by taking computing load off the main processor. * May use specialist processors such as Digital Signal Processors, dedicated video RAM and circuitry on a slot-in board or card to either supplement or replace the computer's own graphics system. * Also known as graphics boards or graphic cards.

See AGP; VRAM.

graphic arts camera

Camera used to produce high-contrast film for printing press. * Consists of film-holder and lens running on an axis shared with an easel which holds the object, usually a print or paste-up, for copying: the distance between lens and copy can be changed to alter magnification. * Largely obsolete, having been replaced by scanners.

graphics boards

See graphics accelerators.

graphics tablet

Input device for fine or precise control of cursor or brush when used in graphics, painting or image manipulation program. * Consists of the tablet, an electrostatically charged flat board connected to the computer, and the pen, which interacts with board to give precise information on the location of the pen tip. Most systems are also sensitive to the pressure applied to the tip. Movements of the pen cause corresponding movements of the cursor on screen. * The best systems use cordless pens.

Grassman's Laws

Empirical observations about colour and additive colour mixtures. * (i) Any colour can be matched by a combination of three others provided none of the three colours can be created by the combination of the other two. * Red, green and blue primaries meet this criterion. (ii) A mixture of any two colours can be matched by adding the mixtures of any three other colours, one mixture matching the first colour while the other mixture matches the second of the colours.

Even more acceleration

With today's insatiable demand for graphics capabilities – Photoshop users can say a big 'thank-you' to those nerds who spend all their time playing games – all decent computers use a graphic card to help out the main processor. They hugely speed up work and are anyway essential for demanding display needs e.g. when many millions of colours are displayed on large, 22", screens. Some cards are designed to work with specific programs e.g. Photoshop or Windows.

(iii) Colour matching persists at all light levels in which photopic vision is possible. * NB: the observations do not apply to scotopic (dark-adapted) vision.
See chromaticity; colorimetry; tristimulus value.

grating
Optical component used to disperse light. * Consists of a regular arrangement of grooves, pattern of markings or such like: these break up the wavefront of the light into separate fronts – either on transmission or reflection – which interfere with each other. * Pattern may be square wave or cosine in form.

gravitational imaging
Display of changes in gravitational field to show up changes in density underground. * Data from gravimeters (which detect and measure minute changes in gravitational field) is digitized for graphic display.

gray
(1) US spelling for 'grey'. (2) Appearance of a roughly polished surface e.g. lens before it receives the final polishing grinding. (3) Unit of radiation absorption.

greeking
Representation of text or images as grey blocks or other simple approximation. * Technique for avoiding lengthy screen re-draws that allows rapid scrolling through a document.

greyed
Feature of graphical user interface in which a menu or dialogue box item is shown grey, rather than black, to indicate it is not available or cannot be accessed. * Also referred to as greyed-out.

green disc
CD-interactive format disc. * The CD-i standard is known as the Green Book. * This specifies use of audio, digital, graphics and MPEG video data. * Now largely obsolete. * Set out by Philips in 1991.

Gregorian telescope
Design of telescope using aspherical mirror surfaces. * The primary mirror is a concave paraboloid with an ellipsoidal secondary concave mirror: the image is viewed with an eyepiece through a hole in the primary mirror.

grenz rays
Low-power i.e. soft x-rays with wavelengths close to ultra-violet used to image relatively radio-transparent materials with a narrow range of densities.

grey component

That portion of a mixture of dyes, inks or filters that tends to dilute or lower the saturation of colours. * Normally two separation colours in a three-colour system are sufficient to reproduce a given colour: if the third separation colour is present, it tends to reduce the saturation or intensity of the overall colour – in an additive system the grey component lightens colour; in a subtractive system, the grey component darkens a colour.

See GCR; UCR.

grey level

Discrete brightness level or value of a pixel or group of pixels. * When an image is digitized or scanned, the brightness levels, which vary continuously, must be quantized i.e. assigned a discrete value on a scale between white and black: that value is the grey level.

See greyscale.

grey ramp

Settings that define the generation of black in the making of CMYK or Hexachrome separations. * Usually displayed as a set of curves of each separation relating the value of each colour to a grey value.

greyscale

(1) Set of grey levels or brightness steps available to or defined in a system. * E.g. the Zone System uses a greyscale with ten values; a scanner working to a depth of 8 bits digitizes or quantizes to a greyscale with 256 values, from 0 to 255 (black to white). (2) May be used to refer to step wedges.

See bit depth; step wedge.

greyscale image

(1) Image made up of lightness values only i.e. with no colour information. (2) Digital image with a single channel comprising pixels with more than two brightness values.

See bit-mapped.

greyscale modification

Image manipulations which change either only brightness values or all colour channels simultaneously by the same amount e.g. changing each pixel's brightness value by an identical brightness value, to a degree within the range available. * If pixel values are divided or multiplied, then contrast is changed. * According to the colour space in use, the change of brightness values may or may not change the image colour.

When white is not driven snow

The trouble is, no-one tells you exactly what separates one grey level from the next: a poor-quality scanner can produce 256 levels just like one costing a thousand times more. The difference is, of course, that the 256 levels of a poor scanner are much closer together than those of a good one: its greyscale may range over a density variation of under 3 density units, whereas a good one separates over a range of nearly 4 units – in photographic terms, that's a difference of nearly three stops ... the difference between men and boys.

G

grid

Noun: (1) Arrangement of lines criss-crossing at right angles used to place or frame items accurately as used e.g. in viewfinder, copying table. (2) Arrangement and specification of basic elements of a printed page e.g. column width, base-line intervals, margins, etc. (3) Adjective: two-dimensional array e.g. ~ sensors.
See array.

grinding

Step in the manufacture of an optical element that gives it the shape required by the designers. * One or more blank elements are held in a holder like the inside of a shallow bowl (for concave elements) or an upturned bowl (for convex elements). A correspondingly shaped grinder is rotated under pressure against the glass blanks: the grinding action imparts the shape of the inner surface of the grinder to the optical elements.

ground glass

Plate of glass used in focusing screens to capture a real image for focusing or viewing; also to diffuse light e.g. in viewers. * The surface is frosted, usually by acid etching or by grinding, to scatter light. * Used in large format cameras, usually with Fresnel field lens to even out rapid light fall-off away from the optical axis.

GUI

Graphical User Interface: type or design of interface – the area on the monitor screen where computer operator and computer interact – that is based on extensive use of icons, graphics and text. * Methodology of providing interaction between computer and its user through an interface combining graphical symbols and text. * Contrast with text-based interfaces. * Now standard for nearly all person-to-computer interactions and many GUI conform to published standards e.g. Mac OS, BeOS, Windows 98, etc. * Pronounced 'goo-ey'.

guide number

Value used in flash photography to calculate the correct lens aperture for a given flash-to-subject and film speed. * Guide number for a given film speed, when divided by distance (metric distance for metric guide number), equals lens aperture. * E.g. for ISO 100 film, a metric guide number of 45 (GN 45/ISO 100) and a shooting distance of 5m gives a working aperture of 45 divided by 5 equals f/9. * Also known as guide factor.

Don't write off glass

Instead, write on it. Despite being heavy, fragile, optically inefficient, glass has not been totally supplanted by plastics for large-format cameras. The reason is simply that you can write on it, stick tape – eat your lunch off it if you must – and it will take it all and come out completely unscathed. Unlike any plastics.

gum dichromate

Printing process based on sensitized gum arabic carrying coloured ink. * Gum arabic (water-soluble glue from acacia tree) is sensitized with potassium dichromate. When paper coated with pigment-dyed sensitized gum is exposed by contact to a negative, unexposed areas are soft and can be washed away by hot water, leaving hardened, coloured areas behind. The result can be re-coated with another layer, with a different colour. * Obsolete commercially, but various forms revived for art and special effects.

gun camera

(1) Stills or cine camera set on a weapons system to provide a photographic record of the weapon's performance.
(2) Early camera types based on form of the hand-gun.

Gurney-Mott theory

Explanation of formation of latent image in photography which proposes that metallic silver is formed at sensitivity centres located at imperfections in the structure of silver halide crystals. * Proposed in 1938. * Now accepted as the most persuasive model of latent image formation.

gutter

Central area down the middle of a printed publication on either side of the fold or binding. * Always kept empty of text and formerly photographs were also kept away but modern printing has encouraged their use right into the gutter.

gyroscopic camera mount

Mechanism using battery-powered gyroscope and a suspension mount to isolate a camera from high frequency vibrations. * The mechanism itself may be mounted on the operator for further absorption of vibrations. * Large, cumbersome and very expensive: they are being superseded by image stablization technology in video and still cameras but are still needed in cinematography.

H

Symbol for photographic exposure. * It is equal to illuminance at the film gate multiplied by exposure time. * Its unit is the lux-second.

H&D curve

Graphical representation of response of light-sensitive material to exposure for varying exposures and a given processing regime. * The plot is of the log of exposure (or energy) on the abscissa (x-axis) against density on the ordinate (y-axis). * Also: characteristic curve, D-Log E curve.

halation

(1) Unsharp image seen to surround an image of a bright object when recorded on a photographic film or plate. * Caused by light penetrating the light-sensitive layer then reflected back from the backing layer, being scattered in the process. (2) Glow surrounding a bright spot that appears on the fluorescent screen of cathode-ray tube: caused by reflections from the glass front of the tube. (3) May be used, inaccurately, to refer to bloom on CCD or other photo-sensors – in which excessive light causes leakage of charge into neighbouring sensors.

See anti-halation layer.

H

half-frame

Film format measuring nominal 18x24mm. * Also known as single-frame i.e. a frame of 35mm cine film.

half-duplex

Two-way communications system which can transmit in only one direction at a time.

See duplex.

half-silvered

Transparent material coated with a reflective layer e.g. film of metal so that it transmits half of the incident light and reflects the other half. * The proportion of light transmitted can be controlled by the thickness of the layer, depending on material used and properties of the substrate. * Used to split beam of light into two parts e.g. in main mirror of auto-focus SLR viewfinders, for front-projection, holography, etc. * Also known as semi-reflective, semi-transparent mirror. But compare with dichroic mirror.

See dichroic.

half-wave plate

A plate or layer of electro-optical material that serves to rotate the plane of polarization of a light beam.

half-tone

Adjective: describing any process in which tonal gradations or transitions are represented by variation of density or size of dots of uniform darkness or colour. * That is, changes in image density are not represented by variations in the density or colour of the ink, etc. forming the image. * As seen in photomechanical, ink-jet and laser printing. * Do not confuse with grey-scale image.

half-tone cell

Unit used by a half-tone printing or reproduction system to simulate grey-scale or continuous tone reproduction. * In mass-production printing e.g. off-set lithography, the half-tone cell is defined by the screen frequency, measured as lpi (lines per inch): continuous tone is simulated by using dots of different sizes within the half-tone cell. * With desk-top printers e.g. laser and ink-jet printers, the half-tone cell comprises groups of individual laser or ink-jet dots e.g. 16 dots arranged as a square of 4x4 may represent one cell, giving 5 grey-scale steps thus: no dot in the cell is white, 16 dots is black; greys lying in between. * Half-tone cells are always much larger than a printer's stated dpi (dots per inch) and are the practical measure of a printer's spatial resolution.

See dpi; lpi; half-toning.

half-tone factor

See quality factor.

half-tone screen

Glass plate used to convert continuous-tone (full-tone) originals to half-tone. * The screen is printed or etched with a fine grid of lines or dots which cast a slightly unsharp shadow over the film: variations in brightness of the original are thus translated into dots of varying sizes (i.e. as half-tones) onto the film, which is then used to create the half-tone printing plate. * Largely obsolete, being replaced by scanning and rasterizing technology.

half-toning

Reproduction technique which uses discrete units of ink or other marker of fixed strength or intensity, or their absence, to simulate the appearance of continuous tone e.g. off-set lithography, ink-jet and laser printer. * Note variation in strength of colours, etc. is not obtained by varying the strength of the ink or marker. * Nothing to do with a semi-tone in music, which is about half of a whole tone interval.

See dpi; half-tone cell.

halide

Compound of any one of halogens (fluorine, chlorine, bromine, iodine or astatine). * Compounds with silver are variously light-sensitive.

halo

(1) Light rim at edge of darker area: an artefact caused by over-sharpening using e.g. unsharp masking. (2) Light coloured or rainbow hued ring around a light-source seen through fog or light clouds. (3) Light ring seen around a photographic image of a bright light-source. * Caused by halation.

halogen

Group of the elements – chlorine, fluorine, bromine, iodine and astatine. * Members of Group 17 of the Periodic Table, characterized by reactivity with metals to form salts and oxidation number -1.

hand viewer

Device for viewing of mounted slides or transparencies. * Usually consists of magnifying glass or loupe focused on slide holder with small light-source or frosted plate for use with any convenient light-source.

handle

On a box enclosing graphics, picture or text: a token or access point which allows the box and/or its contents to be

changed in shape, size or to cause allow flow of content e.g. into another box. * Usually shown by small icon e.g. square or handle on the box which must be contacted by the mouse and, usually, dragged to a new shape or size.

hard

Adjective: (1) ~ lighting: one giving rise to high-contrast lighting i.e. difference between shadows and lit areas in excess of about 1:20 e.g. from a spotlight or full sun. (2) ~ paper: one tending to print high-contrast images due to a limited range of exposure i.e. with a high-gamma light-sensitive layer. (3) ~ negative: one showing a high-contrast image, possibly as result of over-development. (4) ~ water: one with relatively high content of calcium or magnesium salts dissolved. (5) ~ x-rays: those of short wavelength, therefore high energy – these penetrate deeply. (7) ~ coating: protective layer used on lenses, filters, etc., comparable in hardness to glass and applied on top of softer material e.g. plastics or another surface e.g. anti-reflection coating.

hard-disk

Device for storing large quantities of digital data: consists of a series of thin, rigid, circular disks coated with magnetic material on which data is stored as series of minute fields with differing polarities. * The disks spin at over 7000rpm under a head which lies extremely close to the disk – only a few millionths of an inch away – to read off the changing magnetic fields. * A hard-disk may consist of a stack of one to eight or more disks on a shared central spindle. * Modern hard-disks carry from 2GB to 80GB per unit. * Some types e.g. Zip, Jaz are effectively hard-disks in which the disks are removable and enclosed in a casing for protection.

hard copy

Visible form of a computer file printed onto a support such as paper, film. * As opposed to soft copy: what is seen, impermanently, on a monitor screen.
See soft proof.

hardener

Chemicals used to strengthen gelatin of films or printing papers. * E.g. potassium aluminium sulphate, formaldehyde: these are usually added to the fix.

hardware

Capital or major items of equipment such as cameras, computers as opposed to connectors, storage media or software.

haze

Reduction in visible contrast of a scene due to scattering of light by particles suspended in air. An aggravated form of fog in a polished surface caused by the scattering of light. The defects causing haze are larger than those causing fog, but singly are not large enough to be seen by the unaided eye. * May also refer to light scatter in transparent material e.g. film base.

HD CD-ROM

See DVD.

heat development

Method of developing an image by use of heat. * Principle used by Fuji for use in thermal printers: micro-capsules of dye are burst by the action of heat provided by row of small pins. * Also known as thermography.

heat-absorption filter

Filter designed to absorp infrared or heat energy while transmitting visible light. * Used in enlargers and projectors. * NB: they are useless if not cooled with forced convection – otherwise they merely re-radiate the heat they absorp. * Also known as heat-absorbing filter.

Hefner unit lamp

Standard gas lamp used as a physical standard for the measurement of luminous intensity in 1900s. * Obsolete: candela now used.

See flux.

helical

Mounting for lens or optical component that moves up and down a central axis when rotated: consists of corresponding or mating spiral threads cut into the mount and the barrel of the lens so that as one is fixed, the other is driven along the axis. * The rate of translation along the central axis depends on the steepness of the thread.

heliograph

Instrument for recording duration and intensity of solar radiation.

HeNe laser

Type of laser using helium and neon. * The most widely used laser e.g. for holography as its output is highly monochromatic. * It is most commonly set up to emit light at 628nm.

Herschel effect

The reduction or destruction of the latent image by the effect of infrared radiation. * Produces decreasing of the

Hazy filtration

Ultraviolet and blue light is scattered more than longer wavelengths, so the so-called 'haze' filters are designed to absorp short wavelengths, consequently appear faintly pink. Being logical you think to yourself, actually such filters should be called minus-haze filters – seeing as they are supposed to cut haze. I have never known them to work terribly well, by the way: sometimes the pink combines with the blue to give a magenta cast. I'd rather have haze.

The more, the smoother

Multi-start helicals – with several spirals running parallel to each other – give the smoothest and most durable movements for focusing (the kind we know and love in e.g. Zeiss and Leica lenses) but are extremely taxing to machine. Unfortunately, they also require high torque to turn, which makes them useless for auto-focus lenses and their feeble motors.

H

density and contrast of the developed image. * Also known as intermediate Herschel effect.

Hertz

Unit of measurement of vibration or other regular, cyclic change: defined as the number of complete cycles per second e.g. of sound vibrations, alternating current, frequency of light vibrations, number of clock cycles controlling an integrated circuit chip and so on. * Abbreviation: Hz. * kHz: kiloHertz equals 1000 cycles per second, MHz: megaHertz equals 1,000,000 cycles per second.

heterochromatic light

Light with more than one colour: virtually all usually encountered light- sources are heterochromatic, apart from some fluorescent or metal vapour sources.
See monochromatic light.

Hexachrome

Proprietary printing process based on use of six coloured inks: orange and green in addition to cyan, magenta, yellow and black. * It provides a significantly wider colour gamut than CMYK. * It works best with stochastic screens. * Trademark of Pantone Inc.
See four-colour.

hickey

Bits of dust or fluff, etc. sticking on printing plates which cause defects in the print. * Also known as bull's eyes. * Plural: hickies.

high

Adjective: (1) ~ contrast: showing or causing a wide range of luminance (lighting) or density (developer, printing paper). * Often used in the sense that the brightest and darkest are at or close to their maximal and minimal values. (2) ~ value: brightness that is significantly greater than mid-tone. (3) ~ key: image or lighting in which most of the tones are high value or bright. (4) Noun: a surface which should be planar but is very slightly convex i.e. it contacts a flat test plate only at one point.

High Sierra

Former standard for CD-ROMs: now obsolete. * ISO 9660 does the same job but is not compatible with it. * Named after hotel which hosted the committee that wrote the standard.
See MPC-3; QuickTime.

high-gain screen

Screen which reflects with high efficiency into a small

viewing angle. * Uses beads or rods to focus reflected light. * Employed for front-projection effects where a bright projected image is essential.

high-pass filter

Type of filter than lets through only high frequencies. * E.g. sharpening filters in image manipulation software are essentially high-pass filters. Also music recording mixers filter out rumble from mains and microphones to prevent low frequencies from interfering with music.

> See low-pass filter.

high-performance serial bus

See IEEE 1394.

high-speed holography

Recording of sequences of events of very short duration using holographic techniques. * Exploits lasers whose outputs are characterized by extremely brief pulses of light. * A short series of events can be captured on a single hologram using multiple laser beams.

high-speed photography

Photography of events that occur too quickly or which last too short a time to be recorded by conventional photographic techniques. * Depending on the event to be recorded, techniques may range from use of ultra-short duration flash exposures to the making of hundreds of exposures in a split-second.

high-speed shutter

(1) In general photography: shutter capable of giving exposure times shorter than around $^1/2000$sec. (2) In scientific community: shutter types capable of timings in the order of nanoseconds, i.e. several thousand millionths of a second.

highlight

Brightest part of an image i.e. that area having the greatest luminance: usually the light-source or a specular reflection of the source. * In photography, usually understood to mean the luminance is sufficiently high to cause marked over-exposure.

highlight mask

Low-density negative image made by contact with e.g. colour transparency to put some density into the highlights to make it easier to produce a tonally balanced print i.e. used to reduce local contrast.

Hill cloud lens

Lens of ultra-wide view with allowed fish-eye distortion for

H

photographing nearly the entire hemisphere of sky. * Its design is the precursor of modern ultra-wide angle photographic lenses.

hints

Artifical intelligence built into outline fonts which are used to turn elements of a font on or off according to the size of the font to improve e.g. legibility, balance and design. * For example, if the serif of a very small point size letter were kept in proportion to the x-height when enlarged to poster size, it would look much too big: hints reduce the size of the serif and change its shape as point size increases. * Hints are also required when rasterizing outline fonts for display on-screen.

histogram

Meeting on the level

In image manipulation, histograms are used to analyse overall quality and brightness distribution of an image e.g. if all columns are roughly the same height, there is an even distribution of light values; if the columns over dark values are much higher than the rest, most of the pixels are dark; a distribution with many gaps – like a comb that has been to the wars – is usually caused by poor scanning or results from someone playing around excessively with software brightness/contrast adjustment.

Statistical graphical representation showing the relative numbers of a variable or part of a range of variables e.g. population of pixels with a certain value: the taller the column at a certain value, the more pixels have that value, the width of the column representing the range of values being counted.

See levels.

HLS

Hue, Lightness, Saturation: colour model in which three mutually perpendicular axes represent each variable. * Similar to Hunter system of hue, saturation and darkness.

HOE

See holographic optical element.

Hogarth curve

Notion in fine-art theory that objects arranged along an S-shaped line suggest grace and beauty.

holocamera

Mechanical rig for making a hologram of a subject. * Not strictly a hologram as there is no light-tight box used. * May use pulsed or continuous-wave laser as the illuminating source.

hologon

Holographic disc with multiple faces or hologram of multiple optical components that is rotated to deflect incident light to a lens or system of lenses. * Used in scanning, laser printers, remote sensing.

hologram

Photographic image which, when suitably illuminated, reconstructs a same-size three-dimensional image of the original object as seen from the position of the film at the

time of exposure. * A hologram is a recording of the interference pattern created by the interaction of two beams of coherent light which are derived from the same source: a reference beam which illuminates the recording medium and the object beam, which is that reflected from the object. The result of interference between these two beams is a diffraction grating. * This produces an image beam that reconstructs the original wavefront from the object as an image of the object – usually with full parallax or three-dimensional information – but only when illuminated by a replica of the reference beam e.g. white light shining on the hologram at the same angle as the reference beam shone on the film.

holographic grating
Creating a series of fine etched lines using holographic processes.

holographic memory
Storage of digital data using holographic processes. * This exploits the very high density of information that can be held in holographic emulsions.

holographic optical element
Hologram of a lens: this can, in some circumstances, be used instead of the lens. * May be used where diffractive effects are preferred over refraction. * Also known as HOE or holographic lens.

holography
(1) Study of the science of holograms. (2) Technology of producing and using holograms. * Production usually requires the following basic conditions to be met: (a) coherent light-source e.g. laser (b) optical bench for alignment of components (c) means to separate the original beam into a reference (unmodulated) beam and the object beam (to be modulated by the object) (d) total and complete elimination of all noise from vibration or movement by using massive vibration-absorbing rigs or using flash (pulse-laser) exposure (e) recording medium with extremely high resolving power i.e. sufficient to record interference fringes.
See hologram.

hot mirror
Mirror whose coating reflects infra-red radiation but transmits visible light. * Opposite in effect to a cold mirror.

hot spot
Smaller area within a larger illuminated area that is brighter

Patently stupid thing to do

You may remember that holograms were the 'wow' of the visual world some years ago. So why did they sink almost without trace in the art world, surviving only on bank notes and credit cards? That it was a hellishly tricky and expensive laboratory habit is only part of the story. It did not help that some of the great pioneers were also too greedy. A case in point is that one geometry for creating rainbow holograms was patented by Stephen Benton (hence also known as a Benton hologram). This restrictive move was symptomatic of a lack of openness amongst some leading early holographers which sadly led to the inevitable last quack of their Golden Goose. What would have happened to photography had Fox Talbot won his attempt to patent his discovery?

H

or more intensely lit than the surrounding area: the bright part of an unevenly lit area.* Even a laser beam may have a hot spot, usually due to variations in atmosphere.

hot-plugging

Adding a peripheral device or component while one or more connected devices are powered on. * Should be done only with systems designed to be hot-swappable or hot-pluggable.

hot rolling

Method of producing smooth surface on paper using heated rollers clad in cotton. * Type of calendering.

hot-swappable

Feature of device or connection that allows devices to be taken out and replaced by another while the system is powered on.* FireWire serial buses are hot-swappable, whereas SCSI is not. * See also hot-plugging.

HSB

Hue Saturation and Brightness: colour model in which a vertical axis measures brightness or lightness, another axis measures saturation and a third axis mutually perpendicular to the others measures hue. * Used in colour pickers in software as the model is fairly intuitive e.g. saturated colours are shown on the outside of the wheel, becoming less saturated towards the centre, which is white. A separate control adjusts darkness. Other configurations may be seen.
> See HLS.

HTML

Hyper Text Mark-up Language: file format which embeds mark-ups or tags into text which can then be read by Internet browser software e.g. Explorer, Netscape. * It can be written by simple word-processing software.
> See browser.

http

Hyper text transport protocol: the rules or protocol used for sending documents around on the World Wide Web.

hue

Name given by observer to the visual perception of the colour e.g. blue, brown, purple, aquamarine. * It is the attribute of light that varies with wavelength or, more commonly, with the combined wavelengths of the most energetic parts of a sample of light. * Neutral colours such as greys, white, black – i.e. the so-called 'achromatic colours' – have no hue.
> See chroma; Grassman's Laws.

Powered disasters

A common cause of damage to equipment is the hot-plugged item that wasn't designed to be hot-unplugged. Of course, it's a bore to turn everything off just to add a scanner or printer. Which is why second-general bus standards – e.g. USB, FireWire – are hot-pluggable. But unless you are sure, do turn the whole procession of connected equipment off before plugging anything in or taking any item out.

Mark this: it was never meant for layout

HTML was thought up to help organize information (Header 1, Header 2, etc.) and never intended for describing graphic elements. How could it, most computers at the time were still working on command-lines and text only. It says a lot for the ingenuity of nerdkind that the sophisticated Web pages of today are still founded on HTML whose roots will be familiar to those who have ever tagged Wordstar documents for printing or anyone old enough to have marked up typewritten copy for printers to set.

Huffman coding

Data compression technology in which the amount of data used to code a symbol or piece of information varies with the probability of its occurrence. * The algorithm reduces frequently occurring strings of data to shorter codes in order to save on memory, hence also known as Code Length Optimization. * For example, character strings such as '-ing' and '-ation' occur commonly in English; space savings are made by replacing them with codes e.g. 'pg' and 'tn'. * Information with a high probability of appearing are coded with fewer bits of data, information with low probability are coded with more bits of data. The result is more efficient coding of data than if all codes were the same length. * Described by D A Huffman in 1952. * Used in JPEG compression.

Hurter-Driffield curve

See H&D curve.

See characteristic curve.

hybrid array

Photo-detector in which each pixel is connected to its own pre-amplifier on the chip. * This allows improved signal/noise ratios (i.e. higher sensitivity) and the pre-processing of the signals.

See array.

hygroscopic

(1) Material which absorbs water e.g. silica gel used to keep equipment and film dry. (2) Fibre optic whose properties – e.g. transmission – are changed if water vapour is absorbed.

HyperCard

Information management and authoring software for Apple Mac: able to organize data, produce graphics and make presentations; also scriptable. * Last update in mid 1990's; now obsolete.

hyperchromic shift

Darkening of a dye or colour without changing colour. * Decrease in transmission of visible radiant energy of a dye without a change in hue.

hyperfocal distance

Distance from the lens (at a given aperture) to a subject in focus such that the far depth of field extends to infinity. * This is equal to the nearest point at which an object appears sharp when the lens is focused at infinity, at a given aperture. * In practice, it is regarded as that focused distance which gives the greatest extent of depth of field.

H

hypermedia

Type of file holding information in several media – e.g. text, image, animation, sounds – embedded with links to other parts of the document, other files and media, and even to remote sources of information. * By extension to hypertext, hypermedia combine different types of media with links that make it easy to navigate interactively i.e. to consume the information in a non-sequential manner over which the consumer has some control.

hypermetropia

Condition of eye in which distant objects tend to be focused behind the retina when the lens accommodation is relaxed. * It is corrected by introducing a converging or positive lens of appropriate strength in front of the eye. * Also known as far-sightedness, hyperopia.

hyperopia

See hypermetropia.

hypersensitizing

Techniques or processes designed to increase the effective speed of light-sensitive materials between its manufacture and before exposure by e.g. heat treatment, exposure to mercury vapour or dilute solution of various chemicals, exposure to weak uniform light.

hyperstereoscopy

Stereoscopic photography in which the distance between the two view-points is greater than the typical distance between the viewer's eyes: this exaggerates the impression of stereoscopy i.e. increases sense of depth.

hypertext

Type of text file embedded with links to other documents or parts of the same document and even to remote sources of information. * HTML was designed to make it easy to jump from one part of the document to another e.g. reading this you may want to jump to 'HTML' to learn what it stands for: in a hypertext document you might simply click on the word and the software would take you to the entry for HTML. * The link may be to another document altogether, residing on a server somewhere in the world: the Internet is therefore arguably one enormous hypertext document.

hypo

Sodium thiosulphate (formerly hyposulphate): used as fixing agent i.e. to react with undeveloped silver halide to form water-soluble compounds. * Slower acting than ammonium thiosulphate but preferred for some applications.

Hot stuff for astronomy

Astronomy makes extreme demands on film, what with exposures that run into countable photons (individual particles of light). In desperation, astronomers have been known to resort to any measure to hypersensitize their film, going as far as putting it into their ovens for lengths of time. Which gives another meaning to the phrase 'roasting film'.

hypo-alum

Type of toner for producing brown tones. * Consists of solution of sodium thiosulphate (hypo), potassium aluminium sulphate (potassium alum) and other chemicals.

hypo-clear

See hypo-eliminator.

hypo-eliminator

Bath used after fixer bath and intermediate wash to remove fix from film or print. * Consists of e.g. hydrogen peroxide with ammonia which react with thiosulphate to make highly soluble compounds. * Distinguish from wash-aid which does not react with hypo. * Also known as hypo-clear.

See wash-aid.

Hz

Hertz: measure of frequency.* The number of cycles or repetitions per second.

I

International symbol for luminous or radiant intensity.

I-beam

Moveable mark or cursor shaped like a capital 'I' seen on monitor screen: used to provide the computer user with feedback as to the location of the insertion point.

IEEE

Institute of Electrical and Electronic Engineers: US-based organization with international membership which sets standards and is a forum for industry matters to do with electronics, computers, etc. * Founded in 1884.

IEEE 1394

Standard for connecting electronic peripheral devices. * A relatively high-speed serial input/output digital standard able to transfer data between a computer and its peripherals e.g. video cameras, hard-disk drives up to 400Mbps, potentially up to 2Gbps. * Individual cable length is limited to 4.5m but up to 16 cables can be daisy-chained giving a total of up to 72m. * Up to 63 different devices can be linked in a tree-like structure (i.e. it does not have to be linear like SCSI) and devices are hot-swappable. * Uses a 6-wire cable capable of carrying up to 60 watts. * Created by Apple

Computer Corp in whose implementation it is known under the trademark FireWire. * Also known as High Performance Serial Bus and iLink (Sony Corp.).

IEEE 802

Set of widely adopted standards governing protocols, data structures, architecture, etc. of computer networks.

See Ethernet.

illuminance

Measure of strength of light energy at a point on an illuminated surface. * Unit: lux, which equals lumens per square metre. * Luminance is a measure, at a surface, of the illumination incident on it.

illuminant

Standard light-source as defined by convention or standards, usually in terms of spectral quality. * E.g. Illuminant D has colour temperature of 6500 K, Illuminant A, a colour temperature of 2854 K, photographic daylight, 5500 K, etc.

illumination

(1) Application of light onto a subject. (2) The way a subject is lit or the qualities of a subject's lighting. * Note: do not confuse with illuminance, which is a measure.

illusion

Perception of an object or illustration that does not correspond to the visual stimulus itself. * Also known as visual illusion, optical illusion.

image

(1) Visible product of a system capturing and recording a representation of a subject based on the energy radiation emitted by or reflected from it. * Image may be directly produced e.g. that seen in camera obscura or telescope; or indirectly produced e.g. monitor display of multispectral satellite image, shock-waves from Schlieren photography. (2) Reproduction or representation of an object produced by light rays.

See real image; virtual.

image amplifier

See image intensifier.

image aspect ratio

Comparison of the depth of the image to its width e.g. the nominal 35mm format in landscape orientation is 24mm deep by 36mm so the aspect ratio works out to be 1:1.5. * Used to indicate shape of box bounding the image assuming the sides are at right angles e.g. high aspect ratio is long and thin; an aspect ratio of about 1 is squarish; while

Illuminating illusions

There are some dozen or so well-known optical illusions, rejoicing under names such as Hering-Hermann's Grid (appearance of darkish spots in a grid of white lines between black squares), Schroeder's Staircase (a line illustration looks like a staircase seen from below, no, it doesn't, it's a staircase from above, no, maybe it's from below) and Poggendorf's Illusion (a diagonal line with a square over the middle does not appear continuous). They all tell us something about the way the retinal cells are 'hard-wired' to extract information – sometimes erroneously, when we set out to fool them.

images with aspect ratios less than 1 are tall and narrow. *
Useful in calculating file sizes on change of reproduction
scale, given that the aspect ratio is locked or fixed.

image brightness

Bright of the image through an optical system. * Apparent
image luminance as viewed in an instrument. * It varies with
the object luminance, the optical system's transmittance,
diameter of the exit pupil of the system and, indirectly,
contrast of the system (as a contrasty image appears
brighter than a low contrast one).

image correlation

Comparison of a template of an image with an actual image
for machine vision. * The template image (correlation kernel)
is superimposed on the actual camera image of an object to
generate the correlation image to display match or disparity.
* Used for character recognition (e.g. machine reading of car
licence plates), flaw detection, etc.

image distance

Separation between the lens and the image. * Strictly, the
length of the line on the optical axis jointing the rear nodal
point of a lens with its focused image. * This distance
increases as the lens is focused to nearer objects and is at a
minimum with the lens focused at infinity.

image enhancement

Manipulation of a digital image to improve the visibility or
clarity of information in an image. * E.g. image blur may be
reduced to show a moving object more clearly; unsharp
masking may be applied to increase apparent detail.

image intensifier

Opto-electronic instrument designed to make something
out of nearly nothing i.e. to obtain an image at extremely
low light levels of e.g. moonless nights. * The dim image is
projected by the light-gathering lens onto a screen that
projects a slightly amplified image onto another screen
which relays a further amplified image to another screen
and so on: each step builds on the previous steps to give
very great increases in sensitivity while minimizing the effect
of noise. * Photo-multiplier tubes used in drum scanners are
another type of image intensifier which goes some way to
explaining their superiority over CCD-based scanners.

> See noise.

image inverter

Device which rotates the image 180° around its axis. * May
be fibre optic, prism assembly, etc.

Brighter manual focus

Image brightness is not just about comfort i.e. the brighter the image, the easier it is to see and compose it, while colour appreciation is also improved. But it is additionally about focus accuracy. As image brightness increases, so it is easier to see small differences in contrast – it is this variation in contrast which is crucial to the accuracy of manual focusing.

I

image plane
Surface representing the focus of an image of an infinitely distant object. * In theory, the surface is a flat plane, but in practice, the surface is more or less irregularly curved. * Usually, the image plane is normal (at right angles in all directions) to the optical axis. * Where the object is not distant, and the lens is inclined to it, the image plane of the object is inclined to the lens axis (such that the Scheimpflug condition is met). * Also known as focal plane.

image processing
(1) Analysis of digital image data using computational, algorithmic means in order to extract information required by a process e.g. parts identification, character recognition, quality control. (2) Manipulation of digital image data using image manipulation software in order to change characteristics, contents or other features of the image.

image processor
Device consisting of a photo-detector array with microprocessor which captures the image, converts the data to digital form and subjects the data to manipulation to enhance information in preparation for further analysis or use. * Arguably, all digital cameras are image processors.

image quality
Assessment or subjective measure of how accurately or fully an image of a subject represents that subject. * For a critical observer, it is based on e.g. the brightness and evenness of illumination, contrast, resolution, geometry, colour fidelity and colour discrimination of an observed image. * It can be affected by e.g. lens aberrations, diffraction and reflection effects, pollutants such as dust and scratches on the lens and in the atmosphere, effects of heat on detectors, motion of subject or optical system.

Crucially inexact
For such a vital subject as image quality, it is curious there is no universally applicable precise way of measuring it. But there can be none: quality is just too slippery. The most objective measure is MTF which gives a good measure of the sharpness (contrast related to resolution) of an image but ignores geometry of the image, cannot fully account for many other factors – and tests only in white light.

image-setter
Device for writing on film or paper at very high resolutions, usually for purpose of producing material suitable for plate-making for printing purposes. * Can be used for making large negatives or inter-negatives for photographic printing.

immersion fluid
Liquid to fill the gap between a high-power objective lens of a microscope and the glass top of a microscope slide in order to improve optical efficiency. * First used by Ernst Abbe, who employed cedar oil (refractive index 1.515).

in-line
Image or other feature of a World Wide Web page that is a

part of the Web page document; it cannot be altered without altering the page. * Contrast this with on-line, in which images are available to be downloaded.

in-line holography

Production of single-beam holograms.

> See Denysiuk hologram.

incandescence

Radiation of light by a source heated to a sufficiently high temperature for its radiation to become visible. * Household tungsten bulbs and tungsten-halogen lamps in e.g. modelling lamps of studio flash are incandescent sources: if heated to lower than working temperatures, they are merely hot i.e. radiate invisible infrared. * Compare with fluorescent sources, which do not produce light as a result of heat action (although they do emit some heat).

incident light meter

Exposure meter designed or adapted to measure the light falling on the scene: it measures scene illuminance. * Consists of a hemispherical or hollow conic light receptor that collects light from a wide angle, typically up to 180°. * In use, the receptor is pointed towards the camera lens from the subject.

incident ray

Light ray reaching the surface of e.g. a lens. * As opposed to reflected or refracted ray.

incoherent light

Light waves vibrating randomly or not in time with each other. * Absence of fixed phase relationship between light waves. * Note: while heterochromatic light is obviously incoherent, monochromatic light can also be incoherent. * Normal light is highly incoherent; lasers are the only normally encountered coherent light.

index of refraction

Measure of how much a transparent material bends light that falls on it. * Equals: ratio of the velocity of light in a vacuum to the velocity of light in the refractive material, for a given wavelength. * Also given by ratio of sine of angle of incidence to sine of angle of refraction (from Snell's Law).

indexed colour

Method of creating colour files or defining a colour space. * The index refers to a table of 256 different colours held as normal 8-bit data, but these colours are chosen from a full 24-bit palette (i.e. from over 16.7 million different colours). A given pixel's colour is then defined by its position or index in

Lazy readings

It was for those unwilling to make the trip to their brain, that the incident light meter was invented. It cares not a whit what the subject is, what is its colour, tone – or even if it exists. It merely assumes you want an average density image in the lighting to which you expose the exposure meter. And most of the time it gets it right – in as much as a mid-tone result is mostly right for most subjects in most light. It's the automatic manual metering method.

I

the table (also 'colour look-up table'). * It is a compact way to store colour information, but can led to problems when tables of different systems fail to match up. * Particularly useful when colour range is not wide yet must be accurately reproduced e.g. silk-screen printing on packaging or for Web pages.

See CLUT; colour space.

indicator

Chemical or other mechanism to show state or condition of a substance. * E.g. indicator stop-bath uses a dye that changes colour when pH rises beyond a set limit; indicators in silica gel show when it is saturated with water.

indicator stop bath

See stop.

indirect illumination

Light on a subject that has undergone one or more reflections between light-source and object: in so doing, it takes on some property of the surface from which it is reflected. * E.g. to soften the light from a spotlight it may be bounced off a diffused reflector. * In microscopy, light incident on the object from right angles to the optical axis e.g. in dark-field illumination.

infectious development

Type of chemical development in which development of slightly exposed grains is much accelerated when adjacent to well-exposed grains. * This tends to lead to very high contrast images and is used e.g. in lithography.

infinity

Noun: (1) in optics: an object at infinity is so distant, the light rays from it are, for all purposes, parallel. (2) In geometrical optics: the image of an object at infinity lies on a lens' principal focal plane. (3) The maximum attainable gamma for a given film/developer regime: as in gamma ~. (4) In computing: instruction or loop that repeats endlessly unless terminated by e.g. re-booting. (5) Adjective: ~ stop: mechanical detent or limit on focusing mechanism of optics at which objects at infinity should be sharply focused.

infrared

Radiation beyond visible red, of wavelengths between about 700 and 500,000nm. * It is invisible but the near-infra-red can be felt through the sensation of heat.

infra-red film

Light-sensitive material sensitized to near-infrared radiation. * May need to be used with filter to cut out shorter

wavelengths (blues and greens) if it retains sensitivity to these. * For colour reproduction, reds and infrared are reproduced as red, green colours are reproduced blue and blue colours are reproduced green (but note green leaves usually reflect infrared efficiently, so they may come out red).

infrared filter

Filter designed to absorb all but infrared wavelengths. * May appear black, as all visible wavelengths are absorbed, or yellowish-red for filters designed to be used with infra-red film.

infrared mark

Index shown on some lenses for focusing when using infrared materials. * Compared to working in normal light, the object generally appears slightly nearer in infra-red – for which the infra-red mark compensates.

initialize

To format or prepare a memory-storage device to take data. * In most initialization regimes, any data already on the device will be lost. * As a result, initialization is a good way to clean up a hard-disk.

ink-jet

Printing technology based on the controlled squirting of extremely tiny drops of ink onto a receiving substrate. * There are three basic types: (1) BUBBLE-JET: a nozzle filled with ink has a heating element at the far end: when this is heated up, it boils the ink, creating a bubble of gas which ejects the ink. (2) PIEZOELECTRIC: ink is literally squirted out by squeezing the nozzle, using crystals that change shape when a charge is applied across them. * In some designs, dot size can be varied. (3) CONTINUOUS FLOW: electrically charged ink flows continually across a gap. But most of this ink does not reach the paper and is re-circulated through the ink reservoir. When an electric charge is applied it causes a deflection of the stream of ink forcing droplets to hit the paper. Drop size can be easily varied and it is possible to build up ink on the same spot.

input resolution

Measure of ability of input device e.g. scanner, digital camera to distinguish detail: the upper limit is determined by the number of pixels available, the pixels' size and their density or, in the case of a scanner, resolution of the driver stepper motor. * However, input resolution may be lower for a variety of reasons including poor focus of optics,

I

mechanical jitter in driver mechanism, off-axis illumination (e.g. flare), low system contrast.

inside curve
See cementing surface.

instrument myopia
Observation that many users will adjust their viewing instruments so that the viewed image appears closer than infinity.

integral density
Measurement of colour film density in which all the layers contribute. * As opposed to analytical density, in which each layer is considered separately.

integral tripack
Colour material in which all three layers sensitive to different primary colours are laid on one piece of film. * As opposed to composite colour films.

integrating sphere
Hollow sphere or hemisphere made of white diffusing material used to collect or integrate light from a wide area onto a light-detector. * Used in taking incident light readings and in densitometry.

intensification
Increase in density of image, usually of negative, through chemical treatment. * Many print-toning processes are effectively also intensifying processes.

intensity
(1) Measure of energy, usually light, radiated by a source. * Strictly, intensity (also called 'luminous intensity') is rate of emission of light energy from a point source in a specified direction; unit is the candela (lumen per steradian). (2) Also loosely used to refer to apparent strength of colour as in ink, photograph, monitor colour etc. in a sense roughly equivalent to 'saturation' plus a dash of emotion.
> See lumen; saturation.

intensity resolution
See bit depth.

inter-frame sensor
Type of CCD design in which each cell consists of a light-accepting area and an adjacent storage area shielded from light: the charge from the light-accepting area can be shunted to the storage area – or shift register – to be read allowing the light-accepting area to be 'flushed' of charge to take the next reading. * This is the basis of the video chip, as it allows very rapid reading and refreshment of each pixel.

More punch than a six-pack

While modern films are still based on the principle of separating sensitivities to each of the three primary colours, there are now far more than three layers used. Although some films have seventeen layers and over, many are not light-sensitive as such but are used as barriers to stop one layer interfering with adjacent ones. Nonetheless, one colour-sensitive layer may be divided into several sub-layers such as fast- and slow-speed to control factors like contrast and reciprocity characterisitics.

I

* Also widely used in consumer and prosumer grade digital cameras where there is obviously no need for a mechanical shutter. * It has the disadvantage of needing relatively high and varying voltages (around 20V at peak) through the capture/read-out cycle compared to e.g. CMOS sensor. * Also known as inter-line sensor.

inter-leave

(1) Type of design for RAM (Random Access Memory) that speeds up operation. * The total RAM is divided into memory boards e.g. SIMMs or DIMMS which are slotted in by pairs e.g. instead of one SIMM of 32MB, two SIMMs of 16MB are used in paired slots. Data can be (a) read off in larger chunks than with non-interleaved RAM and (b) can be shared sequentially between pairs of slots, enabling the micro-processor to read one off while the other half is being refreshed. (2) Arrangement of the sectors of a hard-disk to optimize data transfer. * Sectors of data which are arranged one after another will pass data to the reading head faster than the hard-disk controller can handle. Inter-leaving creates an ordered, non-sequential arrangement of sectors.

inter-line sensor

Type of CCD photo-detector in which the charge from an exposure is kept on the original detector before being shifted off for read-out. Also known as inter-frame sensor.
See full-frame sensor.

interchangeable lens

Lens mount design in which the attachment to a camera is the same as that of other lenses, so one lens can be used instead of another on the same or compatible camera body.

interface

(1) Software or part of application software which enables a user to work a computer or use an application. * Interface design usually adheres to standards and conventions set by the operating system. (2) Component or accessory that enables different hardware to communicate with each other e.g. adaptor enabling USB devices to be used with SCSI ports; FireWire card enabling computer to use IEEE 1394 devices. (3) Point of connection between different hardware e.g. CompactFlash card and its reader.

interference

Addition of two or more waves which changes energy levels. * Many familiar phenomena are caused by interference e.g. iridescent colours of butterfly wings or those seen on CDs; also Newton's Rings.

Sermon on the mounts

To Our despair, all manufacturers have a Babel of mount designs. In atonement, all good mounts shall be expensive mounts. The narrow mount is cheap but maketh life hard for lens designers, therefore be not tempted. Changing a mount design brings down the wrath of the Market: therefore avoid doing so unless you have a jolly good reason. The future-proof mount shall inherit the market.

I

interference colour
Visual sensation of colour caused by interference between two or more light beams.

interference filter
Design of filter based largely on interference to produce highly selective filtration. * Usually consists of two thin films of metal carefully spaced to split the beam and cause interference between the resulting beams.

interimage effects
Degradation of image quality in multilayer colour films caused by development or other process in one layer affecting processes in an adjacent layer. * E.g. high exposure in one layer may release developer inhibitors which migrate to the next layer and slow development in the wrong colour, causing inaccurate highlight reproduction.

interlace
Technique of projecting images on television and computer monitor screens as two parts or fields in such a way that the scan lines of one alternate – i.e. interlace – with the other. * This reduces flicker: a TV showing a movie at a rate of 25 non-interlaced frames per second (fps) will appear to flicker but if it is presented as 50 interlaced fields per second (overall frame rate is still 25fps), flicker is reduced to acceptable levels provided the image is not static.
See field; frame; refresh.

intermittency effect
Change in apparent speed of light-sensitive material with short exposures. * E.g. ten exposures of ten-thousandths of a second may not produce the same density as one exposure of one-thousandth of a second. * May be said to be reciprocity failure with short exposures.

intermittent agitation
Circulation or mixing of processing chemicals which occurs at regular intervals through the processing cycle. * E.g. in film processing, a hand-tank is inverted, rotated and reverted five times every 60sec during development.* As opposed to continuous agitation, when the circulation takes place throughout the processing cycle in question.

international candle
Unit of luminous intensity.
See candela.

internegative
Copy of an original made for the purpose of making a further copy or print i.e. an intermediate copy. * E.g. to make

a C-type print from a colour transparency, an internegative on colour negative material must first be made. * The step of creating an internegative enables adjustments such as contrast and colour balance to be introduced. * Also called interneg.

Internet

Worldwide collection of networks and computers connecting them based on TCP/IP protocols for communication. * The prime feature is that a number of networks or nodes joining them can malfunction without threatening the operability of the whole Internet. * People access the Internet through Internet Service Providers, so that their own computers join the network.

See intranet.

interocular distance

Distance between the centres of rotation of the eyes. * Also known as base-line.

See interpupillary distance.

interpolation

Process of inserting extra values based on existing values e.g. introducing extra pixels into an existing digital image. * Used to: (i) re-size an image file when a bit-mapped image is enlarged (ii) produce an apparent (but not real) increase to resolution e.g. in scanned images; (iii) effect rotation or other transformations of image e.g. create tweens in animation; (iiii) produce anti-aliased edges. * Values of interpolated pixels always depend on values of the pixels adjacent to the central pixel: (a) if it is from the nearest neighbouring pixel, the interpolation algorithm is 'neighbouring' (b) if from the four pixels at the sides, the interpolation is 'bicubic' (c) if all eight contiguous pixels are considered by the algorithm, the interpolation is 'bilinear'. * Algorithms may be chosen to optimize preservation of overall dimensions (as in scanners) or to preserve brightness values, high-frequency detail, etc. depending on purpose.

interpolated resolution

Measure of performance of input device – e.g. scanner, digital camera – in terms of the resolution of file it produces following interpolation process. * This is not true optical resolution but may be better than an interpolation done to the data after capture.

interpupillary distance

(1) Distance between the centres of the eye pupils when distant objects are viewed. * The normal distance is between

Law of Manipulating Multiples
I have observed that the more steps it takes to produce an image, the more interesting, controlled or more permanent it can be. So you can make colour prints in one step, using normal materials: but go through an interneg and the print can be much more subtle. Go through twelve extra steps and you get the permanence and irreducible tactile supremacy of a dye transfer print. So my Law states that control over the final image increases in proportion to the interposition of multiple steps into the process.

64-62mm. (2) Separation between the exit pupils of an instrument e.g. binoculars, binocular microscope. * Usually made adjustable to suit user.

interrupts

Signals to the central microprocessor of a computer to tell it to stop while e.g. new data is loaded or the contents of memory banks are shuffled. After this interruption to its thinking, the microprocessor can continue. * Interrupts greatly slow up a single processor but do not affect parallel processors so much: while one processor sorts out input/output, another can continue calculating.

intervalometer

Timing device designed to trigger e.g. camera exposure at regular intervals for time-lapse photography.

intranet

Network of computers and servers based on TCP/IP or similar protocols used within an organization or group of related organizations, usually with links to the Internet.

invar

Steel with high nickel content much used in optical instruments because it hardly changes length with temperature change. * Coefficient of thermal expansion is less than a millionth per ° Centigrade.

inverse square law

The brightness of an area illuminated by a point light-source falls rapidly as the light-source is taken away, such that: at e.g. double the original distance, the brightness is a quarter of the original; at triple the distance, the brightness is a ninth, etc. * The illuminance of a surface normal to a point source varies with the square of the distance from the source to the surface. * For ordinary light-sources, the law holds for general purposes, but clearly fails with (a) large sources e.g. fish-fryer or fluorescent tubes and (b) highly focused ones e.g. spotlight. * Also known as distance-luminosity relationship.

inverted

Adjective: (1) ~ image: one that shows the subject upside down when projected or seen. (2) ~ telephoto: design of lens with strongly negative groups in front and positive groups behind for short-focal lengths such that the distance from the rear vertex to focal plane is greater than the focal length. * Also known as reversed telephoto or retrofocus. (3) ~ selection: process in image manipulation in which all the objects not at first selected become selected, thus reversing

or inverting the original selection. (4) ~ microscope: made to look at underside of objects which cannot be turned over e.g. Petri dishes, so the objective points vertically upwards.

inverted telephoto
See retrofocus lens.

ion-assisted deposition
Process used to coat lenses with thin films to correct colour balance and reduce reflections. * The thin film is bombarded with ions e.g. argon and oxygen to break up the film and allow molecules to re-arrange themselves at higher density than simple deposition permits.

IP address
Internet Protocol address: number that uniquely identifies a host computer connected to the Internet. * It is a 32-bit number, expressed in dotted quad form i.e. four sets of numerals separated by dots e.g. 196.7.114.138 in which the first set identifies the network, the others the unique computer. * Also known as IP number.

IrDA
Infrared Data Association: organization of computer and software manufacturers setting standards for infrared communications between computers and peripheral devices e.g. digital cameras, printers, palm-top devices.

iridescence
Bright, sometimes sparkling, display of different colours from fine reflective materials e.g. butterfly wings, birds' feathers. * Created by light of different wavelengths being reflected from adjacent layers so closely spaced as to cause interference of the light rays.

iris
Circular pigmented membrane separating the cornea from the lens, attached by its rim to the ciliary body, with a central hole, the pupil. * Contraction and relaxation of muscles in the iris changes the diameter of the pupil, thus controlling intensity of light entering the eye.

iris diaphragm
Device within a compound lens which controls amount of light let through the optics by adjusting its effective diameter. * Consists of set of curved blades set on a ring or cam so that the angle that the blades make to the ring can be changed, so covering more or less of the lens aperture.

iron process
(1) Reproduction process based on chemical conversion of iron salts. * Based on reduction reaction of iron ions i.e. the

The more, the rounder

The shape of the aperture left by the iris diaphragm is more important than might be expected: it is not merely a hole, it shapes the image, particularly the out-of-focus image as well as internal reflections. The more circular it is, the better – obviously that needs more blades. Unfortunately, using more blades greatly slows down any stop-down operation. So you'll find circular holes only on large-format and rangefinder lenses.

conversion of three-valence to two-valence under influence of radiation. (2) Toning of prints based on iron compounds.

irradiance

Measure of rate at which a surface receives energy: units watts per square metre. * Compare to illuminance, which measures light.

irradiation

(1) Scattering or diffusion of energy in a photo-sensitive layer or photo-detector which causes an increase in image size or signal. (2) Application of radiant energy – e.g. x-rays, gamma rays – to an object.

ISDN

Integrated Services Digital Network: digital communications service provided by telephone companies designed to carry digital data as well as capable of carrying analogue transmissions such as voice over a wide area network. * The service consists of two kinds of channels: (i) B (bearer) channels which carry up to 64Kbs of data on full-duplex which are circuit-switched (i.e. connected by phone service to one destination). B channels carry data or digitized voice. (ii) D (delta or data) channels which carry up to 16Kbs of data on full-duplex which are packet-switched (i.e. can go to different destinations at once). D channels carry voice or ancillary signals and codes. * These may be configured thus: (i) BRI (Basic Rate Interface) which offers two B channels and one D channel and (ii) PRI (Primary Rate Interface) offering up to 30 B channels, according to country, and one D channel; and (iii) B-ISDN: broad-band ISDN, capable of exceeding rates of 2Gbs (gigabits per second). * May also be known as Integraded Services Distributed Network.

ISO

International Organization for Standardization: association of the national standards organization of the member states.

ISO 9660

Standard for CD-ROM that defines logical, file and record structures. * Widely accepted, and as a result, is best for cross-platform – e.g. Mac and PC – use of CD-ROM discs. * Based on High Sierra standard, with some changes, agreed in 1985.

isocandela diagram

Graphic representation of brightness distribution of a light-source: lines join up points of the same brightness, like a contour map. * Curves are projected on an imaginary sphere at whose centre is the light-source.

All the same, ISO is the name

You should realize that the acronym for this organization is actually IOS. So what is ISO if it is not an acronym? Anyone has to be forgiven for thinking ISO actually stands for 'International Standards Organization'. But it doesn't because that's not the right name for the august body. The name ISO is actually from the Greek word 'isos' meaning 'equal'. See? What could be simpler? Or is the idea of anything simple about an international body merely oxymoronic?

isochromatic

Of the same chromaticity or hue. * Two sources may be of different colours but the same hue i.e. isochromatic – they could differ in saturation or brightness, or both.

isoplanatic

Optical design offering a good level of correction for coma.

isotropic

Material in which velocity of light is the same for all directions. * Most glasses used in photography are isotropic. * Compare with anisotropic.

IT8

Standard colour reference target used for calibration in the printing industry. * IT8/7.1 and IT8/7.2 are essentially RGB targets which facilitate checks on input devices by providing tonal varieties from highlight to shadows, a range of pure colours including additive and subtractive primaries, plus 'natural' colours: IT8/7.1 is for transmission, IT 8.7/2 is for reflective originals. * IT8/7.3 is a CMYK target which facilitates checks on output devices by providing spectra with differing amounts of black plus neutrals and solid colours.

See calibration.

IX240

Tecnical specifications for the Advanced Photo System, hence may be used to refer to the format.

Ivanoff corrector

Lens system used in underwater camera housing to enable normal (i.e. terrestial) lenses to be used underwater. * Consists of plano-convex front element with plane surface outermost and field lens: of overall negative power to compensate for higher refractive index of water compared to air.

IVUE

File format native to Live Picture software: it consists of a high-resolution image plus a sequence of images at a quarter and sixteenth resolution. * Editing effects do not alter the IVUE file but are stored in a FITS file: when needed, the FITS file is convoluted on the IVUE file i.e. IVUE is mathematically altered by FITS.

jack

Socket designed to accept a matching plug to make electrical connection. * A plug using a single pin, with co-axial terminals i.e. different polarities, etc. are arranged along the length of the pin, separated by insulators.

jack in

(1) To connect to an electrical system. (2) To log onto a computer system or network. (3) To enter a virtual-reality simulation.

jack out

(1) To disconnect from an electrical system. (2) To log off from a computer system or network. (3) To exit from a virtual-reality simulation.

jacket

Noun: (1) Film ~; disc ~: protective cover or casing for film-strip, disc, etc. (2) Water ~: container, usually filled with heated water and fitted with a heater connected to a refrigeration unit, used to maintain the working temperature of a solution or of machinery in e.g. film processing, image capture. (3) ~ sound jacket: padded material wrapped round machinery to reduce noise e.g. to silence workings of camera. * Also known as blimp. (4) Job ~: collection or

J

assembly of instructions or order together with the artwork materials, disks, etc. required to complete pre-press work.

jaggies

See stair-stepping; also see alias.

Jamin refractometer

Instrument for measuring refractive index of a gas. * Two beams of coherent light are made to interfere: without the test gas, both have the same path-length so there is no interference. When gas is introduced to one beam this causes a slight change in path-length of that beam causing it to interfere with the other beam: refractive index can be calculated from the interference pattern.

Java

Programming language which is widely used for small Web-based applications, or applets. * It is designed to work on any platform by running within its own software environment. * It is based on C++ but is more compact, more portable, more secure. * Developed by Sun Microsystems. * Do not confuse with JavaScript.
See virtual machine.

JavaScript

Language used to add basic functions and applications to Web pages with compliant brower. * Related to Java but easier to write, is not compiled and is nowhere near as powerful. * It is embedded within HTML code as a script. * Developed by Netscape Communications and Sun Microsystems.

JEIDA

Japan Electronic Industry Development Association: organization comprising leading manufacturers which sets standards, protocols, etc.

JFIF

JPEG File Interchange Format: common language data format for JPEG designed for cross-platform use.

jitter

(1) Jerky, irregular movement of image due to variety of causes e.g. unsteadiness of film transport in gate of projector, faulty animation, low refresh rate of monitor, slow transfer of video data e.g. in videoconferencing or from CD-ROM player. (2) Small fluctuations in time base e.g. irregularities in the stream of pulses used to synchronize multiple tracks; poor synchronization in wire transmissions leading to jagged images. (3) Irregularities or small variations in the response time of terminals in a network.

* NB: irregularities in the clocks that regulate computer functions are usually fatal, at least to the computer.

joule

Unit of energy: one joule is transformed when one newton of force moves one metre. * Symbol: J. * Used in photography in a measure of so-called 'power' of flash-units – the joule-second.

JPEG

Joint Photographic Expert Group: (1) Acronym referring to a data compression technique that can reduce file sizes to as little as 10% of original with only a slight loss of image quality and to less than 5% by sacrificing a bit more quality. * JPEG compression has the following characteristics: (a) it is lossy: i.e. compression loses data that cannot afterwards be recovered (b) its degree of lossiness can be varied to balance reduction of file size against loss of image quality (mainly seen as loss of resolution) (c) JPEG compressed files do not need to be decompressed before use. (2) Name of committee jointly sanctioned by CCITT and ISO that researched and set up the standards.

See compression.

Judas optics

Door viewer giving wide-angle view from inside, a narrow, unfocused view from outside. * Optically it is a Galilean telescope whose positive lens is to the inside of the door.

jumper

Metal clip or connector, which may be insulated, used to complete a circuit. * Used e.g. to configure hard-disk drives, network connections.

junior

American slang for mid- to small-sized spotlight.

justification

Process, in desktop layout applications and typography, of adding or subtracting free space between words and letters to fill out a column width of text. * Forced ~: ensuring that every line is the same measure (length) – often resulting in unsightly, large spaces between words in the short final line of a paragraph or where long words are used.

See vertical justification.

JVM

Java Virtual Machine: software 'processor' which compiles Java source-code into a form – bytecode – which the computer's processor can interpret.

JPEG – in detail

*The technique – 'jay-pegging' – consists of three steps: (i) The Discrete Cosine Transform (DCT): an algorithm similar to that of the Fourier Transform takes data in 8x8 pixel blocks and converts them from the spatial domain to the frequency domain – similar to re-presenting a graph of a continuous curve as histograms. This step compresses data, loses no detail and identifies data that may be removed. (ii) Matrix multi-plication: the data is re-ordered for quantization. Here variable amounts of the data can be discarded through the choice of the quantization coefficient. This is what is controlled when you choose 'low', 'medium' or 'high' quality or adjust sliders. (iii) Coding: the results of the last manipulation are coded using yet more compression techniques (including a sneaky little zigzag trick that makes the most of the fact that the last procedure makes data with a lot of zeros in it) but this time with no loss of data. * The sum of these effects helps to achieve JPEG's very high compression rates: files can be reduced by 70% (i.e. to 30% original size) with very little visible image degradation; even with 94+% reduction, the image is usable for certain purposes. A new standard, JPEG2000 may supplant its now dated technology.*

k

kilo. * NB: lower-case 'k': one thousand, a nice round decimal thousand i.e. 1000, with no extra bits like the binary thousand, which is spelt with a capital K – see below.

K

(1) Kilo-: binary thousand i.e. 1024 or 2^{10}. * E.g. KB: kilobyte equals 1024 bytes of data. (2) Key colour or blacK: the fourth colour separation in the CMYK four-colour reproduction process. * It is usually the last colour laid onto the paper. * Its screen angle is usually about 45°. (3) Measure of line resolution of film recorders e.g. 4K means the film recorder displays a maximum of four thousand lines (usually running horizontally). * Irrespective of size of film, no more than 4K lines can be recorded over the format.

Kb

Kilo bit: binary thousands of bits i.e. 1024 bits or 2^{10} bits.

KB

Kilo Byte: often, incorrectly, abbreviated to K.

keeping quality

Stability of chemicals or materials when kept under specified storage conditions. * NB: for modern materials, keeping quality can only be a projection from short-term tests.

Changing times

The KB is such a small amount of information (equivalent to about three times the size of this entry), most of us do not notice it nowadays. It was used to measure the storage capacity of obsolete removable media e.g. the floppy disk holding a maximum of 512K, remember them? By the way, many have asked why the four separation colours cyan, magenta, yellow and black can't be abbreviated CMYB. But then it would be easy to confuse B with blue, which is the name printers use for cyan.

Kell factor

Measure of effective resolution of an interlaced scanning system. * The effective resolution is always less than the number of scan lines because of factors such as the random nature of subject detail. * The factor is usually taken as 70% of the scan frequency for broadcast TV, based on work by R D Kell in 1934.

See Nyquist rate.

Kelvin

Unit of temperature relative to absolute zero. * Temperature in kelvin is Celsius plus 273.16. * Used to express colour temperature. * Symbol is K (with gap but no degree sign). * Named after physicist who first described absolute zero.

Kepler telescope

Optical design using a fixed positive front lens and a focusing eyepiece: the front lens forms an intermediate image in the lens which is projected by the eyepiece to give an inverted, reversed image. * Principle much used and still in use for viewfinders as a frame-limiting mask can be placed at plane of intermediate image, but image must be rectified with prisms or mirrors.

kernel

(1) Group of pixels, usually a square ranging from 3 pixels to any odd number of pixels across (generally up to maximum of 61 per side), that is sampled and mathematically operated on for certain image processing techniques e.g. filtering for noise reduction, sharpening, blurring, etc. * Takes name from the fact that the central pixel in the square is the target of the operation, its final value depending on those of the surrounding pixels. (2) The core portions of an operating system that must be present constantly in memory – e.g. for controlling disk input-output, tracking central memory – for the whole computer to work.

See mask; matrix.

kerning

In desk-top publishing and typesetting: the spacing between pairs of letters. * PostScript and other outline typefaces have kerning pairs built into the library which are designed for normal reading sizes: if type is set to very large sizes e.g. displays and headlines, kerning may have to be manually adjusted – usually to decrease space between those letter-pairs in which the first letter should slightly overhang the next e.g. Wo or Ti.

See tracking.

Kerr cell

Type of shutter used for very short exposures (down to nanosecond) with very rapid reaction. * Based on the Kerr effect: a cell filled with liquid e.g. nitrobenzene is sandwiched between two polarizing plates or prisms and wired to receive an electrical field: application of the field rotates plane of polarization of the cell, which cuts the light transmission through the cell. * Also called electronic shutter.

Kerr effect

Change in the light propagation properties with electric field. * Exists as: (i) electro-optical effect: a liquid or crystal becomes anisotropic or birefringent when an electric field is applied to it (ii) magneto-optical effect: polarized light is reflected with different changes to the plane of polarization according to the magnetic field applied to the reflector.

key

Noun: (1) part of a computer, peripheral or keyboard that produces a character. (2) Any artwork, guide or (in printing) physical forme that establishes the relative positions of graphics elements, type or other printing element. (3) Piece of information that unlocks an encrypted message – e.g. an algorithm or number which, when entered, turns gibberish into sensible data. (4) Black separation in the four-colour process, i.e. the 'K' in CMYK. Verb: (5) To add one image from one source to another source, usually moving images: the first image is likely to be the 'key' frame defining the start of a sequence. (6) To enter characters or text by tapping away on a keyboard. (7) Adjective: ~ light: the luminaire providing the main source of lighting in a studio set-up.

key-line

(1) In desktop publishing, a fine outline running round a graphic, artwork or image, usually in a colour contrasting with the background, that helps define the shape without actually highlighting it. (2) An outline on artwork that provides register with other separations or colours.

key plate

In colour separation printing, that plate to which the others are aligned to ensure good registration or fit. * Usually the one with most detail, typically black; and never the yellow plate.

key tone

(1) The black tones in an image. (2) The principal or most important tone in an image. * For an average image, it is

usually the equivalent to about 18% reflectance grey, hence with a high-key image, the key tone is of a high value i.e. brighter than normal, so the image is overall bright. * With a low-key image, the key tone is lower than mid-tone i.e. it is darker than usual, bringing down overall image brightness.

keyboard

Device for communicating with a computer – to input data, commands, control the mouse, etc. * Keyboard layout varies from country to country.

keyboard shortcut

Combination of keystrokes that executes a command, usually the equivalent of access to that command through drop-down menus.

keystoning

Distortion of shape of projected image seen in a failure to project squarely onto the projection screen i.e. so that the optical axis is perpendicular to the screen e.g. when slide projector is tilted upwards to project onto a wall, image shape looks trapezoidal, i.e. like a keystone. * As the upper part of the image is further away from the projector than the lower part, the upper part of the image is projected at a greater magnification i.e. it appears larger and becomes progressively smaller: obviously this occurs only where the image and the subject planes are not parallel to each other.

kHz

KiloHertz: thousands of cycles per second. * Used to measure regular, periodic changes or events e.g. rate at which sound is sampled for quantization; specifications for loudspeakers, audio equipment.

kill

Verb: (1) To decide not to publish or broadcast (ever) a picture, story or other material. (2) To turn off a light-source.

kiss

(1) Keep it sweet and simple (also: keep it simple, stupid). * All-round sound, golden rule. (2) Lightest pressure needed to produce a good impression or ink-transfer, as in printing.

kluge

Expedient or temporary solution for a software or other problem e.g. to resolve a conflict between device drivers. * Pronounced 'klooj'. * Also spelt 'kludge'.

knockout

Type that appears light or white on or against a darker background. * Also known as dropout, reverse, or wob (white-on-black).

Koch curve

A type of fractal, usually seen as a snowflake, generated by substituting one segment of a curve with another of more complex shape and repeating the process. * It is an instance of an L-system – named after Lindenmayer, who invented it to model the growth of plants (of the green kind).

Kostinsky effect

Type of edge effect in which two adjacent dense areas appear to move apart or two adjacent areas lighter than their surroundings appear to move closer together. * With dense areas, developer is exhausted more quickly between these areas than at the other fringes, so reducing local development. * With light areas, developer remains active for longer, so increasing local development.

lag

(1) Time interval between issuing a command or initiating an action and the action taking place. * E.g. shutter-lag: the time between pressing a shutter button and the shutter run. (2) Light emission from a phosphor that continues after end of stimulation by energy. (3) The electric charge remaining on a camera tube or photo-detector after first being formed by the image – which may run into subsequent frames or exposures. (4) Time interval between collection of data and the necessary correction having effect e.g. in controlled chemical processes.

lambert

Measure of luminance i.e. luminous intensity of light emitted per unit surface area by a source. * Equals $1/\pi$ candelas per square centimetre.

lambertian

Perfectly diffuse reflector or source i.e. one from which light leaves equally in all directions. * A surface which obeys Lambert's cosine law that flux per unit solid angle is proportional to the cosine of the angle.

LAN

Local Area Network: set of connections between computers

or nodes with peripheral equipment such as printers, scanners, etc. situated in a specific location which enables the various components to communicate with each other. * May be just a couple of computers talking to each other in a small home office or the entire complex of a large university or science park.

land

Reflective flat area on a CD-ROM that lies between non-reflective pits. * Represents 'off', where the land-to-pit and pit-to-land transitions represent 'on'.

lap

Tool used to grind lenses: its surface is formed to be precisely the opposite of the curve to be produced on the glass. * A blank of glass of roughly correct shape is ground under pressure against the lap, using abrasive compounds and a lubricant, until it attains the required shape.

Laplacian edge enhancement

Sharpening filter: an image-processing filter which increases contrast at edges. * A Laplacian kernel convoluted on a pixel array tends to increase the standard deviation of densities.

large-format

Adjective: ~ camera, ~ enlarger: equipment which uses film that is 4x5" or larger. * Note: not necessarily cut-film, as some aerial cameras use roll-film to expose 4x5" negatives.

laser

Light Amplification by Stimulated Emission of Radiation: production of a highly monochromatic, coherent light. * Consists of a cavity, with mirrors at the ends facing each other. The cavity is filled with lasable material i.e. one in which the majority of atoms are capable of being excited(i.e. pumped) to a semi-stable state by light or electric discharge. The light emitted by atoms as they return to their ground energy state stimulates other excited atoms to radiate energy: this continually increases as light bounces backwards and forwards between the mirrors. * One mirror is slightly transparent: a beam of monochromatic, coherent light emerges from this. * The beam can be a continuous wave or a brief pulse of energy. * If the mirrors are flat, the beam is collimated, if concave, the beam appears to emerge from a point source. * Lasable materials can be gas, liquid, semiconductor crystal, etc.

laser printer

Output device based on photocopier principles: a laser beam writes on a electrostatic drum which picks up toner and

deposits it onto paper which is then heated, thus fusing the toner to the paper. * Four or more different coloured toners may be used to create colour output.

latensification

Latent image intensification: treatment of the exposed image prior to development designed to increase image density and/or contrast. * Techniques include exposure to very low light levels, exposure to mercury vapour, dunking in various weak acids, etc.

latent image

The invisible pattern of physical or chemical changes in a light-sensitive material resulting from an exposure to light. * In photographic materials, the latent image is probably a distribution of silver atoms on silver halide crystals. * The latent image must be developed before it can be seen: it is virtually undetectable otherwise.

lateral colour

Lateral chromatic aberration.
 See chromatic aberration.

lateral shift

Sideways movement of a lens or film standard on a view or studio camera. * This movement alters the position of the image on the film: with a camera set up normally, a lateral shift to e.g. right shows more of the right side of the subject.

latitude

Allowable or tolerable error or inaccuracy in a setting of controls or an action.
 See exposure latitude.

law of reflection

The angle of reflection is equal to the angle of incidence Where the incident and reflected ray with the normal to the surface at the point of reflection all lie on the same plane.

law of reversibility

A light beam follows the same path through an optical system irrespective of the direction of travel.

layer

(1) Metaphor for the manipulation of multiple virtual objects in applications software e.g. page layout, image manipulation which locates each object in a layer, one on top of another. * Several layers may be created and it is usually possible to change the order of them, thus changing their relationships and interactions. (2) Set of protocols determining a level of services, etc. within a suite of communications protocols.

Squeezed dry
It is nearly pointless attempting these witch-craft latensification techniques with modern materials which are about as efficient as can be. The old techniques relied on there being exposed silver halides which would not develop without a bit of encouragement. However, you can try it when making prints: latensification with a very, very low uniform exposure to light can help eke out a touch of high-key detail when working with silver-rich papers.

L

layer mode

Image manipulation or processing technique determining the way that a layer in a multilayer image combines or interacts with the layer below. * E.g. in normal mode, the upper layer covers the layer below; in darken mode, pixels are darkened only where the top layer is darker than the base layer. * Layer modes are calculated by the software which compares values of corresponding pixels of the upper and lower (or receiving) layers and performs a calculation based on pre-programmed conditions.

layout

(1) Arrangement of graphic, text and other elements on the printed or virtual page. * Note: hence, to 'lay out' is to create a layout. (2) Process of positioning and marking a blank of glass before working on it.

LCD

Liquid Crystal Display: design of compact changing display for letters, numbers or symbols which consumes very little power in use. * A layer of liquid crystal is sandwiched between transparent electrodes and a layer of polarizing filter: a charge across the electrodes lines up the liquid crystals which is becoming polarizing: this crosses with the polarization of the polarizing layer, creating a dark patch the same shape as the crystal.

leader

Length of material used to load film onto machinery so that the working part of the film is in position when the machinery is properly prepared. * E.g. film leader connects the film canister or roll to the take-up spool before the camera is closed and made light-tight: then the leader can be wound on until the first frame is in position.

leaf

Thin blade- or leaf-shaped opaque material used in construction of aperture diaphragms or inter-lens shutters. * A set of such leaves are rotated at their base on the circumference of the lens so that they can be made to open or close the cross-section. * Hence interlens shutters may be known as leaf shutters. * Also known as blade. * Plural: leaves.
 See iris.

LED

Light-Emitting Diode: semiconductor device that produces light. * Based on electroluminescence: recombination of hole-pairs in a p-n junction emits photons given a strong bias voltage.

Lempel-Ziv coding

File compression algorithm that identifies repeating elements in order to replace them by tags or markers referring to a table. * Used with text files and can compress files by 50-65%.

See LZW compression.

lens

(1) Transparent material shaped to focus light in order to form an image. (2) Combination of several lenses designed to work together as a single optical unit. (3) Set of electrical coils and magnets used to focus electron or other energetic beams in e.g. electron or x-ray microscopy.

lens barrel

The mechanical structure that contains and protects (i) individual lens elements or lens groups (ii) mechanical arrangement for focusing (iii) mechanical arrangement for adjusting lens aperture (iiii) mount which connects lens to instrument such as a camera. * May also feature mount for accessories, mount for attachment to tripod and other equipment e.g. auto-focusing mechanism.

lens board

Metal or plastics plate drilled with central hole to which lens is attached with retaining ring or simply screwed in directly. * Inexpensive basis for interchangeable lenses, used mainly with studio or field cameras and enlargers.

lens coating

Thin and even layer or layers of transparent dielectric substance e.g. magnesium fluoride applied to lens in order to increase light transmission (i.e. improve transmittance) and reduce reflection (i.e. reduce flare and increase image contrast). * Works by causing destructive interference of reflected rays.

See anti-reflection coating; coated optics; multicoated.

lens moulding

Production of lens blanks by pressing between moulds glass which has been heated until it is soft. * The glass is then in approximately the correct size and shape for polishing.

lens mount

Mechanical and electronic interface on a camera which locates and holds the camera lens. * It consists of a face-plate, precisely aligned to the film-plane, which mates with the rear face of the lens so that (i) the attachment is secure (ii) the lens is correctly aligned to be square on to the film-plane and centred on the optical axis (iii) interlinks and

Mouldy old ways come back

Posh manufacturers used to turn their nose up at moulding lenses: it was too inaccurate, produced variable results and the moulds kept on having to be remade. Moulding was for baby bottles and fun-fair prizes. But no more: modern ceramic and other materials which allow sub-micron precision in forming and offer unparalleled physical stability are changing it all. Plus the huge new demand for tiny optics for e.g. digital cameras – moulding a smidgeon of a 6mm lens for a digicam is a whole different game from moulding one large enough for 35mm photography.

L

communications between lens and camera e.g. to signal maximum aperture, focal length and aperture set, etc. are properly set up.

lens performance

Assessment of quality of function of optics in terms of its ability to form a high-resolution, high-contrast, aberration-free image. * May also include assessment of other parameters e.g. the focusing range, photometry of the image, etc.

> See MTF.

lens shift

Mechanics in lens mounting that allows the lens to be moved sideways i.e. at right angles to the optical axis. * This changes the field of view without change in perspective.

lens speed

Measure of how little light is needed by a lens in order to work: a fast lens needs little light, a slow one needs more. * In practice this is measured by maximum aperture: large maximum aperture for a given class of lens equates with a fast lens, small maximum aperture with a slow lens. * E.g. $f/2.8$ is very fast for a 400mm lens, but for a 50mm, the aperture should be $f/2$ or larger for the lens to be considered fast.

> See f/number; relative aperture.

lens system

(1) Two or more lenses or groups of lenses designed to work with one another. (2) Set of lenses of different focal lengths, maximum apertures and design offered by a camera manufacturer.

lenticular colour photography

Additive system colour photography. * Based on system of small lenses and filters arranged to separate colours into separation primaries of red, blue and green. * Best example is Polaroid Polachrome film which uses stripes of red, blue and green filters (with some light-gathering power) exposing onto panchromatic film. After processing, a positive black & white image corresponding to exposure through the filters – e.g. red light through red filter causes high density in negative leading to low density in the positive – this in turn modulates the transmitted light, with the filters still in place, to reconstruct a full-colour but highly dithered image. * It is arguable that many video-chip based digital cameras work on the same principle.

Let's get it in perspective

Lens shifts are used most often to reduce foreground coverage and increase what can be seen in the upper part of the image. This helps overcome converging parallels as the camera back can then be kept more parallel to the subject than otherwise. Unfortunately, a certain ignorant camera manufacturer dubbed their popular shift lens 'Perspective Control', giving rise to the myth that such lenses change perspective. No lens can change perspective. Only change in your position changes perspective.

lenticule

Small optical element. * Usually part of an array or arrangement of such elements e.g. beads in high-gain projection screen, collecting elements on an inter-frame CCD sensor, ridge-like elements in colour reproduction systems, etc. * Also called micro-lens.

levels

Graphical representation in histogram form showing which brightness levels have the greater or fewer numbers of pixels. * E.g. a dark image produces a graph showing that there are many more pixels at low than at high levels.
See histogram.

light

(1) Noun: that part of the electro-magnetic spectrum, usually taken to be from about 380 to 760nm (420nm to 760nm for older people), that can be sensed by human eyes by the stimulation of the receptors of the retina and give rise to visual sensations. * It is radiant energy by which human vision operates. * Light of different wavelengths is perceived as light of different colours: red light has wavelengths of about 700nm, blues have wavelengths of about 400nm and so on. (2) Verb: to supplement, subtract and otherwise manipulate sources of light and light-shapers to alter the illumination on a subject in order to add to or change the meaning, mood or appearance of an image of the subject.
See light-shaper.

light-balancing filter

Filter used on light-source to produce small change in colour temperature to match or balance source to film being used. * E.g. an incandescent source like a household bulb may prove to be burning too cool for the tungsten-balanced film being used i.e. the light is too yellow: a bluish light-balancing filter over the source makes it behave like a tungsten-halogen lamp.

light-box

Viewer for transparencies and films consisting of translucent diffusing top (usually made of plastics, rarely glass) lit from below by colour-corrected fluorescent tubes to give daylight equivalent light suitable for colour-matching purposes and judging density. * Usually set up as a box but may be set into a desk or work-top and can also be used for inspecting prints.

light-emitting diode

See LED.

Reading your fortune in Levels

On first encounter, the Levels display is not so distant a cousin of the tea-leaves left in the bottom of a real cup of tea. The difference is that you can tell your future in Levels. The trick is to see if the display is a thick display like an unbroken hedge of more or less the same height. Yes? Then you've got happy hours of image manipulation ahead for what you have is a file full of information throughout the dynamic range. Beware the Levels that looks like a comb that has been through the wars: broken, uneven and full of gaps. This little monster will be very rebellious as soon as you try to improve its tonal qualities – which you are sure to want to do. My advice: ditch the file and sort out another scan, unless you like making life difficult for yourself.

Lighting standards for boxes

A standard for light-boxes is BS950 part 1: the correlated colour temperature of the light should be 6500 K; the illumination should be at least 750 lux to 3200 lux and that the surroundings be neutral in colour.

light-meter

Instrument designed to measure intensity of light or luminance of subject. * Many varieties of light-meters exist, designed to do slightly different jobs and based on different properties of light.

See exposure meter.

light-negative

Adjective describing substance whose electrical conductivity decreases when exposed to light.

light-shaper

Accessory for luminaire such as studio lights or flash-gun designed to change the quality and spread of light projected by e.g. interposing a physical baffle to diffuse light or a honeycomb to limit the spread of light, limiting spread of the light beam with flaps like barn doors or using optical devices such as Fresnel lens to vary the concentration of light.

light-source

Main illuminator or generator of light in a given scene or situation. * E.g. light-source outdoors on a clear day is the sun, on a moon-lit night it is the moon.

light adaptation

Physical and physiological changes in an eye to adjust to change – usually increase – in the brightness of light. * NB: adjustments to a drop in brightness to low levels are usually referred to as dark adaptation.

light modulator

Device designed to change qualities of a light beam – usually laser – by acting directly on it.

light ray

Path taken by a light particle e.g. that arising from a patch or light-source in a subject, travelling through space into the lens, passing through the lens and finally being absorbed in the film's silver halides or in the electron sink of a photo-detector. * Path of a point on a light wavefront.

lighting ratio

Comparison of the brightness of main lumination on a subject with the secondary, less bright, lumination.

lightness

(1) Amount of white in a colour, which affects the perceived saturation of the colour: the lighter the colour the less saturated it appears to be. (2) Axis of the L*a*b* colour space, corresponding subjectively to brightness. (3) Loosely, an antonym of 'density'.

The stuff of portrait school

Lighting ratio is, pedantically speaking, not a comparison of the brightness of the light-sources themselves, but, strictly, of their effect on the subject. That is, lighting ratio is not luminance ratio (ratio of luminance of the brightest part to luminance of the darkest part) – but in practice, there's not too much difference. An incident light meter reading gives a good enough guide to lighting ratio.

lightness constancy

Phenomenon of visual perception that the lightness of a surface appears the same under a range of different lighting conditions e.g. white tea-cup looks white in bright light as well as in dim room light.

line art

Artwork that consists of black lines and areas with no intermediate grey tones or, less frequently, white lines on a black background e.g. scraper board. * Line art does not need half-tone reproduction and may be digitized into simple binary files (on/off or black/white) since there are no tonal gradations.

> *See bit depth.*

line of sight

Projection from an optical instrument to the object it is pointed at or focused on: usually applied to distances much greater than the focal length e.g. object being viewed by telescope. * Projection of the optical axis of an instrument to the centre of the subject field. * Note: it may not necessarily be a straight line due to refraction effects in the atmosphere or to motion.

line spectrum

Light in which a small number of visible wavelengths are represented. * There is very little or no spread of wavelengths: between the few peak wavelengths, no other colours are present.

linear

Adjective: (1) ~ relationship, ~ property: one in which one variable varies proportionally with another; one in which the input to output ratio is constant. * Also known as a straight-line relationship. (2) ~ magnification: ratio of image width to subject width e.g. if 24x36mm is enlarged to 48x72mm, the linear magnification is 2X. * The area magnification is 4. (3) ~ perspective: one in which the perception of depth or distance is produced by seeing the convergence of lines known in real life to be parallel. (4) ~ scale, ~ series: measure or sequence of numbers in which the same gap lies between each number – they are equally spaced – e.g. the Celsius scale or metre rule is linear, as is the Exposure Value series, but the *f*/number or ASA film speed series are not.

linear array

Photo-detector consisting of a single row of light-sensitive devices, used in e.g. flat-bed scanners, scanning back cameras. * May be configured as three lines, each under a

Sometimes it doesn't always work against you

It's just as well that line art files can be kept small because when you scan line art on a desktop scanner, you'll find you need to work at the highest resolution you can set. The high contrast lines offer what amounts to very high frequency – this means that resolutions too low for the detail you want will show up as ugly stair-stepping which, in continuous tone images, is usually disguised by intermediate tonal changes. But in line-art it shows up as, well, ugly stair-stepping.

filter of the separation colours red, green and blue: in this case may be called trilinear array. * Also called a line array or line sensor.

linescreen

Plate of glass marked with a grid of opaque lines criss-crossing at right angles: when an image is projected onto the printing plate with the linescreen just above the plate, the image is broken up into a grid of circles of light and dark. * Also known as crossline screen.

See half-tone screen.

link

Feature of file that enables one of its parts or components to communicate directly with another part or component of the same file or those of another file or which connects to another file in another node or network. * Typically, software embeds into one end of a link the address or location of the other end of the link e.g. analogous to a chapter entry in a contents list that gives the page reference, a hypertext link provides a direct route to another piece of text. * Links may be dynamic i.e. changes at one end of the link automatically update the entry at the other end.

See hypertext.

liquid crystal

Material whose molecular structure changes according to changes in temperature, magnetic field, etc. depending on type of crystal.

See LCD.

live

See real-time.

lithography

Printing process based on water repellency: image (printing) areas repel water but are receptive to oil-based ink, non-image (non-printing) areas are water-loving and so repel the oil-based ink. * The vast bulk of printing in the modern world is lithographic.

See off-set.

load

Verb: (1) To copy enough of the application software into the computer's RAM for the computer to be able to open and run the application. (2) To copy a file into the computer's RAM so that it can be opened. (3) Noun: the strain put on the electrical power supply when a device is operating and drawing current. * A heavy load tends to lower the voltage of the supply, reducing the power available to other devices.

logarithmic speed

System for denoting film speeds in which equally spaced steps represent twice the speed or sensitivity. * E.g. in the DIN system, a step of 3° – e.g. from 18° to 21° – represents twice the sensitivity i.e. for a given scene luminance, half the exposure is needed for the same density.

longitudinal chromatic aberration

See chromatic aberration.

lossless compression

Computing routine or algorithm that reduces the size of a digital file without reducing the information in the file i.e. there is no loss of data: this means files cannot be compressed as much as with lossy routines. * E.g. LZW compression and routines used in archiving software e.g. Stuffit, Zip.

lossy compression

Computing routine or algorithm that reduces the size of a digital file but also loses information or data: generally this information is more or less redundant, and its loss allows for a greater compression than with lossless routines. * Compression routines which give the highest compression ratios are lossy e.g. JPEG, MPEG.

See JPEG.

lossy medium

Any material which scatters or absorbs radiation passing through it.

loupe

Magnifier constructed on a stand which holds it at the correct height above the material being examined. * Quality ranges from simple positive lens to a flat-field, achromatic design. * Used to examine textile, print, photograph, film etc.

low contrast

Property of material, reproduction, optical instrument, image, etc. such that variations in brightness in the subject are rendered as smaller variations in brightness or density in the image or record. * In lighting, the property such that shadows are soft and the range between shadow and highlight is narrow.

low key

Image that is darker than average: generally the key tone is darker than mid-tone grey. * In digital images, gamma (usually linked with the mid-tone value) is lower than usual.

low-end

Type of equipment, production or implementation that is

Losing a free lunch or two

If you want the smallest possible file size – say, for illustrating your Web site so that people spend time looking at your site instead of picking their noses waiting for your images to download – then you want lossy compression. JPEG can reduce file sizes to a tenth of their size or less with not much loss in image quality. But new number-crunching, like wavelet maths, may allow improvements in compression ratios without compromise in image quality.

It's all relative

Low-end is more or less synonymous with entry-level, but still suggests that purchasers of such gear are trying to save money, rather than simply having little of it to spend (such people buy entry-level). And it all depends, of course: a low-end scanner to an amateur – costing, say, less than a meal for celebrating something special – is merely an over-sized door-stop to a pre-press professional.

L

cheap, cheerful but sufficient for non-professional needs or for non-critical professional work.

low-pass filter

Filter of optical or software type that lets through low-frequency data and blocks higher frequency data. * Optical type: softening filters used for portraiture are low-pass: they let through the low-frequency data of facial shape and main features, but block high-frequency data such as wrinkles and spots. * Software type: used to reduce noise by smoothing out differences in values of adjacent pixels e.g. by replacing the value of each pixel with the average of that pixel plus its neighbours. * Also known as spatial averager.

See convolution; descreening.

lpi

lines per inch: measure of resolution or fineness of photo-mechanical reproduction. * Defines the half-tone screen ruling used to create a printing plate, hence sets the upper limit on fineness of detail that can be printed. * Normal magazine printing uses screen rulings of 133lpi to 150lpi, up to 180lpi for very high quality. 300lpi may be used for top-notch art reproduction onto top-quality paper stock.

See resolution.

lumen

Measure of the amount of light emitted into space by a light-source i.e. of luminous flux. * A point source of one candela emitting equally in all directions emits one lumen into the solid angle of one steradian (measure of solid angle: about six and a quarter steradians cover a hemisphere).

lumen-second

Measure of the quantity of light or output: the luminous flux of a light-source multiplied by the time during which it emits light.

See joule.

luminaire

Lighting unit comprising the light-source, reflector and other light-shapers or diffusers.

luminance

The amount of light emitted or reflected from a surface. * The luminous intensity emitted or reflected from a surface, measured in candelas per square metre. * A surface with luminance 1 candela per square metre emits or reflects 1 lumen per square metre into one steradian (measure of solid angle: about six and a quarter steradians cover a hemisphere). * Also known as brightness.

Forget Nyquist, just double up

As a general, easy-to-remember rule for doing those tricky resolution sums, assume a screen ruling of 150lpi. With an over-generous quality factor of 2X to make things simple, you will want a file size that can deliver 300dpi over the final image area. This gives a rather bigger file than is required. If that's too big, try using a screen ruling of 133lpi with quality factor of 1.5X, to give an output dpi of about 200. You may find this gives results that are pretty indistinguishable.

luminance range

Measure of level of contrast of a subject: a wide range – due to a large difference between highest and lowest luminance – indicates high-contrast lighting on an object, a narrow range – due to small difference between highest and lowest luminance – indicates low-contrast or flat lighting. * Also called subject luminance range.

luminosity

Appearance to the eye of more or less light or that feature of an object that appears to emit more or less light. * Also known as brightness.

luminous

Adjective: (1) ~ object: one that radiates light or appears bright. (2) ~ radiation: that which has the property or capacity to make itself visible or cause a visual stimulus i.e. visible spectrum of electromagnetic radiation. (3) ~ efficiency: measure of visual response to different wavelengths: high efficiency wavelengths (e.g. green compared to violet) cause a greater visual response.

lustre

(1) Appearance of colour that is seen or appears to be seen through another e.g. as seen in paints containing reflective particles and dyed plastics. (2) Glossiness or shine of polished surfaces. (3) Surface finish to printing papers which is intermediate between glossy and semi-matt.

lux

Unit of strength of illumination: one lux is that illumination produced by a luminous flux of 1 lumen equally spread over a surface of 1 square metre normal to the incident light. * Symbol: lx.

lux-second

Unit of exposure to light: the total amount of light energy applied to a surface over a given time of exposure. * The time-integrated value of illuminance.

LZW

Lempel-Ziv Welch: type of file compression, widely used to reduce file size without loss of data. * It takes a length of data from the incoming stream and gives it a code, then it codes the next length and so on. These codes go into a table together with their number of occurrences: thus the entire data stream may be coded and compressed, without any loss of information. * It is an adaptive compression, used e.g. with TIFF and GIF formats.

See adaptive compression; Lempel-Ziv coding.

It isn't big enough until it matters enough

In practice, the true luminance range in a subject is not what is at issue, it's the luminance range of the bits that matter which matter. Small regions can be as bright or dark as they like, so long as they are small enough to not matter. Classically, for example, specular highlights can be extremely bright, but they are usually ignored when assessing the luminance range.

Mac

Macintosh: proprietary name of computer manufactured by Apple Computer Inc. or, for a short time in late 1980's, clones of the same, all using Mac operating system.

Macbeth ColorChecker

Standard target for colour calibration, testing film, etc. consisting of a pattern of 24 coloured squares printed, on board measuring 230x330mm, to guaranteed standards of consistency. * Colours include primaries and subtractive primaries, neutral greys as well as a series of nominal dark and light flesh colours, leafy and sky colour, etc.

See IT8.

Mach bands

Optical illusion seen at the junctions of dark and light tones in which there appears to be a light area or band in the dark tone and a dark area or band in the light tone. * This has effect of increasing definition of the junction whose transition between the dark and the light may be abrupt or, as originally observed, gradual. * Also known as Mach rings.

machine vision

Programmed evaluation of an image of an object or scene by photo-detectors which are driven by software for specific

Clearer limits

Mach bands are the psycho-physiological sign of a neuronal mechanism which tries to improve edge definition i.e. to help one see more clearly, and it's one which digital techniques such as unsharp masking imitate. The physiological mechanism is called lateral inhibition: a bunch of excited neurons in the eye tends to inhibit the sensitivity of neighbouring neurons.

M

uses e.g. reading car licence plates, identifying shapes, locating defects, etc. * Data from machine vision may be output or used to drive mechanisms e.g. to pick up an item.

macro

(1) Close-up viewing or photographic range: giving reproduction ratios of between about 1:10 and 1:1 (life-size). (2) Small routine or mini-program within larger software program that performs a series of operations: may also be called script or action.

macro lens

Photographic lens designed to produce optimum results within macro or close-up range. * May be optimized, for magnification of 1:1 or less, e.g. 1:5 but usually capable of excellent results when focused at distant objects.

macrophotography

Photography in the macro range i.e. between approximately 1:10 to 1:1.

macroscopic

Small object or detail that is large enough to be seen at close-up distances by the unaided eye.

macula lutea

Area of the retina correlating to the region of highest visual and colour acuity: lying just below the optic disc (where the nerves enter the eye), it is 3-5mm in diameter (representing 5-10% of the visual field) with around twice the number of cones to rods. * The centre of the macula, the fovea centralis, contains all cones and is surrounded by high density of nerve cells. * The macula, apart from the fovea, is yellowish hence also known as the yellow spot.

magenta

Reddish-blue colour: it results from the subtraction or removal of green from white light or from the additive combination of red and blue light. * A subtractive primary colour. * Also known as process red.

Magic Wand tool

Digital image manipulation 'tool' e.g. in Photoshop: used to select pixels more or less similar in value to those first sampled. * Controlled by 'tolerance': low tolerance selects pixels very similar to the sample, high tolerance selects pixels only a little similar to the sample i.e. more pixels will be selected. * Pixels may be selected 'contiguous' i.e. all touching or 'non-contiguous' i.e. not touching.

magnesium fluoride

In photography, a material used for anti-reflection coatings

Marvellous macros

These lenses are often not noticed by the amateur, who generally takes a fancy to the faster, more glam lenses. But if you want sharp, distortion-free, high-contrast and generally impeccable image quality, macro lenses are the best buys on the planet as most are cheap for the tremendous image quality they offer. For 135 format, 50mm is good for flat-copy and small objects, 100mm or so is best for nature photos.

on lenses as it is almost colourless with a low refractive index of 1.38. * It is fairly tough and chemically stable. * Deposited on lenses by vacuum thermal evaporation or electron beam process to form coating only a few molecules in thickness.

magnetic disk

Circular, plastics disk carrying magnetic material on which data can be stored. * The disk is coated with a thin film of ferric oxide or other magnetic material. * The polarity i.e. positive or negative charge of small areas of the coating can be changed or read off by a head carrying a current which rides just above but not touching the disk: the sequence of positives/negatives constitutes the machine code for the data. * This principle is the foundation of most computer storage systems, from hard-disk drives to removable media such as floppy disk, Zip or SuperDisk.

magnification

Measure of how much larger the image of an object is compared to the size of the object. * Various types of magnification according to the dimension being measured e.g. (a) lateral or linear magnification: ratio of length of a given portion of the image to the length of the corresponding part of the object (b) area magnification: ratio of area of image to area of corresponding object (c) angular magnification: the ratio of the apparent angular size of the image seen through the optics to that of the object viewed by the unaided eye.

See empty magnification.

magnifying glass

(1) Simple positive power lens used to enlarge small objects for visual examination. (2) Type of icon in graphical user interface used to signify ability to zoom in or out of an image.

magnifying power

Measure of the ability of an optical system to make an object appear larger. * E.g. a two-times (2X) magnifying power means an object appears twice as large as life-size.

magnitude

In astronomy: measure of the relative brightness of a celestial body. * Based on quantification of observations of Hipparchus in which first magnitude is brightness of brightest star and sixth is that of faintest visible star. * A difference of 5 magnitude steps equates to a difference of 100X in brightness.

When is it a 'k' and why a 'c'?
Konfusion in this category of question is almost kustomary. Actually the convention gaining ground is that 'disk' is for magnetic storage media like floppies, Zips, etc. and 'disc' is reserved for opto-electronic media such as CD (Compact Discs), MO, etc. It's easy to remember then: 'c' for stuff like CDs.

M

Maksutov corrector

Lens used to correct spherical aberration in catadioptric systems i.e. those using mirrors and lenses to form an image. * Meniscus lens set concentric with the centre of curvature of the primary mirror.

Mangin mirror

Lens-shaped element with a mirror coating at the second or rearmost face: the first spherical surface acts as a corrector for spherical aberrations introduced by the spherical mirror at the back.

marching ants

Graphical user interface device for making it easy to see the margins of a selected area: instead of using a static line, the margin is animated with black and white dashes which appear to jog along, looking like ... you guessed it.

marginal rays

Light which passes through an optical system away from the optical axis, towards the edge of the lens aperture.

Misleading names

Marginal in name but not in effect: while these rays may appear to be dismissed, they are the ones responsible for many of the image quality problems we have to deal with. Marginal rays become more of a problem as the field angle increases.

marquee

Selection tool used in image manipulation and graphics software. * So-called presumably because it covers a rectangular area as it is used.

mask

Noun: (1) Technique used to selectively obscure or hold back parts of an image while allowing other parts to show. * It may be physical (e.g. sheet of paper, image on film) as used in the darkroom to hold back foreground while burning in skies; chemical (e.g. certain colours or parts of image are bonded with a chemical to render them inactive) as occurs in the Sabattier effect or in photomechanical reproduction; digital (e.g. a selection is laid over another layer or turned into an alpha channel). (2) An array of values that is used by the computer in digital image processing to calculate digital filter effects such as unsharp masking, noise reduction or increase etc. * Array or matrix of coefficients used in convolution of a kernel in image processing. * Sometimes used synonymously with 'kernel'. (3) Screen-like structure drilled with holes to direct electrons from cathode-ray tube to appropriate colour phosphor; used in colour monitors. (4) Verb: to make and apply a mask to an image.

master

(1) Noun: original or first, and usually unique, incarnation of a photograph, file or recording: the one from which copies will be made. (2) Adjective: ~ copy: that from which copies

are to be made e.g. master duplicate. (3) Verb: to make the first copy of a photograph, file or recording e.g. to master a CD is to create a new CD from which others may be made. (4) To have climbed up the learning curve of some software to the point where you can actually do some useful things with it.

mat

(1) Card-mounted display for prints. (2) Home for the computer mouse, its special run: an area meant to be free of coffee cups, pens and ashtrays to allow the mouse to work unhindered.

See matte.

match

Being identical in appearance in one or more specified regards.

See colour match.

matching

Process of comparing a test sample of print, print-out or other output against a source or standard in order to make adjustments in the devices used so that the colour, tone and brightness reproduction of the test looks the same as the source or standard.

matrix

(1) The flat array of CCD sensors. (2) Mathematical technique that arranges numbers into a grid or array in order to facilitate calculations: used in programming of image processing filters e.g. sharpening, noise reduction.

matt

Quality of a surface which appears equally bright when viewed from any direction: it diffuses light effectively. * When illuminated it reflects light more or less equally in more or less all directions: no material or surface is perfectly matt, but fine powder coatings can be highly matt. * May be spelt 'matte' in some usages.

matte

(1) Box-shaped accessory placed in front of camera (usually cine or video, can be stills) lens to act as lens-hood or to hold accessories such as vignettes, gels. (2) Card or conservation board whose centre is cut out to create a window to display prints: a standard way to display fine-art prints as the precious things are protected from abrasion yet can be seen easily, without the distraction of any covering. (3) Mask that blanks out an area of image to allow another image to be superimposed: the mask is usually cut out to be

M

the same size and shape as the image to be superimposed – as used in film and digital image manipulation.

Maxwell triangle

Diagram showing intersecting circles of red, blue and green representing the essential trichromatic combinations of additive colour.

measuring eyepiece

Design of eyepiece used in microscopes: it carries a ruling which appears superimposed on the focal plane. * Objects seen in the microscope may be measured by the ruling and their size calculated from the magnification and ruling interval. * Also called an eyepiece micrometer.

mechanicals

Final pages or artboards complete with pasted up pictures with galleys of type and other details such as colour swatches set up and camera-ready for the printer to work on to produce the printing plates. * English usage prefers 'art-work' although this tends to cover everything apart from type and text.

median filter

Digital technique for reducing noise in images. * The central pixel value is replaced by the median value (mid-value between the extremes) of the surrounding four or eight pixels. * A rather crude filter, offering no control.

medium

Noun: (1) Material or method used to print out, store or publish data, images, text, etc. * Plural: media. * E.g. storage media: various methods of keeping data, such as hard-disks, CDs. (2) Mode or method of delivery, dissemination or publication of created content. * E.g. print medium: printing content on paper for publication; electronic medium: using electronic techniques for disseminating content. (3) In physics: types of matter through which an electromagnetic wave may propagate. * E.g. glass is a medium through which electromagnetic waves or radiation such as light can propagate. Adjective: (4) In photography: a value more or less half-way between two given extremes. E.g. ~ film speed: between slowest and fastest films. * In general usage, more likely to indicate a median value i.e. one in the middle of the range, rather than an average value.

mega

One million i.e. 1,000,000. * Prefix used in SI system to signify 10^6. * May also indicate binary million, i.e. 1,048,576 or 2^{20}. * Abbreviation: M in either case.

Surviving digitization

The original meaning of the term is now largely obsolete thanks to digital techniques killing off the camera operator, but it struggles on to mean anything which brings together the various elements of a page in more or less final form.

megapixel

Million pixels: measure of information capacity of image capture device, usually digital camera based on total number of pixels nominally available on CCD or similar sensor. * E.g. a 3-megapixel camera may offer some 3.34 million pixels on the sensor.

meniscus lens

Lens element with one surface convex, the other being concave. * Most spectacle lenses are meniscus types. * It is also widely used in disposable cameras.

meridional

See tangential.

meridional ray

Any ray of light which lies in the plane containing the optical axis.

mesh

See wire-frame.

mesopic vision

Vision at light levels at which both retinal cones and retinal rods are stimulated. * Vision intermediate between photopic and scotopic. * Also known as twilight vision.

metamerism

Visual psychology effect in which the apparent colour of an object changes with a change in the colour of the illumination falling on it. * A metameric match is obtained when two physically – i.e. spectrally – differing colours appear to the eye to be the same.

metric

(1) Adjective: derived from or based on system of measurements founded on the Standard Metre. Noun: (2) Data or rules used by applications software to define or draw objects e.g. for fonts in desktop publishing. (3) Any system or method for measuring or quantifying visual or other experiential phenomenon. * E.g. Zone system represents attempt to provide a metric for tonal analysis.

metric photography

See photogrammetry.

micro

One millionth part. * Prefix used in the SI system to signify 10^{-6}. * Abbreviation: μ.

micro-optics

Small to very small optical components such as lenses used in e.g. endoscopes. * Diameter of the lenses may be 2mm or even smaller.

Mega complicated chain

It would be nice if the number of pixels on the capture device actually bore a direct relationship to the image resolution or some measure of the information that is actually captured; but life is not so easy on us. The fact is that colour information is captured in groups of four pixels: two for green, one each for red and blue (or, rarely, two yellows, one each for magenta and cyan) so each pixel's value must be extrapolated from the values of its neighbours. How exactly this is done are usually the proprietary secrets of the chip manufacturers. Besides, the topography of the sensors themselves vary e.g. with Fuji's array rotated an eighth turn compared to others – so you can never easily work out how the sensors arrive at the final image. Whatever method is used, rest assured it's not straightforward to get from number of pixels to image resolution.

M

Just so we know
To add to the fun, people on Continental Europe (as opposed to those living on the Continental Shelf) generally use the term microphotography to mean the photography of terribly little things enormously enlarged i.e. what others call photomicrography. Which, of course, is not to be confused with the microphotograph – an extremely small photograph. What I cannot find out is the name for the process of producing a microphotograph – probably because it's something like 'photomicrophotography' – which of course no-one in their right mind would admit to.

micro-photography

Photography of small objects from life-size to modest enlargements of up to about 10X. * Such photography can be undertaken by normal cameras equipped with modestly specialized equipment e.g. bellows attachment and reversal of lenses: greater scales generally need microscopes.
* Compare with photomicrography: photography through microscopes.

microdensitometer

Instrument used to measure transmission of film, etc. over very small diameter apertures. * Used to calculate density of film, measure granularity, etc.
See grain.

microfiche

Storage medium for printed pages on which images of pages are reduced 20X-25X: a microfiche reader enlarges the pages onto a screen for reading. * One standard uses A6 sized sheets of film coated with high-resolution, high-contrast emulsion, on which 60-100 pages are stored using a microfiche camera.

microfilm camera

Instrument designed to photographically reduce original material by 30X or more onto a strip of film.

micrometer

(1) Adjective: ~ drive: mechanism using precision screw to control device e.g. movement of scanning head. * A very fine pitch of screen coupled with rapid rotation combines high precision movement with practical speeds. (2) Noun: Instrument used to make accurate measurements of e.g. thickness of materials.

micrometre

Measure of distance in SI equal to 10^{-6}m. * Also known as micron. * Abbreviation: μm.

micron

See micrometre.

microphotograph

Highly reduced and/or very small photograph. * Beloved of spy tales, in which several pages of documents are reduced to fit onto film no larger than a spot about 1.5mm in diameter. * Invented in 1853 by J B Dancer. * Compare with micro-photography.
See photogmicrography

microreciprocal degree

See mired.

microscope

Optical instrument designed to give a very high magnification image of very small object. * Optical microscopes consist of (a) a tube 160mm long with (b) an objective lens at the object end and (c) an eyepiece at the viewer end plus (d) a stage on which the object is carried and finally (e) a lighting arrangement, usually in the form of a sub-stage condenser focusing a light-source into the objective. * The objective forms an aerial image of the object on the focal plane of the eyepiece which enlarges the image for the viewer's eye.

See electron microscope.

microscope immersion fluid

See immersion fluid.

mid-tone

Tonal value midway between highlight and shadow i.e. 50% grey or 50% of dot area covered in ink or a grey level of 128 on 8-bit grey-scale.

mid-tones

That range of tones which lie between highlights with detail and shadows with detail. * Usually represents the portion of tone reproduction in which gradations change in proportion to change in brightness. * Compare with mid-tone.

mil

One thousandth of an inch. * Largely obsolete but may be used by Americans to refer to thickness of paper or gauge of thin items. * English usage prefers the thou (as in 'thousandth').

milky

Appearance of cloudiness or lack of clarity in a substance or material. * Usually a sign of a problem. * E.g. partially fixed film is milky in appearance; chemicals take on a milky look when they are exhausted or not fully mixed.

milli

Prefix meaning one-thousandth, 10^{-3}. * E.g. millimetre is one thousandth of a metre. * Abbreviation: m.

milling

Process of generating a surface shape on e.g. glass using abrasion by tools.

minus

Adjective: (1) Cutting out or reduction of a colour e.g. minus red is the removal of red by a filter (which consequently appears green); a magenta filter is minus green (it appears blue-red to the eye because it cuts out green from white

If nature abhors a vacuum

Then photography abhors the milky: clarity in all things photographic is the root of all goodness. Film should be clear, as should lenses and all chemical solutions. Even the monitor screen: there is little more clearly indicative of a sloppy worker than one who tolerates dust and muck on their screen which should gleam as sparkly as the day it left the factory.

M

light), and so on. (2) Negative power: e.g. a minus element is a negative power or diverging lens.

mirage

Apparent distortion of an image caused by the condition of the atmosphere between the object and the viewer. * Marked differences in the temperature of layers of air cause variations in the refractive index of the atmosphere, which bends light rays abnormally.

> *See fata morgana,*

mired

Micro-reciprocal degree: measure of colour temperature of light-source. * Equals the reciprocal of the colour temperature multiplied by a million. * Also reciprocal megakelvin or microreciprocal Kelvins (M/K⁻¹) or mireks. * Filters used to raise or lower colour temperature may be nominated by their 'mired shift'.

mirek

Micro-reciprocal Kelvin degrees.

> *See mired.*

mirror

Any surface designed to reflect radiation of a specific range: it may be flat or curved, usually very smooth for efficient reflection. * The actual reflecting surface is not necessarily the first surface encountered by the light rays.

mirror cut-off

Darkened upper portion of a single-lens reflex viewfinder image. * Seen when long-focal length lenses or extreme lens extensions are used. * Caused by use of a mirror that is not sufficiently long to catch all the light rays.

mirror lens

Optical system using only curved mirrors to form the image. * Contrast with catadioptric systems which use both mirrors and lenses. * Used to form image with ultraviolet or infrared radiation. * Also known as catoptric lens.

mixing

(1) Combination of different components so that they are thoroughly interspersed among each other e.g. of chemicals or coloured light as in colour enlarger. (2) Superimposition of two or more channels or streams of data in e.g. digital image manipulation, music, video for a desired result. (3) Combination of light beams – e.g. laser – of different frequencies so that a single beam is formed whose frequency is either the sum or the difference of the original beams' frequencies.

Computational shenanigans

*This is the kind of arithmetical fiddling that drives normal people crazy. The point is to correct a non-linearity: a unit change of colour temperature at one end does not have the same effect as a unit change at the other, whereas with mireds (and sons of mireds, the decamireds) a unit change as caused by e.g. a filter has visibly about the same effect. * It is intended to approximate the smallest change in hue that is detectable by the human eye – but you're forgiven for being suspicious that the figures come out so neatly.*

M O

Magneto-Optical: type of digital storage technology. * In writing, when a spot on the media is heated, its polarization can be changed by an electromagnet on the other side of the media. For read-out, a laser beam is pointed at the media and the polarization state of each spot is determined. * A stable and reliable medium, but its slower speed and higher cost has restricted adoption.

mode

Method, state or manner of operation or function. * E.g. passive mode is a method of working that does not use an active beam of energy (as in auto-focus); simple mode is one that removes advanced options; safe mode is one with only basic programs loaded (the PC equivalent of 'extensions off' on Mac OS).

modem

Modulator-demodulator: electronic device that can both change (modulate) signals from a computer into a form that can be handled by a telephone system and change back signals from the telephone system into a form the computer can handle (demodulate). *Modems must speak the right language i.e. conform to standard protocols in order for the phone system to accept them e.g. V90. * The rate at which modems can transmit data is measured in baud.

modular

System of software or hardware in which more or less self-contained modules or parts are integrated or designed to work with each other in such a way that each module adds features or functions to the overall system. * Professional camera systems are highly modular: each module adds a specific function or capability to the camera. * Software such as QuarkXPress and Adobe Photoshop are arguably modular in that extra functions can be added by inserting Xtensions or Filters or Actions into the programs.

modulation

Alteration or change in one quality or signal by another factor or signal e.g. contrast in the subject is reduced or distorted by the imaging system: the system modulates the subject contrast. * Strictly: the change to a wave train caused by the superimposition of another wave. * May be used to mean contrast, in optical testing.

See MTF.

modulation transfer function

See MTF.

Revolution in a box

We go gooey over the revolutions wrought by the Internet but who gives a thought to the humble box that wheezes and squeaks when you wake it up? Without the modem, you can kiss good-bye to a great idea. Modems made it possible to use ordinary phone lines laid in their drillion miles all over the world. Otherwise a whole new infrastructure would have had to be laid ... ask the cable companies how much trouble that would have been.

M

moiré

Apparent pattern of alternating light and dark lines or rings seen when two or more regular patterns are superimposed. * It results from the interaction of two regular patterns such that where dark lines of the two patterns are superimposed, the resulting pattern looks bright, and where the dark lines lie between each other, the pattern looks dark: over a distance this alternates at a frequency related to the difference between the frequencies of the two patterns. * Moiré is seen when e.g. stripes on a shirt are imaged on a TV screen.

monochromatic

(1) Light made up of one wavelength or wavelengths lying in a very narrow range e.g. light from a laser. (2) Photograph or image displaying a very limited range of hues e.g. a cyanotype (blues) or, more loosely, e.g. a landscape of reds and yellows. * Compare with monochrome.

monochromator

Instrument for isolating narrow bands of the spectrum. * A prism or diffraction grating spreads out the spectrum of a light-source which is masked by a narrow slit. Changing the position of the slit changes the band selected. To improve purity, the first band may be spread by another prism or grating and again masked. * Contraction of monochromatic illuminator.

monochrome

Photograph or image made up of black, white and greys. * Strictly the greys are neutral in colour but in practice they may be somewhat coloured or tinted and still be described as 'monochrome'.

monocular

(1) Instrument with a single eyepiece e.g. telescope, microscope, single-lens reflex camera. (2) Image or perception from a single angle e.g. as seen by one eye.

monolithic lenslet module

Array of micro-lenses used e.g. over CCD arrays in digital cameras to improve light-gathering performance. * The lenses may be round, square or hexagonal in shape, and are 20μm or less in diameter. * Used also in photronics with lasers and fibre-optic testing.

morphing

Image manipulation or computer animation technique used progressively and smoothly to transform one shape or image into another.

mosaic

(1) Regular grid of sensors: an array. (2) Image made up of small areas of uniform colour chosen from a limited range of colours. * Possibly the result of applying a mosaic filter.

motherboard

Flat piece of insulating material onto which is printed the circuitry connecting the components and devices of a computer such as the main microprocessor, the memory as well as connectors for plug-in cards and input and output devices.

motor-drive

Camera component or accessory which winds on the film and cocks the shutter automatically; may also rewind film.

moulded lens

Optical component, one or both sides of which are shaped under high temperature and pressure. * Formerly used for non-critical components such as lenses for condensers and viewfinders, particularly to create aspheric surfaces, but increasingly being used for photographic lenses thanks to ceramic moulds which reliably produce accurate aspheric shapes.

movement

See camera movement.

movement parallax

Visual phenomenon in which two objects travelling at the same speed and direction appear to be moving at different speeds. * Seen when the two objects are at different distances from the observer.

MPC-3

Multimedia Personal Computer-3: standard for multimedia system compliance arrived at by consortium including Microsoft and Philips. * Obsolete. * Do not confuse with MP3.
 See QuickTime.

MPEG

Moving Picture Experts Group: digital standards for video and sounds including compression standards and file structure consisting of layers carrying video data in a hierarchical form. * Do not confuse with Motion JPEG.

MTF

Modulation Transfer Function: measure of the quality of performance of an optical system based on the comparison of the contrastiness of the image projected by the system with the contrastiness of the original subject. * A perfect system would project an image that is as contrasty as the

It all sounds the same to me

The Internet music format is called MP3, which is short for MPEG-2 Layer 3: which, just to confuse things, is not a motion picture standard at all. It is audio only (maybe why it is also called MPEG-2 Audio). It compresses audio files by as much as 12 times with quality loss being evident only to golden-eared audiophiles (the main consumers of MP3 are half-deafened already).

M

original: real systems lose some contrast due to imperfections in lens design and manufacture, lens flare, diffraction effects, and so on.

muddy

Appearance of print in which tone reproduction is low in contrast, lacking deep blacks or brilliant whites.

multiband camera

Instrument for capturing images in a variety of wavebands: usually consists of a set of three or more cameras loaded with different films and equipped with appropriate filters and lenses to suit a different section of the spectrum. * Used in survey and spy aircraft.

multicoated

Adjective: referring to lens elements of optical system with many layers of lens coating (of transparent dielectric material) to increase transmission of light and reduce reflection: layers are usually arranged with alternately low and high refractive index. * Multicoating can ensure optics transmit nearly 100% of incident light and help ensure a neutral colour image by compensating for colour of glass or pass specific wavebands of light.

See coated optics; lens coating.

multifocal lens

See vari-focal lens.

multigrade

Adjective: (1) ~ paper: black & white printing paper whose contrast grade varies with the composition of light. * Also known as variable contrast or vari-contrast paper. (2) ~ enlarger: one with a specially designed light-source designed for working with multigrade papers. (3) ~ head: light-source for enlarger designed for multigrade papers, either using a filter in front of one lamp or varying the mix of light by controlling two lamps – usually specified so that changing grades does not alter exposure.

multilayer

(1) Anti-reflection and protection coating on lens consisting of several layers. (2) Film or paper emulsion coating consisting of several layers e.g. with sensitivities to different wavebands. (3) Digital image consisting of more than one layer, with each carrying a different part of the image, or text or an alpha or other channel, etc.

multiple exposure

Photographic technique in which more than one exposure is made on the same piece of film.

multiple lens camera

Instrument for capturing brief events at extremely high frame rates: consists of a multi-faceted rotating mirror at the centre of arc of lenses. As the mirror rotates it projects images into the lenses . * The images are recorded on a stationary piece of film. * Frame rates running several million frames per second are practicable.

multiplex

(1) Verb: to combine two or more signals or types of data e.g. for transmission; for slide projection or creating an image or record. (2) Noun: the combination of two or more different types of data e.g. audio and video with synchronization. * Also known as MUX (pronounced 'mucks').

multiscan

Monitor or cathode-ray display accepting different timings for the horizontal scans and vertical intervals thus allowing different resolutions of display.

multisession

Multiple session: format for CD-ROM which allows data to be added at different times. * Each session requires a fixed amount of space for register information, so less data can be stored on a CD written over many sessions than one written in a single session.

multispectral photography

Use of special filters and films to image land-use and other features not easily discernible in normal photography. * The filters transmit only a very narrow part of the spectrum and are matched to films with suitable spectral sensitivities. * Do not confuse with multiband photography.

Munsell system

Atlas of colour attempting to space standard colour patches at equal intervals based on hue, value (lightness) and (chroma) saturation values. * A colour may be defined by three-dimensional alphanumerical coordinates (hue, value, chroma) in the system.

myopia

Condition of the eye in which distant vision is blurred: the image of a distant object is focused in front of the retina when accommodation is relaxed. * A negative lens in front of the eye corrects this refractive defect. * Also known as nearsight or short-sightedness.

n
> Symbol for refractive index of a medium. * A subscript, where present, denotes the applicable wavelength.

nanometre
> A standard unit for measurement of length: 10^{-9}m, commonly used to measure wavelength of light. * Based on the standard metre, itself based on measuring the wavelength of a precisely fixed colour.
>
> *See Å.*

narrow-band filter
> Type of filter which transmits light over only a very restricted range of wavelengths or over narrow spectral bands. * Usually made from thin dielectric materials and works with the help of interference effects to limit wavelength spread.

native
> (1) File format belonging to an application program, usually structured optimally for the parent software. (2) Application program written specifically for a certain type of processor e.g. for the PowerPC processors of PowerMac.

navigation
> (1) Structure, organization or architecture of elements of

Web site, multimedia programme or other organised information plus the links and methods of moving through the Web site, etc. (2) Process of moving from one part of a Web site or multimedia programme, including use of hyperlinks, etc., graphic elements such as buttons, signs, etc.

ND
Neutral Density filter.

near-letter-quality
Print-out from printer which approximates that of a printing press. * Formerly applied to dot-matrix printers.

near infrared
The shortest – i.e. nearly visible wavelengths – of infrared radiation i.e. over the range 0.75 to 3 μm, approximately.

near point
(1) Point closest to the lens that is rendered acceptably sharp, for a given focus. * Used in calculations for depth of field. (2) The closest comfortable viewing distance of the unaided human eye. * Nominally 250mm; but this distance generally increases with age.

near ultraviolet
The longest – i.e. nearly visible wavelengths – of ultraviolet radiation i.e. over the range 300 to 400nm, approximately.

nearest neighbour
Type of interpolation in which the value of the new pixel is copied from the values of the nearest pixels.
See interpolation.

negative
Noun: (1) Image in which the tone reproduction is reversed from that in the subject. (2) Film carrying a negative image after processing.

negative carrier
Component of enlarger, scanner or other device holding film: it grips the film at the edges to avoid scratching the image, is designed to hold film flat and parallel to the lens plane or scanning array.

negative distortion
Lens aberration in which magnification drops from the centre to the edge of the image: a straight line is imaged as curved, with the ends curving towards the centre of the image. * Also known as negative geometry; barrel distortion.

negative lens
Type of lens which causes a parallel beam of incoming light to diverge on exit: by convention it is taken as negative power.
See concave lens; diverging meniscus.

Flat-earth? Fat hope.
In fact, there are very precious few negative carriers that really hold the film flat – and these use two plates of glass which also do an excellent job of holding dust and fluff at just the right distance from the lens. The best ever was Leitz's design using just one glass plate but that works only for small film formats. Some scanners get round the problem by continuously varying focus as they scan: but your piggy-bank had better be fat and full if you want one of these.

negative stereoscopic image

What is seen when a stereo pair of images is switched so that the right eye sees the left-hand image and the left eye sees the right-hand one. * This reverses the stereo information, thus reversing depth perception: what is prominent appears to recede, what recedes appears to protrude.

neutral density filter

Accessory used to reduce light intensity without changing colour balance of light: it reduces all visible wavelengths equally. * Filter made of glass, polyester or gelatin which is dyed or coated with neutral colour: used e.g. to allow large aperture to be set on a lens when fast film is used on a bright day. * Also known as a grey filter.

neutral mixture

Combination of colours that results in a visual grey i.e. it is lacking in hue: colours may be combined additively or subtractively.

Newton's rings

Pattern or series of rings or bands seen when e.g. film is placed on glass or two sheets of glass are placed together. * Caused by interference between light waves reflected from the surfaces together with the contribution of refraction by the thin layer of air of varying thickness trapped between the two surfaces. * Used to check flatness or goodness of fit of a sample to a test glass in optical manufacture. * An optical phenomenon that is destructive of image quality in scanning when film is placed on a glass surface: avoided by using scanner oil to fill the air-space.

See anti-Newton.

Newtonian telescope

Simple type of catadioptric telescope. * Consists of a concave paraboloidal objective mirror with a small flat secondary mirror on the main axis which reflects rays from the primary mirror laterally. The image is viewed with an eyepiece pointing at the secondary mirror i.e. looking at right angles to the main axis.

NF

Naturally Flat: design of cathode ray tube in which the front of the screen is flat in both axes. * This reduces screen image degradation from stray reflections and from distortion of the image by a curved tube but lesser, more complicated distortions remain.

See FST.

Measures for busting the ring

If you try to reduce Newton's rings by squeezing the film closer to the glass the problem only gets worse. The best is to use anti-Newton glass which has been treated to a polished kind of dimpling that optical scientists call 'orange peel' – a microscopic version of the wrinkly glass in bathrooms. Some people recommend warming the whole thing with a hair-dryer to dry out the film. Hmmmm. The best way is to use an oil with a refractive index between that of glass and film – as used for drum scanning.

Flat-out clever

Today's top-rank monitors combine large size (22" across the diagonal) with totally flat screens in a way once thought impossible. What it takes is horrendously complicated mathematics applied to the electronics for bending the cathode rays so that they converge perfectly even in the far corners of the screen. Plus an aspherical field-glass to bend the light from the phosphors. And the precision of manufacture needed (three phosphors for each of the 1600x1280 screen pixels?!) staggers belief too.

NiCd

Nickel Cadmium: key component of a type of rechargeable cell or battery. * Falling out of favour due to environmental concerns and memory effect – in which recharge of a partly discharged battery does not hold a full charge. * Pronounced 'nye-cad'.

See NiMH.

night-viewer

Viewing instrument which enables user to see in extremely dim, low-light situations. * Uses photomultiplier tubes – usually more than one, working in a cascading series – to amplify existing light, which may be visible or infrared. * Also known as scotoscope, night vision device.

NiMH

Nickel Metal Hydride: type of rechargeable cell or battery. * Compared to NiCd, it offers less memory effect, longer life and more rapid recharging.

nit

Unit of luminance: equals one candela per square metre. * One nit equals 0.094 foot lambert.

nitrogen-burst

Type of processing in which agitation to chemicals is given by bubbling nitrogen through the solution. * Used to give controlled continuous or intermittent agitation in film processing. * Nitrogen is preferred because it is chemically inert with photographic chemicals.

nodal points

In geometrical optics: the two points on the axis which are positioned such that a ray entering one point leaves the other at the same angle as it meets the first point. * In general, object distance is measured from the front nodal point, the image distance from the rear nodal point. * In practice, rotation of the optic about its rear nodal point changes the part of the subject imaged, but does not change the position of the image: it therefore defines the axis of lens rotation for panoramic photography.

nodal testing

Measurement of main optical properties of a lens and the image it projects: including effective focal length, back focus, nodal point separation, T-number as well as higher order properties such as lens aberrations. * Testing of resolution or MTF require a different set of tests.

node

(1) Computer linked to others in a network or on the

Internet. * Strictly, any point at which data are interchanged. (2) Word or short phrase that is linked to other text elsewhere in a hypertext document e.g. as used in Web pages on the World Wide Web; also in help screens for programs.

noise

Unwanted signals or disturbances in a system that tend to reduce the amount of information being recorded or transmitted. * In scanners: may be caused by electrical disturbance, mechanical instability. * In digital cameras: may be caused by thermodynamic fluctuations (heat) causing disturbances in the minute currents generated by the CCDs or CMOS sensors.

noise filter

Image manipulation technique used to reduce or increase noise in an image. * To reduce noise, the filter reduces the difference between values of adjacent pixels or groups of pixels; to increase noise, the filter exaggerates local differences in values.

Nomarski microscopy

Minute examination of smooth surfaces using illumination techniques exploiting polarization and phase shift effects to show up defects in a plane surface as different colours.

non-actinic

Light of a wavelength which does not affect light-sensitive materials e.g. red light is non-actinic to lithographic film.

non-linear

Adjective: (1) Relationship between two variables which is not constant e.g. response of film to light is non-linear. * The output from the sum of two inputs cannot be deduced by calculating the inputs separately. (2) Data stored in such a way that it is accessible or editable in any order: e.g. music clips on hard-disk; this is in contrast to linear data such as tape or wire which can be read sequentially only. (3) Optics of certain characteristics of laser light some of which are cumulative in effect.

non-read colour

Ink formulated to dry to a highly reflective finish which cannot be read by a scanner or optical reader. * Also known as non-scan ink.

nonsilver

Adjective: photographic processes which are not based on the action of light on silver halide salts, but on e.g. iron salts, impregnated plastics, etc.

No noise can be bad news

Noise, despite its pejorative overtones, is not necessarily always a bad thing: some noise added to e.g. a smooth gradient can help prevent banding caused by unevenness of printing, particularly where the printer head runs parallel to the band of colour. Noise in a digital image prevents it from looking too artificially smooth. A few moles and pimples on Lara Croft would make her more real ... as if that matters to anyone.

normal

Adjective: (1) ~ development; ~ process: one which produces a standard result e.g. the usual film speed or density.
(2) ~ contrast: average in tonality, in which all tones from white to black are represented or visible, with more or less equal progression of tones. Noun: (3) An axis or line lying perpendicular or at right angles to a surface.

normal lens

See standard lens.

notch

Cut into edge of film, rule, etc. to identify position, etc.
* Used to enable large format film to be identified in the dark as to (a) film type (b) emulsion side.

notch filter

Type of filter designed to block a very narrow range of wavelengths of radiation. * The opposite of a narrow-cut filter, i.e. a notch filter lets through most wavelengths.

nox

Equal to one-thousandth of a lux (10^{-3} lux). * Handy for measuring low light.

NTSC

National Television Standards Committee: broadcast and video standard used in United States and certain of its dependencies. * Runs at 525 lines, nearly 60 fields per second and 30 frames per second. * Based on the YIQ colour model.

nudge

To move a graphic element or picture by a small distance.
* In a bit-mapped image this distance cannot be less than a pixel width, but in outline or vector graphics, the limit is set by the application.

null lens

Lens used to test the accuracy of aspheric lenses.

numerical aperture

Measure of light-transmitting power of optical systems, usually applied to microscopes. * Equals the sine of the angle between the normal ray and the furthest ray entering the system multiplied by the refractive index of the medium.
* Microscope objectives may quote their 'speed' as the NA.

Nyquist criterion

In digitization, the 'rule' that the sampling frequency should be at least twice as high as the highest frequency – of sound, image detail, etc. – which is to be resolved. * Where this condition is not met, aliasing occurs: this may be visible

Feel in the dark and find me

By convention, the emulsion side of large-format film lies under the thumb when the film is held near its edge in the right hand between thumb and second finger such that the notches lie under the first finger. This is fool-proof but you need to practise in the light to convince yourself it works every time. For left-handers, the emulsion side is obviously under the second finger, with the film held in the left hand and the notches falling under the fore-finger.

as irregularities in the sample, particularly with straight lines angled to the raster or scan, or with smoothly curved lines.
See aliasing; Nyquist rate; stair-stepping.

Nyquist rate

In signal processing theory: the sampling rate needed to turn an analogue signal into an accurate digital representation of it is twice the highest frequency found in the analogue signal. * For example: if the highest frequency we want to record is 20kHz, then theory says the Nyquist rate is 2 x 20kHZ = 40kHz i.e. the sampling rate required to avoid aliasing. * If the sampling rate is less than the Nyquist rate, artefacts are introduced: this is the cause of stair-stepping or jaggies seen in images. * Also known as Nyquist limit. * Harry Nyquist is the man to blame.
See quality factor.

nystagmus

Rapid, involuntary and repetitive movements of the eye. * Micronystagmus (physiological nystagmus) is the very small movements which are healthy and occur when the eyes fixate on an object. * There are numerous other types of nystagmus – characterized by easily visible movements – which are mostly pathological in origin.

object

Noun: (1) What is seen or imaged by an optical system. * It may be the actual object, or a real or a virtual image of the object which has been formed by another optical system. (2) In programming, variables – i.e. routines with data – which are treated as discrete entities. (3) Adjective: ~ code: machine language or lowest level code which a computer can read and respond to directly. * Output of a compiler or assembler when given higher-level code.

object-oriented

(1) Page description language that uses basic objects and actions such as line, fill, rotate etc. to define graphic objects such as letters and designs. * E.g. PostScript language. * Such languages are resolution-independent i.e. resolution is not defined by the file itself but by the output device. (2) Type of programming language e.g. C++ that uses basic, self-contained objects such as data structures, windows, sets of functions etc. which interact with each other in order to produce application software.

See bit-mapped; vector graphics.

object beam

One of the two beams of laser light used to create a

hologram. * The object beam is directed onto the object to be recorded from which it is reflected to interfere with the reference beam: the resulting interference pattern is recorded on the holographic film.

object distance

Gap or distance between the object and the first surface of the optical system viewing the object e.g. cornea of eye, or lens of camera objective.

objective

(1) Optical element closest to the subject which receives light from the subject and projects it into the rest of the optical system. (2) Camera lens: the entire optical assembly that receives light from the object, then focuses it for projection into the camera body.

objective grating

Optical component used to measure relative brightness of stars.

oblique

Adjective: (1) ~ errors: off-axis lens aberrations such as abaxial spherical aberration, coma, etc. (2) ~ lighting: illumination of an object from an angle to the optical axis e.g. as is usual in photography. (3) ~ aerial photography: photographs of the earth made from the air which are not taken vertical to the earth's surface. (4) Letter form created by slanting or distorting a standard Roman or Book font to make it look like an italic face. (5) Backward-slanting letter-form i.e. reverse of italic. * NB: mainly US usage.

OCR

Optical Character Recognition: technology for 'reading' scanned images of text i.e. analyses bit-mapped images of printed text to turn them into letters in a word-processor document.

octet

Group of eight bits of data. * Term commonly used in data communications. * Distinguished from byte in that the bits in an octet may not be related to each other or mean anything as a group.

ocular

Optical components closest to the observer's eyes. * Also known as eyepiece.

OEM

Original Equipment Manufacturer: builder or source of equipment such as computers, scanners, digital cameras, printers, etc. which supplies to other manufacturers to re-

badge or alter products cosmetically. * May sell under its
own name at the same time as others are available.

off-line

(1) Mode of working with data or files in which all required
files are downloaded or copied from a source to be accessed
directly by the user, without direct connection with the data
source e.g. pages of Web site are viewed on user's computer
with no connection to the Web site itself. (2) Separation of
data analysis from data monitoring e.g. in production or
process control. * This introduces a time-lag into corrective
measures. * Antonym for both meanings: on-line.
> *See node.*

off-load

Processing of data by moving it to another device or part of
a network in order to free up immediate resources. * Used in
processor-intensive production e.g. 3-D rendering.

off-set

(1) Verb: to transfer ink or dye from one surface to another
before printing on final surface. * Also occurs inadvertently
when printed material or photographic prints are pressed
together. (2) Adjective: ~ lithography: that which transfers
ink from the plates to a rubber mat which then transfers the
ink to the paper. (3) Noun: alignment of calibration or other
marks or parts of image to achieve required effect: e.g.
shadows for lettering are off-set from the text to achieve
their effect; fiducial or crop marks may be off-set to
distinguish left from right.

oil-immersion objective

High-power microscope objective which requires the small
space between the microscope slide and the front element
to be filled with an oil whose refractive index is the same as
that of the lens.

OK sheet

Proof or printing which has been approved by the customer
or quality supervisor.

Olympic filter

Type of filter which discards the extreme top and bottom
values of e.g. a grid of pixels, before making a calculation.
* Named after practice at some Olympic games in which
extreme scores given by judges on a panel are discounted
when calculating the average.

on-line

Mode of working or operating with data or files in which the
operator maintains connection with a remote source e.g.

O

when working on the Internet an operator is on-line to the Internet. * E.g. an on-line picture service allows you to download an image from a library of images against payment of a fee. * Antonym: off-line.

See in-line.

one-shot

(1) Imaging device which makes a colour record during a single, brief exposure. * As opposed to those which make three separate exposures or require a long exposure to allow a photo-detector array to scan the image. (2) Chemical preparation which is designed to be used once, then discarded e.g. one-shot developer. * Such preparations are not designed to be replenished.

one-time use

Licence for publication or broadcast of copyright material which permits material to be used only once, after which the licence expires.

one-to-one

Life-size reproduction. * An image magnification of 1:1 or 1X i.e. the image is the same size as the object.

opacity

(1) Measure of a medium's ability to restrict the transmission of light. * It is the ratio of the incident light to the transmitted light; also equal to the reciprocal of the transmittance; also the anti-log of density. (2) Indication of ability of an ink or dyestuff to cover or obscure what lies beneath it. * Also known as covering power.

opal glass

Type of glass which is opaque and white, used to diffuse light e.g. as in envelope of domestic light bulb. * Some types (flash opal) use a layer of diffusing material e.g. white powder, coated onto ordinary glass; others (pot opal) use beads embedded through the depth of the glass.

opaque

(1) Adjective: radio ~; light ~: material that transmits no radiation of the specified type. (2) Noun: paint or coating used to stop light from being transmitted e.g. used as mask or to remove spots in film.

See opacity.

opaque projector

Design of projector for solid objects: a very bright light shines on the object: a projector lens focused on the object projects the image through via a mirror to laterally correct the image. * Also called episcope.

A little revolution in relationships

One of the little revolutions in photographic practice that digital technology has given us is right here: whereas life-size reproduction called for photographic skills of the highest order, it is now, in one department, taken for granted. That is in making duplicates: we hardly ever make duplicate transparencies now, as we scan them: my professional slide duplicator (which cost a fortune years ago) is gathering dust while my film-scanner is getting worked into the ground.

operating system

The software program (which may also reside in hardware) that underlies the functioning of the computer, allowing applications software to use the computer. * The operating system controls internal workings such as the way data is received in and sent out of the computer, how the data is handled within the computer. The system also checks and coordinates the functioning of the computer's components as well as relationships with peripheral devices and so on. * A computer's OS can be held on a disk or hard-disk, as with DOS, or in ROM, as with the Mac OS, where it is significantly faster in use but limited in upgradeability.

optic axis

Line through a doubly refracting crystal along which double refraction does not take place. * Do not confuse with optical axis.

See birefringence.

optic disc

Region of the eye which marks the entrance of the optic nerve. * It corresponds to the blind spot, as there are no light-receptors in this area.

optical activity

Ability of a medium to rotate the plane of polarization of incoming light.

See birefringence; optically active material.

optical axis

Line passing through the centres of curvatures of all the lenses or mirrors in an optical system. * Do not confuse with optic axis.

optical bench

Solid column or long bed on which optical devices and light-sources may be supported and moved relative to one another: used primarily for optical testing and experimentation. * The darkroom enlarger, large-format studio cameras and process cameras are applied examples of the optical bench.

optical blacking

Light-absorbing material painted or applied to e.g. edge of lenses or inside surfaces of lens tube to prevent internal reflections. * Its refractive index should be at least equal to that of the glass.

optical blank

Glass moulded to nearly the final shape ready for the processes that will grind and polish it to final, precise form.

It is all the same difference

Actually most users don't give a tinker's as to which operating system they are using: so long as it works and they can work it, that's all that matters. Under the hood, however, the OS makes all the difference to a productive day or a wasted day. Unfortunately as they get more clever, they eat up more and more space and resources. After a while you yearn for a simple, no-nonsense interface – perhaps one reason behind the great popularity of palm devices such as those from Palm and Psion.

O

optical brightener
See whitener.

optical character recognition
See OCR.

optical contact
Sticking together of two surfaces of glass which are close-fitting. * Where the surfaces are sufficiently clean and precisely matching, cement may not be necessary for the adhesion to be extremely durable.

optical density
(1) Measure of light-stopping or dispersing power of a transmitting material. * It is equal to the logarithm of the ratio of the illuminance of the incident to the illuminance of the transmitted light. (2) Measure of light-reflecting or dispersing power of a reflective material. * It is equal to the logarithm of the ratio of the illuminance of the incident to the illuminance of the reflected light. * In photography, density is usually normalized to a base density of zero. * In both senses: may be referred to simply as density.

optical distance
Physical length of the light-path in a medium multiplied by the refractive index of the medium, assuming the medium is of constant refractive index. * Also known as path length; also equivalent air path.

optical element
Single optical component e.g. lens (which could be part of a group of lenses), holographic element, prism or mirror.

optical fibre
Extremely narrow filament of drawn or extruded glass or plastic having a central core and an outer cladding of lower index material. * Light travels the length of the fibre due to internal reflection, with minimal loss. * Used to transmit pulsed optical signals for communications as single fibres in e.g. cable phone and TV; or in tightly organized bundles to transmit images or to pipe light. * In the latter case may be referred to as fibre optic.
See fibre optic.

optical flat
Precision ground piece of glass or similar material whose flatness is generally better than around 60nm.
See flat.

optical path difference
Variation in the optical path length of different rays in an optical system. * In theory, perfect systems show no optical

All of life in four units

Photographically speaking, all of life gets crammed into four little density units: for that is about as much as any photographic system can handle and therefore all that we ever see or work with as photographers. In practice we're talking about a range of about twelve stops or more like ten or eleven. That is enough to express all the subtlety of tones, the glory of colour and richness of life. It's poetry, that's what it is.

path difference; in practice all systems exhibit small differences: these may cause phase variations which can in turn reduce image quality, particularly where the path length is long and complicated, as in binoculars.

optical resolution

Measure of the ability of an optical system to distinguish detail: may be quoted as line pairs per millimetre, with reference to a standard target and the image examined under standard conditions or with the target photographed under standard conditions. * In non-photographic applications, may be quoted as angular resolution i.e. the angle subtended by two distant point sources which are just visible in the system.

See device resolution; input resolution; output resolution.

optical sapphire

Synthetic crystal similar to ruby but colourless offering very high refractive index and extreme hardness and used in specialist optics.

optical spectrum

That part of the electromagnetic spectrum between far ultraviolet (wavelength around 40nm) to the far-infrared (wavelength around 1mm). * That is, the optical spectrum is wider than the visible spectrum.

optical system

Combination of lenses, prisms or mirrors or fibre optics working together to perform some optical task e.g. project slide image onto wall, collect light to starlight analyser, allow surgeon to view interior of body.

See camera system.

optical transfer function

Modulation transfer function taking account of phase shifts. * Seldom applied in normal photography, which works with incoherent light and is therefore insensitive to phase.

See modulation transfer function.

optical transform image modulation

Technique for detecting and measuring atmospheric pollution. * Test source shines light into the atmosphere: this is reflected to the instrument and is compared with the source light by making the two interfere: the interference patterns help identify pollutants in the air.

optical viewfinder

Type of viewfinder that shows subject directly, through lenses, rather than via a monitor screen e.g. LCD screen. * It is preferable to the LCD screen for framing shot because it

Tell me the optical
The term 'optical resolution' be used to refer to the 'true resoolution', as opposed to the interpolated resolution of a scanner or similar capture device. This is not quite accurate, but can be a helpful distinction between what the system can do in opto-mechanical terms and what can be done with the information once obtained e.g. to bump up the file size – and apparent detail – with interpolation.

Well, fancy that
Sapphires have also found their way onto up-market cameras, to give that exclusive touch ... and an excuse to touch your wallet for a hefty premium. And where else would you find the sapphire but under your finger – it is the shutter button.

O

takes up no power at all to operate. * Also known as direct vision viewfinder.
See SLR; TLR.

optical-grade silicon

Highly purified elemental silicon: it exhibits a very high electrical resistance and is transparent to the infrared between around 0. 5 and 15 μm.

optically active material

Light-transmitting medium able to rotate the polarization of light. * Typically, such media have different refractive indices for left- and right-circular polarizations.

optics

Science of electromagnetic radiation in the optical spectrum wavelength from 40nm to 1mm (ultraviolet to infrared): includes vision, geometrical and physical optics. * Modern term, to include electronic and quantum effects, is photonics.

opto-electronic

Adjective: utilizing or characteristic of optical power. * E.g. ~ devices transduce electrical energy into optical power, or turn optical effects into electrical power. ~ phenomena are those which involve optical power e.g. charging of CCDs by incident light.

optometer

Instrument designed to measure the refractive state of the lens of eye.

Orange Book

(1) Standard for recordable CDs, including hybrid types such as Photo CD. * Developed by Philips and Sony. (2) US government standard for security of computer system e.g. ability to resist hacking.
See ISO 9660.

orange peel

State or appearance of lens surface, typically that of moulded lenses. * Indicates poor or incomplete polishing or low-quality heat polishing.

orthochromatic film

Black & white film which is insensitive to one part of the visible spectrum – usually red – but sensitive to the rest of the spectrum.

orthogonal

Adjective: ~ tool, ~ operation: producing or working along straight lines which are oriented vertically or horizontally.

orthographic camera

Instrument for recording true perspective relations between

objects in the field of view. * Uses a telecentric objective with a narrow field of view.

orthoscopic

Adjective: optical system with high level of correction for distortion. * Synonym: rectilinear.

OS

See operating system.

Ostwald ripening

Stage in manufacture of silver halide emulsions during which halide crystals are allowed to grow to a certain size. * Also known as physical ripening.

Ostwald system

Colour classification system proposed by Wilhelm Ostwald. * Essentially same as Munsell system, formerly widely used in Europe.

OTF

Off-The-Film: Adjective: ~ metering: variant of through-the-lens metering in which the sensor is positioned to look at the film gate. * Strictly, OTF is applied to flash metering in that the exposure reading for the flash-gun is taken off light reflected off the surface of the exposed film during shutter-run. * May be used to refer metering systems that take their reading off the shutter curtain which is suitably painted to reflect light.

otoscope

Optical instrument for examining the inner ear.

out-of-date

Materials which are past their sell-by date or whose performance or activity is below specifications. * Out-of-date film is typically lower in sensitivity; lower in contrast and exhibit higher levels of fog. * Out-of-date chemicals are typically lower in activity; exhibit more turbid solutions; may have components crystallized out. * Also outdated: mainly in US usage.

out-of-focus

Adjective: image which appears unclear, unsharp, lacking in contrast and fine detail because the lens is not at the correct distance from the film- or projection-plane for the distance between lens and subject. * Usually applied to a real image (i.e. one that can be caught on a screen) although it can equally apply to a virtual image.

See conjugate.

out-of-gamut

Colours that are visible or reproducible in one colour space

Olympus the first

OTF was pioneered by Olympus in their OM-2 camera as a result of their discovery that different films – black & white or colour of various types – surprisingly have nearly identical reflectance (i.e. reflect nearly exactly the same proportion of incident light). Metering off the shutter curtain is regarded as too crude for modern auto-focus SLRs but is effectively implemented in the Leica M6 series of cameras.

O

but which cannot be seen, output or reproduced in another.
* E.g. many bright and highly saturated colours visible in RGB space are out-of-gamut in the CMYK space of lithography i.e. cannot be printed with process colours.
See process colour.

out-take

Image or images removed from consideration or use by a selection or editing process.

output

(1) Result of any computer calculation i.e. any process or manipulation of data. * Depending on the operation, output may be in form of new data, an instruction for controlling an output device, a transmission to a remote terminal, etc.
(2) Hard-copy print-out of digital file e.g. as ink-jet print, film or separation films.
See hard copy.

output device

Equipment or mechanism used to make visible or display computer output e.g. monitors, printers, video projectors.
See hard copy.

output resolution

Measure of finest detail which can be printed or displayed by an output device. * This is determined by numerous factors. (a) For printers, variables include: half-toning algorithms for creation of half-tone cells, mechanical accuracy of paper driver, dot gain of substrate, quality of substrate, resolution of files being output, etc. (b) For display devices variables include: beam convergence, viewing distance, etc.
See device resolution.

over-correct

(1) In optical design: to make more correction for an aberration than strictly necessary, usually in order to make it easier to correct another aberration or, occasionally, to produce specific effect e.g. softening from spherical aberration. (2) In tone reproduction: to exaggerate tonal differences in black & white film by using coloured filters e.g. use of red filter to darken blue skies and accentuate clouds.

over-develop

Production of excessive density (in negative-working processes) or excessive lightness (positive-working).

over-exposure

Application of more radiation to a sensitive material than needed for its proper exposure. * Proper or correct exposure

How to over-do it

Over-development is due to one or combination of inter-related factors: (a) using a development time longer than specified (b) using solution hotter than specified (c) applying more agitation than necessary (d) using insufficiently diluted or an over-active developer.

being determined by the material and its intended use.
* With negative-working materials, the resulting image
appears more dense than normal; with marked over-
exposure, there is noticeable density in shadows and
blocked highlights. * With positive-working materials, the
image appears lighter than normal; with marked over-
exposure, shadows are filled, and there are no black tones.

over-sampling

Process of improving reproduction quality by digitizing or
quantizing the source at a frequency or resolution that is
higher than that which is strictly needed or is normal. * In
scanning, an image captured at 42-bit has been over-
sampled if it is to be used at 24-bit.

See bit depth.

over-scanning

Process of scanning an original more than once – at different
settings – in order to combine the resulting data to produce
a scan superior in quality to that possible in a single scan.
* E.g. one scan optimizes highlight detail, the second scan is
optimized for shadow detail: the combination can then be
blended. * Also known as multiple scanning.

overall distance

Length of the imaginary straight line joining the object to
the image on the optical axis. * Also known as overall length.

overcoat

Final layer applied to a substrate e.g. photographic film,
paper, etc. to provide physical or mechanical protection.
* E.g. overcoat on photographic film may help prevent
scratches; overcoat on printing films helps reduce build-up
of electro-static charge. * Also known as supercoat.

overhead projector

Instrument for displaying large transparencies on the wall in
a darkened room e.g. for presentations or lectures. * It
reverses the image, so the original must be reversed.

overlap

Common area between adjacent images of e.g. series of
pictures taken for panorama, aerial photographs to be used
for mapping.

overlay

(1) Verb: to superimpose text or graphic elements on top of
each other. (2) Noun: transparent material carrying e.g. print-
out or drawn image which is laid on top of printed or other
material. * Used e.g. to check positioning and proportions of
printed elements: largely superseded by digital methods.

Beware free samples

*Take care, however, that
when you appear to get lots
of bits for your money, it's
not quite all you might
have hoped for. Some
scanners may appear to
work in 36-bit but
actually sample in 24-bit,
leaving the other bits for
miscellaneous information
such as file attributes. The
information germane to
image quality is still
limited to 24-bit, like most
machines.*

package

Noun: (1) Software applications or suite of applications designed to work together. * A single application may combine many different functions e.g. handle text, produce or alter graphics, export to HTML, link to spreadsheet, etc. (2) Combination of computer hardware and peripheral devices plus software designed or intended to work together e.g. computer with scanner, digital camera, image editing software. (3) Verb: combining materials for purpose of marketing and distributing a product, usually multimedia e.g. the CD, booklet, jewel case, etc.

packing density

(1) Measure how many items or parts are present for a given unit area e.g. how many light-detectors are on a sensor chip, number of components e.g. transistors on a processor. (2) Ratio of the cross-sectional area of a fibre optic's core to its total cross-sectional area.

pAg

Measure of concentration of silver ions in solution or an emulsion. * Logarithm of the reciprocal of the concentration of silver ions: it is related to e.g. response of emulsion to addition of sensitizers, etc. * Analogous to pH.

P

page

(1) Single side of a printed document together with the elements e.g. text and graphics which are printed on it. (2) Representation on the monitor screen of a printed page. * May be known as the canvas. (3) Unit, of information, usually defined by its address (the URL), on a Web site. * See Web page. (4) Portion of computer or video memory which contains the data for an entire screen. (5) Section or block of memory in some memory management systems.

page description language

Programming language used to control output devices based on instructions on how to construct graphic elements such as lines, circles to construct e.g. typeface. * The translation of these instructions is carried out by the output device or by its controlling software therefore the resolution of the output is determined by the device. * Best known is PostScript, also Apple QuickDraw, PCL (Hewlett Packard Printer Control Language). * Also PDL, and referred to as vector language.

See RIP.

paint

(1) Verb: to apply colour, texture or effect with a digital 'brush' in picture processing. (2) Noun: colour applied to image, usually by altering the underlying pixels of bit-mapped images or by filling a defined brush-stroke of graphics objects.

paired cable

Electrical lines used in data communications – e.g. networks – consisting of one or more pairs of cables twisted or spiralling round each other. * The twist reduces interference between the pairs and between the pairs of lines.

PAL

(1) Phase Alternation Line: broadcast television and video standard in wide use in Europe and former Eastern Bloc countries. * So-called as one of the chrominance signals is reversed in phase for every other scanning line. * It scans 625 lines per frame, at a rate of 25 frames per second. (2) Programmable Array Logic: type of integrated circuit which allows different interconnections to be made during manufacture, allowing creation of customized processors.

palette

(1) In drawing, image manipulation program etc., a set of tools e.g. brush shapes and their controls presented in a small window that is active together with other palettes and

the main document window. (2) Range or gamut of colours available to a colour reproduction system e.g. monitor screen, photographic film or paper, depending on the colour characteristics of the phosphors, dyes or processing used. (3) Specific data-set of colours that can be addressed by a system to reproduce a range of colours e.g. as used in now obsolete video graphics standards.

See custom palette.

panchromatic

Type of light-sensitive material more or less equally sensitive to all colours visible to the eye. * Formerly specifically referred to film with extended red sensitivity in addition to blue and green. * Usually refers to black & white film.

See orthochromatic film.

panoramic camera

Design of camera to produce an image covering a field of view that is wider than that given by any lens, usually, but not always, in the horizontal direction. * The field of view is continuous and unbroken: achieved in one of two main ways: (i) the lens is rotated about its rear nodal point while the film lies on a curved film gate with the shutter moving at the same rate; alternatively the camera may rotate about its centre. (ii) Separate images are made, with the camera rotating over the axis of the read nodal point, and then 'sewn' or blended together, usually in specialist software which matches overlaps to make the joins invisible.

See panoramic distortion.

panoramic distortion

Change in the shape of an image compared to the subject caused by the geometry of the lens movement used to create the panorama. * The magnification is greatest in the centre of the panorama i.e. where the lens is nearest the subject and drops to either side as the lens points away.

Pantone

Proprietory name for system of colour coding and classification. * Consists of swatches or patches of colour printed on various papers as well as equivalent digital files. * Specifying a Pantone colour should ensure that it is printed colour-correct (even if it's the only one). * Full name: Pantone Matching System.

paraboloidal condenser

Design of condenser used to produce dark-field illumination in microscopy. * Uses a paraboloidal reflector so that light reaches the object only from the periphery.

Everything is not the same as all equal

Panchromatic films may respond to all the wavelengths that we humans do but, unfortunately, they do not match our eyes' varying sensitivity to different colours. We see greens quite brightly, for example, but panchromatic films treat them no differently from reds, as a result of which the rendering of greens in black & white films usually seems too dark.

When letter-box isn't panoramic

Some cameras which parade as panoramic – in fact most of them – aren't at all. They are merely wide-angle cameras which lop off lots of the top and bottom of the image, so you think they're panoramas. One way to tell is when the camera points upwards or downwards; this is usually when the horizon doesn't run across the centre of the picture: if it's curved, you've got a real panorama; if not, it's a letter-box. In fact, off-axis horizontal lines are rendered curved.

P

parallax

Apparent change in size or position of image with change in viewpoint or other factor. * (1) Monocular ~: the relative shift in position between two objects with change in position of viewing. * This is the most common experienced and is seen e.g. when comparing the image seen through the viewfinder of a direct-vision camera and the image taken by the lens. (2) Binocular ~: difference in angle subtended at the eye by an object when viewed with one eye, then the other: apparent when e.g. a box is viewed close up: one eye may see one side of the box that is hidden to the other. (3) Time ~: change in position of moving object between moment that exposure is initiated and when photograph is actually taken. * Also known as shutter-lag. (4) Chromatic ~: apparent shift in position of e.g. red and blue objects when viewed in certain controlled conditions when the eyepoint is moved laterally. * When parallax appears in a telescope between the image and reticle, this indicates the image has not been formed in the plane of the reticle.

parallax correction

Markers or other aids to compensate partially for monocular parallax e.g. in direct-vision viewfinders, marks in the field indicate the boundaries of the image in close-focusing range. * Other corrective measures include use of a prism to shift the image, moving wires or masks in a viewfinder, etc.

parallel port

Type of connector between PC-compatible computers and directly connected parallel port devices e.g. printers. * Data and control bits are sent at the same time through wires connected in parallel. * Being superseded by USB.

parallel scanning

Method of scanning in which a line of detectors covering the length of one axis is swept along the other axis to cover the full area of the object. * It is the commonest way to implement scanning and is seen not only in flat-bed scanners but also scanning backs in cameras and other capture devices. * Also called pushbroom scanning.

paraxial

Ray or bundle of rays which lies close to the optical axis. * How near the axis may be determined by how accurately Gaussian theory describes the rays' behaviour: if it does, the rays are paraxial, within the permitted errors. * It may also be taken that the aperture is extremely small. * Also called first-order optics, or Gaussian optics.

parfocal

Adjective: ~ lenses: set up or arranged so that when one lens is changed for another, there is no change in focus. * Applied usually to turret mounted lenses e.g. on microscope; also in telescopes: ~ eyepieces: changing one for another does not require refocusing. * When the distance from the object to the rear principal plane of each lens is equal, they are said to be parfocal.

passband

Portion of electromagnetic spectrum which is let through by a filter e.g. passband of a blue filter is blue light.
See bandpass filter.

passive AF

Passive auto-focus: type of auto-focus which relies on analysis of the image projected by a lens and which does not use a beam of light or ultrasound to measure the object distance. * All single-lens reflex AF cameras use passive AF systems except in very dim conditions, in which case many emit a beam of short infrared light to assist the passive focusing.
See active AF.

paste

Software application command which places or inserts temporarily stored data (e.g. image, text) into file (e.g. image, document) currently open. * The term derives from days of creating camera-ready paste-ups (see below): 'insert' or 'drop in' more intuitively describes the actual command.

paste-up

Combination of pictures, printed text and other elements which are stuck onto a board ready for photomechanical reproduction of the page, usually by being photographed using a process camera and lithographic film.

path-reversal principle

Fundamental assumption in optics that the path that light takes through an optical system is the same whether the light is entering or leaving the system. * The optical path is invariant with direction.

PCI

Personal Computer Interconnect: specification for local data bus which allows up to 10 compatible cards to be run in one computer to provide extra functions such as video acceleration, alternative or additional connectors to peripheral devices, etc. * Most useful feature to user is that PCI boards are plug-and-play. * Introduced in 1992.

Burying the paste-up

The fine art of sticking bits of paper and galleys of text (mmm, do you remember the heavenly perfume of hot wax and glue?) is now nearly as extinct as the coelacanth (it pops up from the depths now and then, just to remind us), as pages are almost always produced from the desktop and sent directly to film, even direct to printing plate. The trouble with DTP (much as it has made life easier, cheaper, quicker, cleaner) isn't that it just don't smell good, it doesn't smell at all.

P

PCMIA

Personal Computer Memory Card International Association: a standard for removable memory and hard-disk cards used in laptop computers and larger digital cameras. * Often abbreviated to PC cards. * All are 68-pin and measure overall 85.6 mm x 54 mm. * Type I cards are 3.3 mm thick and used for memory; Type II are 5mm thick and used for modems, interconnect adaptors e.g. for network; Type III are 10.5 mm thick and Type IV are 5.5 mm thick – both used mainly for hard-disk drives. * A Type II will accept a Type I device.

PCX

Bit-mapped image format used in Microsoft Windows for the Paint application. * Suffix is .pcx.

PDF

Portable Document Format: file format native to Adobe Acrobat. * It is based on PostScript, and preserves text, typography, graphics, images and layout of a document: there is no need to embed fonts in the document. * It can be read, but not edited, by Acrobat Reader which is freely available. * Suffix for Windows is .pdf.

PDL

See page description language.

peak

Adjective: (1) ~ output: maximum intensity e.g. of flash-bulb. * The synchronization of a camera shutter is timed so that it is fully open at the highest light intensity of a bulb. (2) ~ delay: the time interval between the initiation of the flash and its reaching peak output. (2) ~ wavelength: that at which a source of radiation emits at the highest power.

peaking

Edge enhancement by exaggerating density differences at borders of detail.
See USM.

pel

Picture element: see pixel.

pellicle mirror

Thin mirror used to split a beam into two unequal parts i.e. the mirror is nearly transparent in one direction. * Used in SLR cameras to avoid the need for a mirror that flipped up and down, which also permitts simultaneous viewing and taking. * Usually made of coated thin glass flat but may also be stretched plastic membrane cemented to a supporting frame. * Now largely abandoned for normal photography due to its tendency to collect dust and its great fragility.

pen plotter

Printer technology designed to produce large, accurate drawings e.g. for architecture and engineering consisting mainly of lines. * May use 4 or more different pens for different colours.

pentaprism

Design of solid block of glass used to turn light rays around: it has five sides when viewed in section, with the main reflecting faces angled at 45° to each other. * Used in single-lens reflex cameras to flip image so that it is laterally correct i.e. left-right relationship is as normally seen; also in range-finders and measuring devices to define a right angle.

penumbra

Partially dark outer rim of a shadow of an object lit with a nearby light-source. * A large and distant light-source does not cast a significant penumbra.

> See umbra.

perceived colour

Perception or report of a perception of colour: this may differ from the colour as physically measured e.g. in cast of colour-blindness.

perforation

Hole punched in a series near one or both edges of film that is used by mechanism to transport film through camera, processor or projector. * Distinguish from hole punched into film for registration purposes in e.g. audio-visual production.

peripheral

Adjective: (1) ~ field: at the edge or boundary of the field of an optical system. (2) ~ vision: visual sensations arising from stimulation of the retina 5° or more away from the fovea. * Peripheral vision is good at picking up motion but not detail or colour. (3) Noun: device externally connected to a computer and under its direct control. * Formerly used to distinguish the central processor unit (now loosely called the 'computer') from the components attached to it. * Now generally refers to any equipment such as printers, monitors, scanners, modems connected to the computer and not part of a network.

periscope

Optical system which displaces the line of sight vertically (or sideways). * Best known in submarines and other military uses: it enables user to view at a point much lower than the actual line of sight. * Several instruments used in medical examination are also periscopes.

P

perspective

(1) Characteristics of a view determined by the position of the viewer with respect to the view. * Perspective interacts with factors such as projection of an image in ways that may create e.g. distortion of projection. * For example, a low position looking up at a tall building causes the projection distortion of keystoning. (2) Tool in graphics or image manipulation software that simulates effect of changing perspective: it distorts the image shape to e.g. produce converging parallels.

See aerial perspective.

perspective distortion

Variation of image from being an accurate representation of object caused by viewing image from an incorrect perspective e.g. when a small print taken with an ultra-wide angle (short focal length) lens is viewed at normal viewing distances. * For accurate perspective, the angle subtended at the viewpoint by a given object should equal the angle subtended by the object at the camera. * This effect is best treated as an optical illusion.

See geometrical distortion.

Petzval lens

Family of lenses based on two achromats, one on either side of the aperture. * It features good correction over a narrow field and relatively high speed. * Used for portrait lenses, projection, low-power microscope objectives.

Petzval surface

Curved surface centred on the focal point on which lies the image of an object plane parallel to the focal plane. * The surface is a parab0loid because of the aberration of field curvature.

phase

(1) Stage which a cyclic or regular event has reached e.g. the waning phase of the moon, the wind-on phase of a motor-driven camera. (2) Physical state of substance, usually varying with temperature e.g. water can exist in gas, liquid or solid phase.

See phase change printer.

phase change printer

Design of printer in which dyes or pigments are changed from one phase to another in order to effect printing e.g. dye sublimation heats a solid dye to gas (sublimes) which diffuses to the receiving layer; wax thermal printers heat a stick of colour to liquid which is then squirted onto the paper.

From the ball to the eye-ball

Correct viewing distance for a photograph – i.e. to reproduce the taking perspective and avoid distortion – equals the focal length of the lens multiplied by the enlargement factor e.g. with a 50mm taking lens and a print enlarged 10 times, the 'correct' viewing distance is 500mm. Therefore correct viewing distance varies with focal length of taking lens. Now, as prints are viewed or seen usually at a more or less constant reading distance, it follows that the perspectives of images are usually distorted – this is, of course, what enables us to enjoy the variety given by the use of different focal length lenses.

phosphor

Substance that emits visible light as a result of being radiated or primed with electromagnetic energy e.g. electron beams or other light. * The physical phenomenon involved is luminescence. If the luminescent light persists more than a second or so after the incident light is removed, the effect is called phosphorescence; if persistence is short, the effect is fluorescence. * Used in colour monitor screens: different formulations emit different colours, hence the slight variations in performance between manufacturers and even between similar models from the same manufacturer. * For monitors, one wants phosphors that fluoresce; phosphoresence is for watch faces.

phosphorescence

See phosphor.

Photo CD

Proprietary system of digital image management based on storage of image files (called Image Pacs) onto CDs. * The system scans an image to digitize it into Kodak's YCC format – the resulting file is stored on the CD at five different levels of resolution; maximum capacity of disk is about 100 images. * The CD can be played back on any CD-ROM player in an Apple Mac-compatible or IBM PC-compatible computer that is multisession compatible.

photochromic

Substance having the property of reversibly changing its colour or molecular structure in response to exposure to light. * Certain glasses with dispersed silver or treated plastics darken in response to short wavelength light and return to transparency when radiation is removed. * Used in sunglasses.

photoconduction

Change in electrical resistance in a substance or semiconductor device when it is irradiated with light. * Basis of exposure meters such as CdS (cadmium sulphide) types in which resistance drops with increasing flux. * Also used in photoconductive detectors for detecting non-visible e.g. infrared radiation.

photocopy

(1) Noun: facsimile of an original made through a photocopying process, typically xerography. * (2) Verb: to make a facsimile of an original, usually two-dimensional, through xerography. * Sometimes, but decreasingly, used synonymously with 'to Xerox'.

Photo CD answers to questions you never asked

Introduced in September 1990, the tricky and clever part of Photo CD is the Image Pac – the files making up one image. After scanning, the digital file is written on the CD at five different resolutions: (1) Base/16: 128x192 pixels for thumbnails; (2) Base/4: 256x384 pixels for low-res images; (3) Base: 512x768 pixels for TV quality; (4) 4 Base: 1024x1536 pixels for HDTV quality and (5) 16 Base: 2048x3072 pixels: the top resolution for Photo CD. The top res is 64 Base i.e. 2048x3072 to 5230 pixels – depending on film format – on Pro Photo CD. These files do not take up as much room as you'd expect as they are not only compressed, they are stored as 'residues' i.e. higher resolutions are stored as differences from the lower resolution.

photodetector

Device designed to capture light and produce an output that is proportional to the strength of the incident light. * Many types of semiconductor or electronic devices in use.

photodiode

Device that responds very quickly and proportionally to light falling on it. * Used as light sensors for measuring exposure in cameras and flash-guns; may also be found in specialist scanners. * It is a semiconductor usually of the p-n or p-i-n type, operated at either below or above the breakdown voltage i.e. voltage at which there is a sudden decrease in the resistance of the device. The effect of light falling on the device is to create a current which can be measured and is largely proportional to the energy of incident light.

photoelasticity

Change in optical properties of transparent materials under stress. * Usually seen as change in polarization: patterns of stress in materials are shown up in cross-polarization of light.

photoelectric effect

Ejection of electrons from a surface e.g. metals as a result of light falling on it. * The energy of the electrons depends on the frequency, not intensity, of the light.

photoelectric multiplier

See photomultiplier tube.

photogram

(1) Photograph that is produced without projecting an image through an optical system. * E.g. by laying semi-transparent materials directly on enlarging paper and exposing the paper through the materials. (2) Image produced or used for photogrammetry.

photogrammetry

Use of photography to obtain accurate measurements. * Basic trigonometry is used to deduce spatial information from measurements made on a photograph, given information on taking distances, focal length and known distortion characteristics of the lens used. * Fiducial marks on the image are characteristic of photogrammetric images. * Can also be applied to film e.g. cinetheodolite following a rocket's trajectory. * Also known as metric photography.

photograph

(1) Noun: record of physical objects, scenes or phenomena made with a camera or other device, through the agency of

radiant energy, onto sensitive material from which a visible image may be obtained. * '... a recording of light or other radiation on any medium on which an image is produced or from which an image may by any means be produced, and which is not part of a film' (Copyright, Designs and Patents Act, 1988, UK). (2) Verb: to make, create, take, or arrange for the taking of, a photograph.

photographic exposure
See exposure.

photographic resolution
See resolution.

photolithography
Printing technique in which photography is used to create a lithographic plate.

See lithography.

photomask
Negative image of circuit pattern for one of the layers of an integrated circuit. * Used to make extremely high-resolution patterns on silicon wafers using step-and-repeat cameras in fabrication of e.g. microprocessors.

photometer
Instrument for measuring light levels. * According to the measuring or comparison principle used, it can measure, or be used as the basis for deducing, luminance, illuminance or luminous intensity of a light-source or object. * Basis for exposure meters used in photography.

photomicrography
Photography of objects seen through a microscope: giving a highly magnified image – from about 20X with a stereo microscope to over 1500X with research microscopes. * A camera may take the place of the eyepiece in basic outfits, or the light-path may be deflected from the eyepiece to a camera in specialist outfits. * Also known as photomicroscopy.

photomontage
Noun: (1) Photographic image made from the combination of several other photographic images. * The process of combining the images may be done by multi-exposure of sensitive material; simultaneous multiple projection as in slide-show presentation; by physically sticking the prints etc. together or digitally, in computer with the aid of image manipulation software. * (2) Process or technique of making a photomontage. * Also verb: to create photomontage.

See compositing.

Death of a practice, death of a term

Photolithography was formerly synonymous with lithography – in the days when pasted-up artwork was photographed in a process camera to create the litho plates. But now most lithographic plates are made from digital files, so those lovely process cameras are mostly rusting away and getting dusty. As will the term 'photolithography'.

Blurring the edges

If photomontage works only with images, then digital working – which often drags in text as well as other graphic foreigners – ain't photomontage no more, but more like collage. But do we care: collage, photomontage, montage – they're all about cobbling various bits together in the hope that the whole is greater than the sum of the parts.

photomultiplier tube

Device for producing amplified signal from a photo-detector. * Consists of a vacuum tube with a photocathode followed by a cascade of cathodes. * When exposed to light the cathode releases electrons which are accelerated across an electrical gradient to fall upon another metal surface where more electrons are released which are accelerated to yet another cathode, and so on. * The amplification possible is very high – over ten-fold – and output is linear. * Used in e.g. drum scanners; densitometers.

photon

Single unit of light energy. * Quantum of electromagnetic energy, which equals hn, where h is Planck's constant and n the frequency of the propagating electromagnetic wave.

photonegative

Substance whose electrical conductivity decreases with increasing intensity of incident light.

photonics

Science and technology of the generation and utilization of light for e.g. image capture, communications, signal or data processing.

photopic vision

Vision at high light levels (above about $10cd/m^2$) resulting from stimulation of cone, providing colour vision. * Also known as daylight vision; diurnal vision.

See mesopic vision; scotopic vision.

photopolymerization

Creation of polymers under action of light: used to make e.g. instant-process holograms. * Monomers and suitable catalysts are mixed, then exposed to light.

photopumping

Use of non-laser light to improve efficiency of a laser or to initiate the lasing.

photorealistic

(1) Creation of images which are as close to real life as possible – looking as if they are photographs – building it up from primitive graphic elements to provide life-like textures and lighting effects. (2) Digitally based printing process which produces results close to that of photographs, both in image quality and physical characteristics e.g. handling like a print. (3) Reproducing or capable of reproducing life-like colours and tones. * May be used as equivalent to truecolour or 24-bit colour (not a recommended usage).

Claim and fact

The term 'photorealistic' has not received a standardized and recognized definition, so it must remain more of a claim than a statement of fact – although of course some printer manufacturers might want to make a strong claim to fact. The problem is that what looks 'photographic' to an untrained eye can be obviously not photorealistic to the expert. And being a photographic print rests on more than its image quality alone.

photoresist

Substance e.g. dichromated gelatin, light-sensitive polymers, etc. which change a property e.g. solubility in water, hardness, when exposed to light. * May be coated onto e.g. metal plate so that after processing which removes unexposed areas, the exposed areas remain to protect metal from etching effects of acid; or e.g. in case of photoresist on silicon wafer, after processing, unexposed areas remain to protect wafer from addition of dopants.

Photoshop

Proprietary name of Adobe for image editing and manipulation application software. * May also be used as a verb, meaning to manipulate an image.

photosite

Unit of light-detection on photo-detector array. * May be used synonymously with pixel.

photovoltaic cell

Light-detector based on photoelectric effect. * May use selenium layer or silver on a semiconductor deposited on a ferrous support to generate current when it is exposed to light. * Used in some exposure meters, best known of which is the Weston series.

physical optics

Part of science which treats light as a wave phenomenon i.e. the spread or course of light is taken as the propagation of wavefronts: it is able to account for phenomena such as diffraction and interference.

See geometrical optics.

physical ripening

See Ostwald ripening.

PICT

Macintosh Picture: graphic file format widely used on Mac OS: it contains raster as well as vector information but is nominally limited to 72dpi, being designed for screen images. * PICT2 supports colour to 24-bit depth.

picture basket

Work-station or server computer used in newspapers, news stations, etc. which receives digital images sent at intervals by a 'wire' or other picture service provider to the subscribing organization. * The images wait in the basket until retrieved by the picture or news editor for viewing and evaluation. * Picture may be viewed in low-resolution form without charge but may be charged for when retrieved in high-resolution form.

Just gets better and better

The latest versions of Photoshop are an object-lesson for other software developers in the depth of understanding of the business that it demonstrates. It's come a long way from a utility for converting file formats that Adobe bought. Its market domination is proven by having its name elevated to the dubious pantheon of other trade-marks that entered our lexicon of verbs like Hoover, Xerox.

picture editing

Process in which photographs are selected and assembled from various sources in order to produce an illustrated publication, Web site or exhibition, etc. according to defined aims and requirements.

picture element

See pixel.

piezoelectric

Describing material that (a) produces electricity when distorted e.g. by bending, squeezing or (b) which distorts when an electric field is applied. * A piezoelectric crystal can be cut in different ways according to the orientation of mechanical-to-electrical modes required.

pigment

Substance that is (a) coloured and (b) insoluble. * Pigments are mixed with substrate materials to add colour to the substrate. * Used in thermal wax machines and a new generation of desktop printers: the density of colour and minimal dot gain enable very high output quality to be achieved.

See dye.

pincushion distortion

Lens aberration that causes a square to be projected pincushion-shaped i.e. the sides cave in so the middle portions are closer to the centre than the outer portions. * It is a positive distortion i.e. image magnification increases with increasing field angle. * In photographic use, a distortion of greater than about +3% is regarded as unacceptable for professional-quality work but, for certain applications e.g. flat-copying, even that amount is excessive, and should be less than 0.1%. * Also seen in monitors.

See curvilinear distortion; barrel distortion.

pinhole camera

Design of camera in which a small hole replaces the lens. * Such a camera offers a wide-angle field, is free of distortion and does not require focusing but field curvature and chromatic aberrations are a problem. * The hole must be very cleanly cut e.g. with a laser: the focal length of the camera is the distance from the hole to the film. * The optimum diameter of the hole may be calculated. One guide formula is: the diameter of the aperture equals the square root of the focal length multiplied by 0.035.

pinhole eyepiece

Type of eyepiece using a small hole as the eye lens: used for

Doesn't make the juice flow, but ...

The piezoelectric effect is one of the unsung, uncuddled cornerstones of modern technology: piezoelectric crystals provide the precise frequencies used as oscillators to time clocks and computers; they are used as transducers in microphones; piezoelectricity is used to power certain flash-bulbs (and to light gas ovens) and piezoelectric distortion is used by most ink-jet printers to squirt the ink. Stop the squeezing and the industry will grunt to a halt.

Bet you never thought of this

As pinholes bend any radiation (which doesn't go straight through the surround) it follows they can be used to record any radiation. That's right, you can use pinhole cameras to record ultra-violet or infrared ... even x-rays (put your pinhole through a solid lead plate). All you need in the box is a suitably sensitized film. Which, incidentally, you can place curved, so as to compensate, at least a bit, for the field curvature.

adjusting microscopes e.g. lighting set-up. * Better than taking off the eyepiece altogether, which is what is usually done.

pitch
Noun: (1) Interval or separation – along a defined axis – between neighbouring and corresponding elements e.g. of phosphor dots of a monitor, scanning movement of CCD, etc. (2) Tilt or orientation of camera away from vertical e.g. in aerial photography. (3) Noun, also verb: presentation or making a presentation to a potential client with aim of winning a contract or commission.

pixel
(1) Picture element: the smallest, atomic, unit of digital imaging used or produced by a given device to create an array or raster of pixels which constitute the digital image. * Usually, but not always, square in shape. * Device may capture image in sets of three or four contiguous pixels but delivers image as a single, interpolated, pixel. * Also known as a photosite, pel. (2) Measure of image size, hence resolution, of capture device e.g. digital camera. * It is effectively the area of an image (length x width) in pixels: the larger the 'area', the greater the amount of data captured.
See interpolated; primary colour.

pixel aspect ratio
Ratio of pixel width to pixel height. * Most pixels are square but some devices work with rectangular pixels and so may distort an image composed of square pixels. * Do not confuse with image aspect ratio.

pixelation
Appearance of a digital image whose individual pixels are clearly discernible. * Usually objectionable, as it means the resolution of the image is rather lower than the viewer's and our visual culture expects images normally to have sufficient resolution to hide image structure. * It follows that pixelation is a relative term of abuse – an image pixellated at one magnification may look acceptable at a lower magnification. * Also occurs when image has been over-compressed with a lossy process e.g. with JPEG.

placeholder
Stand-in or surrogate item, usually of low resolution and file size, in design or production which is replaced for final output or recording with the actual item. * Usually used to speed up editing and design by keeping total file sizes small.
See thumbnail.

You say 'pixillation' and we say 'pixelation'
You being cinemato-graphers and we being photographers – and that is for the good reason that we mean different things. Pixillation means the break-up of the normally smooth motion picture into jerky movement by skipping or repeating frames, etc.

P

Polarization is a fact of life

Light is very often polarized: birds and bees rely on it to go about their business – that is, to navigate by. It happens every time light reflects off most non-metal (dielectric) substances – most clearly seen in glass, water, polished tables and also leaves. Photographically, we use polarizing filters – usually not to create polarization as such but to clean out polarized light. These filters are not efficient, so the cost is that quite a lot other light is also suppressed. Also many filters are not neutral in colour: it pays to spend the money to get truly neutral polarizing filters.

Pamper your platen

It never ceases to amaze me how dusty some people allow their monitor screens to get, how scratched a light-box can be and – you guessed it – how messy platens are allowed to get. Mucky platens translate into hours wasted in otherwise unnecessary re-touching of the same old scratch on the glass, the same traces of glue carelessly left on the glass appearing on every scan you do. Life is too short for a mucky platen.

planar

(1) Any surface on a three-dimensional structure that is flat or nearly so. (2) Planar: family of camera optics derived from the Double Gauss design which gives a flat field.

plane-polarized light

Beam of light in which most of the light waves vibrate with the same orientation. * Light in which the electric vectors of the majority are oriented parallel to each other.

plano

Surface, usually of lens or mirror, that is flat. * In some contexts it may imply perfect flatness, in others e.g. description of lens section, the lens may have a large radius of curvature i.e. is merely not very curved.

> *See planar.*

planoconcave

Optical element with one surface that is flat, and the other concave.

planoconvex

Optical element with one surface that is flat, and the other convex.

planographic

Printing system or image carrier that is flat: inked and non-inked areas lie on the same plane e.g. lithography. * Compared with relief systems in which ink is held in wells or on protruding type.

plasma display

Display based on layer of gas e.g. neon between two electrodes: the gas glows when the electrodes are energized. * Used on some portable computers but too power-hungry for wide acceptance. * Also known as gas discharge or gas plasma display.

plastic lens

Optical component made from transparent plastics or optical resin. * Larger lenses, say more than 70mm diameter, may be machined and polished e.g. for spectacles; smaller ones are injection-moulded. * Not reserved for low-quality instruments: good quality camera lenses may carry some plastics component e.g. the plastic is moulded to fit a glass lens, then fused onto it: this creates an aspheric surface at a lower cost than grinding a glass one.

platen

Glass-covered bed of a flat-bed scanner on which is placed the material to be scanned. * The glass protects the scanning mechanism.

platform

Type of computer system, usually defined by the operating system used e.g. the Apple Macintosh or Mac platform uses Mac OS.

See cross-platform.

platter

Component of hard-disk drives which carries the data. * Consists of a circular core shaped like a dinner plate which is set on a spindle: its surface is covered by ferro-magnetic material which carries the data. * Most hard-disk drives consist of two or more platters.

plug-and-play

Accessory which, when connected to the computer, will work with minimum of set-up and installation: in particular, without having to tell the computer what is connected or where. * PCI boards are plug-and-play on Apple Macs: once slotted in, there is usually nothing more that needs be done to use the board although a control panel may be installed to change settings.

plug-in

Application software that works in conjunction with a host program into which it is 'plugged' so that it appears in a menu, pretending to be part of the program itself. * This 'open architecture' of software is much used to improve productivity and also to correct defects of host program: e.g. for some, the numerous plug-ins (called XTensions) for QuarkXPress only prove how deficient the basic program was in the first place. On the other hand, one need install only those plug-ins that are needed. * Also used with applications to interface the program with a device such as digital camera or scanner e.g. the 'acquire' plug-ins for Photoshop.

See TWAIN.

Smug and play

Plug-and-play is a secret that Windows users were let into years after it was standard in the Macintosh world: it was a much trumpeted feature of Windows 95. But even now, it is far easier to get most peripherals recognized by a Mac than the same peripheral recognized by a Windows machine, even with USB and FireWire devices.

PMS

Pantone Matching System. * See Pantone.

PMT

(1) Photo-Mechanical Transfer: trademark of 3M: a type of diffusion transfer technique. * Used to produce screened prints by exposing silver-based negative material and, after processing, transferring the image onto the receiving layer using diffusion. (2) See photomultiplier tube.

PNG

Portable Network Graphics: file format for losslessly compressed images recommended for use on the Web. * It

supports indexed-colour, greyscale and truecolour images (up to 48 bits per pixel) plus one alpha channel, with sample bit depth of up to 16 bits. * It can be streamed, with progressive display. * It is intended as a replacement for GIF and may well kill off TIFF on the Web. * It does not support CMYK colour space. * Pronounced 'ping' (like the Chinese duck my children used to love reading about).

point light-source

(1) In photographic studio: small light-source without reflectors or light-shapers, used to throw sharp shadows, also to place in confined spaces. (2) In darkroom: lamp with very small filament and no diffuser used to provide a high-contrast source for enlarging. (3) In physics: a source of light with extremely small angular subtense e.g. distant star, pin-hole illuminated by large source of light. (4) In optics: theoretical infinitely small source of radiation.

point spread function

Expression of the relationship between light intensity or energy and distance from the centre of an image of light coming from a theoretically perfect point: usually shown as graph plotting distance from centre of image and light intensity. * Basis of optical calculations such as modulation transfer function which measure actual optical performance.

polariscope

Instrument for detecting e.g. stress in transparent materials based on measuring rotation of the plane of polarization caused by the materials.

polarization

Phenomenon of ordering or alignment of the vibrations of electromagnetic radiation: the alignment is at right angles to the axis of the radiation. * Restriction of oscillations of a field vector to a single plane in a beam of electromagnetic radiation: usually the plane of polarization is that of the electric field vector. * A beam may have two components of plane-polarization: if these are at an angle to each and out of phase, the combined vector follows an elliptical path i.e. the plane of polarization rotates as it propagates. * In the special case of a spiral i.e. pitch equals diameter, confusingly, such a beam is said to be circularly polarized.

See plane-polarized light.

polarizer

Device which turns natural, unpolarized, light into polarized light: usually by transmitting only those rays whose polarization are correctly aligned to the polarizer.

pole

(1) Point where the optical axis enters the surface of an optical component. * Also known as vertex. (2) One of the ends of a magnet.

porro prism

Reflecting prism with corners at 45°-90°-45°: the 90° angle turns the incident beam through 180°. * A pair of porro prisms are overlapped in classic-style prism binoculars: the light-path is compacted, the field of view can be enlarged and the image is erected at the same time.

port

(1) Noun: window or sealed aperture through which projection or photography takes place e.g. on an underwater camera. (2) Verb: to carry or transfer data, a file or program from one system or platform to another.

portable document format

See PDF.

positive

Adjective: (1) ~ film, ~ image, ~ working: one in which the tone or colour reproduction is broadly similar to that of the image i.e. light tones are reproduced light, blue colours are blue, etc. * Antonym: negative. (2) ~ lens, ~ element: one which converges an incident beam, to produce a real image. (3) ~ distortion: lens aberration in which the image size increases with distance from the optical axis. * Synonym: pincushion distortion. (4) ~ film curl: one in which the emulsion side is concave. (5) ~ screen: type of screen used to make positive half-tone plates.

See reversal.

posterization

Representation of an image using a relatively very small number of different tones or colours which results in smooth tonal transitions being rendered as bands of different tones with flat areas of colour. * Seen where the colour range or greyscale available are a long way short of what is needed to represent the image realistically e.g. where bit-depth of colour monitor is too low.

PostScript

Language designed to specify elements that are printed on a page or other medium e.g. packaging; also called a page description language; also includes programming elements. * *De facto* standard used by graphics and desktop publishing programs to instruct printers and image setters what to print (drawings, fonts etc.) and at what size. * Ensures

Reversing the rules

While we take it for granted that the way we see is the correct way (bright is bright, surely) photography works at heart the opposite way: essentially all photographic processes are negative-working. In order to get a positive image we (almost) always need to interpose an extra step which is, itself, of course negative-working too. Test: which photographic process is positive working? (Clue: it died an early death.)

resolution- and device-independence because the language uses primitive elements which make no reference to final size or resolution, therefore output should be as high-resolution as the printer can make it. * Usually works in the background but needs conversion through a RIP (raster image processor) before its files can be printed.

See font; primitives; RIP; TrueType.

power

Noun: (1) Rate of transfer of energy from one system to another. * Measured in watts in most applications e.g. electricity, motor; in lumens for light-source. (2) Magnification power or increase in apparent size of image given by optical instrument e.g. 8X power of binoculars means object appears 8 times larger; a 500X power microscope objective projects an image 500X larger than the object. (3) Measure of ability of lens to bend light: equal to the reciprocal of focal length. (4) Telephoto ratio: in a telephoto lens design, the ratio between the focal length and the flange focal distance. (5) Verb: to provide a source of energy for a device e.g. four NiMH batteries are used to power a digital camera. (6) Adjective: ~ user: advanced or expert user of e.g. software or operating system or one who makes exceptional demands on the system.

See dioptre.

power pack

(1) Electrical apparatus used to control electronic flash-units: usually carries condensers and control circuitry for modelling lamp as well as flash, usually powered from mains supply. * May be portable or massive and may be directly or indirectly connected to flash-units. (2) More or less portable unit containing batteries and circuitry to adapt mains power to be used by connected equipment e.g. digital or other camera, flash-unit, etc.

power spectrum

Graphical representation of the relationship between wavelength of light and power of emission at that wavelength for a given light-source. * From the power spectrum it is easy to see e.g. that incandescent sources emit more or less evenly over a broad range of wavelengths but e.g. fluorescent sources emit most of their energy into two or three very narrow wavebands.

power supply

(1) Specification of voltage and current for the correct operation of a device. (2) Unit which adapts mains supply to

voltage and current suitable for the device being powered.
* Power supply may also be designed to prevent power
surges or stabilize the power supplied to device.

ppi

Points per inch; pixels per inch: measure of input resolution
e.g. of scanning device, measured as the number of points
on the object at which a sample or measure is taken or
which are resolved by the device per linear inch on a given
axis: e.g. 600ppi means six hundred points per inch, usually
along the axis of the scanner sensor.

See dpi.

pre-exposure

Process of applying a uniform, non-image forming exposure
to sensitive materials prior to image-forming exposure.

See Clayden effect; pre-flashing.

pre-flash

Application of brief overall exposure prior to the image-
forming exposure: used to reduce contrast in e.g. printing
contrasty negatives, making duplicate transparencies. * Form
of pre-exposure.

pre-press

Stage of production of material for mass production printing
prior to making printing plates and setting up the printing
press. * At pre-press, checks are made on e.g. colour and
tonal reproduction, page imposition (distribution of pages
on the press so that they are in the right order when the
print-out is folded and cut), all graphics and type elements
are present.

pre-scan

In image acquisition: a quick 'snap' of the object to be
scanned, taken at a low resolution. * This quickly produces
data for setting parameters such as the crop, minimum and
maximum density and colour balance: the final scan usually
takes much longer than the pre-scan.

pre-set focus

Technique of setting focus of lens to a point at which
photographer expects movement or action to take place e.g.
racing cars coming out of a corner or at goal-mouth. * This
avoids the time-lag involved in checking focus accuracy.
* Used even with auto-focus lenses: professional auto-focus
lenses may be able to memorize pre-set positions.

presbyopia

Eye condition in which the accommodation of the lens is not
sufficient to focus on nearby objects. * Normally considered

**Muddying the
resolution waters**

*While there is no doubt
that, in general, a higher
ppi figure indicates higher
resolution, it is not
necessarily the case that the
image quality is higher.
For one thing, the pitch at
which a scanner steps may
actually be smaller than
the area sampled by each
CCD. For another,
resolution is not the only
determinant of image
quality – dynamic range
and linearity of coding for
tonal representation are
vitally important too.
Then there are software
issues such as the bit depth
at which the digitization
takes place. At the same
time you have to be careful
that a ppi rating is not an
interpolated figure.*

P

to occur when the amount of accommodation is less than 4D (dioptres). * Common in people in their mid to late 40's in higher latitudes, but occurs in the 30's in people living in the tropics. * Correction is given by a positive lens, also called an addition.

preview

(1) Representation showing effect of applying command e.g. to print: what the page will look like; to apply filter: what the filtered image will look like. (2) Pre-scan: representation of final scanned image prior to full scan. (3) Stop-down preview or depth-of-field preview: camera control on single-lens reflex cameras which sets lens aperture at working aperture to give user some idea of depth-of-field.

primary chromatic aberration

Defect in optical performance: also known as primary colour.
See chromatic aberration.

primary colour

(1) One of the colours red, green or blue. * 'Primary' in the sense that the human eye has peak sensitivities to red, green and blue and that visible colours are perceived through the agency of varying sensations of red, green and blue combined. * A set of primary colours mix to produce the sensation of white light. (2) In optics: synonymous with primary chromatic aberration.
See secondary colour; trichromatic.

primary spectrum

Spread of white light into different colours caused by a diffraction grating.

prime lens

Base or original optical system to which converters may be attached e.g. a 2X tele-converter attached to a prime lens of focal length 300mm creates a converted lens of 600mm focal length. * The aperture of the prime lens is reduced, in this case, by 2 stops.

primitives

(1) Basic shapes or manipulations which are used alone and in conjunction with other shapes by graphics, 3-D or typography applications to produce larger, more complicated shapes. * Most software relies on the manipulation of a square, ellipse, triangle and line to create nearly any shape required. * May be known as primitive shapes. (2) Basic elements used by a page description language – in conjunction with operations such as 'stroke', 'fill', 'translate' – to define items to be printed.

principal axis

Imaginary line which connects the centres of curvature of reflecting or refracting surfaces of an optical instrument. * Also known as optical axis.

principal focus

See focal point.

principal plane

Surface on which the image projected by a lens falls. * The locus of intersections of incident and projected rays of an optical system. * Almost never planar, the principal plane is usually a complex curve that is more or less flat. * Also known as the equivalent refracting surface.

principal point

Intersection of a principal plane with the optical axis of a lens. * Locating principal points enables simple geometrical optics to be applied to thick or complex lenses.

principal ray

That ray of an oblique or skew beam which passes through the centre of the entrance pupil. * It is used in considering third order aberrations. * Also called the chief ray, also the field ray.

principal section

Plane passing through the optic axis of a crystal and the light ray being examined.

principle of least time

See Fermat's principle.

printer

(1) Device which places text or image onto paper or other substrate. * Computer peripheral which produces hard copy of digital files. (2) Device which exposes photographic paper through negatives prior to development. (3) Person or operative who works with printing devices to create or produce photographic or other prints.

prism

Optical element with at least two flat and polished faces which are inclined to each other: light entering one face is reflected or refracted through the other.

prism binocular

See binocular.

Pro Photo CD

Professional Photo CD: this offers Image Pac files of high resolution (to 64 Base e.g. 4096 pixels along the short dimension of the film depending on format) to Base/16 resulting in files of up to around 72MB with more control

P

over colour balance and density plus ability to scan larger formats (to 5x4") than offered with Photo CD. * Each Pro Photo CD holds a maximum of 30 images.

See Photo CD.

process camera

Instrument designed to produce photomechanical film of camera-ready material – e.g. pasted up pages – for producing printing plates. * Essentially a large camera distinguished from others by its use of a high-performance process lens and half-tone screens in front of the film.

process colour

(1) Colour which can be reproduced with standard web-offset press inks of cyan, magenta, yellow and black. * Colours seen in a book or magazine are process colours except where they have been printed using special inks such as metallics or fluorescents. * With introduction of six-ink printing, the gamut of process colours has been significantly enlarged. (2) A colour belonging to the set of four colours used in four-colour printing. * Also known as process ink.

process control

Collection, analysis and use of data monitoring a production process for the purpose of maintaining the quality of the output e.g. that of developed film, printed materials, etc. * Control may be indirect e.g. adjusting humidity of printing plant, or direct e.g. adjusting replenishment of developer in a film processor. * Control may be continuous e.g. monitoring strength of developer or intermittent (batch by batch) e.g. measuring control strips.

process lens

Optic designed to make separation film for colour printing plates from pasted up originals. * Typically, the construction is symmetrical, it is designed for 1:1 to about 4:1, with a field angle of about 40° at $f/9$ with high resolution, no distortion and apochromatic correction. * Focal lengths vary to accommodate different size paste-ups and film.

processing

(1) Use of data e.g. image file in order to e.g. increase file size, manipulate the image, convert it into a different format, extract extra information, etc. (2) Sequence of chemical reactions which develop and fix the latent image on film.

profile

Description of characteristics of a device e.g. monitor, scanner which is used by other devices to manage or alter their own behaviour. * Profiles are embedded or tagged onto

Hats off and heads down

For the process lens is passing away, along with all the accompanying plate-making technology that was once the back-bone of mass production printing. For it is all being replaced by the virtual page – churned out by the millions now by software such as XPress, Framemaker and InDesign – which is being turned to film by image-setters which cost little more than one process lens did.

a data file so that when the file is opened, devices compliant with the profile can read the extra information and use it to interpret the data. * E.g. an image file has a monitor profile embedded in it: when the image is opened, the profile is read and used to change the colour reproduction on the new monitor so that the colours more nearly match those seen on the original monitor.

projection

Noun: (1) Use of equipment and lighting to cause an image of an object or original to be seen on a screen. * Usually the image is larger than the original and the projected image is positioned to be easily viewed or used for another process. (2) Imaginary extension of a line, plane or axis for some distance to demonstrate the geometry of a set-up e.g. to determine whether the Scheimpflug condition is met. Adjective: (3) ~ printing, ~ paper: process of making enlarged prints from negatives; hence ~ paper: designed for projection printing. * Compare with contact printing, which does not require an enlarger. (4) ~ booth, ~ lens: equipment designed for projection.

projection distortion

Change in shape of an image caused by projection of the image from an incorrect position i.e. not square onto projection surface. * Typical example is slide or LCD projector being pointed upwards at projection screen: the upper part of the image is more magnified than the lower part, which distorts the shape of the projected area into a keystone shape.

proofing

Process of checking or confirming the quality of a digital image before final output, particularly a long printing run producing many copies. * Proofing systems include the soft proof on monitor screens calibrated to appropriate printers; Chromalin and other proprietary systems that use inks similar to those used in printing; suitably calibrated, short-run printers.

protanomaly

Abnormal perception of colour due to lower than normal sensitivity to red.

See anomalous trichromatism.

proxy

(1) Noun: low-resolution version of a file that is used during production to stand-in for the full-resolution file. * This usually saves time as the document size is smaller, screen re-

P

draws may be speeded up. * E.g. DTP software such as QuarkXPress uses proxies in the picture boxes. (2) Adjective: ~ editing: image-editing software which make changes to a low-resolution proxy image to speed up operations: when manipulation is complete, the changes are applied – i.e. the final image is rendered – using the full-resolution file.

pseudocolour

(1) Image coloured by the arbitary assignment of colours to different greyscale values. (2) Arbitrary assignment of colours to different wavebands of sensitivity in colour film or sensors e.g. in infrared photography; in creation of remote sensing images. (3) Process of changing true-to-life colours of an image by using manipulation software.

pseudoptic

Adjective: an image which is laterally reversed relative to the subject. * The image on the focusing screens of waist-level finders are pseudoptic. * Compare with pseudoscopic.

pseudoscopic

Adjective: an image in which objects appear to sink into themselves: reversed contour or inside-out. * The opposite of stereoscopic: seen when the left eye sees the right-eye image and the right eye sees the left-eye image of a stereoscopic pair. * Also seen in holograms: the image offers full parallax, but reversed i.e. moving the viewpoint upwards reveals the underside, and so on.

pulsed laser

Type of laser which emits energy in very brief bursts. * These bursts may be brief enough to capture movement in a hologram.

pupil

(1) Image of the aperture stop as seen from either the front (entrance pupil) or rear (exit pupil) of the lens i.e. from the object or image space, respectively. * In modern camera lenses, the size of the entrance and exit pupils may vary considerably, evident in e.g. retrofocus lenses: their ratio is the pupil factor or pupil magnification. (2) Aperture in the centre of the iris of eye through which light enters the eye.

purity

(1) Colour quality subjectively measuring extent to which the main colour contains other colours. (2) Colour quality of saturation: a high-purity colour is highly saturated. (3) Measure of lack of contamination of chemicals.

Purkinje shift

Reduction in perceived brightness of red relative to blue as

the colours are darkened. * In practice, this is seen in dark adaptation: as overall light-levels decrease, colour discrimination is lost i.e. in the dark, one can see only brightness differences.

See scotopic vision.

pushbroom scanning

See parallel scanning.

pyramid

Coding technique for image files in which the basic large file is compiled in such a way that it can easily provide increasingly smaller, lower resolution files. * Used in Photo CD's Image Pac format and also with software such as LivePicture, xRes.

See Photo CD; YCC; IVUE.

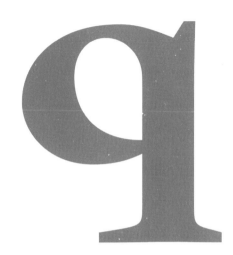

Q factor
(1) See quality factor. (2) See Callier coefficient.

QH
See quartz halogen lamp.

quad-speed drive
Type of CD-ROM drive that transfers data at 600 KBs: this is four times more than the nominal standard. * Speed refers to rate of data transfer, not the rotation or even operational speed itself: quad-speed drives rotate less than 50% faster than double-speed drives while operational speed depends on access times which are difficult to reduce in the drive itself. * Speeds reach to 32X and greater.

See access time.

quadtone
(1) Photomechanical printing process using four inks to increase tonal range: four half-tone screens are made at different angles. * Used in very high-quality print reproduction of photographs for books, posters etc. often with the fourth colour being a metallic ink. (2) Mode of working in image manipulation software that permits printing of image with four inks, each with its own reproduction curve.

Q

Q for more

A common error is to work with files which have far more data that is needed for the output intended. But in this business, to misquote Mother's advice, it is safer to be better than sorry. But if you want to speed up your computer, manipulate files rapidly and save on disk and other storage space, avoid crashing the RIP, and so on: then work with the smallest files you need. Try saving your files at lower and lower resolution settings and checking the print quality. You will be surprised how much you can slim a file down without obvious deterioration in quality. And with FM or stochastic screening, the quality factor may be as small as 1.

Quantum zones

You might never have thought of it, but the Goode Ole Zone System is a quantization of continuous tonal or luminance variation: into rather widely spaced ten zones. It's just like saying someone is 'x years old' is to quantize the continuous variable of a person's exact age into the quanta of whole years.

quality factor

In pre-press work: multiplication factor used to ensure that graphics or image file size i.e. amount of information is sufficient for requisite quality. * The normal requirement is that file size should be sufficient for 1.25X to a maximum of 2X the screen or output frequency e.g. for a screen of 133 lpi, the image file should have available from about 166 to not more than 266 pixels per inch of the final image (output or printed) image size. * PostScript RIPs ignore data that is in excess of 2.5X more than the screen ruling. * Also known as half-tone factor, Q factor.

See Nyquist rate.

quantization

Process of dividing or sampling a continuously varying signal or quality into a series of discrete levels or quanta for the purpose of creating an accurate copy or facsimile of the signal. * Equivalently, it is the processing of reducing the number of bits needed to describe a variable by reducing the precision with which we store the variable. * It is the crucial, critical step in creating a digital copy of an image. * The frequency at which the signal is divided before quantization should be at least double that of the highest frequency in the signal: if not, the reconstruction of the original signal is likely to contain artefacts, or aliasing. * Note: the quantization may be linear i.e. equal steps in the source are matched to equal steps in the quantized data or not linear i.e. more steps in the quantized data are allocated to some parts of the source signal than to others – e.g. more quanta are assigned to low levels (shadows) than to high levels.

See alias; sampling; Nyquist rate.

quantum efficiency

Measure of effectiveness of light-sensitive system: (1) In a photo-detector: the ratio of induced current to incident flux: measured in electrons per photon or amps/watt. * May be measured in terms of photons absorbed. (2) In sensitized film: the number of silver halide crystals made developable per unit light flux incident or absorbed. (3) In a source of radiation: the ratio of the number of photons emitted to the number of electrons flowing through.

quarter-tone

Tonal value midway between white and the mid-tone i.e. 25% black or 25% of the dot area filled with ink or a grey level of 64 in 8-bit greyscale.

Q

quarter-wave plate

Coating or thin plate which induces circular polarization in light passing through. * The material is double-refracting such that it forces a phase difference of a quarter of cycle or wavelength between the ordinary and extraordinary rays, causing the magnetic vector to rotate about the axis of propagation.

quartz halogen lamp

Type of incandescent light-source in which a filament or coil made of tungsten is heated in a quartz bulb containing a halogen gas. * Variant of tungsten lamp, usually distinguished by small envelope or bulb, operation at very high temperatures and very high light output. * Also known as QH lamps.

quasi-monochromatic

Light radiation in which most of the energy is confined to a single wavelength or a very narrow waveband. * Light which behaves similarly to ideal monochromatic light. * Light from certain gas discharge lamps is quasi-monochromatic.

quenching

(1) Reduction of flash-output by diverting and losing part of the electrical charge from the flash-tube in order to shorten flash duration. * Now obsolete: thyristors reduce flash duration with minimal loss of energy. (2) Reduction of phosphorescence or fluorescence by application of radiant energy of different wavelength from the initiating radiation.

QuickDraw

Object-oriented graphics routines native to the Mac OS which tell the computer how to draw boxes, text, images, icons etc. on the monitor screen. * It is also responsible for PICT format images. * It may be used to output text and graphics etc. to printers. * Implemented on the computer Read Only Memory, hence integral part of system.

QuickTime

Software technology in Mac OS which integrates time-based media across applications (from its inception in 1991) and across platforms (from QuickTime 3, of 1998) to enable recording, manipulating and playing back time-based data such as video, animation, sound etc. * Accepted by ISO as part of MPEG 2 specification and from MPEG 4 as the preferred multimedia architecture.

QuickTime VR

QuickTime Virtual Reality: extension of QuickTime 2 and later which allows playback of panoramas as virtual reality i.e.

Handling? No sweat

QH lamps should be handled with great care: not only are they expensive to manufacture (and buy), their quartz envelopes are highly fragile and susceptible to chemical attack. This is because the lamps work at such high temperatures that so any sweaty acid left on the envelope by a squidgy finger (ugh!) can weaken the envelope catastrophically. Always handle the lamp with e.g. tissue paper.

Q

users can move freely around the space, with the views, perspective changing appropriately.

quit

To close or exit a program in a dignified manner i.e. by using normal commands: this ensures there will be a warning if there is any unsaved work and any current changes to configurations or preferences will be saved.

See restart.

qwerty

Design of keyboard dating from beginning of twentieth century designed to slow down typists' fingers to prevent the striker keys of a typewriter from jamming but still standard in English-speaking world. * Derived from sequence of first row of letters. * Proven time and again to be the most inefficient layout imaginable, but still it hangs on in there as English-speaking-world standard.

rack

Noun: (1) Track or bar with indents or teeth which engage in circular gear-wheel or pinion to create a rack and pinion: used for focusing or aligning optical equipment e.g. on enlarger or bellows extension. (2) Hanger to hold roll or sheet film for processing, or for drying prints. Verb: (3) To focus or change position of an instrument or optical component e.g. on enlarger or process camera.

radial

See sagittal.

radial astigmatism

See astigmatism.

radial distortion

Variation in magnification from the centre of the optical field to the periphery. * It is an optical aberration, usually caused by an error of lens assembly.

See geometric distortion.

radial gradient lens

Optical component in which the material's refractive index varies with the radius: such lenses can focus light even when they are planar. * Also known as Wood lenses.

See gradient index lens.

R

radiant

Adjective: ~ energy, ~ intensity: relating to electromagnetic radiation, irrespective of wavelength. * Compare with luminous: relating to visible wavelengths.

radiation

(1) The process of producing, emitting or propagating electromagnetic energy. (2) Propagation or emission of electromagnetic energy.

radiation-dosimetry

Use of specially sensitized film to record ionizing radiation e.g. x-rays, gamma rays. * After processing, the film's density is a measure of the level of radiation. * Also known as radiation-monitoring.

radio-autograph

Image of a thin specimen dosed with a radioactive isotope made by laying it in close contact with a photographic plate: the image, usually made in conjunction with a normal image, shows the location of concentrations of the isotope.

radiograph

Image produced by exposing sensitized film to a subject receiving x-rays: the rays are not significantly deviated by subject, but differences in absorption (radiopacity) are recorded. * The image is the same size as the object.

radiosity

Mathematical model used to compute appearance of the surface of a solid. * The surface is divided into patches and calculations are made of the light reflected off or received by each patch in relation to other patches that can be seen, i.e. are directly in line, from a given patch, irrespective of the viewer's position. * The more patches used, the more accurate the modelling: can give very realistic rendering but heavy-weight computing needed. * As the calculations are based on patches on the surface itself, the solid may be viewed from any angle.

RAID

Redundant Array of Independent Devices: a configuration of hard-disk drives that share data and markers for data in order to minimize loss due to corruption or breakdown of one drive. * High-level RAIDs allow total recovery of all data should one or more drives break down but lower levels will tolerate less breakdown before the whole system crashes and data is irrecoverable.

rainbow hologram

Hologram made from another hologram in which change of

Raid the Piggy-bank

RAIDs are highly recommended for high-volume needs i.e. when hard-disk drives are 20GB or more in size. The angst and bother resulting in a loss of a 500MB file is bad enough, but losing more than 5GB at once just doesn't bear thinking about. The paranoid (who are the only ones who survive, remember) will back-up their RAIDs with tape, CDs and whatever else they can lay their hands on. The more you value your work, the more you back-up.

viewpoint results in change in hue of the image. * A slit transfer hologram: the real image of the original hologram is the object for the rainbow hologram but is copied through a horizontal slit: this largely removes vertical parallax so changes in viewing position causes viewer to see different parts of the dispersion spectrum. * Belongs to class of white-light transmission holograms.

See hologram.

RAM

Random Access Memory: component of the computer in which information can be stored or accessed directly by the microprocessor without having to shuffle through locations in sequence until the required information is found. * Essential to computer working, the RAM is the primary memory, in which program instructions and data are stored for use by the central processor unit (CPU): that is why the larger the RAM, the faster the computer can work. * RAM typically requires the CPU constantly to refresh it, hence the qualifier Dynamic RAM or DRAM, in contrast to Static RAM or SRAM which can hold its data for longer. * Of course data held on the hard-disk or disk-based or flash-memory removable media is also random access memory but is hardly ever referred to as such.

See inter-leave; ROM.

The fine art of acronyms

From the definition it is clear that what we are talking about is far more accurately called Direct Access Memory. For pretty obvious reasons, the acronym for Direct Access Memory never had great prospects.

Raman effect

Optical phenomenon in which adsorption of a photon is followed by emission of another of different frequency. * The frequency of part of the scattered light compared to that of the incident beam is related to the vibration frequency of the scattering molecules. * Seen most clearly in laser light.

Ramsden circle

The circular image seen in the eyepiece of an instrument e.g. telescope, binocular when the eye is slightly removed from the eyepiece. * The exit pupil of an instrument.

random

Differences or characteristics which are caused by chance events. * Unpredictable or without discernible or measurable pattern e.g. grain distribution in silver-based emulsion, but only within very tight limitxs.

See noise.

range

(1) Noun: extent or spread of values or types e.g. range of densities of captured image, range of hues in scene. (2) Verb: to measure a distance or separation between two objects.

R

range axis

Depth or axis of distance between object and an imaging system. * The Z-axis or third dimension.

rangefinder

Just so you know

Strictly speaking, passive phase-difference auto-focus systems are not rangefinders. Instead they detect out-of-focus conditions by splitting a beam into parts and checking the phase difference between them.

Device for measuring distance between object and observer, usually to focus a lens on the object. * May be based on triangulation: the device deduces the distance by the difference in angles from two viewpoints given a fixed distance between the viewpoints (the base or base-length): this may be measured visually e.g. by making two images coincide or actively, by using infrared beams sent out at different angles: the distance is deduced from the angle of the reflected beam. * Another type measures distance based on phase differences in the reflection of an ultrasonic beam.

rapid rectilinear lens

Family of lens designs based on Dallmeyer's design (of about 1866) which offered low distortion, lateral colour and coma at a relatively fast speed of $f/8$ (instead of $f/16$ or slower) but narrow field. * Consists of two symmetrical menisci on either side of the aperture stop.

rare-earth elements

Elements with atomic numbers between 57 (Lanthanum) and 71 inclusive. * Some are not that rare. * Used in semiconductor fabrication and anomalous dispersion lenses (so-called rare-earth glasses). * Also known as lanthanides.

raster

Structure of the digital world

The raster has emerged from the jargonistic depths of the language to become one of the backbones of the digital era. For very few are the visual things touched by technology that are not based on the raster – which means much the same as 'grid' but sounds more technical. Note that not all rasters are aligned horizontally across and vertically: some image sensor grids are lined up at 45° and 135°.

Noun: (1) The regular arrangement of addressable points of any output device such as printer, film-writer, etc. (2) The pattern of lines traced by the scanning in display or output systems e.g. monitors, laser printers. (3) Adjective: ~ image, ~ graphic: bit-mapped image or one based on a raster structure. * Antonyms: vector image, vector graphic.
See addressable; bit-mapped; RIP.

raster image processor

See RIP.

raster unit

Distance between two addressable points on a raster-based output device. * Measured either vertically or horizontally, it is a measure of the basic resolution of device.

rasterization

(1) Process of converting vector-image to a rasterized form e.g. prior to output at a specific size. (2) Process of converting a bit-mapped image to a rasterized form suitable for a given output device or purpose.

raw

Adjective: (1) ~ file, ~ scan: computer file or scan data prior to its manipulation e.g. to convert it into a certain format; to convert from scanned 42-bit data into a 24-bit image file. (2) ~ data: information before it has been analysed to yield further information or deductions. (3) ~ glass: optical glass before it is processed, moulded and ground to create an optical element.

ray

Representation of light in terms of its direction or path through a medium. * An imaginary line in the direction of the light's propagation: it is normal to the wavefront and taken as having only one dimension.

See geometrical optics.

ray trace

(1) Computational construction of light paths from light-sources and the reflections off objects to create natural-looking lighting in 3-D graphics. (2) Geometrical construction or mathematical calculation of paths or rays of light through an optical system.

Rayleigh criterion

Definition of limit of resolution of optical system free of aberrations. * For most practical purposes, the smallest detail resolvable or resolving power equals the reciprocal of the product of wavelength and relative aperture i.e. resolution falls with increasing wavelength and with smaller aperture.

RC

Resin-Coated: describing printing papers whose paper base is coated on both sides with a thin layer of water-resisting resin. * This reduces water and chemical absorption, allowing shorter post-fix processing.

re-sizing

(1) Changing the resolution or file size of an image. * Reducing the resolution or file size results in irreparable loss of information as data is discarded. * Increasing the resolution or file size requires pixel interpolation. * Re-sizing may or may not result in a change in the size of the image when it is finally printed. (2) In desktop publishing: to change the dimensions of a box containing an image or a graphic, at the same time changing the size of the object enclosed in the box. (3) In darkroom work: to move the film stage to a different position and refocus the image, thus changing reproduction ratio.

See interpolation, re-sampling.

Long live misnomers!

In fact most so-called RC papers are coated with polyethylene. So if you want to confuse everyone yet be in the right, call them PE papers.

re-sampling

Addition or removal of pixels from an image by sampling or examining the existing pixels and making the necessary calculations. * Part of the process of re-sizing an image, and of interpolation.

read

To access a digital file or obtain data from memory or archive e.g. to be able to read a CD is to be able to open and use the files on it.

read-only

Property of digital data storage system – e.g. computer memory, CD – in which files may be opened or copied i.e. play-back only but not altered or edited in any way.
* Storage media such as removable disk or hard-disk may be locked mechanically or set by software to be read-only.
> See ROM.

real image

One which is constructed by the convergence of actual rays of light following reflection or refraction in an optical system. * It can be caught on a screen or detected by sensitive material or sensors. * Antonym: virtual image.
> See aerial image; image; virtual.

real-time

Events or responses that take place with little or no time-lag or delay or which follow control or adjustments at the same time as they are made or which are experienced at the same speed as the event itself. * Real-time responses mean that the system may be able to adjust rapidly enough continuously to keep track of changes. * May be used synonymously with live: e.g. with live update in a dialogue box, changes made to one control are immediately (in real-time) reflected in the image.

rear projection

Arrangement for viewing of projected image in which the screen lies between the viewer and the projector, with the image being projected onto the back of the screen. * The slide must be placed back-to-front, to ensure the image is not seen laterally reversed. * Used where the viewing area cannot be darkened; also in portable projection systems.
> See front projection.

receiver primaries

Set of three colours of fixed hue but variable brightness: variations in the proportions of their mix form other colours.
* Named after the colours used in television receivers: red,

green and blue are most commonly used, but cyan, magenta and yellow have been experimented with. * Also known as display primaries.

reciprocity failure

Behaviour of light-sensitive material such that its response is not proportional to the total energy of incident light e.g. reducing the working aperture by one stop is not compensated for by increasing the exposure time by one stop. * Encountered mainly in low-light conditions but may also occur with extremely short exposure times.

> See reciprocity law.

reciprocity law

Observation that, within variable limits, the response of a light-sensitive material is proportional to the total incident light energy i.e. proportional to the product of illuminance and exposure time. * This is the basis for the practice that permits e.g. a reduction in working aperture of, say, three stops, to be compensated for by an extension of exposure time by three stops.

reconstructed image

Image produced by illuminating a hologram with a replaying or reconstruction beam of light. * The reconstruction beam may be any suitable source – laser, daylight, spot-lamp – depending on the hologram type so long as it is aligned to replicate the original reference beam.

rectification

Procedure to ensure that the main object plane is parallel to the printing or projection plane e.g. to correct distortion caused by misalignment. * Used in enlargement to correct distortion e.g. by tilting baseboard and in photogrammetry and mapping to ensure accuracy of measurements. * Do not confuse with restitution in photogrammetry.

rectilinear

Adjective: (1) ~ optics, ~ system: are those in which images of straight lines are themselves straight, not distorted. * Such optics or systems are corrected for distortion and spherical aberration. (2) ~ propagation: is that in which a wavefront travels in a straight-line path e.g. applies to light when it moves through a medium of constant refractive index.
(3) ~ scanning: that in which the scanning head moves in straight lines, as opposed to e.g. in a circle.

Red Book

(1) Standard for basic audio CDs. * Developed by Philips.
(2) Standard set by US government for network security.

Predictability failure

There was a time when most films behaved similarly, so you could be fairly sure that where one 400 speed film started to fail in the reciprocity stakes, other 400 speed films would do so. And this was normally when exposure times were more than a second long. Nowadays, while some 100 speed colour films fail at around 2 secs, others hold reciprocity to over 30 sec exposures. Answer: read the instruction leaflet.

red eye

Bright red dot which may be seen in the eyes of subjects photographed with electronic flash: it is caused by light entering the eye and being reflected from the blood-rich retina to the taking lens. * The basic conditions for red eye are (i) dark ambient conditions, which cause the pupils to dilate (ii) flash lighting which is of too short duration to cause pupils to close down (iii) flash lighting which is very close to the optical axis (iv) subjects looking in general direction of the taking lens. * In animal photography, the colour may be white, green, etc. according to the animal.

redevelopment

Stage in processing light-sensitive materials in which unexposed and undeveloped silver remaining from the first development is developed after a fogging exposure e.g. as in reversal processing.

reducer

(1) In photography: bath used to lower density of image e.g. Farmer's reducer bleaches silver to reduce density. (2) In printing: additive to ink which lowers tackiness, makes it run more easily.

reference beam

Part of the light from a laser used to create a hologram: it is split from the beam illuminating an object and is therefore unmodulated. It is then directed to interfere with the beam reflected from – i.e. modulated by – the object: the interference patterns are recorded to generate the hologram. * Also known as carrier beam.

reference white

Target used to provide a standard for checking white balance for e.g. digital camera, video: e.g. a diffusely reflecting white surface on which the test illuminant is shone.

reflectance

Measure of ability of object to reflect light. * Ratio of reflected flux to incident flux, where reflected flux includes all reflection. * White objects have reflectance of about 0.8 and black objects a reflectance of around 0.1.

reflected light meter

Design of exposure meter which measures the luminance of the subject i.e. light reflected from the subject, in order to calculate camera settings. * May accept light from a relatively wide angle e.g. 60° to very narrow e.g. 1° or smaller: may be modified to measure incident light.

See incident light meter.

reflecting microscope
Laboratory instrument using catadioptric or catoptic objectives i.e. in which the image formation is largely or entirely through reflection rather than refraction. * Usually for examining samples using ultraviolet or infrared.

reflecting objective
Microscope optics using internal reflection rather than refractive effects to form image. * This allows a high level of colour correction.
> See mirror lens.

reflection
(1) Change or reversal in direction or deflection of a ray or energy when it hits a surface or change in refractive index: on reflection the ray stays on the same side to the surface as the incident ray. (2) Mirror image: laterally reversed and virtual image seen in a mirror.

reflection hologram
Type of hologram in which the reconstructed image is seen as a reflection from the hologram. * The image beam is on the same side of the hologram as the viewer when the hologram is suitably illuminated i.e. with a replica of the reference beam.

reflex camera
Apparatus in which the image for viewing arrives at the focusing screen via a right-angled reflection in a mirror e.g. a single-lens reflex camera. * Also in twin-lens camera: the image from the viewing lens is seen after being reflected in a mirror. * The reflection is needed in order to revert the inverted image projected by the lens; however, the image is still laterally reversed after reflection: in a single-lens reflex camera, a prism or set of prisms corrects the image.

refracted
Adjective: ~ ray, ~ wave: light which has had its direction altered because it has encountered a change in refractive index, usually by entering a medium whose refractive index is different from that of the medium it is leaving.

refraction
Change in the direction of a ray of light at the point it crosses from one medium to enter another of different refractive index: the ray moves from one side of the boundary to the other. * A special case of the phenomenon is offered by gradient index glass in which the ray of light changes direction continuously i.e. follows a curved path as it traverses a gradient of different indexes.

R

refresh
The changeover of one frame of a CRT or computer monitor screen to the succeeding frame.

refresh rate
The rate at which one frame of a CRT or computer monitor screen succeeds the next. * Measured in Hertz (Hz) i.e. cycles per second. * It is equal to the frame rate on non-interlaced screens and equal to half the field rate on interlaced screens.

registration
Noun: (1) Superimposition of a set of colour separations which gives the best reproduction, without colour fringes or other defects. * It is said that such a separation set is 'in register' or that the 'fit is good'. Verb: (2) Sign up to, and agree conditions for, use of a software application, use of service on Internet, etc. * Registered users generally enjoy benefits which non-registered users cannot.

relative aperture
Indication of how bright is the projected image of a lens. * Measured as the ratio of the diameter of the light beam entering the lens (the entrance pupil) to the focal length of that system. * Symbol: $f/$ followed by the value: e.g. $f/2$ means that the diameter of the entrance pupil is equal to half the focal length.
See f/number; lens speed.

relay
Adjective: referring to an optical component used to gather light from one part of instrument to project it to another. (1) ~ condenser: in projectors, it improves efficiency by collecting the light from the bulb and focusing it onto the slide. (2) ~ optics: in a camera, it collects the image from a lens or focusing screen to project the image to the film or viewer. * Also known as optical relay.

relief
(1) Distribution of tones in a subject which gives the impression of depth or three-dimensionality when seen in a two-dimensional image. (2) Reconstruction of the experience of seeing three-dimensional objects by viewing stereoscopic images to give the appearance of depth and distance. (3) Distance between viewer's eye and eyepiece which gives a clear view through the optical instrument. * Low or narrow relief indicates the eye must be nearly in contact with the eyepiece, long or high relief indicates a larger distance, usually to accommodate wearers of spectacles.
See bas relief.

rendering

(1) Computation to create the appearance of a fully formed object using data from outline drawings, data on shading of the surface and information about light-sources. * Used in 3-D modelling programs, architectural CAD systems etc.

(2) Computation turning outline data into a specific form for use by other programs or device e.g. turning the work files of applications such as Live Picture or xRes into printable files. * Often used in sense of converting resolution-independent information, e.g. vector-based graphics, into a file of specific resolution for specified purpose e.g. printing.

(3) Reproduction or simulation of tone in e.g. print.

> *See proxy.*

reproduction scale

Ratio of a dimension in an image to the corresponding dimension in the object e.g. if one centimetre on the image corresponds to two centimetres on the object, the reproduction scale is 1:2. * Also known as magnification.

res

Measure of the resolution of a digital image expressed as the number of pixels per side of a square measuring 1x1mm e.g. a res40 image has a resolution of 40 pixels per millimetre i.e. there are 1600 pixels per square millimetre.

residual

Low levels of a contaminant or defect which may be acceptable in practice. * E.g. (i) ~ aberrations, ~ noise: uncorrected defects in image formation or capture which are of a sufficiently low level not significantly to impair performance; (ii) ~ hypo: permissibly low concentration of fix left in film or print.

resolution

(1) For input devices e.g. cameras, scanners: measure of the ability of a system to reproduce details present in a subject so that they are in the image. * Measure of highest spatial frequency which can be recorded by the system. * Units: total number of usable pixels for digital cameras; points per inch for scanners (ppi); line pairs per millimetre for camera objectives (do not confuse with lines per inch). (2) For output devices e.g. printers, film-writers: measure of system's ability to address or refer to separate points or lines of output. * Units: dots per inch (dpi). (3) Measure of system's ability to distinguish variations in colours or of density. * Units: bit depth (total number of bits available for encoding values) e.g. 24-bit. (4) For positioning or focusing

Not all contaminants are bad

Far from being bad to leave some residual fix or hypo behind in the final film or print, there is evidence that it is bad for the gelatin to be entirely free of hypo as it may help strengthen the structure – so long as you do not leave so much fix behind that the sulphur can crystallize out. So, all ye who washed your precious films for hours to extract the last atom of thiosulphate may weep into your sinks. The moral: if it's too hard, it may be okay not to try.

mechanisms: measure of the minimum repeatable adjustment increment achievable.

See bit depth; lpi.

resolution target

Chart for testing resolution ability of optical system e.g. lens, lens/film combination, scanner: various designs depending on purpose. * May consist of series of sets of lines at progressively smaller spacing or series of lines radiating from centre etc.

See target object contrast.

resolving power

Measure of the highest spatial frequency which can be recorded by an optical system. * This is limited according to the wave nature of light, and varies with wavelength, according to the Rayleigh criterion.

resource

Part of Mac OS application which holds information peripheral to the application as well commonly used items e.g. icons for tools, dialogue boxes, user settings, location of associated files, etc. * The resource fork is that part of a Mac OS-compliant file which points the application to the resources.

response

(1) Noun: signals or recording resulting from radiation or other stimulation falling onto a light-sensitive or sensitized system. * May be characterized as e.g. linear i.e. response is proportional to strength of radiation or non-linear.
(2) Adjective: ~ time: the length of delay between a stimulation or signal and the reaction e.g. how long it takes for a sensor to register a change in environment, how quickly a camera takes a picture when commanded to, by pressing the shutter button.

See shutter-lag.

restart

To cause the computer to close down all applications and repeat its boot-up or starting procedure. * This does not involve first turning off the power.

restitution

Geometrical construction which relates points in an image to defined reference points in the object. * Key procedure in photogrammetry. * Restitution permits inferences as to spatial relations in the object to be calculated from an analysis of the image.

See rectification.

More contrast, better figures

In quoting resolution figures for lenses, we are seldom told the target object contrast – but we should be. A lens can seem to resolve very well with high-contrast targets which are much higher contrast than normally encountered: more realistic figure would come from testing with a medium-contrast target, say, 1:32, which is already a four-stop difference – whereupon the resolution figure usually plummets.

restrainer

See anti-foggant.

retardation plate

Optical element used in filters: light incident on the filter emerges as circularly polarized light. * Consists of a thin layer of dielectric material which changes the phase of the electric vector of a light wave: the emerging beam recombines electric and magnetic vectors to form a polarized beam whose character depends on the degree of retardation induced.

reticle

(1) Component of optical instrument which is used for pointing, measuring or helping focus image e.g. enlarger focusing aid, measuring microscope or loupe. * May consist of fine wires or an etched pattern of a scale or circle and is usually located at the main image plane i.e. so it appears sharply superimposed on the focused image. (2) Image, which may be etched on a glass or quartz layer, used in production of integrated circuits.

reticulation

Irregular pattern of cracks and uneven surface seen in e.g. photographic emulsion. * Caused by stresses within the gelatin layer brought on by sudden changes in e.g. pH of solution, temperature or concentration.

retina

(1) Light-sensitive membrane lining the inside of the mammalian eye. * In humans it is transparent, very thin and rich in nerves and nerve endings. (2) Scanning mechanism in digital reader e.g. for optical character recognition.

retina camera

Instrument designed to photograph retina of the eye: it exploits the eye's lens as part of the optical system. * Also known as photographic ophthalmoscope.

retouching

Process of making alterations to an image to improve its subject's features e.g. remove zits from face, make hair more blond, cut out telegraph wires, etc.

retrofocus lens

Type of wide-angle lens designed so that the space between the back of the lens and the focal plane is greater than the focal length. * This is required e.g. in single-lens reflex cameras in order to leave space for the mirror to move. * Consists of negative power lens groups in front which gather the image and a positive power group at the rear

Retardation and auto-focusing

The auto-focus systems split beams of light which always causes some plane polarization. So if you try to use a normal polarizing filter on an AF SLR, you completely screw up the AF system: more like than not, the polarized beam entering the AF system will be crossed with respect to the polarization inherent to the system, so drastically reducing brightness – exactly what happens when you cross the polarizer to darken skies. Fortunately, you can avoid the problem by first circularly polarizing light ... and a retardation plate (more likely layer, really) is the way to do this.

Retrospective splitting of hairs

Single-lens reflex cameras are often credited with being the reason for the invention of the inverted telephoto lens. In fact it was invented for cine-matography: the Technicolor process of the 1930's used a beam-splitting unit behind the lens to create colour separations: the back focal distance needed was large. The retrofocus lens was created to deal with the problem: it had all the modern features of a very large front element and complex rear group.

R

which extends the back focal distance. * Also known as inverted telephoto lens.

retroreflector

Optical device designed to return reflections close to the direction in which they are incident i.e. to retroreflect. * Usual design uses three mirrors facing each other and mutually at right-angles i.e. arranged like the corner of a room with its floor and two walls.

reversal

(1) Process in which a normal negative-working reproduction is made to produce a positive-working image e.g. black & white negative film may be processed as normal until before fixing, when it is re-exposed and bleached to remove the negative image, which leaves behind a positive image. (2) Effect seen when a second exposure, either before or during development, reduces the effect of the first exposure e.g. Clayden, Sabattier effects. (3) Result of extreme over-exposure: instead of high density of image, there is a low density e.g. when sun is photographed, may show a dark centre. * Also known as solarization.

reverse-reading

See wrong-reading.

reversed telephoto

See retrofocus lens.

reverted image

Image in which the right side of the object appears on the left side and vice versa. * More usually referred to as 'flipped'; also laterally reversed image.

revolving back

When revolving is easiest way to be lining up

It is much easier to line up the revolving back on large-format camera with, say, the horizon than to struggle with the tripod head – and it is also far more precise.

Design of film-holder, film magazine or digital back of camera which can be rotated about the optical axis to change format or alignment. * Essential in waist-level viewing cameras to allow landscape or portrait format to be easily chosen as desired.

rewind

To spool or roll film back into its cassette or container. * Applies mostly to 35mm film, in which the usual practice is to wind out the film from the cassette frame-by-frame: at the end of the roll, the film is wound back into the cassette. * NB: some 35mm and all APS cameras unwind the film out onto the take-up spool before the first exposure is made, then wind the film back as each frame is exposed.

RF CD

Royalty-Free Compact Disc: see royalty-free.

RGB

Red Green Blue: colour model that defines colours in terms of relative amounts of red, green and blue components; black is defined as zero amount of the components, white is maximum amounts of the components. * Monitor RGB describes the specific colour space of monitors.
See trichromatic colour theory.

rhodopsin

Visual purple: a pigment responsible for visual sensitivity. * It changes chemical form when stimulated by light, which causes changes in the potential of membrane of the retinal cell which leads to the neural response to light. * It is easily returned to its original form, ready to be isomerized again when struck by light. * Its peak sensitivity is about 498nm.

RIFF

(1) Resource Interchange File Format: file format for multimedia use across platforms. * Introduced in 1990 by Microsoft and IBM: stores different data in 'chunks' which are tagged as to type. * An extensible specification which can take in new elements. (2) Raster Image File Format: file format similar to TIFF that is proprietary to Letraset and native to Letraset Colour Studio.

right-reading

Image, text etc., which appears correctly oriented i.e. is not laterally reversed.
See wrong-reading.

ring around

Series of tests made to determine which settings on e.g. colour enlarger are needed to give correctly colour-balanced prints or other output. * Every combination of filter settings is systematically tested: after processing, the test prints can be assessed and the associated filter settings used for the final print. * Do not confuse with runaround.

ring-flash

Lighting unit used to provide medium-soft frontal lighting to the subject, with minimal shadow. * Consists of one or more electronic flash-tubes bent into semi-circle or circle like a ring doughnut – i.e. a torus – which is large enough to allow the lens to look through the central gap. * May, e.g. in endoscopy, use bundle of fibre optics wrapped around the lens. * Units may be very small and battery-powered for field use or as larger mains-powered units for studio. * Used for close-up photography and also in portraiture or fashion. * Also known as ring-light.

R

RIP

Raster Image Processor: software or specialist hardware dedicated to the conversion of outline fonts and graphics into rasterized information i.e. to turn outline instructions like 'fill' or 'linejoin' into a set of dots. * Often associated with interpreting or processing PostScript files, hence term 'PostScript RIP'. * Often extremely processor-intensive so for professional use it is best to have a dedicated hardware RIP – essentially a computer dedicated to RIP-ing.

RISC

Reduced Instruction Set Computer (or Computing): design of microprocessor which executes a small set of simple instructions very rapidly. * All modern Apple Mac computers use RISC processors in the form of the PowerPC line of chips; the Sun SPARC work-stations are also RISC-based.

RLE

Run-Length Encoding: algorithm for compressing data in which significant portions consist of strings of repetitions e.g. consecutive pixels all of the same value. * Simplistically, e.g. a portion of data that looks like this (80,80,5), (80,80,5), (80,80,5) … repeated 300 times (say, a red line one pixel wide, 300 pixels long) could be encoded as (80,80,5)300. * Used in RLE versions of TARGA format.

rods

Rod cells: light receptor cell of the retina, responsible for night or scotopic vision. * They are highly sensitive but low resolution and not colour sensitive. * The human retina contains some 130 million rod cells.

See cones.

ROM

Read-Only Memory: digital storage system which can be read or accessed but whose data cannot be edited in any way. * ROM may be used to store key information such as the operating system of e.g. hand-held device to run the system e.g. the basic set-up of the computer, to provide basic functions for application software programs to use; to control activity of input and output ports, manage the hard-disk and so forth. * But may be larger scale e.g. CD-ROM or some flavours of DVD.

roof prism

Type of prism consisting of a roof-shaped profile on the long, parallel-sided reflecting faces of a right-angle prism. * It erects an inverted image (or inverts an erect image) and bends the line of sight through 90°. * Used as an erecting

Where would we be without batteries?

Answer: completely up the ROM tree: the ROM in desktop computers usually keeps user settings (e.g. date, identities) in reserved RAM which needs power to maintain, hence the need for a small battery in the computer which takes over when the main power is turned off. On Apple Macs, the reserved RAM is called PRAM (Parameter RAM).

system in telescopes and some designs of binoculars. *
Designed by GB Amici. * Also known as Amici prism.

rotogravure
Printing process based on a printing cylinder that is etched
so that ink is carried in etched (sunken) areas.

royalty-free
Scheme for licensing use of images, graphics or music which
allows purchaser of a collection e.g. on CD to use the
material in the collection for unlimited or nearly unlimited
purposes without payment of further fees. * Note copyright
does not pass to the purchaser, but generally remains with
the publisher or author of the images.

rubberstamp
Image manipulation tool which allows user to replicate or
clone one part of the image directly elsewhere in the same
image, possibly into another image. * The part to be cloned
or rubberstamped is sampled, then it can be replicated
anywhere else in the image. * The cloning may be direct or
different modes of blending may be chosen.

run
(1) Verb: to print off or produce a series of similar items e.g.
printed pages, magazines, prints. (2) Noun: the series of
prints or items produced without interruption on one
occasion. (3) Verb: to instruct a computer to execute a
program or to perform a task or series of routines.

run-length encoding
See RLE.

runaround
Layout or setting instruction which flows text to follow or
flow around the shape of a graphic or a box containing
other text.

The royal road to riches
*Well, maybe: royalty-free
images or whatever, and
whatever you might think
of them, are here to stay.
They are a major resource
for users of photographs,
music, etc. who otherwise
would not have access to
such material. The cost of
one search fee at a picture
agency alone pays for one
or more CDs carrying fifty
or more high-quality,
professional images. There
is no contest. Content
creators like photographers
and artists have only one
question to answer: which
publisher to go with? Or
miss the boat: for every
photographer who gets on
his high horse, there are ten
who will grub for their
own CD. But don't expect
a pot of gold: the days of
easy money are over.
You've missed them.*

Sabattier effect

Partial reversal of a partially developed image given by a brief re-exposure to light, followed by full development and the normal post-development steps. * When exposed to light part of the way through development, the already deposited silver masks part of the still-sensitive silver while other parts, now sensitized by developer, are partially solarized by the second exposure. * Incorrectly referred to as solarization.

safelight

Work- or darkroom illumination coloured or filtered so as not to fog sensitive materials but provide enough light to work in. * Normal lamps e.g. fluorescent tubes may be filtered to eliminate harmful wavelengths or specifically coloured sources with narrow band emissions e.g. LEDs may be used. Also known as safelamp.

sag

(1) Short-term drop in voltage levels from the normal operating voltage. * Most often caused by an electrical device like a motor or compressor starting up.* If the voltage drop is below a certain limit, another plugged-in device may malfunction e.g. a computer crashes. * Frequent sags reduce the lifespan of equipment. (2) Abbreviation for sagittal.

The Colour Safe

*The colour of safelight you need depends on the materials processed: amber or orange is fine for most black & white printing papers, holography or PMT film; deep green is cool for inspection processing of black & white film. * For working with colour materials, you can use infra-red but you'll need special viewers to see with.*

sagittal

Adjective: ~ rays, ~ line: of a fan of rays or imaginary line which is aligned on a radius of a circle which is centred on and lies at right angles to the optical axis. * Synonymous with radial. * Sagittal rays are extremely difficult to compute. * Compare with tangential.

See astigmatism.

sampling

Process of repeatedly taking measurements of a small but representative part of a larger whole in order to make deductions about or to reconstruct the whole e.g. measuring the strength of an analogue signal at regular intervals (usually at intervals shorter than the shortest wavelength). * A continuously changing variable is thereby turned into a series of discrete values. * This is the key step in the quantization or digitization of constantly or continuously changing analogue values.

See Nyquist rate; resampling.

sandwich

Overlapping or laying two or more negatives or transparencies one on top of another in order to create special effects. * The overall contrast is usually extremely high as the maximum density may be doubled but minimum density remains low.

sans serif

Letterforms which lack the small line or extension at beginning or ends of strokes i.e. without serif.

saturation

(1) Subjective experience of vividness, depth or richness of colour. * That attribute of a colour which distinguishes it from a grey of the same brightness: it is correlated with colorimetric purity. * Also known as chroma. (2) Condition of substance being unable to contain or accept more e.g. a saturated solution will not dissolve any more of a solute; at saturation, a colour cannot be more rich or vivid.

See HSB.

scale

(1) Range of exposures to which a sensitive material responds. * A long-scale paper responds to a wide range of exposures i.e. it is low-contrast. (2) Range of tones which a system is capable of reproducing. * Matt surface papers offer a narrow or short scale, colour monitors can reproduce a very wide or long scale of tones.

See greyscale; reproduction scale.

scanner

Opto-mechanical device used to create a digital replica or facsimile of an original by analysing successive lines or portions of the original: the lines are then assembled or reconstructed to display the replica.

See drum scanner; film scanner; flat-bed scanner.

scanning

(1) Process of analysing or digitizing an object by systematically traversing it with a measuring device e.g. as in a scanner. (2) Process of synthesizing an image by systematically building it up with traverses of a beam e.g. as in a television or monitor screen. (3) Use of a device to monitor or check a process and to initiate corrective measures or sound alarm e.g. radar-based early warning systems for bad weather or aircraft.

scanning electron microscope

Instrument for creating high-magnification images with high depth of field. * A beam of electrons accelerated to high energy is focused on the sample which has been prepared so as to scatter electrons: the beam is made to scan the sample's surface which ejects secondary electrons which are 'read' by a detector. * As the beam is highly collimated, depth of field is very considerable for the image scale. * The scans are built up from the detector into an image displayed on a monitor.

scattering

Diffusion of light as it reflects off small particles or bubbles or penetrates translucent material. * Change in the spatial distribution of light due to interactions with material similar in size to wavelength. * Note that the wavelength of light is not changed, but as scattering increases inversely with wavelength, there may be an apparent shift in colour.

See Callier effect.

Scheimpflug condition

Rule which states that the lane of best focus meets the line of intersection of the image plane and the plane cutting through the lens axis. * In normally set up camera,the condition is met as a special case as the plane of best focus, image and lens planes all meet at infinity. * Named after Austrian surveyor.

Schlieren optics

System designed to record small variations in refractive index of e.g. air due to changes in density or depth. * Used in e.g. observing air-flow over objects. * The object to be

examined is illuminated by a very bright light through a very narrow slit (Schlieren projector): this casts a shadow of the object with gradients of light and dark around it, which correspond to density variations in the air.

Schmidt

Optical system of relatively large field and very high speed. * It is based on a concave spherical mirror with an aspheric plate (Schmidt plate) located at the mirror's centre of curvature. * Coma and astigmatism are highly corrected because the aspherical plate correcting spherical aberration and the aperture stop are at the centre of curvature of the mirror. * Widely used in astronomy: hence ~ camera, used in astrophotography, from 1931.

Schumann plate

Photographic coating on glass plate for recording ultraviolet wavelength radiation. * It uses the minimum amount of gelatin to hold the silver halide crystals so the crystals are almost bare in order to minimize absorption of ultra-violet by the gelatin.

scotopic vision

Vision at low light levels (less than about 10^{-3} cd/m^2) resulting from stimulation of retinal rods, with little or no colour vision. * The eyes must be dark-adapted: red light can be used to illuminate the darkness without destroying dark adaptation. * Also known as nocturnal vision.
See mesopic vision, photopic vision, Purkinje shift.

scotoscope

See night-viewer.

scratch

Surface defect which is longer than it is wide. * A scratch on film can be troublesome to remove: some scanner software is capable of automatically processing a scratch out of the image. * A scratch on a polished optical surface e.g. of a lens may be unsightly but by itself usually causes no visible image degradation.

scratch disk

Area of hard-disk used as temporary store of data during virtual memory operations. * Term generally used by Apple Mac users. * Synonym: swap file.

screen

(1) Surface onto which an image is projected for viewing. * The surface may be treated to improve reflective qualities and be curved to correct for projection defects e.g. in IMAX projection. * Viewers may be on the same side as the

projector or the screen be placed between projector and viewers: this is rear projection. (2) Plate etched with fine grid of lines used to convert an image into an array of dots of varying sizes in order to make half-tone reproduction printing plates in photomechanical production. * Now largely superseded by digital processing e.g. raster image processing and writing directly to film.

screen angle

Orientation of half-tone screen used in photo-mechanical reproduction. * Where two or more screens are superimposed to create a duotone or colours, moiré effects (screen-clash) will be seen if their angles of orientation are not varied with respect to each other.

 See CMYK.

screen-grab

Conversion of image seen on computer monitor into an image file. * Many utilities can perform this useful little job: screen-grabbing is actually part of the Mac OS. * Also known as screen dump. * Do not confuse with screen-save.

screen-save

Use of moving or changing monitor image to prevent permanent damage to the phosphor screen caused by the 'burn-in' of an unchanging image.

screw mount

Design of method of attachment of one component to another e.g. filter to lens, lens to camera which consists of a fine screw or helical thread on one item mating with the corresponding thread (i.e. same pitch and diameter) on the other. * Secure and capable of precision alignment but not convenient and can be easily damaged.

 See bayonet mount.

scrim

Sheet of gauze or translucent material used to weakly diffuse a light-source, giving a soft but still directional light like hazy sunlight.

scrolling

Process of moving around a document or image that is too large to show all at once on a monitor screen. * Scrolling may take place by clicking on scrolling arrows, dragging on bars or on the document itself using the mouse or other pointer.

SCSI

Small Computers Systems Interface: a standard and protocol for connecting devices to enable them to share data. * SCSI

Ah, for the good old days of papyrus and silk
The term 'scrolling' sweetly harks gently back to the basis of the whole metaphor of the page, it being the widest extent of a scroll of silk or papyrus which you could comfortably hold in your hands and read. Thus the analogy is remarkably sound: the monitor screen sets the size of what can be shown: by changing resolution it may seem as if you can see more of a page, but of course the page must be smaller so details can't be made out.

S

SCSI troubles

While SCSI devices continue, their conflicts will too. If your device doesn't mount: (i) the terminator may have to be inserted in a device in the middle of the chain i.e. its ID number is not the highest in the chain or the terminator may even have to be left off altogether (ii) change the IDs of the unmounted device for another free ID number (iii) swop ID numbers around (iiii) use shorter cables. Remember to re-boot with any change. (v) If all fails, sorry, but you probably have a Windows machine and need more help than I, or anyone else, can give.

chains in basic form support up to seven devices, each of which must have its unique ID or identification number from 0 to 6, where 0 is usually the computer or its start-up hard-disk. * The last device in a chain must be terminated i.e. to close the circuit: some devices can detect they are the last item and terminate themselves: the autoterminator.
 See terminator.

SCSI, Fast

Fast Small Computers Systems Interface: a version of SCSI-2 but with double the data transmission i.e. up to 10MB/sec. * Most PowerPC-equipped Apple Mac computers use Fast SCSI as the internal SCSI bus.

SCSI, Ultra

Ultra Small Computers Systems Interface: doubles the speed of SCSI-2. * When combined with Fast SCSI-2, the maximum throughput of data is 20MB/sec. * When combined with Wide SCSI, the maximum throughput is 40MB/sec. * An accelerator card is needed to provide Ultra SCSI.

SCSI, Wide

Wide Small Computers Systems Interface: by adding another cable in the connector, its throughput can be increased up to 20MB/sec, if combined with Fast SCSI; or 40MB/sec when combined with Ultra SCSI.

SCSI-1

Small Computers Systems Interface: the basic SCSI standard, with slowest throughput of data.

SCSI-2

Small Computers Systems Interface: improvement on SCSI-1, with throughput of up to 5MB/sec. * Usually used as the internal data bus in Apple Mac computers with two SCSI buses.

SECAM

Séquence Couleur à Mémoire: sequential colour with memory: broadcast television and video standard used in ex-Soviet, European and Middle East countries. * The 625 scan lines are sequential and the field frequency is 50Hz.
 See PAL.

second-generation copy

An image or recording which is a copy of a first-generation copy. * The first copy of an original is first-generation: copies made from this copy retain and may increase any defects of the first copy. * Generally applied to analogue copies: digital copies are, on the whole, free from generational decay in quality.

secondary bow

Rainbow which accompanies the primary rainbow. * It is always present but seen only in favourable conditions, usually when the primary bow is very intense. * Its colours show in the opposite order to the primary bow.

secondary colour

Visual sensation of hue resulting from the additive mixture of two primary colours. * The usual set of secondary colours is cyan, magenta and yellow: cyan is the result of green and blue added together, magenta results from red and blue, yellow results from red and green. * Do not confuse with secondary spectrum, an optical aberration.

secondary spectrum

Chromatic aberrations present in an achromat i.e. an optic with basic correction for chromatic aberrations. * Seen as difference in focal length of one remaining waveband e.g. green where two others are corrected: causes at best loss of definition, at worse, colour fringing.* Apochromats or fully corrected optics show no secondary colour. * Do not confuse with secondary colour, i.e. one resulting from mixture of primary colours.

Seidel aberrations

Set of primary, monochromatic aberrations of a lens system: spherical aberration, coma, astigmatism, curvature of field and distortion. * Deduced by L von Seidel in 1885. * Also known as third order aberrations.

select

Software command or process of identifying part of a larger object. * The object may be a page-layout, image, text, database, etc. * Once selected, the items within the selection can be operated on without affecting the rest of the object e.g. selected pixels may be made brighter, selected text may be enlarged, and so on. * Hence a selection is that part of a file or object which is so identified.

selective focus

Use of limited depth of field to focus sharply on a specific object in a scene, while other parts are clearly out-of-focus.

selective reflection

Reflection of different amounts of light from a surface or just below the surface, depending on wavelength. * Where this takes place with visible wavelengths, it causes objects to appear to be of different colours.

selective transmission

Transmission of different amounts of light through a

Going soft on favouritism

When working with images you may have a choice of selecting with a hard edge or a gently feathered one: which is best depends on the job in hand. Usually you have to decide how soft or feathered you want the selection before making it. Sometimes over-softened selections can be counter-productive – usually if there is not enough data to prevent posterization, then artefactual fringes may appear.

S

medium, depending on wavelength. * Where this takes place with visible wavelengths, it causes the media to appear to be of different colours.

selectivity

Measure of a film developer's ability to take a normally exposed film to working densities without creating fog. * It is the ratio of the rate of development of normally exposed areas to the rate of increase of fog density, and is therefore a measure of signal/noise ratio for a given film and development combination.

selenium

Element used in photography in toning formulations to convert silver to silver selenide which is more resistant to attack than other silver compounds. * Heavy toning produces a reddish tone but light treatment can slightly lift contrast by increasing maximum density while barely affecting the tone colour, particularly with chloro-bromide emulsions.

selenium cell

Photoelectric device used as exposure meter: selenium generates a small voltage when light falls on it: this is used to deflect needle to indicate exposure. * Once popular as it was self-contained, requiring no battery and its sensitivity spectrum closely matched the human eye but its response is not linear and is unreliable at low light levels.

semiconductor laser

Type of light-emitting diode designed to output coherent light by stimulated emission. * Also known as laser diode and diode laser.

sensitivity

Measure of a system's ability to respond to a stimulus. (1) For a detector e.g. film, CCD, light-meter: the ratio of the output signal to the input signal. * E.g. high-sensitivity film produces a high density in response to low light. * Many measures e.g. film speed, signal/noise ratio, quantum efficiency, etc. (2) For pointing device e.g. mouse, graphics tablet: how far the cursor moves compared to the movement of the device.

sensitometer

Instrument for studying the characteristics of light-sensitive materials. * Consists of light-tight box containing (i) regulated light-source of known properties (ii) shutter or similar device (iii) method for giving simultaneously different exposures to the test material, usually a step wedge

Unsung heroes of the Modern Era

The lowly diode laser sounds like a laboratory curiosity; a solution awaiting a problem? Think again. It is what sits under the little aspheric lens under all those CD drives, MiniDiscs, DVD players which we all have. Get the idea? Let me tell you, then. Diode lasers are a cornerstone of modern technology: they are incredibly reliable, incredibly cheap. Next time you feel neglected, cheer yourself up by breaking open a bottle of bubbly for the over-looked semiconductor laser.

or tablet. * A variant provides constant illumination with variations in exposure time.

sensitometry

Study of film's response to light, primarily based on the use of a sensitometer followed by development in specified conditions.

See characteristic curve.

sensor

(1) Detector of radiant energy. * May include entire system including the necessary optical components and controlling circuitry. * E.g. CCD, light-meter, infrared rangefinder, flash-detector in automatic flash-unit, etc. (2) Detector designed to register a change e.g. to detect whether a camera is being held to take a portrait or landscape format shot; to signal whether an image is focused or not.

separation

(1) Noun: process of converting a coloured image or original into a set of three images, one for each primary colour. * Each image represents the distribution of its corresponding colour in the image e.g. a dark area in the green image indicates there is little green in that area, whereas in the red image, the same area appears light, so there is more red. (2) Adjective: ~ filter, ~ film, ~ negative: red, blue or green filter, film, etc. used in making or resulting from making a separation. * E.g. ~ print: colour print made by making separate exposures on colour material through separation filters, so it is possible to make colour prints with a black & white enlarger.

serif

Small line or extension to beginnings or ends of strokes of printed letterforms. * Stylized from the shapes which are easier for carvers to cut in stone.

server

(1) Computer which administers or provides services to a network e.g. local area, intranet or Internet: it supervises access to the network, allows computers to access each other and, in a local area network, may allow access to peripherals such as printers and provides resources e.g. applications software, data storage space. (2) Software waiting for command from a client computer to provide services, data, etc. over the Internet or other network. * E.g. DNS (Domain Name System), FTP (File Transfer Protocol).

settings

(1) Camera ~: values or positions of the basic camera

S

controls of aperture and shutter time i.e. the aperture setting and shutter (time) setting. * As cameras become more automated, with user-set features, the term increasingly refers to the user's preferences e.g. behaviour of flash, of LCD screen, image quality, etc. (2) Custom ~ or preferences: choices made as to how an applications software should behave e.g. where it stores certain files, how tools behave, whether it opens with an open document or blank screen, etc.

shade

Noun: (1) Hood or other shield used to protect lens from unwanted light. (2) Colour or hue: as in 'a darker shade of green'. (3) Verb: to blend one colour or tone smoothly with another. * To create a smooth gradient of change.

shadow mask

Type of colour monitor technology. * A plate perforated with extremely high-precision, fine holes which is placed between the electron gun (i.e. the focusing and accelerating electrodes) and the tricolour phosphor screen of red, green and blue in a television monitor tube. * The holes select correctly aligned beams to allow them to reach the correct member of the triad of coloured phosphors while blocking incorrectly aligned electrons. * Sophisticated aspherical optics and electronics enable totally flat screens to be made, even as large as 22".

See aperture grille.

You don't need to know this, but ...

As the plate is flooded with electrons, many of which do not pass through the holes but land on it, so it gets hot. But it must not expand or the precision alignment will be lost. A special metal alloy, called Invar, of extremely low coefficient of thermal expansion must be used. This problem does not affect aperture grille types to the same extent.

shareware

Class of software that is offered on the basis of 'use, then pay': the software is free to try out but should be paid for if kept and used. * Any kind of software is available as shareware from powerful database applications to useful little utilities. * In paying for the shareware, users do not normally gain any other rights e.g. over the alteration or distribution of it.

See freeware; royalty-free.

sharpness

Subjective quality of an image indicating clear or distinct reproduction of detail: associated with resolution and contrast. * Hence a sharp lens is an optic capable of giving sharp images.

See acutance.

shift

Movement on a vertical or horizontal axis at the lens or film standard on a camera. * Serves to alter position of image on

the film e.g. to remove unwanted foreground or to view more of one side of the image than the other.

shim
Thin piece of metal or other durable material used as a spacer or to align optical equipment.

short-flash light-source
See strobe.

shoulder
Porton of characteristic curve representing high values with some detail. * Turning-point of curve as response levels off.

shutter
Device which controls the time that a light-sensitive material or detector is exposed to light or other radiation. * May be mechanical device e.g. curtain or series of blades or electronic e.g. based on Kerr cell. * Note that 'electronic shutters' in cameras are almost always mechanical devices under electronic control. * In digital cameras, the 'shutter' in inter-frame devices is indeed electronic in the sense that each pixel shunts its charge under a light-shield to 'take' or expose the shot.

shutter-lag
Time that elapses between initiation of exposure – e.g. by pressing shutter button – and the moment exposure is actually made e.g. by shutter run or shunting off signals from an inter-frame CCD.
See parallax.

shutter-priority
Shutter-priority automatic exposure control: semi-automatic exposure control in which user chooses a shutter time and the camera system adjusts lens aperture setting or f/number to give the correct exposure (for given film speed setting) according to scene luminance or the metering system's interpretation of the luminance distribution.
See evaluative metering.

shutter efficiency
Measure of performance of a real-world shutter compared to that of an ideal, perfect shutter. * Ratio of total light passed by a shutter during exposure of given duration compared with the light that would be passed by a perfect shutter open for the same duration.

shutter speed
Speed at which blinds of a shutter traverse the film gate. * In modern cameras, this is constant after the initial acceleration, irrespective of shutter time set.

Tricks of the trade: Part ...
The shim sounds like a shady character in an underworld novel but it can be the cheapest, easiest step to improved dark-room quality you could possibly imagine. All but the best enlargers are slightly off true alignment: a shim placed between, say, the lens stage and the lens carrier slightly to displace a lens can help ensure everything is lined up just so. All it takes is a bit of experimentation and fiddling about: place slivers of metal or plastic at the lens stage and negative carrier in different positions and prepare to be delighted.

Time to speed isn't speeding time
Shutter speed – the velocity at which the blades or curtains of the shutter actually move – of modern shutters is substantially constant, apart from the extremely rapid acceleration and deceleration at the start and end of a shutter run. The leading edge of the blades or curtains of a shutter run at exactly the same speed irrespective of the shutter setting. Any musician knows that their fingers must move at the same speed to play a note whether they play fast or slow: the speed of movement stays the same, the timing of the note is different.

S

shutter time
Setting of a camera control that determines the time for which the film or light-detector is exposed to light. * Almost always incorrectly referred to as 'shutter speed'.

signal/noise ratio
Comparison of the power of a signal in a system to the noise (random, non-informative disturbances) present in the system in the absence of a signal. * Generally measured in decibels. * Also written as signal-to-noise ratio or S/N.

silica gel
Whitish powder or granules used to absorb moisture. * When sealed up in plastic bag it helps reduce humidity of film and equipment kept with it.

silicon photodiode
Device that widely used as a light-detector e.g. exposure meters in cameras, flash-meters, etc. * Based on a PN or PIN junction which absorbs photon energy between 1.06 and 1.03eV (electron Volt) to excite carriers from one energy level to a higher state resulting in a change of charge. * These devices are stable, rapidly and linearly responsive, making them ideal for exposure control.

silver dye-bleach process
See dye destruction process.

silver halide
Chemical compound of silver with a halogen. * In photography, the important compounds are silver with bromine (silver bromide), silver with chlorine (silver chloride) and silver with iodine (silver iodide).

SIMM
Single In-line Memory Module: type of memory module in which the connector pins form in a single line. * Preferred by computer manufacturers because it takes up less room on the motherboard than DIMM type.

skew ray
Ray of light which does not intersect with the optical axis. * Any ray which is not a meridional. * It is very difficult to calculate the progress of such rays through an optical system.

skiz
To skeletonize the background by joining up all points equidistant (i.e. halfway) from boundaries of features of an image: this effectively maps areas around each feature. * Used in image analysis.

sky filter
Graduated filter designed to darken the sky so as to

decrease the brightness difference between sky and foreground. * Consists of neutral-density or coloured gradient from darkest at the top to transparent at the bottom. * Do not confuse with skylight filter.

skylight filter

Type of filter designed to absorb ultraviolet and a little blue: appears nearly transparent with yellowish tint. * Helps to reduce ultraviolet haze as recorded on film, so distant views appear higher contrast than to observer.

slide

(1) Colour transparency mounted in a frame, ready for projection. * Hence colour slide. (2) Accessory device which allows two pieces of equipment to share a common position e.g. at the focal plane. * Consists of plate attached to camera so that plate carries e.g. viewfinder on one side and on the other e.g. film-holder or digital back: you simply interchange the items by sliding them from one side to the other.

slide duplicator

Instrument designed to make same-size copies of colour transparencies: consists of rig holding light-source equipped with variable cyan, magenta and yellow filters in line with camera bracket and focusing mechanism, with mount for enlarging or specialist 1:1 macro lens. * May have arrangement for intentionally fogging film in order to reduce contrast.

SLR

Single-lens reflex: type of camera in which subject is viewed via reflection in a mirror behind the taking lens. * On exposure, the mirror flips or drops out of the light-path to allow the lens to project its image onto the film. * In waist-level type cameras, the subject is viewed directly on a focusing screen: the image is laterally reversed. * On cameras equipped with a pentaprism, the subject is viewed in the eyepiece as an aerial image of the focusing screen, correctly oriented by the prism.

See TLR.

SMILE

See spherical micro-integrated lens.

SMPTE

Society of Motion Picture and Television Engineers: organization producing video, audio standards.

Snell's Law

The ratio of angle of incidence and angle of refraction is a constant for a given refracting medium. * Alternatively:

S

And that's the
problem with
digital

*It doesn't smell (unless you
count the warm dust off
the monitor). No, my
hands are up: I do miss the
smells of the darkroom,
dominated always by the
odour of hypo: neither
pleasant nor unpleasant,
it merely said 'This is
photography' and did so
from Day One, hence its
almost numinous quality.
And do you remember that
sound of running water as
it sloshes over the cascade
caressing your prints
round and round? STOP
me, I could go on.*

N sin i = M sin r where the indices of refraction on either side of a refracting surface are N and M, and the angles of a ray to the normal are i and r.

sodium thiosulphate

Salt of sodium used as fixing agent i.e. to react with undeveloped silver halide to form water-soluble compounds. * Slower acting than ammonium thiosulphate but preferred in some applications. * Also known as hypo.

soft-focus filter

Accessory for camera lens to soften image outlines. * Made of glass or clear plastic etched with lines or ridges which diffuse the image or with moulded bumps which increase spherical aberration.

soft-focus lens

Design of camera lens to give images with soft outline but a well defined core. * Usually based on the deliberate under-correction of spherical aberration: the soft-focus effect is greatest at full aperture and is reduced with smaller apertures. * Some designs offer adjustable softness settings.

soft proof

Use of monitor screen to proof or confirm the quality of an image. * This assumes that the screen has been calibrated to produce an image that matches that of the printer to be used. Check or monitoring of reproduction quality or accuracy solely by assessment on a computer display. * In contrast with hard proof: monitoring quality by printing out onto paper or other support.

See proofing.

solarization

(1) Reduction in the developable density of a photographic emulsion which has been greatly over-exposed. * Tone reversal with gross over-exposure: seen in e.g. photographs of explosions and of sun (hence name). (2) Damage to lasing crystal due to absorption of ultra-violet radiation leading to drop in efficiency of a laser.

See reversal; Sabattier effect.

solid optics

Design of lens whose elements are assembled with no air spaces between them. * Makes for extremely robust optics e.g. a Vivitar 800mm solid catadioptric lens was famous for being able to survive being dropped on a concrete floor.

Sonnar

Family of mid- to long-focal length camera lenses offering low flare, high speed and good correction. * Characterized

by very thick negative meniscus lens and compact design.
* Introduced by Bertele in 1932.

SPARC

Scalable Processor ARChitecture: type of RISC processor.

spatial filter

(1) Pinhole used to produce a clean laser beam for e.g.
holography: a precision laser-cut hole in a metal plate is
placed at the rear focal plane of a laser beam expander
(usually a microscope objective). * The hole lets through
only the central, most coherent, core of the laser beam. (2)
Mask e.g. a clear ring in an opaque plate designed to
separate a desired part of a coherent light-beam.
See speckle pattern.

spatial resolution

Measure of photo-detector's ability to discriminate detail:
equals image width (or depth) at the image plane divided by
the number of sensitive elements in the corresponding
dimension. * Units: millimetres per pixel e.g. spatial
resolution of a sensor 22.7mm long with 2160 pixels on that
axis equals 0.0105mm/pixel.

speckle pattern

Constantly changing pattern of light and dark seen in laser
beams. * Caused by interference within the beam due to tiny
changes e.g. in air density, laser output itself.

spectral power distribution

Display or graphical plot of the relative amount of energy
emitted by a light-source at a given wavelength. * From this
may be deduced the colour-rendering properties of the
source e.g. if most of the power goes into a narrow band of
yellow, the light appears yellow and any objects coloured in
blues and greens appear very dark under that light. * Also
known as spectral energy distribution.

spectral response

Measure of a light-detector's signal or developed density of
light-sensitive material when exposed to radiation of varying
wavelength. * Depending on data required, amount of
exposure may be varied or may be held constant: the
response may be measured or the detector may be
stimulated to reach a given value. * Whole array of tests also
called variously spectral sensitivity or spectral efficiency.

spectrograph

Instrument for forming the spectrum of a light-source and
recording it on a film. * A prism or a diffraction grating may
be used for the light dispersion.

specular reflection

Reflection of incident rays of light with minimal scattering e.g. as seen in mirror or polished metal surface. * The term is often used to refer to the reflection of a point source of light – e.g. the sun – which itself behaves as a point source.

speed

(1) Film ~: measure of sensitivity of sensitized materia. * This is usually measured relative to white light. (2) Shutter ~: used to mean shutter or exposure time. (3) Processor ~; chip ~: rating of main computer chip e.g. G4 or Pentium in terms of fastest rate at which it can perform calculations e.g. 733MHz.

spherical aberration

See aberration, spherical; spherochromatism.

spherical micro-integrated lens

Extremely small field lens used to collect light for CCD elements. * Moulded or etched in an array to cover inter-frame charge-coupled devices: one lens to each pixel. * It improves light-gathering by about one stop, but limits the field angle of the taking lens – one reason why ultra-wide angle lenses cannot be used with some digital cameras.

spherize

Image manipulation causing image to appear to bulge.

spherochromatism

Defect of image formation in which spherical aberration varies with wavelength. * The chromatic variant of spherical aberration, a fifth-order aberration.

Faster, shorter

Generally, the higher the rotational or spindle speed, the shorter the access time. So, yes, faster is better. But demands on mechanical precision rise very rapidly.

spike

Sudden, short-lived and massively large rise in voltage of an electrical supply which may threaten the equipment being powered. * Usually due to lightning strike or when power returns after a power cut or outage. * It is essentially to protect computers, TV sets, hi-fi, etc. against spikes where lightning strikes or outages are common.

See surge; UPS.

spike filter

Optical component designed to pass only a very narrow band of wavelengths. * Usually constructed with multilayered coatings. * Also known as narrow-cut filter.

spindle

(1) Rod or cylinder on the main axis of a rotating device e.g. CD player. * Hence rod on which CDs may be stacked or stored. (2) A single polishing machine in a lens manufactory.

spindle speed

Rate of rotation of disk or platters of a hard-disk drive, of CD

or DVD in drive. * Usually constant, and measured in rpm: rotations per minute. * Spindle is the central metal spike or other axis on which rotation takes place. * Low speeds are about 4000rpm; fast about 10,000rpm and up.

See AV drive; CLV.

split lens

Accessory mounted on normal lens: used to create image in which a close-up object is in sharp focus as well as the background. * Consists of half a close-up lens cut through the centre to make a half-moon shape and a clear space: the half-lens can be rotated to position it. * A special effect lens once popular but now made largely obsolete by image manipulation. * Also called split-dioptre lens.

split-image

Type of rangefinder in which the image is divided in two: the range is found or focus achieved when the two halves match precisely. * In direct-vision viewfinders each half is produced by a different lens. * In SLR cameras, two prisms lying on the focusing screen and opposed (angled in opposite directions to each other) will divide the image unless the image is focused: strictly, the split-image prism is a focusing aid. * Also known as split field.

spot colour

In printing, a plate that carries solid colour to provide simple blocks or lines of colour, usually where black is the only other ink being used. * As this may not be a process colour – i.e. does not use CMYK inks – it is possible to achieve effects beyond the reach of CMYK e.g. metallic finishes or fluorescent colours. * A clear varnish to give a high-gloss finish may be also be the 'colour': hence spot varnish.

spotmeter

Reflected light exposure meter which detects the luminance of a very restricted part or spot of the scene: usually with a field of view in the region of around 1°. * Consists of exposure meter with telescope for relaying light to the light-detector together with a viewfinder device for accurately aiming the spot. * Modern meters may be able to evaluate flash exposures. * Also referred to as telephotometer.

spot variation

The change in size of a spot laid down by output device such as laser, ink-jet, dye sublimation printer when the spot reaches the support material e.g. paper, plastic film, fabric, etc. * Generally spot grows slightly in size as it spreads into the support (where it is also known as dot gain), but may get

smaller e.g. on polished metal surface. * Spot variation with support material used must be adjusted for in order to maintain density and colour accuracy.

See bleed; dot gain.

spot varnish

See spot colour.

spotting

Process of removing dust spots, hairs and other small blemishes from a photograph or image. * The content of the image is not changed: compare with retouching.

spurious resolution

Optical phenomenon in which a highly corrected objective that is slightly out of focus appears to resolve detail, particular where the detail is high contrast.

sputtering

See vacuum deposition.

stabilization

(1) Any process which reduces rate of change or degradation in a material. (2) Any process which reduces degradations to an image caused by movement in the camera or lens. * May be (a) active process e.g. gyroscopic sensors which detect movement in lens and shift elements or change shape of a prism in such a way as to compensate for the movement or (b) passive process i.e. image is analysed at the image sensor so compensation for image movement can be accomplished in software control of the process of image acquisition.

stair-stepping

Jagged, rough or step-like reproduction of an originally smooth line or boundary. * Do not confuse with staircase.

See alias.

staircase

Step wedge of progressively increasing densities used for calibration in video applications.

standard

(1) Adjective: ~ lens: camera objective whose focal length is roughly equal to the diagonal of the film format of the camera e.g. nominally 50mm for 35mm format, 80mm for 6x6cm format, 150mm for 5x4" format, etc. * This produces a field of view of approximately 45°, irrespective of size of format. * Also known as normal lens. (2) Noun: lens ~, film ~ standard: that part of a view or studio camera to which either the lens or the film-holder is attached: it also carries the bellows which joins the two standards and rests on the rail or camera bed.

star topology

Arrangement of a local area network in which each computer (satellite node) is individually linked to a central server (hub). * Also known as star network. * Compare with e.g. ring topology, which is self-explanatory.

statistics

In image editing: display, usually in histogram form, of distribution of values of pixels. * A tall column indicates that many pixels have the value at the position of the column.

status

In densitometry, the filters through which measurements are taken, matched to the inks being measured. * Status A: colour transparencies for projection viewing; Status D: colour prints (reflective); Status G: photomechanical reproduction; Status M: colour negatives; Status V: visual.

steep

Adjective: (1) ~ curve, ~ straight-line portion: the gradient of the plotted line is steep i.e. a given change in input causes a large change in output e.g. litho film. * Antonym: flat.
(2) ~ curvature: the radius of curvature is relatively small, producing a highly curved surface.

Stefan-Boltzmann law

The rate that energy is emitted by a body rises with the fourth power of the absolute temperature of the body.

steganography

Technique or process of concealing a message or sign within a digital file so that it is invisible and does not alter the functioning of the file. * Used e.g. in systems which code copyright data into an image: the code survives manipulation of the image because e.g. it is stored in the least significant bits of the image data.

step wedge

Target or filter with progressive change in density used in exposure measurement or to deliver varying doses of radiation to a sensitive material. * Each step differs from its neighbour by a specific amount e.g. 0.3 units of density. * Key component of the sensitometer. * May also be called greyscale or step tablet.

step-and-repeat

(1) Noun: the software operation which effects a command, moves a set distance and does the command again e.g. graphics element is copied, pasted in position, then copied again and pasted in a new position. (2) Adjective: ~ camera: apparatus in which successive exposures can be lined up

Another aimless obscurity?

But didn't you always want to know why a small but very hot bulb e.g. the tungsten halogen types, running at a low voltage, can emit much more light than a large bulb taking much more power? Now you do ... even if you didn't.

S

and equally spaced on a sheet of film or silicon wafer.
* Different designs used in making microfiche copies of printed material, in the manufacture of printed circuits, integrated circuits, etc.

step-up ring

Adaptor which enables a lens to use a filter whose diameter is larger than that of the lens. * Usually simply a ring with male thread for the smaller diameter and female thread for the larger. * Rarely: step-down ring: to enable a smaller filter to be used.

stepper motor

Type of electric motor which rotates in discrete steps, with no intermediate positions possible i.e. it rotates a fraction of a 360° turn when the motor coils are activated. * Typically, consists of a number of magnets with gaps in between: the magnetic field forces the rotor to lie in certain positions. * Also called stepping motors.

stereo camera

Apparatus with two matched taking lenses taking slightly differing views. * System of mirrors or prisms in front of a single lens may have same effect. * In either case, two images are recorded simultaneously on adjacent frames: when viewed with a stereoscopic viewer, a three-dimensional image – i.e. one with relief and distance information – can be seen.

stereoscopic distortion

Exaggeration of appearance of depth or distance when stereo photographs are viewed. * Occurs where the taking lenses are farther apart than the eyes of the viewer.
See stereoscopic radius.

stereoscopic photography

Recording a scene with two images so that, when viewed in a suitable viewer, a three-dimensional view with depth and relief is simulated. * Contrast with holography in which the image itself is in fact three-dimensional, and no paired lenses are required either for photography or viewing.

stereoscopic radius

Maximum distance at which the stereoscopic effect may be observed i.e. the eye cannot tell whether the object is at infinity or nearer. * For normal, unaided eye, it is about 500m. * This follows from the observation that the minimum difference in angle subtended at the eye which an observer can detect is plus or minus 30 seconds of an arc. * Also known as stereoscopic range.

Unsung heroes of the Revolution: Part ...

The stepper motor is the mythical little man in the machine whose tireless and mostly reliable operation drives camera film advances, camera shutters, zoom lenses and their covers, auto-focusing, scanner heads ... and the rest. In short, everything that needs precision movement these days is stepper driven. Interestingly, it is one of the few key modern technologies not invented in the US: the genius behind it was Japanese.

stochastic screen

Type of half-tone screen produced digitally in which dots are not laid in a grid-like pattern, but appear random, with their frequency in a small area related to the density of the colour required. * Where only the frequency of the dots varies, the screen is said to be 1st order stochastic. Where both frequency and dot size varies with colour density, the screen is 2nd order stochastic. * Also known as FM – frequency modulated – screen.

See Hexachrome.

stock

(1) Unexposed light-sensitive material e.g. film, printing paper as in 'film stock' or 'raw stock'. * Also store of unexposed material. (2) Support or substrate for mass printing e.g. paper stock, card stock. (3) Collection of images, edited and ready to be used for publication e.g. stock library. (4) Support for camera, usually enabling whole unit to be pressed against the shoulder, like a rifle stock.

stop

(1) Noun: Step or unit of change in exposure. * Camera controls are arranged so that (a) a doubling or halving of shutter time equals a stop increase or decrease in exposure e.g. $^1/_{700}$ sec to $^1/_{350}$ sec or to $^1/_{1400}$ sec (b) a change by a factor of square root of 2, or approximately 1.414X, in the lens' working aperture equals a change in exposure of a stop e.g. $f/4$ to $f/2.8$ or to $f/5.6$. (2) Adjective: ~ bath: Acidic bath used to arrest development of e.g. silver-based materials. * Usually a dilute solution of an acetic acid is used: if an indicator dye is used, known as indicator stop bath. Verb: (3) To arrest the action of a processing stage e.g. development. (4) To arrest or abort a computer action or process usually with specific command.

storage media

Material constructed to hold digital data in conjunction with storage devices: data from e.g. computer, digital camera is written by storage device onto storage media. * May be magnetic e.g. Zip, Jaz, SuperDisk, CompactFlash disks; may be optical e.g. CD, phase-change optical, e.g. DVD; or may be magneto-optical e.g. MO disks.

straight-line

Portion or region of a characteristic that is relatively straight i.e. shows a uniform or proportional change of density (or other response) with exposure. * Lies between the toe and shadow portions.

No sarcasm: this might be the final frontier

Stochastic screens return half-tones to the subtleties of the photograph. It makes full use of image data, so the quality factor is a saintly unitary – that is, file sizes are at least 50% smaller than with normal screen of the same effective ruling, moiré problems are reduced if not eliminated, and tonal transitions are oh soohh, so smoooth. However, FM screening needs heavy computer firepower and it takes skill to get right – sound like poor reasons for not using it when you can.

streak camera

Apparatus for recording extremely brief events e.g. explosion. * A strip of film is driven through the camera at high speed so the event is spread or smeared along the film as a streak.

stress marks

Defects in processed film caused by folding or creasing the material e.g. by forcing the film when loading.

stripping

Process of placing film in position prior to making printing plates. * A vital step in mass printing, needing the highest precision and careful working: still done by hand but steadily being replaced by CTP (computer-to-plate). * Do not confuse with striping: a method of managing data across multiple disks.

strobe

Stroboscope: type of electronic flash-unit in which the flash repeats more or less rapidly. * Flash frequency can be a few flashes per second to many thousands of flashes per second, and the flash duration can be shorter than a micro-second. * So-called because it can produce stroboscopic effects i.e. it makes e.g. rapidly rotating parts appear to stand still when the rate of flashing of light equals the rate of rotation. * Also known as a short-flash light-source.

structured light

Grid or other pattern of light projected onto an object in order to learn about its shape. * May be used e.g. in machine vision to identify production items.

subject luminance range

See luminance range.

subminiature

Film format which is smaller than standard format of 24x36mm e.g. APS, 126, half-frame or 16mm Minox formats.

substage condenser

Optical assembly used to collect light and focus it on a microscope specimen. * Consists of achromatic light condenser placed between a light-source and the specimen locating stage. * In inverted microscopes, the condenser is of course above the stage, but in most instruments the condenser is indeed under the stage.

subtractive colour

(1) One obtained by removing a colour from white light e.g. red removed from white leaves green and blue, to create magenta; and so on. (2) Effects obtained by mixing inks or

dyes of different colours: as each ink subtracts from white in order to create its colour, such a mixture becomes more dark as each ink is added. * Inks of secondary or subtractive colours are therefore more effective for colour reproduction than inks of primary or additive colours.

superchromat

Design of optical system in which four separate wavelengths are brought to a common focus. * Three wavelengths brought to a common focus (as in an apochromat) is generally sufficient for very high quality images in the visible spectrum so the fourth is generally used for correction either into the ultraviolet or infrared, enabling the lenses to be focused in visible light for recording in the extended wavelength. * They are also without exception damned fine optics for normal photography.

supercoat

See overcoat.

superior mirage

Image of an object that appears above the object's true position. * Caused by refraction due to variations in density of the atmosphere, usually as result of steep temperature gradients in hot weather.

supertwisted display

See supertwisted nematic.

supertwisted nematic

Twisted nematic phase liquid-crystal display in which the angle between the two plates sandwiching the nematic crystals is between 180° and 270°.

See twisted nematic.

supplementary lens

Optical component fitted to a camera lens to extend the close-focusing range. * Usually a simple positive meniscus lens, but may be an achromatic doublet construction to improve chromatic correction. * Usually available in different sizes according to front lens mount and in various strengths, marked in dioptres.

surge

Sudden, large rise in voltage of an electrical supply lasting at least $1/100$ sec that may threaten connected equipment. * Surge protectors are electrical devices that use various technologies to prevent the rise in voltage from damaging sensitive equipment such as computer chips and hard-disk mechanisms. * May drop off back to normal voltage after short time, hence may be used synonymously with 'spike'.

S

suspension

Distribution of fine particles in a medium in which they do not dissolve and in which the particles do not settle or settle only very slowly.

SVG

Scalable Vector Graphics: format for Web-based graphics designed to provide high quality graphics with small file sizes. * An open-ended standard proposed by Adobe, Sun, IBM, Microsoft and others, it is part of Extensible Mark-up Language (XML). * To read it, a plug-in for the Web browser is needed. * Do not confuse with SVGA: see below.

SVGA

Super Video Graphics Array: enhancement of the VGA video standard offering 256 colours at 800 pixels by 600 lines through use of video adaptors. * 256 colours at a resolution of 1024 pixels x 768 lines also possible. * An ageing monitor standard.

> See VGA.

swap file

Area of hard-disk used for temporary store of data during virtual memory operations. * Term generally used by Windows users. * Synonym: scratch disk (Mac OS).

swing

Adjustment about a vertical axis of camera or film standard on a view or technical camera. * Used to control placement of depth of field in a vertical plane or to adjust the shape of the image.

> See shift; tilt.

SWOP

Standard Web Off-set Press or Specifications for Web Off-set Publications: a set of inks used to define the colour gamut of CMYK inks used in the print industry. * Needed as variations in inks create different colour gamut. * The standard now admits a fifth and sixth ink.

> See colour gamut; CMYK.

symmetric

Design of lenses in which the components either side of the iris diaphragm are mirror-image similar in composition or disposition. * Symmetric constructions allow the highest level of correction, particularly for distortion: used in e.g. macro (usually quasi-symmetric) and reproduction lenses for making film for printing plates.

synch

See synchronization. * Also spelt sync.

synchro-sun

Lighting technique in which flash exposure is balanced with ambient light exposure. * Usually calculated to improve lighting in shadow areas while maintaining natural-looking backgrounds, but may be used deliberately and in a controlled manner to darken or lighten the appearance of the background. * Also known as slow flash or long flash.

synchronization

Technology or process of ensuring the proper timing of different events e.g. sounds have to be simultaneous with the corresponding action; electronic flash must occur after the shutter is fully open but before it closes. * Synchronization technologies include timing tracks that control various devices such as slide projectors and tape-recorders, mechanical switches such as those used in cameras for flash synchronization and software calls to a database as may be used in computer animation.

Syquest drive

Proprietary name for largely obsolete removable media.

system

Noun: combination or collection of components or devices designed to work together or complement each other in function. (1) Camera ~: collection of camera bodies, lenses, motor-drives, flash-units, close-up accessories, etc. designed to be compatible with each other. (2) Computer ~: collection of computer with its peripheral devices e.g. monitor, scanner, printer, CD writer, removable drives, etc. which are connected to each other and work together. Adjective: (3) ~ requirement: specification defining the minimum configuration of equipment and version of operating system needed to open and run application software or device. * Usually describes type and version of processor, amount of available RAM, amount of free hard-disk, version of operating system and, according to software, number of colours that can be displayed on monitor as well as need for specific hardware or connectors e.g. DVD player, FireWire. (4) ~ disk: CD, etc. which contains operating system: used to boot up computer. * Also called start-up disk. (5) ~ error: fault in execution of operating system which prevents it from working. * Usually calls for a forced re-start or re-boot. (6) ~ folder: in Mac OS (before OS X), a directory which holds the major and crucial operating resources e.g. Finder, drivers, preferences, fonts, control panels.

The old-type shutters are the flashiest

If you want to indulge in lots of synchro-sun work – and who admires the work of A Leibovitz who doesn't? – you know there's only one kind of camera to use and that's one that uses leaf or interlens shutters. And of these, there is none that can touch the sophistication of the Rolleiflex 6000-series cameras. The best leaf shutters are nothing like as reliable as the best focal-plane shutters, but when it comes to flash versatility, they are still tops.

No safety in numbers, then

Syquest drives enjoyed ordered compatibilities with each other but quickly fell out of favour when Syquest introduced at least five different, largely incompatible, types. Which epic stupidity goes a long way to explaining why the entire lot is obsolete, despite enjoying total market dominance for a few years.

T

(1) Time: usually in reference to camera shutter setting. (2) Time exposure: the shutter is opened on the first full pressure on the shutter release and stays open until the second press on the shutter button. * See bulb exposure. (3) Transmittance.
See T-number.

T-number

ƒ/number of a lens corrected for the light lost during transmission through the lens. * ƒ/number of a perfectly transmitting lens which would give the same illuminance on the axis as that produced by the test lens. * Equals the ƒ/number divided by the square root of transmittance (assuming a circular aperture) e.g. if transmittance is 50% (only half light entering system exits the system), square root of a half is $1/\sqrt{2}$, so T-number is one stop more than the ƒ/number, so a relative aperture of ƒ/4 with transmittance 50% is a therefore a T-5.6 lens. * Also known as T-stop.

T-stop

See T-number.

tag

(1) In Hyper Text Markup Language, code which denotes the

T for tau?

Actually T for transmittance is a mis-reading of the Greek capital letter tau 't' (which is hardly surprising), that the Powers That Be had decreed to be the international symbol for transmittance. But don't confuse this with T-number, which is indeed pronounced 'tee-number'.

T

type, formatting, position, etc. of an element such as graphic, text, etc. * Used by browser software to determine how to display the element. (2) Part of computer file containing ancillary information which is kept separate from the main data e.g. in the header. * May provide data indicating e.g. the byte order of the data, version and creation data, compression used, output size, etc.

taking lens

(1) The lower of the two lenses of a twin-lens reflex camera, which actually takes the picture. * It is equipped with aperture diaphragm and shutter and is a higher quality optic than the viewing lens. (2) Of the lenses held on a turret of two or more lenses, the one that is operational.

Talbot

Unit of light energy: equal to one lumen per second. * Total energy equals Talbot value multiplied by duration of exposure to light. * Note it does not define how concentrated the light is i.e. solid angle of flux is undefined, so should not be used as unit of exposure. * SI unit of quantity of light.

tangential

Adjective: ~ rays, ~ line: that which lies parallel to a line just touching an imaginary circle (e.g. outer rim of lens) drawn at right angles to the optical axis. * An off-axis fan of rays or image line parallel to the tangent of a circle normal to the optical axis. * Synonymous with meridional (since the locus of intersections of tangents defines the meridian). * Compare with sagittal.

See astigmatism.

tanning

The hardening of gelatin emulsion using e.g. ultraviolet light. * Usually the layer of gelatin is exposed through a contact negative so that dense areas in the negative are protected (remain soft) and low density in the negative leads to tanning of the emulsion underneath. * Used e.g. in gum dichromate process.

target

(1) Object printed to defined standards used to test image acquiring devices e.g. scanner, photocopier, lens. * Printed with bars of different sizes, panels of standard colours etc. * E.g. Macbeth ColorChecker, IT8 samples. (2) The anode or anti-cathode of a ray tube which emits rays when bombarded by electrons e.g. cathode-ray tube, x-ray source. (3) Prepared specimen being imaged during electron microscopy.

One big family
Through TCP/IP the following can communicate: Mac OS, PCs with Windows or OS/2, IBM mainframe, DEC minicomputers, UNIX computers. A typical TCP/IP stack needs the following data to connect your computer to another e.g. for Internet access: IP address, subnet bit mask (tells TCP/IP whether the destination is on the network or not), default gateway/router (which server, if any, connects the network to the outside), DNS: IP address of the friend your computer wants to talk to.

target object contrast

Ratio of dark parts of a target to the light parts of a target e.g. a high-contrast target has ratio exceeding 1:1000, a low contrast target may have ratios of 1:4 or lower. * Often abbreviated to TOC.

TCP/IP

Transmission Control Protocol/Internet Protocol: enables many different types of computers and operating systems to talk to each other. * Devised by US Department of Defense and incorporated into UNIX, formerly provided as separate utility to operating systems but now standard part of e.g. Mac OS and Windows.

tele-converter

Optics designed to increase the effective focal length of a lens (which is then called the 'prime' lens). * Usually a compound optic the sum of whose powers is negative. The design may be complicated in order to preserve image quality of prime lens. * Mechanical precision of the mount is a major factor in final image quality.

See Barlow lens.

telecentric

Optical design that ensures only essentially parallel rays of light reach the film or sensor i.e. the exit pupil is at infinity. * An aperture stop is placed at either focus, usually the rear focal point. * Can increase depth of field, reduce parallax. * Used in photogrammetry, scanner optics, microphotography and reticles in e.g. rifle sights.

telephoto

(1) Noun (also as adjective: ~ lens): optical design in which the focal length is greater than the physical length of the mounted lens. (2) Noun (also as adjective: ~ lens): lens with much longer than normal focal length e.g. 300mm where normal is 50mm. (3) Adjective: ~ power: ratio between the focal length and the back focal length of a telephoto design lens. * Also known as telephoto ratio. * Catadioptric lenses have the highest telephoto ratios thanks to doubling of the light-path onto itself.

telephotometer

Instrument used to measure the luminance of a distant object. * The photographic version is the spotmeter.

telescope

Optical device used to magnify a view seen at a distance. * Afocal devices that enlarge the image on the retina. * Used as attachments to camera lenses or as in viewfinders.

Give one, take other

The increase in focal length with fixed maximum aperture forces the maximum aperture (and smaller apertures) to be decreased by a factor equal to the increase in focal length e.g. 2X increase causes a loss of 2 f/stops; a 1.4X increase loses one stop. Any lens aperture ring is therefore rendered inaccurate.

Not all teles are photo

Early long focal length lenses were like telescopes – as long as their focal length: the best of them, e.g. from Leitz, used the simplest of constructions – a doublet or triplet lens, offering excellent flare control and high contrast. The discovery that a negative power group at the rear of the lens could produce a shorter optic was tempered by increases in aberrations, which needed more correction but are now the norm.

tempered glass

Type of glass with higher tensile strength than normal.
* Created by cooling the glass more rapidly than normal,
creating internal tension between the skin and interior of
glass which gives it strength: to break the glass the internal
compression must be overcome.

terminal adaptor

(1) Device that connects non-ISDN device – e.g. computer –
to an ISDN network. (2) Device that terminates a SCSI chain.
See terminator.

terminating resistor

See terminator.

terminator

Terminal resistor or terminal adaptor: a device – usually a
rectangular block that mates with the SCSI port – that closes
the circuit on a SCSI chain: in theory it is added to the last
item in the chain. * Also known as a terminal adaptor.
See autoterminator.

Tessar

Family of lens designs widely used for normal focal length,
medium-speed lenses in cameras, cine cameras, enlargers.
* Based on the triplet design of two positive elements either
side of a negative, in which the rear element is turned into
an achromatic doublet.

texture mapping

Process in which a three-dimensional image is mapped or
repeated onto a two-dimensional image so that the flat
image takes on the surface appearance and shading of solid
textures (the texture map).

thermal dye sublimation

See dye sublimation.

thermal imaging

Process of making visible the variations in temperature of or
the infra-red radiation from a scene. * E.g. by using infra-red
viewer which enables wearer to see infra-red or sensing
devices which detect infra-red radiations and display them
on a monitor.
See thermogram.

thermal lensing

Distortion of an optical component due to action of heat. *
The effect is usually insignificant apart from work with
lasers: the tiny fluctuations can alter the mode or divergence
of a laser beam passing through the affected component. *
Do not confuse with effect of temperature on lenses: the

major effect is on the lens barrel, changes in dimensions of which affect e.g. infinity focus.

thermal wax transfer

See wax thermal.

Thermo-Autochrome

Print system using dyes held in micro-capsules which burst on heating to release colour. * A laminated paper contains three layers of separation dyes in the subtractive primaries (cyan, etc.) held in micron-sized capsules. On printing, the paper passes between two sets of tiny pins which are heated to different temperatures according to the colour required: different combinations of heating of the upper and lower pins selectively heat different layers. * Proprietary name belonging to Fuji Camera Co.

thermogram

Image corresponding to variations of temperature or radiation of a subject scanned or sensed by a thermal imaging device. * Also known as analogue thermogram.

thermography

(1) Making or recording an image by using the infrared radiation from an object. (2) Development of image using heat. * May be applied to printers which use heat e.g. dye sublimation. (3) Printing process for producing letters slightly raised from the surface – e.g. business cards – using inks which swell when heated.

thick

Adjective: (1) ~ negative: one that is dense with silver or dye. * It has been greatly over-exposed and developed normally or heavily over-developed. (2) ~ emulsion: one of greater volume than usual e.g. used in holography, also nuclear physics. (3) ~ lens: one whose physical dimensions require that for computations the distance between the front and back surfaces must be accounted for. * A compound lens or group may also be treated as a single thick lens.

thin

Adjective: (1) ~ negative, ~ slide: one that has low density of silver or dye. It has been under-exposed or under-developed, or both. (2) ~ film: a layer of material deposited in an extremely thin layer e.g. a few atoms thick. * Used in production of micro-chips, photo-detectors, anti-reflection coatings, etc. (3) ~ lens: one that, for computational purposes, is taken as having no thickness e.g. simple magnifying glass, eyepiece correction or spectacle lenses. * The simple lens formulae apply only to thin lenses.

third-order theory

Calculations from which lens behaviour, including aberrations, can be deduced. * So-called because the power expansion of Snell's equation in radians is third-order. * From this is derived the five von Seidel aberrations and two chromatic aberrations.

thou

One thousandth of an inch. * Largely obsolete but may be used by English to refer to thickness of paper or gauge of thin items. * US usage prefers the mil.

three-quarter tone

Printed tone in which 75% of the available dot area is inked.

threshold

Adjective: (1) ~ exposure, ~ heat: the lowest level of effect or influence which causes a change or phenomenon e.g. value of the exposure which causes a just-detectable change in an emulsion; ~ contrast: that difference in density which is just detectable in normal viewing conditions. (2) ~ level, ~ value: at which a change is allowed or an occurrence counted e.g. all pixel values up to threshold value of 128 are set to black, all above are set to white, to give an image with only black or white areas. Noun: (3) Level of response to an effect or influence which is just measurably higher than that which produces no response. * For detectors e.g. photo-detectors: the signal level at which the probability of detection is just greater than 50%.

through-the-lens

See TTL.

throughput

Measure of rate at which a device or system can process or output material: e.g. number of scans can be done in a day, number of A3 prints can be printed in an hour. * Usually measured when device is in full swing i.e. not counting warm-up and initialization times but including down-time for replenishment e.g. to refill ink cartridges.

throw

The distance, measured along the optical axis, between a projector (slide, overhead, LCD or cine, etc.) and the projection screen on which its image falls. * This is effectively the projector lens' image distance, therefore the greater the distance, the greater the size of the image.

thumbnail

Representation of image, page layout, graphic, etc. as small, low-resolution version. * Used to make it easier for computer

to put image onto screen, where a small image is all that is needed e.g. in dialogue boxes and to show many images at once e.g. to locate files in a folder. * May be saved as a separate file attached to the main file, or created as needed.

See greeking.

thyristor

Type of semiconductor used for switching or control of current e.g. silicon-controlled rectifier. * At a certain threshold voltage, it allows current to flow but allowing passage only to a certain portion of a waveform input, depending on the bias that is set.

TIFF

Tagged Image File Format: structure or method for storing image data, extensively used across platforms and a de facto standard. * A bit-mapped or raster image file format supporting 24-bit colour per pixel with data such as dimensions, colour look-up tables, etc. stored as a 'tag' added to the top or header of the data file. * Variety of tag specifications give many flavours of TIFF – which can lead to compatibility problems. * May be indicated by the file name suffix .tif.

tile

(1) Noun: sub-section or part of a larger bit-mapped image. * May be used for file storage purposes or for image processing. (2) Verb: to print a page that is larger than the printing device available in smaller sections e.g. when only an A4 printer is available, an A2 poster may have to be printed in four or more tiles or sections.

See kernel.

tilt

(1) Adjustment about a horizontal axis – i.e. change in elevation or looking downwards or upwards – of a tripod head or other camera support. * The entire camera's orientation is altered. (2) Adjustment about a horizontal axis – i.e. change in angle of elevation – of lens or film standard on a view or technical camera. * The adjustment may be independent of the orientation of any other part of the camera. * On the front or lens standard, usually serves to control placement or orientation of plane of best focus, and to set camera to Scheimpflug conditions.* On rear of film standard, it usually serves to control shape of image, particularly to maintain verticals in e.g. buildings. * Focus is maintained if the axis of tilt is properly located.

See swing.

Unsung heroes of the Revolution: Part ...

Thyristors have a case for being heroes of environmental friendliness for the amount of power, particularly that of terribly expensive and polluting batteries, which they save. For they are used extensively as an energy-efficient means of controlling flash output. Before, if you didn't use all the charge in a flash-gun's capacitor, it simply drained into the cosmos.

Squashed TIFF

The commonest way to save space when archiving TIFF files is to use LZW compression, which is a lossless method. But beware: some applications can't open compressed TIFF files, including, for a time, the otherwise versatile and unfussy GraphicConverter and Quark XPress (here, if you like the requisite XTension). Also some RIPs will choke on compressed files. If you want to keep friends with bureaux and output houses, give them uncompressed files ... and give yourself an easy night's sleep.

time-lag

Time interval between initiating an action and the action actually taking place e.g. (a) between shutter release and actual camera exposure or shutter run: can vary from a few milliseconds with mechanical shutter to several tenths of a second with auto-focus compact cameras; (b) between turning on a digital camera and its being ready to take pictures: can be as long as ten seconds; (c) between start of flash bulb exposure and the onset of useful light output (d) between the time a correction is made to a processing line and the correction taking effect e.g. any drop in bath temperature below specification is corrected with extra heat which may take several minutes to return the working temperature to normal.

See parallax.

time-lapse

Photography of a subject taken at regular intervals in order to display the separate steps in a transformation or a sequence of events. * Usually requires (i) constant framing of (preferably) static subject (ii) constant lighting or automatic exposure control (iii) reliable timing of interval (iv) camera with automatic film-winding (v) possibly a great deal of film, depending on interval and duration of photography. * Resulting photographs may be shown as a motion picture or used as basis for animation. * If the pictures are shown at a rate faster than they were taken, the movement is speeded up; if the pictures are taken at a faster rate than they are shown, the movement is slowed down.

See intervalometer.

time-temperature

Adjective: (1) ~ development: procedure for processing defined by variations in time of processing and the temperature of active chemicals in which process takes place. * This assumes factors such as agitation, dilution, etc. are held constant. (2) ~ graph, ~ chart: graphical representation of relationship between time and temperature for film processing which enables user to calculate a corrected time for processing at a non-standard (i.e. not at 20°C) temperature.

timer

Device for controlling, indicating or monitoring duration of processes such as enlarger exposures, processing steps or stages, or other procedures which require more or less accurate control of timing or a fixed time interval. * Designs

vary from those that simply indicate elapsed time or show a count-down i.e. time remaining, to those which control directly via switches to e.g. turn off enlarger bulb.

tint

Noun: (1) Colour reproducible with process colours; a process colour. (2) An overall, usually light, colouring that tends to affect areas with density but not clear areas (compared to a colour cast). (3) Colour produced by adding white to the hue. (4) A deposit of less than the maximum amount of ink e.g. in photomechanical reproduction: any dot less than 100%. (5) Surface colour of printing or other paper e.g. bright white of glossy paper intended for reproduction, warm cream of paper designed for exhibition or portraiture. (6) Verb: to colour a print by hand, using brush or air-brush.

tissue optics

Science and study of optical properties of living tissue.
* Applied particularly to medical use of lasers e.g. in eye surgery, cancer operations.

TLR

Twin Lens Reflex: camera design using two lenses placed one above the other on a common panel, with the top lens arranged as a reflex viewing lens (image is seen via a right-angled reflection in a mirror); the bottom lens is the taking lens. As the viewing lens is focused, it automatically focuses the taking lens. * Generally used for medium or roll-film format, rarely for smaller or larger.

TN display

See twisted nematic.

TOC

See target object contrast.

toe

Shadow region of film characteristic curve. * That portion of a density/log exposure curve between the base-plus-fog level to the start of the straight-line portion.
See H&D curve.

tolerance

(1) Allowable or permitted error or inaccuracy. * A high tolerance allows large inaccuracies, a low tolerance does not permit much error. * Applied e.g. to working temperature of chemicals in film processing: black & white processing has a higher tolerance than colour processing. (2) Measure of similarity to a given parameter, usually to define operation of a tool e.g. in selecting more or less similar pixels or changing values of a restricted range of pixel values.

Camera nirvana
The Dalai Lama of TLR-dom is the Rolleiflex which in its last incarnations as the 2.8f and GX was as perfect as any camera could hope to be: the Mecca of superb image quality, the Disneyland of easy facility in use, the … (That's quite enough. Ed.) of utter reliability and sturdiness and with an almost totally silent, smooth shutter and … (Yeah, yeah. We've got the idea. Ed.)

Sensitometric foot fetishes
The shape of the toe portion of a characteristic curve tells you a lot about the shadow response of the film/developer/development combination: a leisurely but steady lift upwards from the fog level towards the mid-tone or straight-line portion is a 'long' toe that enables one to squeeze a bit more speed out of a film (i.e. to exploit the so-called foot speed) whereas a sudden lift up from fog into the straight-line portion of the curve means little hope of rescuing details from the shadows. We photographers do like long toes. (Which, incidentally, is not something you get from most scanners.)

tomography

Imaging technology in which a three-dimensional image is computed or created from a series of cross-sections or slides based on x-ray, radioactive emissions or ultra-sound imaging. * Used in medical imaging for non-invasive examination of soft tissue pathology.

tonal control

See tone control.

tonal distortion

Property of image in which contrast, range of brightness, or colours appear to be markedly different from that of subject. * It can be caused by wide factors including – for black & white e.g. (a) use of special effects filters; unconventional processing (b) over- or under-development (c) use of contrast grade not matched to contrast of negative (d) reciprocity failure, etc.* For colour films, in addition to above, (a) use of light-source not balanced for film (b) reciprocity failure of colour balance (c) unconventional filtration during printing, etc.

tonality

Overall subjective quality of tones – i.e. the overall and local contrast, the highlight and shadow qualities including possibly the image colour – in a black & white photographic print. * Distribution of tones in an image. * The assessment of tonality may or may not relate the tonality of print to that of scene it represents.

tone

Noun: (1)Lightness, brightness or value of a patch in a photograph: dark tones correspond to shadows, light tones correspond to bright or highlight areas. (2) Slight overall colour cast or hint of colour in a print or part of image that should be neutral e.g. green tone in Fujichrome blacks. * Also known as tint. (3) Used as suffix following percentage: percentage of given dot area that is inked e.g. 40% tone is 40% covered in ink. * See three-quarter tone. (4) Verb: to treat black & white print or negative with a chemical that replaces or alters the silver image, usually to change image colour or contrast.

tone control

Alteration of image densities in small, local areas or globally, with uniform changes or changes in proportion to existing densities. * With analogue or silver-based process, it can be achieved by (a) altering camera exposure or (b) altering exposure on printing or (c) burning-in or dodging during

printing or (d) changing development or processing conditions or (e) using different materials or (f) toning existing print or negative. (2) With digital processes it can be achieved by (a) using controls such as curves, levels, contrast or brightness or (b) using digital equivalents of burning-in or dodging or (c) altering printer settings or (d) printing to different papers. * Also known as tonal control.

tone-line

Type of print which shows boundaries or the borders between areas of different brightness, usually as bright lines, with other areas black. * Conventional techniques involve making high-contrast copies and printing out-of-register but that usually loses many of the boundaries. * Digitally, tone-line is simulated by the 'Find Edges' filter or equivalents.

toner

(1) Chemical solution used to alter silver or other metal-based image by replacing the metal with another or forming a compound: usually used to (a) change image colour, also (b) improve archival qualities (c) to improve tonality. (2) Carbon or other extremely fine particles which are electrically charged in xerography or laser-printing to form the copy or print. (3) Powdered pigments used in certain colour proofing systems e.g. Chromalin. (4) Pigments or dyes used to darken an ink used on printing presses; the resulting ink may also be referred to as toner.

tongs

Large tweezer or salad-server-like implement for handling black & white prints or large-format negatives. * Saves hands from getting wet.

tongue

Part of the leader or starting length of film that is shaped to improve film-loading.

tool

(1) Noun: in software applications, a function or effect which is applied selectively on screen under direct control of the operator, usually with control of degree of effect, possibly other options. * Typically, the on-screen cursor acts like a virtual tool, applying changes such as adding colour, reducing saturation, drawing lines etc. * The cursor may change its shape to indicate the tool it has been changed into e.g. brush, magnifying glass, knife. (2) Adjective: ~ kit, ~ box, ~ bar: a collection or family of software functions or effects grouped and displayed together in an application for easy access.

Tongue in check
In fact the tongue is a hang-over from the Leica which was and is still really the only camera to need one – as a result of its load-through-the-bottom system, so highly thought of it was only once, once upon a time, imitated by Nikon ... who soon learnt why no-one else copied the idea.

T

tooth

(1) Surface quality of receiving layer e.g. printing or drawing paper, film or other medium. * Determined by (a) degree of roughness or graininess (b) hardness of substrate (c) degree of randomness of grain (d) adsorptivity, if applied material is wet. (2) Gear-tooth: projection from gear or wheel that engages with another e.g. in a gear-train or a hole or sprocket in roll of film, paper, etc. in order to reel off the roll. * Plural: teeth.

toric lens

Design of lens in which one or more surface is shaped like part of a doughnut or curved cylinder. * In one meridian, the lens has maximum power and in the perpendicular meridian, it has minimum power. * Used to correct astigmatism in human eye.

See cylindrical lens.

total internal reflection

Reflection of light within or inside a dense medium. * It takes place at the interface of the dense and less dense media where the incident light approaches the interface at an angle greater than the critical angle. * The phenomenon is used in prisms e.g. pentaprism of viewfinder, fibreoptics and is an element of the cause of halation in films.

TOYO

TOYO 88 ColorFinder 1050: a colour system providing over 1000 colours based on a set of printing inks mostly used in Japan.

track

(1) Narrow, concentric portions of storage media such as hard-disks, CD-ROM or DVD which are divided up into smaller sectors for locating data. (2) Strip or row on e.g. film, tape, etc. that contains information e.g. on APS film a track carries data on film type, processing history, etc. (3) Row of cogs or teeth on a straight rack to provide a focusing or positioning control for e.g. large format camera.

trackball

Input device for computer to control cursor. * Arranged like a mouse upside down, with a large ball which is manipulated by the thumb or fingers; clicking is done by thumb or fingers. * Touted as good alternative to mouse as it may slow the onset of repetitive strain injury (in the wrist).

tracking

(1) Movement of camera or camera with its support over a distance to follow the path of moving subject or action.

* Also known as trucking, in cinematography. * Compare with panning, in which camera rotates about a fixed axis. (2) (a) Control of alignment or (b) the alignment itself: of a sensor or read-out head in recording or play-back device with respect to the tracks or sectors in the recording or storage medium. (3) Control of the movement of long strips of film through roller or transporter processing machines to ensure they go through without jamming or crossing each other's path. (4) In design and typography: the average spacing between letters. * Wide or loose tracking expands the average spaces between letters; narrow or tight tracking condenses the space between letters. * Also known as letter-spacing.

transfer function

Mathematical representation or comparison of levels of an output with the levels of an input, often against another variable e.g. ratio of output to input as a function of frequency as in modulation transfer function. * Tone reproduction curves in photographic and photomechanical reproduction and the Curves control in digital editing are examples. * Lens tests that compare target contrast with image contrast against frequency also plot transfer functions.

See MTF; OTF.

transfer rate

The speed at which data is moved from one device to another e.g. from harddisk to removable storage, from one networked computer to another.

translucent

Quality of materials which reflect a part of incident light and transmit the rest.

transmission

In optics: the penetration into, then subsequent passage or conduction through, and finally the exit of radiant energy from a medium. * Transmission – e.g. of light energy through glass – always involves some loss of energy on entry into and exit from the medium. * May be quoted as a percentage, as a measure of transmission efficiency: the percentage of radiant energy transmitted compared to the energy incident on the system.

transmission factor

Ratio of amount of energy passing through a medium to the amount of energy falling on the medium. * Also known as transmittance (but use transmission factor in preference).

Message or massage?

Data transfer rates are often quoted in bps – bits per second i.e. kbps or mbps (kilo- or megabits per second). This looks good, or better than the more realistic Bps rate – bytes per second, by a factor of 8 (as 8 bits make one byte). But, hey, the bps rate looks much better, faster, and bigger is cooler these days – and who are we to argue with the marketing people?

T

transmission hologram

Type of hologram in which the reconstructed image is viewed through the hologram itself. * The image beam is on the opposite side of the hologram to the viewer and, in a normal set-up, creates a virtual image.

transmittance

See transmission factor.

transparency

Noun: (1) Film or print-out in which the image is seen by illuminating it from behind e.g. colour transparency, overhead projection film. (2) Degree to which background colour can be seen through a mask or through a pixel in the foreground. * 100% transparent pixels are invisible, 0% transparent pixels completely cover the background colour. (3) Degree to which an observer can see or degree to which light is able to penetrate through or into a medium. Adjective: (4) ~ viewer: instrument for viewing or displaying transparency film. * Numerous and wide range of designs: from large cabinets with built-in projectors to hand-held portable viewers using available light. (5) ~ hood, ~ adaptor: accessory or part of a flat-bed scanner that enables scanning of transparent originals e.g. slides and film. * Usually consists of a light-source in the lid of the scanner: it moves in step with the scanner array during scanning.

See transmission factor.

transparent

Adjective: material or medium which transmits almost all incident light or other radiation with little absorption, reflection or diffusion.

transverse chromatic aberration

See chromatic aberration.

trapping

Set of techniques in photomechanical reproduction for preventing gaps showing between adjacent blocks of colour by introducing a slight overlapping of colours.

trichromatic

Adjective: (1) ~ colour: using three colour sources or filters to reproduce a range of colours e.g. colour monitors or LCD screens. (2) ~ colour theory: psycho-physiological model of colour vision that says colour discrimination is based on three distinct types of light sensors in the eye, with peak sensitivities in three different parts of the visible spectrum, namely, red, green and blue.

See tristimulus value.

trilinear

Design of CCD array as three parallel rows of CCDs, each coverd by its own colour separation filter. * Used in scanners and scanning back cameras to allow single-pass operation.

trilinear array

See linear array.

Trinitron

Design of colour cathode-ray tube based on fine vertical wires which direct electron beams to the phosphors on the monitor screen. * Also known as aperture grille. * Proprietary name of Sony Corp.

See shadow mask.

trip

(1) Verb: to release or start the run of a shutter or other event. (2) Adjective: ~ cord, ~ lead: mechanical or electrical lead used to release shutter or other device or synchronize action of two or more devices e.g. synchronize action of shutter with flash-unit.

triple extension

(1) Mechanical arrangement which stacks and telescopes three focusing rails, one on top of and within another, to permit extra-long extension in a relatively compact design. * Used primarily in field cameras where long extension is required for close-up photography and use of long-focal length lenses but the focusing rail must be small enough to be folded up. (2) Extra-long bellows design permitting extension that is three or more times the focal length of a normal lens for the format e.g. an extension of 450mm for 5x4" format.

triplet

Lens construction or optical component using three lenses or groups of lenses. * NB: one or more of the 'lenses' may be a compound of more than one lens but functionally, the compound acts as if it is a single lens. * Very popular configuration as good correction at low cost is possible.

See rectilinear; Tessar.

tripod

(1) Noun: camera support consisting of three, usually independently articulated, legs joined at a centre-block which may hold a centre column and attachment for the camera. (2) Adjective: ~ head: attachment for camera to a tripod which allows adjustments of the position and orientation of the camera.

See 3-D head.

Got sacked after your trip?
Trip leads are appropriately so-called for their ability to synchronize the collapse of equipment with the movements of three-legged assistants or other agility-challenged people let loose in a studio. Hence the popularity of wireless synchronization – through radio or infra-red – despite their miserable reliability.

T

tristimulus value

Set of values of red, green and blue which, when combined additively, reproduce a specified colour. * In theory there is a tristimulus value for any perceived colour: RGB values are not equivalent because they are based on the colour space of a given device e.g. colour monitor. * Based on trichromatic theory of vision.

tritanomaly

Abnormal perception of colour due to lower-than-normal sensitivity to blue. * Extremely rare defect of colour vision.
> See anomalous trichromatism.

tritone

(1) Photomechanical printing process using three inks to increase tonal range. * Used in high-quality print reproduction of photographs for books, posters etc. often with third colour being a metallic ink. (2) Mode of working in image manipulation software that permits printing of image with three inks, each with its own reproduction curves.
> See duotone.

tropical chemicals

Processes for black & white film or print designed to operate in hot conditions i.e. where high air temperatures make it very difficult to maintain developer temperatures at the usual 20°C. * Formulated to minimise fogging and to harden gelatin which is usually softened by high temperatures.

truecolour display

Any device, particularly a colour monitor, that can show as many colours as can be distinguished by the human eye. * Monitors displaying millions of colours or display to 24-bit depth are truecolour. * Also spelt trucolor.

TrueType

Font technology introduced by Apple in 1991 to challenge supremacy of PostScript. * In this it failed miserably but was adopted by Microsoft and, ironically, it is now standard the Windows platform.

truncate

(1) To shorten e.g. a file name by cutting off some of the letters in order e.g. to make the name conform to a naming standard. (2) To eliminate the least significant digits of a number by removing them from the number, without any rounding off.

Trumatch

A colour system that provides over 2000 colours: all achievable in CMYK and arranged in evenly graded steps,

Fickle figures

The laudatory epithet 'truecolour' formerly referred to devices showing the then remarkable range of 32,768 colours (commonly: 'thousands of colours') – but technology marches on. For some, the 17 million colours of 24-bit ain't enough.

True Trouble

If you want an easy life when sending material to print bureaux, stick to PostScript fonts: you can often get away with mixing PostScript and TrueType fonts in the same document but if the RIP chokes you have only yourself (and TrueType) to blame. Nowadays nearly anything in TrueType is available in PostScript but (as if life were not short and difficult enough) the names may differ.

designed to suit the Computerized Electronic PrePress System. * All colours were originally generated using four-colour printing, can be produced on digital image setters and are matched to the screen colour. * Includes a variety of four-colour greys using different combinations of colours.

TTL

Through-The-Lens: adjective: ~ metering, ~ focusing: optical and electronic system in camera in which readings by the camera's sensors are made through the camera lens. * For exposure measurement, sensors may be placed in many different places around the light-path: looking at the focusing screen, sampling directly from the light-path or via reflections off the film or shutter curtain. * Modern auto-focus cameras commonly take exposure readings by sampling from the beam that supplies the auto-focus sensor or may even read from the auto-focus sensor itself.

See OTF.

tube

Cathode-ray tube: the glass envelope that encloses the electrodes of a television monitor and the screen. * May be used as synonym for monitor.

tunable laser

Type of laser the wavelength of whose output can be adjusted over a relatively wide range. * The dye laser is typical and the range of wavelengths is about plus or minus 30 nm – to a laser physicist, that's pretty big.

tungsten

Adjective: (1) ~ light, ~ lamp, ~ luminaire: type of incandescent light-source in which a filament or coil made of tungsten is heated in a bulb which is partially evacuated of gas or contains e.g. halogen gas. (2) ~ balanced: colour film designed to give the correct colour balance where the main illuminant or source of light is a tungsten light.

See quartz halogen lamp.

tuning

Process of making adjustments to a process or set-up to produce or ensure results which meet specification.

See tweak.

turbidity

Lack of clarity or a cloudiness of medium e.g. glass in lens or photographic emulsion. * Turbidity causes a rise in scattering of light compared to a non-turbid medium. * Low-quality glass or plastics used in inexpensive optics or home-made gelatin emulsions are common examples.

When is a tune too far?

Subtle changes to system settings on your computer, little adjustments to your equipment can make a big difference to performance, comfort and confidence. But too much fiddling about is a common cause of unreliable operation as the equipment has no chance to settle down. Believe it or not, mechanical and electronic things dislike change as much as the rest of us. Inveterate tuners and tweakers – a piece of advice: unplug once in a while.

T

Swing high, swing low

Turret-mounted lenses were used e.g. on a viewfinder for the Leica but were never as popular on stills cameras as on cine-cameras e.g. Bolex where the lens designs were far more compact. Zoom lenses killed the turret-mount off for good, except in the laboratory microscopes where even now zoom optics are the exception, save with low-power stereo-microscopes.

turnkey system

Computer or other system which is substantially self-contained: just plug it in, turn the key and it does the job e.g. word-processing, monitoring telephone calls.

turret-mount

Two or more lenses set on a rotating plate so that one or either of the lenses can be locked into place on the optical axis for operation. * Now obsolete for stills photography but a standard feature in laboratory microscopes.

tusche

Crayons or colours formulated with wax or resins to write on lithographic plates.

Tv

Time value: shutter setting. * May be used to indicate shutter priority setting for auto-exposure.

TWAIN

Toolkit Without An Important Name: driver standard used by computers to control input devices such as scanners. * Also a file format in its own right, although seldom used as such.

tweak

(1) Verb: to make a small change or adjustment in order to improve quality, performance or efficiency, etc. usually in sense of producing a unexpectedly large effect. * E.g. tweak of image contrast can greatly improve appearance of image; tweak of hardware settings can vastly speed up performance. (2) Noun: the small change or adjustment (also the process of introducing the same) which improves quality, performance or efficiency, etc., usually with (hoped for) disproportionately large effect. * Also known as tuning.

tweening

Computation of the tweens required to give a smooth transition. * According to software capabilities, the changes can be made to vary from linear – i.e. evenly spaced – to irregular, with speeding up or slowing down at various points between the key frames of an action.

tweens

The frames in animation sequences produced by interpolating or adding frames in between key frames such as the start and end of an action. * In computer animation, the software does much of the interpolation, given basic information regarding speed, background, perspective and so on.

twilight vision

Vision at low light levels, in which colour discrimination is

almost absent and detail discrimination is low. * Provided by the rod cells of the retina of the eye. * Also known as scotopic vision.

See cones; mesopic vision.

twin-lens reflex

See TLR.

twisted nematic

Type of liquid crystal display. * Liquid crystal in its nematic (thread-like, as in 'nematode') phase is sandwiched between two polarizing plates to which the crystals align: as the axis of one plate is perpendicular to that of the other, they cause the crystals to twist 90° which removes their polarizing ability. * When a voltage is applied, the crystals untwis and become polarizing, which cuts the transmission as the light entering the crystal is polarized at 90° to the untwisted crystals.

See supertwisted nematic.

two-bath

Use of two solutions in sequence to improve on performance of a single-bath process. * Applied mostly to black & white film or paper development and fixing.

UCA

UnderColour Addition: pre-press technique for improving predominantly black areas by adding cyan, magenta or yellow to them – which produces richer, deeper tones.

UCR

UnderColour Removal: pre-press technique for reducing the amount of cyan, magenta and yellow ink where they combine to form neutral tones, and those colours which contain all three of cyan, magenta and yellow, by replacing some (but not all) of the trichromatic grey – mostly from the shadow regions – with an equivalent quantity of black ink.
* Black ink is cheaper than coloured ink: UCR saves money and also reduces problems with trapping.

 See GCR.

Ultra DMA

Protocol for transferring data from harddisk drive to and from the computer: designed for data transfer at rates of up to 12MB/sec.

ultra high-speed

Adjective: (1) ~ film: photographic emulsion with speeds of about ISO 1600/28° and over. (2) ~ camera: apparatus designed to make over a million exposures per second.

U

ultra-miniature camera

(1) Design of camera using ultra-miniature film – i.e. 16mm in width or narrower. (2) Camera made as small as possible to work in confined spaces e.g. pipes, archaeological digs. * Made possible by very small sensor chips needing tiny lenses: all that is necessary is a cable to carry signals to a nearby computer.

umbra

Darkest, central, part of a shadow thrown by an object lit by a point or distant light-source.
> See penumbra.

umbrella

See brolly.

uncorrected

Adjective: (1) ~ lens: optics exhibiting most or all available aberrations. * Such a lens produces sharp images only at small apertures and over a small image field around the optical axis. (2) ~ scan, ~ print, ~ output: not calibrated, colour-matched or manipulated in any way e.g. a raw scanned image prior to processing.

under-corrected

Adjective: referring to an optical aberration that is not fully corrected. * This may be because (a) full correction is too expensive or impractical (b) full correction of one aberration adversely affects correction of another (c) under-correction is deliberate, as in ~ spherical aberration for soft-focus lenses intended for portraiture.

under-develop

To develop photographic material to an extent less than specified or intended. * Caused by e.g. (a) development stage that is too short in duration or (b) working chemicals being too dilute, exhausted or contaminated or (c) working chemicals being too low in temperature or (d) insufficient agitation during development or (e) use of inappropriate chemistry for the materials or (f) any combination of these. * Distinguished by low-contrast, low density image.

under-expose

To cause a quantity of light that is smaller than specified or intended to fall on sensitive material. * This can be because, for a given material's emulsion speed and level of ambient light: (a) the shutter time is too short for a given aperture or (b) the effective aperture is too small for a given shutter time; or (c) the flash exposure, if used, is too low or (d) flash exposure, if used, is wrongly synchronized or (e) losses due

U

to use of filters or lens extension, etc., were not corrected for or (f) as a result of any combination of these. * Distinguished by low density in the mid-tones of a negative and overly flat mid-tones in prints or reversal materials.

undercolour
The yellow, magenta and cyan present in neutral grey or black areas when printed on four-colour presses.

undercolour addition
See UCA.

undercolour removal
See UCR.

undo
To reverse an editing or similar action within application software through a simple keystroke or choice of menu item: most actions have one level of undo i.e. just one action can be undone. * Multiple levels of undo are provided by some software.

unevenness
Unwanted variation in processing activity, density, lighting or other desired effect.

unipod
Camera support using one leg, usually telescopic or extensible.

universal
Adjective: (1) ~ developer: chemical formula can be used to develop both film and papers. (2) ~ adaptor: ring-mount with one end fitting to widely used mount. (3) ~ focus: focus setting of lens at given aperture setting that produces greatest depth of field; usually equal to the hyperfocal distance.

UNIX
Operating system for many users and capable of carrying out many tasks at the same time. * Written in C language, therefore easily used on many different computer systems. * Backbone to World Wide Web. * Provided free to US universities from 1976 because of anti-trust regulations: as a consequence, it is widely used on anything from personal computers to mainframes despite its difficult structure.

unsharp
Adjective: (1) ~ image, print, projection, etc.: one whose fine detail is not acceptably sharp or is of unacceptably low contrast; one whose edges are not distinct or clear. (2) ~ mask: technique to improve apparent sharpness of image.
See USM.

The costs of an undoing
Applications store previous actions in memory, either in the RAM or the hard-disk, therefore the more levels of undo you ask for, the more memory is used or – in the case of image editing – gobbled up. But remember: most actions within the operating system e.g. saves, deletes, replacing a file etc. cannot be directly undone.

Unevenness is in the eye of the device
One of the hidden traps in imaging is the subtle and usually irritating ways in which unevenness makes its presence felt – mostly late in the day. The usual problem is that something which looks perfectly smooth and even in one device or mode, becomes uneven in another. For example the slide on the light-box looks fine until you scan it or the image on screen looks fine until you print it or your ink-jet print looks great until the image is printed in a book. And the point is, you then look back at the first version and, whadyouno? you can now see the unevenness. Moral: see it before it kicks you.

U

unwanted absorption

Absorption of parts of the spectrum by a dye, pigment or filter which reduces their specificity or efficiency, and has the effect of making the colour less pure or bright than would be otherwise. * .E.g. a cyan filter or colorant should absorp only the red-orange-yellow third of the spectrum but usually also absorps small quantities of blue and green.

upload

Transfer of data from a local computer or network to another computer.

See download.

UPS

Uninterruptible Power Supply: electrical device designed to step in immediately and supply power for a short time to devices such as computers when the normal mains supply fails. * Design consists of a battery that is constantly topped up plus sensing circuits that can connect the computer to the battery immediately there is any interruption to the mains supply. There is enough power in the batteries to allow current workings to be saved before shutting the computer down normally until mains power is restored.

URL

Uniform Resource Locator: address on World Wide Web of Web site for file downloading or other resource. * It specifies (a) the protocol to be used (b) the name of the server and (c) the path, if needed.

See ftp; http.

USB

Universal Serial Bus: standard for connecting peripheral devices e.g. digital camera, telecommunications equipment, printer etc. to computer. * Carries data at up to 12 Mbps (1.5MB/sec). * As it carries power as well as data up to 127 items can be added together in a branching topology and share (all in theory) the same computer port. * USB allows for hot-plugging i.e. the connection and disconnection of the peripheral device while either or both the computer or device are on.

useful life

Period of time a chemical process, photo-sensitive material or disposable item such as a light bulb, battery, ink cartridge etc. or mechanical item can be kept or used before the item deteriorates in quality or performance below a specified limit. * The limit will vary with quality criteria e.g. how critical a feature of the performance is e.g. the useful life for a bulb

UPS the best

UPS units are the best cuddling and security blanket you can offer your computer and other equipment. And they are far superior to surge protector sockets when it comes to protection against sudden rises in voltage. If you live anywhere with wobbly mains electricity supplies do yourself, your computer and everyone a favour and get one: they cost less than a good ink-jet printer.

How long is a half?

Typically, the useful life of many things is around half the total life e.g. a print developer's useful life when made up is, say, two hours, after which its strength falls significantly below its original level (and what is industrially acceptable) but it can be used for at least another two hours with increased development time and if a small loss of contrast is acceptable. Some systems do not decay logarithmically, so the useful life can be much longer than half the total life e.g. NiCd batteries maintain their charge up to a point, then the voltage drops very rapidly.

in a sensitometer is far shorter than the same bulb used in a slide projector; the useful life of professional film is much shorter than than for amateur use.

USM
UnSharp Mask: technique for improving apparent sharpness of image. * NB: it is the mask that is unsharp; the result is an image made more sharp. *There are three main types:
(i) Digital: USM applies a Laplacian filter to remove low frequency i.e. big detail, and to pass only high frequencies or sharp detail. * Also known, in print industry, as peaking.
(ii) Analogue: the mask is made from an original negative with a spacer or diffuser in between so that the mask is unsharp. The mask and original are then printed in register: the blur caused by the unsharpness accentuates the boundary between dark and light in the image in the following way: where the image is light, the blurred mask lightens it further; where the image is dark, the blurred mask darkens it. At edges, this increases the apparent contrast between light and dark, causing the edges to look sharper.
(iii) In drum scanning, the difference between small and large aperture signals are added to the large aperture signal.

UV
Ultraviolet: radiation whose wavelength is shorter than violet – i.e. outside range of human vision – down to x-ray wavelengths. * Near UV: 400-300nm; middle UV: 300-200nm; far or extreme UV: 200nm or less. * Highly active, however: it is used in photography to harden or cure emulsions e.g. in photomechanical processes, to dry printing ink, to make exposures e.g. platinum printing and in fluorescence photography. * UV can be seen by many insects and it affects human skin e.g. to give tans.

v-number

Abbe constant. * Incorrect reading of ν-number: ν is Greek letter 'nu'.

V.32

Specification for modem allowing data transmission of up to 9,600bps with full duplex and echo cancelling to remove phone-line echoing. * Part of CCITT V-series of recommendations for standardization of protocols and specifications for modems, accepted by ITU-T and ISO.

V.32 bis

Specification for modem allowing data transmission of up to 14,400bps with full duplex and echo cancelling to remove phone-line echoing. * Part of CCITT V-series of recommendations for standardization of modems.

V.34

Specification for modem allowing data transmission of up to 28,800bps with full duplex. * Part of CCITT V-series of recommendations for standardization of protocols and specifications for modems, accepted by ITU-T and ISO.

V.35

Specification for modem allowing data transmission of up to 48,000bps but is used for rates up to 56,000bps.

V

vacuum back

Device in camera that sucks air out from behind film to pull it flat and firmly against a pressure-plate or holder. * Used in high-quality large-format cameras (and even a 35mm format camera), aerial photography, in photogrammetry, etc. where high dimensional accuracy is needed.

vacuum board

Accessory used to pull printing paper flat and firmly against a board by sucking air from the board. * Used for borderless easels when printing. * Also as vacuum frame: for high-specification printing.

vacuum deposition

Transfer of material from a source onto a surface e.g. lens, glass plate by evaporation of source in very low pressure atmosphere, sometimes with aid of heat. * Used for applying anti-reflection layers to glass. * Not favoured for precision applications as curved surfaces tend to receive uneven thickness of coating. * Also known as sputtering.

value

(1) Level of brightness of pixel or colour as defined in HSV (Hue Saturation Value) colour space. (2) Designation of lightness of colour in the Munsell system of colour nomenclature. (3) Tone or brightness of a colour as assessed subjectively: high values give light colours, low value colours are dark in appearance. (4) The step or zone which, in the Zone System, corresponds to a certain range of subject luminances. (5) Camera setting or range of settings based on scales of shutter time, lens aperture, exposure value, luminance and film speed. * Also known as APEX system.
See EV.

Vandyke

(1) Emulsion composition or paper coating characterized by use of iron with silver salts: processed to give a brown-coloured image. * Used in proofing printing plates on account of low cost due to use of iron salts. * Also known as brownprint or kallitype. (2) Map printing technique producing positive image, based on dichromated fish-glue, invented by F Vandyke, a surveyor in the India Office. (3) Earth pigment, partly organic, used in painting.

vari-focal

Adjective: ~ lens design: one in which focal length may be varied but focus changes also. * A change of focal length necessitates adjustment in focus. * Also known as multifocal or variable-focus lens – not to be confused with a zoom lens.

variable contrast

Type of emulsion coating, used mainly in black & white printing papers, in which the mid-tone contrast can be varied by changing the spectral qualities of the illumination used for enlarging.

See multigrade.

VC paper

See variable contrast.

VDU

Visual Display Unit: monitor screen with which you monitor computer activity.

vector graphics

(1) Definition of graphical elements by a programming language in terms of primitives e.g. lines which are manipulated e.g. rotated, extended, stroked etc. and areas are filled. * Such a description is said to be 'resolution independent'.* Literally: vector is a quantity with magnitude and direction. * PostScript is the best-known vector-based programming language. * Vector-based files usually have to be interpreted or rendered into bit-mapped files for use in e.g. printing or viewing. * Also known as page description language; object-oriented graphics. (2) Type of display in which the graphics are described mathematically.

See bit-mapped; PostScript; primitives; RIP.

veiling

(1) Noun: low level of fog in print or negative, covering a part or over the whole of an image. * Also known as veil.
(2) Adjective: ~ flare: internal light reflections in optical components which cause a slight fogging or loss of contrast, and raising of minimum density (i.e. shadows are less dark) over the whole or a part of an image.

vertex

Point where the optical axis enters the surface of an optical component e.g. on convex lens it is the highest point on the surface, on a concave lens, it is the lowest point on the surface. * Also known as the pole. * Plural: vertices.

VESA

Video Electronics Standards Association: organization gathering manufacturers and re-sellers and devoted to coordinating standards for video and multimedia.

VGA

Video Graphics Array: a display standard for PC computers, capable of showing 256 colours at a resolution of 640 pixels by 480 lines. * Downwardly compatible with all previous PC

We'll see you again, maybe never
Talk about VDUs and you will mark yourself out as an Ancient, one who might have actually owned and used a BBC Microcomputer or even the Sinclair Z-something. Oh, yes, VDU is a hang-over from them misty days when the ability to display anything from a computer was something to discuss over coffee.

video standards namely MDA, CG and EGA. * May be enhanced to SVGA standard.

vertical justification

Process, in desktop layout applications and typography, of adding or subtracting spaces between lines of text in order to ensure all columns are the same depth.

video card

Component that is carried on an expansion board and plugs into the mother-board designed to carry out the computing needed for the monitor display. * It will usually carry a specialist video processor as well as dedicated video RAM: it makes all the difference to how quickly the monitor screen, particularly a very large one, re-draws and responds. * Also known as video adaptor, ~ board, display adaptor.

See VRAM.

videocapture

(1) Noun: the process of collecting the data for a given frame of a video film, recording or broadcast in order to produce a stills image. * Also known as videograb. (2) Adjective: ~ board, ~ attachment: expansion board that fits onto a computer's main motherboard, or an accessory that fits between video source and computer, used to capture a single frame of a video source or collect data for a given frame of video.

vidicon

Design of camera tube using antimony trisulphide layer scanned by low-power electron beam.

view

(1) Noun: appearance, arrangement or composition of a scene or subject for photography. * Depends on factors e.g. (a) perspective or viewpoint of camera i.e. position and distance between camera and subject (b) disposition of elements in the subject being viewed (c) focal length of lens in use (d) format ratio of image as set by film or film gate (e) effect of atmosphere or other medium between camera and subject (f) use of filters or other distorting effects. Verb: (2) To look at or watch a film or broadcast, etc. usually in sense of careful or critical observation. (3) To look at or examine an image through some device e.g. stereoscopic viewer, binoculars, etc.

view camera

Design of camera in which the lens and film holder are held on movable panels which can be tilted, rotated and shifted to control the shape, focus and placement of the image.

* Usually applied to large-format – 6x9cm and greater – cameras with lens and film holder standards or panels sliding on a common rail, with a flexible bellows connecting lens and film holder, the whole being used on a tripod or studio stand.

viewing distance

The distance between an observer and the object being viewed. * With unaided eyes, it varies from infinity to the closest viewing distance, usually at least 250mm. * 'Correct' viewing distance for a print i.e. to reproduce perspective as seen by the lens equals the focal length multiplied by the magnification factor for the print e.g. for an image taken on a 17mm at 10X enlargement, the correct viewing distance is 170mm. * NB: this is of course a much closer viewing distance than normal viewing.

viewing filter

Transparent dyed or coated glass or plastics material used to (a) simulate effect of certain film or lighting e.g. red or amber filter simulates the tonal rendering of colours in black & white materials: largely obsolete (b) improve focusing accuracy in black & white printing when a blue filter is used in conjunction with a poorly corrected enlarging lens: largely obsolete as most modern enlarging lenses are adequately corrected for chromatic aberration.

viewing lens

The upper of the two optical systems in a twin-lens reflex camera, through which the subject is composed and focused. * Its focal length is carefully matched to that of the taking lens, but is usually of smaller maximum aperture, at which it is always used.

viewing screen

See focusing screen.

vignetting

(1) Defect of optical system in which light at corners of image are cut off or reduced by obstruction or restriction in construction of optics e.g. elements used are too small or lens barrel is too long and narrow. * Also occurs when lens attachment is too deep for angle of view of lens e.g. the incorrect lens-hood. (2) Creation of darkened corners to the image e.g. during darkroom printing or by using lens-mounted accessories: the intention is to help frame the image or soften the frame outline. (3) Using a small part of an image or small element to decorative effect.

See fall-off.

View camera lesson in one minute

Shifts of lens or film standards (vertical or sideways movements at right angles to the main optical axis) have the effect of changing position of image. Tilt (rotation about a horizontal axis) or swing (rotation about a vertical axis) of the front standard mostly controls placement of the plane of best focus. Tilt or swing of the back or film standard mostly controls the shape of the image: for the image to be undistorted, the back must be parallel to the front of the image. The most important movement is changing the distance between the two standards, which focuses the image. NB: view camera lenses are specially designed to give a larger image circle than the format, in order to accommodate the movements.

V

violet

Bluish to red-blue colour. * Corresponds to shortest wavelengths of visible light, around 400nm.

virtual

Adjective: (1) ~ image: one constructed from extension or geometrical projection of the path of light rays, not from convergence of actual rays of light. * Where optical system gathers the diverging bundle of light rays from a subject and turns it into a divergent bundle: the image appears at the apparent source of the bundle. * E.g. the reflected image in a mirror is virtual: there is no light 'behind' the mirror. * Antonym: real. (2) ~ reality: computer construction of imaginary or reconstruction of real spaces to simulate experience of three dimensions. * May include controls or navigation through the 'space' based on human movements e.g. follows turning of head or responds to changes in body's position.

virtual machine

Software-based environment within an operating system in which software belonging to another operating system can run. * E.g. Java virtual machine enables Java applications to be run in Mac OS, Windows, etc. similarly with applications such as Virtual PC, which enable e.g. Linux, Windows to run within Mac OS.

virus

Small program designed to enter a computer system undetected and then cause a nuisance or worse; thousands are known for PC-compatible machines. * Can infect a computer (a) when floppy or other disks are shared (b) when files are downloaded from the Internet (c) when files are shared across a network from an infected source (d) when attachments to emails are opened or downloaded (e) as macros to application program. * The (relatively few) viruses that infect Mac OS machines may also be referred to, inaccurately, as 'worms'.

visual

Adjective: (1) Relating to or derived from human vision e.g. visual cortex is part of brain devoted to visual perception. (2) ~ aid: graphic, design or other illustration used to guide, educate, inform etc. e.g. LCD screens on cameras are visual aids to controlling cameras. Noun: (3) Rough, draft or preliminary layout or sketch used as guide for final artwork or as aid to discussion, as stage in evolution of campaign, book, etc.

visual purple

Pigment found in rod cells of the retina of the mammalian eye which responds to light. * Purple, i.e. red-blue, in colour. * Also known as rhodopsin.

volatile

Adjective: (1) ~ liquid or other substance: one that is easily converted to vapour or gaseous state. * Photographic cleaners e.g. isopropyl alcohol are volatile liquids. (2) ~ memory: electronic memory that is stable – i.e. keeps its data – only with continued application of a steady voltage e.g. RAM is volatile memory (it disappears when computer is turned off) but CD-ROM is not.

voxel

Volume picture element: obtained by stacking multiple planes of pixels to fill a 3-D space. With the vertical interval equal to the pixel dimensions, the voxels are cubic which is usually the case but with e.g. computerized tomography it may not be because some scanning processes produce wedge- or rectangular-shaped voxels. * Used to create solid representations from a series of 2-D scans.

VRAM

Video Random Access Memory: specialized high-speed RAM designed to allow the video processor controlling the image on a monitor screen direct access to memory. It is usually located on the video card. * Generally designed for serial access (not parallel as in usual RAM) as this suits computing for the display.

How much VRAM?
2MB VRAM can give millions of colours up to a resolution of 832x624; 4MB VRAM can give millions of colours up to a resolution of 1024x768; 8MB VRAM is needed to give millions of colours at higher resolutions (these figures assume a vertical screen refresh rate of about 75Hz). 16MB is needed by cards designed to run the highest resolutions (1600x1200 at 75MHz or more), games and videos – but a whopping 64MB VRAM is not unknown for avid gamers and graphics-junkies.

waist-level

Type of camera viewfinder in which the photographer looks downwards directly onto the camera's focusing screen, which is held on the chest (usually above waist-level), pointing forwards. * Derived from early Box Brownie cameras which were indeed held at waist-level, and applied to classic designs such as Rolleiflex and Hasselblad. * Also applied to viewing option in certain SLR cameras with removeable pentaprism e.g. Nikon F2, Canon F-1, etc.

walk-through

Step-by-step description of how image or graphic manipulations, effects, software, settings, etc. were applied to create an image, design, Web page or other output.

wand

See Magic Wand tool.

warm

Adjective: (1) ~ colours: those colours ranging from reds through oranges to yellows. * A warm colour cast appears acceptable in more circumstances than a cold colour cast. (2) ~ tone: black & white print which is somewhat yellow to red in tone i.e. very slightly coloured, particularly in mid-tone region. * Antonym: cold.

warm-up

Time required by sensitive material, detectors, processing or other equipment to reach stable or working temperatures e.g. film taken from freezer needs warm-up time to reach room temperature; photo-detectors usually need many minutes to reach the circuit and thermal stability needed for reliable measurement.

warping

Image manipulation technique which distorts the overall shape of an object, usually in a controllable way e.g. by laying an imaginary grid over the image so that when the grid is changed in shape, the image is distorted to the same extent. * May be used synonymously with morphing.

wash

(1) Noun: use of clean water to remove chemicals or debris from material during or at end of its processing e.g. removing fix from film prior to drying. (2) Noun: bath of clean water used to dilute or remove unwanted chemicals from a material during its processing. (3) Verb: to use clean water or other suitable solvent or dilutant to remove unwanted chemicals during or after processing. (4) Light or pastel colours applied to a substantial part or the whole of an image.

wash-aid

In film or paper processing: an alkaline or salt bath that increases the solubility of fixer and its products to make it easier to remove fixer during washing. * Unlike hypo-elimination, wash-aid does not react chemically with hypo. *See hypo-eliminator.*

washed-out

Adjective: ~ photograph, ~ print, ~ image: one which exhibits, in whole or in part, colours which are low in saturation and/or contrast or tones which are low in contrast and too light in density.

washing-aid

See wash-aid.

water spot

Defect on processed films caused by differences in drying rates due to uneven distribution of water. * Most often seen in negatives: a drop of water that is slow to dry tends (a) to leave gelatin that is slightly less compact than faster drying gelatin, thus leaving a slight swelling in the emulsion (b) to allow movement of silver particles through the wet gelatin, causing local change in density.

water-bath

(1) Development process in which exposed material is given a water-bath after the first development step. * During this immersion, developer in the less exposed – i.e. the less dense areas – is less exhausted than in denser areas, so it continues to develop the image: this is said to improve shadow detail in negatives, to improve highlight detail in prints. (2) Quantity of water surrounding a container for developer, etc., which is used to maintain the temperature of the container, hence that of the developer solution.

Waterhouse stop

Disc drilled near its circumference with a circular hole used to change the effective aperture of an optical system. * May be made as a disc with several, different sized holes drilled around its circumference. * Used e.g. in optical experiments and photomechanical cameras where the aperture must be perfectly circular and of high precision.

waterless off-set

Type of inking system in which water is not used to control the consistency of ink on off-set presses. * Leaving out the water obviously allows faster drying; it can also support higher screen rulings i.e. print finer detail.

See dot gain.

watermark

(1) Slight thinness in paper produced during manufacture: used to identify maker or type by creating a design on the wire side of paper-making frame.* By extension, a symbol or words lightly superimposed on the normal print produced by a printer: used to identify the output as e.g. 'draft' or 'confidential'. (2) Element in a digital image file used to identify the copyright holder. * A visible graphic element is created that (a) renders the image unsuitable for reproduction and (b) cannot easily be removed but allows the image to be judged for suitability. * This discourages copyright infringement (but also discourages legitimate use). * Compare with fingerprint, which is an invisible component of digital file. (3) Defect on negative or print caused by deposition of solutes as water dries out, usually deposited on the film side.

See encryption; fingerprint; steganography; water spot.

wavelength

Distance in free space between two successive points at the same phase on the wave e.g. distance between successive peaks of the wave.

W

wavelet compression

Mathematical technique for expressing data in a form which reflects the changes in the values from a computer 'average', rather than the raw numbers themselves. * Applied to complex data structures, great economies can be made in coding the data: this is used in new JPEG2000 standards being adopted which can give enormous data compression. * Also known as sub-band compression.

wax thermal

Printing system based on melting of solid wax colours which are then squirted or transferred onto a receiving layer. * Wax colours are stored in sheets or cakes of colour and melted as required with tiny pins which heat up and apply a dot of colour, usually in three or more separate passes – one for each separation colour. * Capable of vivid colours, prints on most stock and is close to photo-realistic but limited in resolution. * Printers usually less expensive than other types.

weak

Adjective: (1) ~ print, ~ negative: one that is low in contrast and density. (2) ~ substance (usually dissolved): low in strength or chemical activity or concentration. (3) ~ optical system: one of low power. (4) ~ lens (simple i.e. not compound): one of low curvature. (5) ~ picture composition: disorganized composition or not well composed. (6) ~ digital effect, ~ tool: one having little or subtle effect on an image.

web press

Type of printing press in which paper is fed from rolls of paper – the web. * In contrast to the other type of press, the sheet-fed press. * As a lot of paper is used on larger presses just to get it going, it is uneconomical for short runs.
See off-set.

web off-set

Web off-set lithography press: one that uses off-set printing processes i.e. the printing plate does not make direct contact with the paper.

Weber's Law

The increase in strength of a stimulus to be just perceptible is directly proportional to the strength of the original stimulus e.g. if original stimulus is dark, the increase in light required to be just perceptible is very small; if the original stimulus is very bright, increase in light required is large. * The response to a stimulus is proportional to the logarithm of the stimulus. * Applies only to a limited range of perception.
See Fechner's Law.

wedge

(1) Optical component with gradient of densities e.g. filter that is denser at one end than another, with a smooth or stepped transition in between. (2) Thin prism used to rotate light beam by a small angular displacement as used e.g. in close-up attachment of twin-lens reflex camera.

See step wedge.

weight

(1) Measure of thickness and density of paper stock based on weight of 1 square metre of the stock. * Abbreviation: gsm. (2) Mass of an object multiplied by the acceleration due to gravity. (3) Object of known mass used to measure unknown quantity using e.g. balance. (4) Indication of thickness of line or stroke in e.g. graphics or desk-top publishing program.

See double-weight.

wet

Adjective: (1) ~ process: one which uses water or other solvent in which development or other transformation takes place. (2) ~ digital effect: one which mimics the use or addition of water to artistic media e.g. watercolour.

wetting agent

Chemical used in film processing to improve drying of film by encouraging water to spread evenly. * It is added to the final clean water wash. * Usually a surfactant, such as liquid soap, it reduces the surface tension of the water and improves its adhesion to a surface.

white

Adjective: (1) ~ object, ~ pigment or ~ surface: that which reflects high levels of incident light and all visible wavelengths more or less equally e.g. snow, white sand, white paint. (2) ~ light-source: one whose light has no identifiable colour. * One which emits light whose energy is distributed more or less evenly through the visible wavelengths. (3) ~ balance: the relative amounts of red, blue and green in a light-source. The measure of ~ balance enables an image sensor to correct for colour imbalance. (4) ~ point: pixels with maximum values in red, blue and green. Noun: (5) Name of the visual sensation of bright light that is without perceptible or noticeable hue. (6) Pixel whose additive RGB values in each channel are more or less equal and high e.g. 250 251 249. (7) Inked patch or area of four-colour print in which the CMYK values are all zero or very low, e.g. 3 3 2 5.

W

white component

That portion of colour of a light-source that tends to lower the saturation or dilute the colour of a specified other light-source when the two are mixed. * E.g. the green portion of cyan (blue-green) coloured light tends to lower the saturation of red light; green is the white component of cyan in respect of red.

See grey component.

whitener

Substance added to improve the appearance of whiteness of e.g. paper. * Used to improve highlight (zero density) areas of black & white or colour print. * Usually a fluorescent compound that re-radiates radiant energy as blue light is used. * Also known as optical brightener.

wide array

Rows of photo-sensors laid side-by-side in a grid pattern to cover an area. * Used in e.g. most digital cameras.

See array.

wide-angle

(1) Optic with greater angle of view than that of a normal lens for a given format. (2) Optic with focal length significantly less than that of a normal lens for a given format. * NB: both these definitions are functionally identical. * E.g. an optic of 40mm focal length has a 90° field of view on the 6x6cm format compared to the 52° of the normal 80mm lens. (3) Optic with greater angle of coverage than that usual in lenses for a given format e.g. optics designed to allow for shift or tilt movements must cover a greater area than the standard film format. (4) Projection lenses which project a larger image than normal for a given throw (distance between projector and screen).

wide-angle lens

A lens whose effective focal length (efl) is considerably shorter than the diagonal dimension of the image it forms. * Also known as short focus lens.

wideband

Adjective: (1) e.g. ~ colorimeter, ~ densitometer: covering or measuring over a wide range of colours. (2) ~ filters: affecting or producing a distribution of spectral energy over a wide range of wavelengths. Noun: (3) Frequencies covering an extensive range. (4) Data transmissions at high rates. * Synonymous with broadband.

widescreen

Cine or slide projection screen designed for images whose

aspect (width-to-height) ratio is significantly greater than normal e.g. 16:9.

Winchester

Generic term for hard-disk drive based on IBM's 30/30 drives.

window

Noun: (1) Rectangular frame on the screen of computer software that 'opens' onto applications: operations take place within a window. * Several windows may be open at any time but usually only one will be 'active' at a given time. * In multi-tasking environments, two or more windows can be active in the sense that operations can take place simultaneously in each window e.g. an image file is changed in size while a word-processor file is being printed. (2) Aperture – usually rectangular, possibly circular or oval – cut in board or similar material through which a print or picture is framed. (3) Aperture or opening in a camera to reveal e.g. frame counter, markings on film canister or back of roll-film (obsolete), etc. (4) Field of view of apparatus e.g. stereo-viewer. (5) Portion of visible spectrum that is least absorbed by a medium. e.g. blue-green light is transmitted best in seawater, red-orange is transmitted best by dusty or moisture-laden air, hence colour of sunsets.

Windows

Proprietary name for a family of applications program interfaces developed by Microsoft. * Sometimes erroneously regarded as an operating system, it is in fact software that provides a graphical user interface, such as it is, between the user and the underlying operating system as well as a standard for the interface between user and application programs.

See GUI.

Windows applications

Applications software e.g. word-processing, spreadsheet, database, communications etc. that can be used only within the software environment provided by the Windows graphical user 'interface'. * Windows must be running before these programs can be used: as pay-off, they may then share features such as some commands, the ability to exchange data directly and also to share common resources such as fonts, parts of code etc.

winterize

Technical adaptations to prepare apparatus for use in extremely cold conditions. * Applied particularly to use of lenses and cameras: now largely obsolete as modern

You really don't need to know this

But I bet this is all you remember. The Winchester is associative slang from IBM's unthinking designation of its 30MB discs as the 30/30. As every schoolboy used to know, that's the calibre of the Winchester rifle beloved of cowboys (and Injuns). You can guess the rest. Unfortunately, the only people who talk about Winchesters meaning disk drives have grey hair, if any, and are about to, well, go the way of the Winchester itself.

equipment generally uses silicone-based or polymer greases which are less affected by cold than petroleum-based greases or lubricants.

wipe

(1) Transition from one frame or image to another in which vertical line scans across the original image or 'wipes' like a windscreen wiper, replacing the original with the new image as it travels. * Effect first used in cinematography, adapted for animation, multimedia and business presentations.
(2) Process of destroying or erasing all electronically stored data from e.g. hard-disk.

wire-frame

Representation of a 3-D model by a grid of lines which envelopes or encloses the shape.

Wood lens

See radial gradient lens.

Woods glass

See cobalt glass.

work-station

(1) Powerful, stand-alone computer i.e. with fast, often multiple, processors, large amounts of RAM etc. usually designed for specialist applications e.g. animation creation, 3-D rendering etc. (2) Complete set-up of computer directly connected to all the input and output devices it needs to carry out its tasks e.g. digital imaging work-station may include, besides basic computer, DVD-RAM writer, film-scanner, flat-bed scanner, film-writer, graphics tablet and so on. (3) Computer terminal connected to a network, often with limited resources if e.g. it relies on network for e.g. mass data storage.

workflow

Description of the structure of a process to determine (a) key events on which other events depend (b) bottle-necks which set the maximum rate at which work may proceed (c) work-loads of personnel involved (d) points at which supplies or other input must be delivered to ensure smooth progress (e) redundancies or duplication of effort.

working

Adjective: (1) ~ strength, ~ solution: chemical made up or diluted to the concentration required to work to specification. (2) ~ temperature: chemical warmed up or cooled down to the temperature required to work to specification. (3) ~ file: copy of a digital file on which adjustments, etc. are made, leaving the original untouched.

(4) ~ print: one used as a basis for making further or multiple prints or copies.

working distance

Gap or distance between the object being viewed and the part of the optical system nearest the object. * Use of lens-hood or other accessories will reduce the working distance in close-up photography.

worm

(1) Write Once Read Many: data storage device whose data cannot be changed after it has been recorded e.g. CD-ROM. * WORM devices which are reliable are regarded as archival processes. (2) Virus program which copies itself on an infected disk: it may do so until it fills all available space, so causing the system to crash. * So-called because it may be written in separate parts which can join up.

write

Verb: (1) To transfer, encode or lay down data onto an electromagnetic medium e.g. to hard-disk, for later access. (2) To expose film or other light-sensitive material using a progressive or scanning method as e.g. in film-writer or machine printing. (3) To create a CD-R, CD-RW, MO or DVD disc by using laser light to burn data onto the medium, for later access. (4) Display of data on e.g. monitor screen. Adjective: (5) ~ protected: lock or key which prevents data on a disc being written to or existing data being altered. * May be implemented by physical switch or catch; or by software instruction which may be password protected.

wrong-reading

Image, text etc. that is laterally reversed, usually with respect to emulsion side facing the reader. * Used in pre-press or printing work to describe appearance of film or plate when correctly set up e.g. 'emulsion-up wrong-reading' means 'where the emulsion side of the film faces upwards, the text should be laterally reversed (i.e. not right-reading)'. * Also known as reverse reading.

WWW

World Wide Web: all the documents stored on server computers around the world which may be accessed through hypertext transport protocol (http) links in which documents provide links to other documents. * The most visible portion of the Internet, carrying information, advertisements, entertainment, pornography, etc. * The totality of hypertext-linked HTML documents containing text, images, animations, interactive forms, music, video,

Too close for comfort

Working distance is generally applied to close-up photography, but also very relevant when working in smaller studios. For some portraiture, you may not want to be breathing down the forehead of your subject, but put some formal distance between lens and their noses. And don't forget you can't get a full-length shot without a bit of room behind you, so working distance may apply backwards as well as front-endedly.

W

small applications etc. which are stored on HTTP servers around the world and are all accessed through addresses conforming to the URL specifications.

WYSIWYG

What You See Is What You Get: feature of computer interface that shows on the monitor screen a good (but seldom very accurate) representation of what will be printed out. * To distinguish from character-based or plain text displays (which could not display e.g. different sized, bold or italicized text) from those that could display such differences directly. * Popularized by the first Apple Macintosh computers of 1984 and now taken for granted, but computing power required is onerous – hence demand for graphics accelerators. * Approximation of screen image to print-out can lull users into a false sense of security or lead to disappointment when printed image fails to match vigour of screen image.

See calibration; graphics accelerator; GUI.

X-axis

(1) The horizontal line at the bottom of a graph, indicating e.g. the input values. (2) The width dimension in graphics, etc. (3) In aerial photography, the line of the aircraft's flight.

X-synch

(1) Shutter mechanism or technique for synchronizing shutter run with electronic flash in order to ensure even exposure of film to the flash. * With diaphragm shutters the flash is fired as soon as the shutter is fully open. * With focal-plane shutters, the flash is generally fired as soon as the first curtain has traversed the width of the film gate: the X-synch time is therefore the shortest time setting at which the first curtain has exposed the film but the second curtain has not started to cover the film. (2) The shortest or briefest shutter time setting at which X-synch can be reliably achieved.

See peak.

x-y scanner

Flat-bed scanner whose scanner head can be moved to provide high resolution anywhere over the scanning area.

xenon

Inert elemental rare gas. * Widely used in the flash-tubes of electronic flash-units.

Y

Yellow: the yellow separation colour in CMYK reproduction.

Y-axis

(1) The vertical line at the left of a graph, usually indicating the output values. (2) The height dimension in graphics, etc.

YCbCr

Colour representation system very similar to YIQ. * Y is the luminance (brightness) component and Cb and Cr are the chrominance (colour) values.

YCC

Image file format, proprietary to Kodak: used for Photo CD. * Similar to L*a*b colour space.

yellow

Noun: (1) Name for the visual sensation associated with wavelengths of light between green and red, *viz* between 570 and 590nm. (2) Colorant used in colour film to adsorb blue light. * Hence also referred to as minus-blue. (3) One of the separation colours used in 4- or 6- colour reproduction. * The angle for the screen corresponding to yellow is usually 90°. (4) Verb: (of photographic print or paper, etc.) to change colour from white to cream or off-white as a result of deterioration or chemical changes in contaminants due to imperfect processing.

Yellow Book

Standard for storing data on standard CD-ROM. * Derived from the Red Book, it defines two modes, one for data, the other for music or video, plus a third level for error correction.

yellow spot

Disc of 3 mm-5 mm diameter, coloured yellow by a pigment: it lies at the rear of the eye just below the optic disc (where the optic nerve enters the eye). * The fovea, the region of highest visual acuity, with the highest concentration of cone cells, lies in the centre of the yellow spot. * Also known as the macula lutea of the retina.

See fovea.

YIQ

Colour model used for NTSC i.e. the domestic television standard in USA. * Y is luminance – the most important component carrying the brightness information; I and Q carry the colour information or chrominance components.

Young-Helmholtz

Theory of colour vision: its main hypothesis is that colour vision is enabled by the three types of retinal receptors respectively sensitive to red, blue and green light.

Z-axis

(1) Line perpendicular to the plane containing the X and Y axes, which is conventionally taken as the plane facing the viewer. * Usually used to measure a third dimension or variable. * But note: (2) In aerial reconnaissance etc., the Z-axis is perpendicular to the earth's surface or to the plane of the flight path. * Also known as depth axis.

zenith camera

Specialist equipment used to locate precise position of observer on earth: it photographs the night sky to record the star field, from which its position can be calculated, given date and time. * Do not confuse with Zenith cameras, the workable, cheap but unlovely cameras formerly manufactured in the Soviet Union.

zero

(1) Verb: to centre a needle, pointer or LED on a scale or other indicator in order to set camera controls such as shutter time or aperture. (2) Noun: mark or other indicator used to show either control is not in use e.g. exposure override or that a camera movement or setting is centred e.g. on view camera.

zip

Process of compressing or shrinking the size of a digital file. * Decompressing a zipped file is called unzipping.

Zip drive

Brand of removable storage device: each 3.5" disk holds up to about 100MB (94MB of data), depending on formatting.

zone

(1) Ring-shaped region concentric with the optical axis of a lens. * Concept used for optical calculations e.g. zones at different distances from the centre may have different focal lengths, giving rise to spherical aberration. (2) Logical group of network devices or a network under control of an authority or administrator.

zone focusing

Technique of pre-setting focus of lens for a certain distance in anticipation of action or movement taking place within a zone delivering an image of acceptable sharpness. * Used e.g. in close, fast-moving situations such as crowds where there is no time, even for auto-focus mechanisms, to focus each shot. * Much reliance is placed on depth of field for acceptably sharp images so it is most often used with wide-angle lenses: auto-focus should of course be turned off. * Do not confuse with pre-set focus.

zone plate

Component with etched or deposited concentric lines of various thicknesses. * Behaves like a lens when illuminated with coherent light.

Zone system

Technique or methodology for camera exposure and development control of black & white materials based on the concept of change of density in steps of one whole stop change in exposure – the 'Zone'. * Nominally, there are 10 Zones; in practice a very good print exhibits perhaps 9 zones. * Zones are numbered 0 to X: Zone I is shadow with no detail, Zone V is middle grey in a print, Zone X is highlight with no detail visible. * Each step represents a difference of one stop in exposure e.g. from $f/4$ to $f/5.6$ with constant shutter time, or $^1/_{30}$ sec to $^1/_{60}$ sec with constant aperture. * Enunciated by Ansel Adams, refined by Minor White.

zoom

(1) Adjective: ~ lens: type of optical instrument in which focal length or strength of the optic may be varied without substantial change in focus. * Range of focal length is fixed by design e.g. in camera lenses: 17mm to 3 mm, 50mm to 300mm. * The effective aperture of the lens may change with in focal length and may also vary with focused distance. Verb: (2) To change the set focal length of a zoom lens. (3) To change the size of an image as it is displayed on screen. * This does not affect the image file itself but only its representation on the monitor.

See vari-focal.

biblio-graphy

Cotton, Bob and Oliver, Richard
The Cyberspace Lexicon: an illustrated dictionary of terms
Phaidon
London, UK
0 7148 3267 7

> Numerous illustrations and hyperactive layout make for a restless read but it is a veritable visual source in itself. Well worth dipping into and it's hard not to learn something new.

Clugston, Michael J
The New Penguin Dictionary of Science
Penguin
London, UK
0 14 051271 3

> A model of clarity and rigorously concise writing: sound on physics but non-scientists may not have much fun with it.

Groff, Pamela
Glossary of Graphic Communications
Prentice Hall
Saddle River, NJ, USA
0 13 096410 7

> Excellent example of the comprehensive specialist glossary: definitions are brief but sound.

Hansen, Brad
The Dictionary of Multimedia Terms & Acronyms
Fitzroy Dearborn
London, UK
1 57958 084 X
Up-to-date on Internet and multimedia, aimed slightly high at the more knowledgeable reader with extensive appendices listing Java instructions and HTML code, etc.

Hale, Constance
Wired Style Principles of English Usage in the Digital Age
HardWired
San Francisco, USA
1 888869 01 1
Wacky reference on the digitally 'in' terms – hence already somewhat out-of-date but an amusing diversion to trawl through.

Heid, Jim
MacWorld New Complete Mac Handbook
IDG Books
Foster City, California
1 56884 484 0
How can anyone know so much about a computer? How can anyone write so much? Sadly great chunks are now obsolete but it still contains much that is useful.

Hunt, RWG
Measuring Colour
Ellis Horwood
Chichester, UK
0 13 567686 X
Just about anything and everything you need to know about colour, and a good deal more than you'd ever want to know. Awe-inspiring depth of knowledge second to none in this area.

Microsoft Press
Microsoft Press Computer Dictionary
Microsoft Press
Redmond, Washington, USA
1 57231 446 X
Comprehensive, even-handed and very useful. A searchable CD accompanies the book, which is regularly updated.

Nelson, Mark
The Data Compression Book
M&T Books
New York, USA
155851 216 0
> *Essential reference to this specialized area of computing on which so much work depends.*

Ray, Sidney F
Photographic Imaging and Electronic Photography
Focal Press
Oxford, UK
0 240 51389 4
> *More encyclopedia than dictionary: it is strong where entries can be more leisurely and long-winded but shorter definitions are often illuminating only to technophiles.*

Ray, Sidney F
Photographic Technology & Imaging Science
Focal Press
Oxford, UK
0 240 51389 4
> *Good on the photographic technology but not so hot on the imaging sciences. Lengthier entries are helpful but the shorter definitions presume technical knowledge – or demand a lot of digging around.*

Ray, Sidney F
Photographic Lenses and Optics
Focal Press
Oxford
0 2405 1387 8
> *Excellent little reference by an author utterly at home in his subject: should be on all photographers' shelves. Like other volumes in the series, the lengthier entries are more useful than the brief ones.*

Pfaffenberger, Bryan
Computer & Internet Dictionary
Que Corporation
Indianapolis, USA
0 7897 0356 4
> *Well-written dictionary which has now unfortunately outgrown its original compact and easily pocketed format.*

Shnier, Mitchell
Computer Dictionary Data Communications, PC Hardware, and Internet Technology
Que Corporation
Indianapolis, USA
0 7897 1670 4

Idiosyncratic dictionary: very good indeed where it has an entry at all but its many omissions, even within its own field, are by equal measure disappointing.

Stroebel, Leslie and Todd, Hollis N
Dictionary of Contemporary Photography
Morgan & Morgan, Inc
New York, USA
0 871000 065 2

Safe, sound and solid as ever from these authors: clear definitions, excellent coverage but rather hampered by its lack of depth on digital matters.

Saxby, Graham
Practical Holography
Prentice Hall
London, UK
0 13 6937797 7

Apart from being the best general introduction to holography there is, it throws light on many aspects of optics. The glossary is a lesson to us all on how to do it.

Walker, Peter
Chambers Science and Technology Dictionary
W & R Chambers
Edinburgh
0 85296 151 1

Wide-ranging coverage but probably more useful as a reminder to those who know a bit than as a starting point for understanding.

Wiener Grotta, Sally and Grotta, Daniel
The Illustrated Digital Imaging Dictionary
McGraw-Hill
New York, USA
0 07 025069 3

Prolix entries and too many self-indulgently rambling ones obscure a useful contribution. Helpful with explanations of menu items and tools, but dominated by Photoshop.

thanks

I am pleased to thank Dr Miles Weatherall for the help, provided many years ago, which laid the foundation, and provided the impetus, for this work.

Many are my debts to those students and colleagues (you know who you are) at the University of Westminster who have helped make scholarship and research a joy.

To Louise Ang goes my admiration for her speedy yet careful layout work. Gary Jones deserves the credit for making me complete the task.

My thanks to the proof-readers, especially Gillian Kemp, who ensured the work was more accurate than I could have made it. Any errors which remain are entirely my fault – probably for not taking their advice.

Finally, to Wendy there can be no thanks enough for providing me with the total encouragement and environment that I need to get any work done at all.

Tom Ang
London
2001

771 Ang
Digital
 photography.